TOULOUSE-LAUTREC & HIS WORLD

TOULOUSE-LAUTREC & SU ÉPOCA

TOULOUSE-LAUTREC & SON ÉPOQUE

TOULOUSE-LAUTREC & SEINE ZEIT

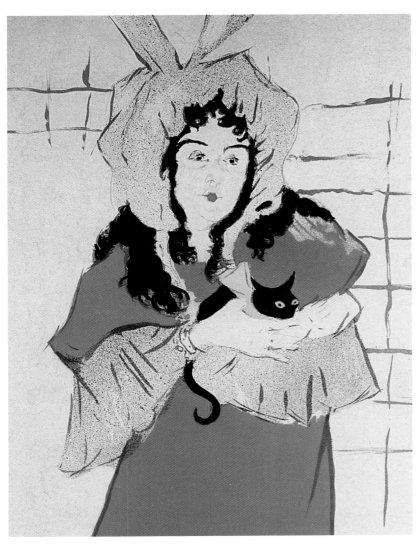

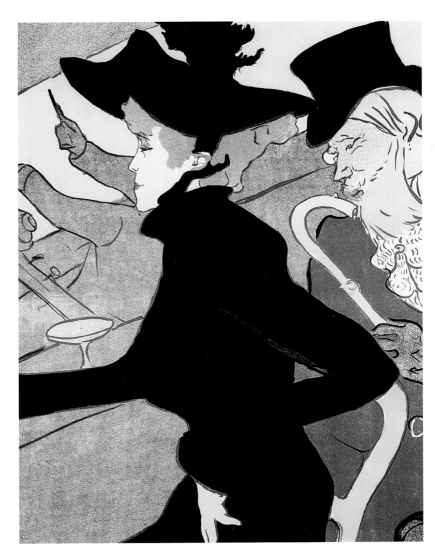

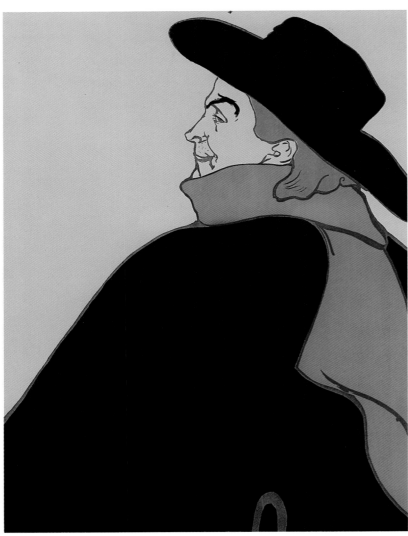

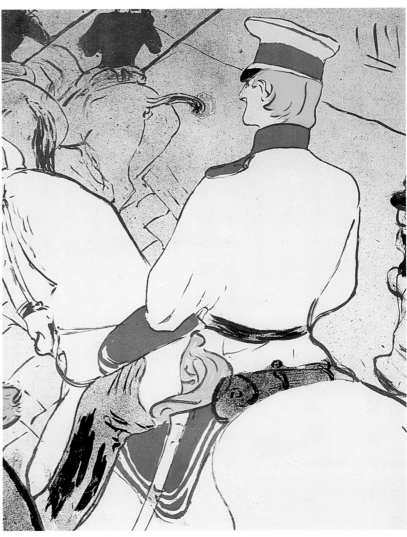

TOULOUSE-LAUTREC & HIS WORLD

WITH AN INTRODUCTION BY MARIA-CHRISTINA BOERNER

VIVAYS PUBLISHING

Published by Vivays Publishing Ltd
www.vivays-publishing.com

Copyright © 2012 Illustrations provided by Museum Herakleidon, Athens, Greece www.herakleidon.com
Copyright © 2012 Introduction text, Vivays Publishing Ltd

This book was produced by Vivays Publishing Ltd, London

A catalogue record for this book is available from the British Library

ISBN 978-1-908126-39-9

Editorial co-ordination: Klaus Kramp, Cologne
Introduction by: Maria-Christina Boerner, Rennes
Translation into German: Ursula Fethke, Cologne (Captions)
Translation into French: Michèle Schreyer, Cologne
Translation into Spanish: LocTeam, Barcelona
Translation into English: First Edition Translations Ltd, Cambridge (Introduction)

Photographer: Evangelos Fragoulis
Colour separation: Nicholas Kapernekas
Design: Ian Hunt
Printed in China

All Toulouse-Lautrec art images are from the collection of the Herakleidon Museum.

Travelling exhibitions organized by Pan Art Connections Inc.
www.pan-art-connections.com

Contents

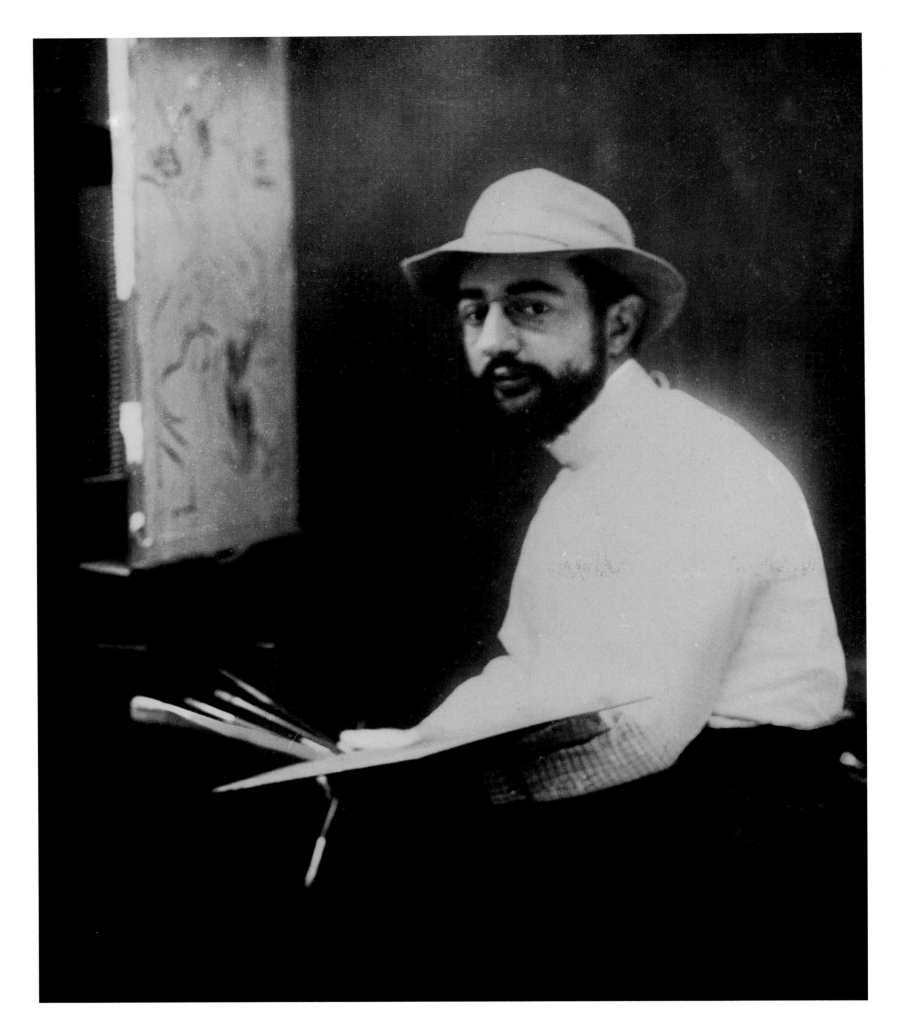

Henri de Toulouse-Lautrec

c. 1894

Toulouse-Lautrec sitting in front of his easel.

Henri de Toulouse-Lautrec

c 1894

Toulouse-Lautrec ante su caballete.

Henri de Toulouse-Lautrec

vers 1894

Toulouse-Lautrec assis à son chevalet.

Henri de Toulouse-Lautrec

um 1894

Toulouse-Lautrec vor seiner Staffelei.

Introduction
Maria-Christina Boerner

In 1893 Félix Fénéon, despite being an impassioned advocate of the Neo-Impressionists, felt compelled to comment in the anarchist weekly *Le Père Peinard*, "This Lautrec is damned brazen; he couldn't care less about outlines or colours. He has a penchant for massive blotches of red, black and white and basic shapes". Fénéon later went on to accuse the artist, whose posters had been causing a great stir in the French capital for two years, of "wilfulness, insolence and spite".

Of course, the critic's stern verdict was due not only to Toulouse-Lautrec's daring, innovative style, but also to his often salacious subjects, taken from Paris's nightlife scene. The anti-bourgeois, rebellious approach of this young artist from southern France is not as immediately apparent to today's viewer as it would have been to most of his contemporaries. Since then, largely thanks to countless reproductions, his works have become almost as evocative and fondly familiar a symbol of the sophisticated capital as the Eiffel Tower itself, built in 1889. From an art historian's perspective, however, Toulouse-Lautrec is indisputably one of the most important avant-garde artists of the late 19th century. His posters and lithographs in particular, with their bright expanses of even colour, sharp contours and sweeping lines, account for both his abiding popularity and his renown as an artistic innovator. The same goes for his acutely perspicacious drawings, which capture the barest essentials with sparse, quickly sketched strokes. His oil paintings, like his drawings, have great spontaneity and freshness, despite the long hours of meticulous work that went into them, securing him a place in the world's great galleries and ensuring that his works sell for record prices in the art market today.

Neither Toulouse-Lautrec's origins in the French aristocracy, with a noble lineage dating back to the time of Charlemagne, nor the two years he spent as an apprentice in the studios of the academic painters Léon Bonnat and Fernand Cormon, held a foretaste of his later meteoric rise as a fêted portrait painter of fun-loving Paris. Yet Henri Marie Raymond de Toulouse-Lautrec-Monfa, born in 1864 in the southern French town of Albi, was the eldest son of a count, and unlike many of his contemporaries did not have to contend with fierce opposition from his family when he chose to become an artist. His father was a true eccentric whose enthusiasms included wearing flamboyant clothing and having himself photographed dressed as a Turk or a Scottish highlander complete with kilt, as well as the staple aristocratic pursuits of hunting and falconry. As such, the Count respected his son's magnetic pull towards drawing, and having received a rudimentary education from his uncle Charles, in 1872 Toulouse-Lautrec went on to be tutored in

painting and drawing by a friend of his father's, the horse-lover and animal painter René Princeteau. Nonetheless, Toulouse-Lautrec's parents, who had been separated and living apart since 1868, urged him to preserve the family honour. When he exhibited works that featured compromising glimpses into the nightlife of Montmartre, they asked him to do so only under pseudonyms like 'Tréclau' (an anagram of Lautrec), 'Monfa' (his third surname) or 'Tolav-Segroeg'. He continued with this practice until 1888, when he participated in the important avant-garde exhibition held by the 'Les Vingt' society ('The Twenty') in Brussels, where he enthusiastically espoused 'the red flag of Impressionism' and signed his works with the family name, Toulouse-Lautrec, for the first time.

From this point onwards the artist, who never grew taller than 1.52 m due to a genetic disorder and two severe fractures of the leg, was destined to suffer often scornful comments by conservative and sententious art critics who jumped at the chance to decry his warts-and-all depiction of the Parisian demi-monde as an expression of aristocratic decadence. At the same time, however, Toulouse-Lautrec did benefit from the privileges of his class; while many of his fellow artists (including Vincent van Gogh [1853–1890], whom he painted in 1887) who delved into the Bohemian life in Montmartre and renounced the prevailing academic artistic taste went hungry as a result, Toulouse-Lautrec received an income from his family and could always rely on financial support from his mother. This enabled him to lead the life of an artist without having to compromise his style by having to depend on gaining commissions. Nevertheless, a few enterprising gallery owners soon recognized the market value of the nobly-born newcomer, and set about selling his work.

Given that Toulouse-Lautrec was so accustomed to the comforts of his social station, what was it that so attracted him to life on the hill of Montmartre, leading the 20-year-old aristocrat to settle here and devote his art almost exclusively to the grotesque characters and hedonistic patrons who populated the area's theatres, cabarets, café-concerts and brothels, for the 16 years up to his death? Like many other artists of the epoch, he was fascinated and inspired by the many disparate facets of this area of northern Paris, which was only incorporated into the city in 1860. While the district, with its vineyards, windmills and gardens, still retained much of its bucolic charm, within the space of a few years countless establishments sprang up, in which Parisians and tourists from all strata of society came together and devoted themselves to the pursuit of pleasure. The common people tended to avail themselves of the innocent amusements on offer

at the popular dance hall 'Moulin de la Galette', a lively spot that Auguste Renoir (1841–1919) had already depicted in Impressionist style in his eponymous 1876 masterpiece, and which Toulouse-Lautrec was inspired to portray in a series of early Post-Impressionist paintings a decade later. Meanwhile, from 1881 onwards the finer elements of society met in the 'Chat Noir', a new kind of cabaret run by Rodolphe Salis. Dandies kitted out in top hats, gloves and monocles, women in elegant gowns, and members of the literati, including Paul Verlaine and Jean Lorrain, all flocked here to watch brilliantly witty shows. Of course, the most famous attraction in those days was the 'Moulin Rouge', which remains popular to this very day. This cabaret, with its replica of a red windmill over the entrance, was opened by Charles Zidler in 1889, and was where the biggest stars of the time made their names, including the dancers La Goulue ('the glutton') and Jane Avril, as well as the zany nude dancer Cha-U-Kao. As a regular, Toulouse-Lautrec immortalized all of them in his work.

The Sacré Coeur Basilica, which was started in 1875 but only completed in 1914 and consecrated in 1919, still looms over the hill of Montmartre like a sentinel against all this hedonism and debauchery, and is testament to the fact that Catholicism also enjoyed a resurgence during the French Third Republic. A board of censors clamped down on overly revealing posters and permissive illustrations in books and magazines, while inspectors from the vice squad kept a close watch on the cabarets to ensure that modesty was preserved. Most notably, when a dancer performed the energetic and risqué 'quadrille naturaliste' or the cancan, both popular dances which featured downright acrobatic contortions, scissor kicks and the splits, her skirt was not permitted to fly up too high, and she was not allowed to show too much skin. In the middle of all this hurly-burly sat Toulouse-Lautrec, condemned to be a mere observer from a table or box due to his physical infirmities, yet riveted by the relentless movement of those provocative dances. He succeeded in capturing the vigour and vitality of the dancers as no other artist of his time had done, and his work made them into a symbol of the pleasure-loving Belle Époque. The distinctive, spontaneous style of his lithographs was partly due to the fact that he almost invariably sketched his compositions straight onto the stone, only resorting to the additional use of copy paper on rare occasions. Increasingly he referred to photographs, as can be seen on the advertising poster for performances by Eglantine Demay's dance troupe at the Palace Theatre in London in 1896. Whereas the photograph which Toulouse-Lautrec used as a model for this poster shows the dancers in a frozen pose, his lithograph transforms the scene into an energetic dance, breathing life and movement into the four dancers, from their black, stocking-clad legs to their plumed hats, using curving lines

and short strokes. Even the floorboards of the dance floor appear to be tilting dramatically, a device often used by Toulouse-Lautrec.

Yet the censors were not absent from Toulouse-Lautrec's sensuous milieu. He drew many biting caricatures of Coutelat du Roché, a censor nicknamed 'Père la pudeur' (Fr Chastity). The caricaturist's instinct for ironic emphasis is very much present in his work, which is reminiscent of that of his famous predecessor, Honoré Daumier (1808–1879). Toulouse-Lautrec's day-job as an illustrator for an array of Parisian periodicals, such as the weekly *Le Rire* or the short-lived satirical monthly journal *La Vache Enragée,* only fuelled his insight as a caricaturist. As his works were mostly based on line drawings, it was not a huge leap to the exaggeration of caricatures and the angular distortion of details. Essentially, he sought to get at the real soul of Parisian life in his caricatures just as he did in his insightful, albeit grittily honest, portraits of stooped washerwomen, dazed absinthe drinkers or haggard prostitutes. In this respect his work was markedly different from any kind of Art Nouveau, the prevailing style of the time, which either had a purely decorative function or – as in the case of Henry van der Velde (1863–1957) – concentrated on abstract lines.

Reactions to Toulouse-Lautrec's unique compositions were often divided. In 1893, when he produced 16 illustrations for an album of songs by one of the stars of the 'Moulin Rouge', the dramatic singer and chanteuse Yvette Guilbert, whom he adored, some praised the expressive boldness of the scenes and bizarre poses, which perfectly reflected Guilbert's eccentric performance style. However, on 2 October, 1894 a harsh review by the writer Jean Lorrain appeared in *L'Echo de Paris,* expounding the view that the album took the 'cult of ugliness' too far and reproaching the cabaret artist for having agreed to the tasteless distortion of her features in her 'pursuit of fame'. Even Guilbert, whose trademark was her long, black gloves, which were depicted on the cover gliding over the steps of the stage like a living thing, had to be persuaded of the brilliance of the illustrations by the art critic Gustave Geffroy.

One hundred copies of the large-format album were published, with text by Geffroy and images by Toulouse-Lautrec, and were well within the public's means at 50 francs each. It was a remarkable item not only from a stylistic point of view, but principally because when taken together with his posters it marked a turning point in the history of advertising, as it was dedicated solely to publicising a particular individual. While the pioneer of the modern French advertising poster, Jules Chéret (1836–1932), predominantly featured anonymous, classical beauties, Toulouse-Lautrec depicted the personalities that lit up the Parisian scene in such a way as to show their distinctive traits, and thus arguably paved the way for the modern cult of celebrity. In 1892 he was commissioned to

draw up several posters for his friend, the singer Aristide Bruant, who sometimes insulted his audience in his cabaret, 'Le Mirliton', and performed anarchistic songs in crude street slang. Modelled on Japanese woodcuts, these posters take the radical step of stripping the whole composition down to a few areas of even colour, showing only the striking silhouette of the singer with his large floppy hat and black cloak, over which is draped a jaunty red scarf, providing a blaze of colour. In the first two versions of the poster, Toulouse-Lautrec faithfully renders Bruant's distinctive facial features, but a year later only his outline was still necessary for identification; presumably all of Paris had come to recognize his likeness in the meantime. The final poster cleverly plays with the assumptions of the viewer; the figure of Bruant appears only from behind, his hands plunged stubbornly into his trouser pockets.

The advertising impact of this simple yet memorable poster design proved equally profitable for both artists, as Toulouse-Lautrec also benefited having his unique style displayed all over the capital. Indeed, the ubiquity of his work was such that some critics felt wearied by it; a 1892 issue of *La Vie Parisienne* contained the lament, "Can anyone rid us of Aristide Bruant's image? You can't go anywhere without seeing him at every turn".

One of the lesser-known aspects of Toulouse-Lautrec's diverse œuvre is his work as a book illustrator. Shortly before his indefatigable output began to wane as a result of his excessive alcohol consumption and dissolute lifestyle in the last few years before his death in 1901, he created ten remarkable lithographs for *Au Pied du Sinaï* ('At the Foot of Sinai'), a book by his friend, the politician Georges Clemenceau. In the book Clemenceau describes the life of Jews in Paris, Poland and Karlsbad, and it was published at a time when France was being rocked by the Dreyfus Affair, a political and judicial scandal concerning the Jewish Captain Dreyfus. Toulouse-Lautrec used thick, heavy lines to sketch the bleak and gloomy pictures, having studied the residents of the Jewish quarter in Paris closely. Apart from the symbolic cover image of Moses and the Tablets of Stone, along with the Golden Calf toppled from its plinth, the amazing sense of realism and expressiveness conveyed by these works is reminiscent of prints by Goya (1746–1828), whom he greatly admired. It would be hard to imagine a greater contrast with his usual images of Montmartre's nocturnal frolics and erotic debauchery. These striking illustrations attest to the fact that the diversity of Toulouse-Lautrec's œuvre is far richer than most mentions of him would suggest. Ultimately, for something to be 'avant-garde' implies not only the revitalisation of style and form, or aesthetic innovation, but also an intriguing and occasionally disconcerting range. It is this remarkable range that can be seen afresh in these pages.

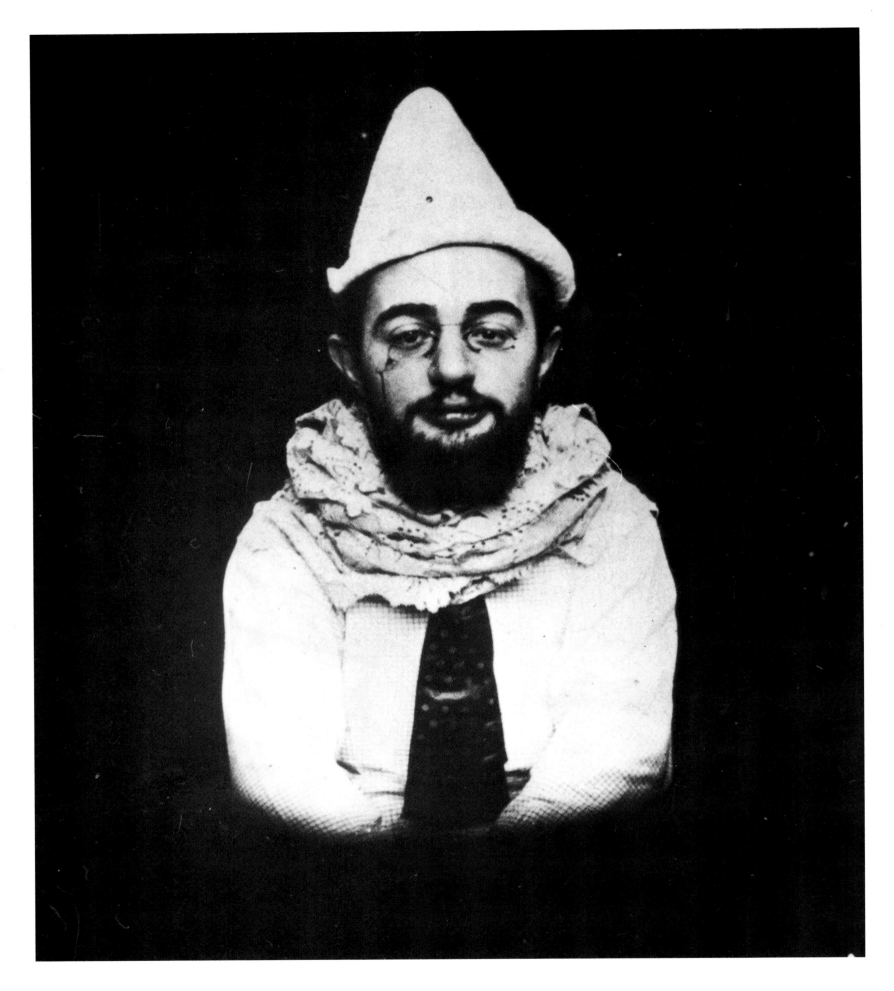

Henri de Toulouse-Lautrec

c. 1894, photograph by Maurice Guibert

Studio portrait of Toulouse-Lautrec, bearded and wearing a pince-nez. He is posing as Pierrot the clown with a pointed hat and a large ruff around his neck.

Henri de Toulouse-Lautrec

c 1894, fotografía de Maurice Guibert

Retrato de estudio de Toulouse-Lautrec, con barba y quevedos. Posa como el payaso Pierrot con sombrero puntiagudo y una gran gorguera alrededor del cuello.

Henri de Toulouse-Lautrec

vers 1894, photographie de Maurice Guibert

Photo en studio de Toulouse-Lautrec, barbu et portant un pince-nez. Il pose en Pierrot avec un chapeau pointu, une ample fraise autour du cou.

Henri de Toulouse-Lautrec

um 1894, Fotografie von Maurice Guibert

Studioporträt von Toulouse-Lautrec mit Bart und Zwicker. Er posiert als Pierrot mit spitzem Hut und einer großen Halskrause.

Introducción

Maria-Christina Boerner

En 1893, hasta el vehemente portavoz de los neo-impresionistas, Félix Fénéon, admitía sin reparos en el semanario anarquista *Le Père Peinard*: «Por todos los diablos, ¡qué atrevido es este Lautrec! No se anda con remilgos ni en sus dibujos ni en sus colores. Blanco, negro y rojo en grandes manchas y formas sencillas: ese es su arte». Fénéon certificaba además la «voluntad, el descaro y la malicia» del pintor Henri de Toulouse-Lautrec, cuyos carteles causaban sensación desde hacía dos años en la capital francesa. La acertada opinión del crítico de arte no solo se extendía a las audaces innovaciones estilísticas de Lautrec, sino también a sus temas, mordaces en muchos casos, relacionados con la vida nocturna parisina. Para el espectador actual, la rebelión artística antiburguesa de aquel joven procedente del sur de Francia no es tan evidente como para la mayoría de sus contemporáneos. En definitiva, debido entre otras cosas a las múltiples formas en que se ha reproducido, su obra constituye hoy en día un símbolo tan familiar y aceptado de la elegante metrópoli como la torre Eiffel de 1889. Ahora bien, resulta indudable que, al valorar su producción desde el punto de vista de la historia del arte, Lautrec es uno de los artistas vanguardistas más importantes de finales del siglo XIX. Su prolongada popularidad y su fama de renovador de las artes gráficas descansan sobre todo en sus carteles y litografías, con sus grandes y luminosas superficies de color sin matices, sus perfiles nítidos y sus líneas absolutamente dinámicas. Lo mismo cabe decir de sus dibujos, increíblemente seguros, que captan siempre lo esencial con unos pocos rasgos de trazo rápido. Además, a pesar de su esmeradísima y por lo general larga elaboración, sus óleos, al igual que su obra gráfica, poseen una espontaneidad y una frescura que no solo le aseguran un lugar en los grandes museos del mundo, sino que le llevan a batir récords de precios en el mercado del arte.

De todos modos, ni el hecho de que Lautrec procediera de una familia noble francesa cuyos orígenes se remontaban a la época de Carlomagno ni su formación a lo largo de dos años en los talleres de los probos pintores académicos Léon Bonnat y Fernand Cormon le auguraban una vertiginosa carrera como celebrado retratista del París frívolo. En cualquier caso, a diferencia de muchos de sus colegas, Henri Marie Raymond de Toulouse-Lautrec-Monfa, que había nacido en 1864 en Albi, en la Francia meridional, y era el primogénito del conde Alphonse, no tuvo que vencer una resistencia demasiado encarnizada de sus padres cuando se decidió por la carrera artística. El excéntrico conde, a quien además de la caza y la cetrería acordes con su condición social le gustaban los disfraces extravagantes y que en más de una ocasión se hizo fotografiar vestido de turco o de escocés con *kilt*, respetó el irrefrenable deseo de dibujar de su hijo, quien tras iniciarse en las primeras letras con su tío Charles, a partir de 1872 recibió clases de pintura y dibujo de René Princeteau, aficionado a los caballos, pintor de animales y amigo de su padre. No obstante, los padres de Lautrec, que vivían separados desde 1868, insistieron en salvaguardar el honor de la familia, por lo que pidieron a su hijo que expusiese las obras en que abordaba sus comprometedoras visiones de la vida nocturna de París solo con pseudónimos tales como «Tréclau» (anagrama de Lautrec), «Monfa» (su tercer apellido) o «Tolav-Segroeg». Todo cambió en 1888, cuando participó en la importante exposición vanguardista de la Société des XX (Sociedad de los Veinte), donde se propuso con total entusiasmo portar «la bandera roja del impresionismo» y firmó sus piezas por primera vez con el apellido Toulouse-Lautrec.

En adelante, el pintor, que como consecuencia de una enfermedad hereditaria y de dos fracturas graves en las piernas solo alcanzaba 1,52 m de altura, tuvo que soportar los irónicos comentarios de una crítica de arte conservadora y moralizante, que disfrutaba interpretando su representación directa del mundo galante parisino como expresión de la decadencia de la nobleza. No obstante, Lautrec se benefició al mismo tiempo de los privilegios de su clase; mientras muchos de sus colegas, como Vincent van Gogh (1853-1890), a quien retrató en 1887, pagaban con el hambre su vida bohemia en Montmartre y su distanciamiento de los gustos artísticos oficiales y académicos, Lautrec percibía una renta de su familia y contaba siempre con el apoyo económico de su madre, lo cual le permitía vivir del arte sin tener que depender necesariamente de los encargos. Por otra parte, algunos avispados galeristas no tardaron en aprovechar el valor mercantil de aquel vástago de una familia noble famosa para vender sus obras.

Ahora bien, ¿qué atrajo de la vida en la Butte, en la colina de Montmartre, a un Lautrec habituado a las comodidades de su posición social hasta el punto de que todo un aristócrata de solo veinte años se instalase en ella y consagrase su arte a lo largo de dieciséis años, hasta su temprana muerte, casi exclusivamente a las extravagantes celebridades y a los clientes ávidos de diversión de los teatros, los cabarés, los cafés-cantantes y los burdeles? Fueron sin duda las múltiples facetas, contradictorias incluso en muchos casos, de aquel distrito del norte de París, que no se incorporó al municipio hasta 1860, las que le sedujeron, como a otros muchos artistas, e inspiraron su arte. Por un lado, con sus viñas, sus molinos de viento y sus jardines, el barrio conservaba buena parte de su encanto rural; por otro, en el transcurso de

unos pocos años aparecieron en él innumerables establecimientos en los que confluían y se divertían vecinos y turistas de diversas clases sociales. El pueblo llano trataba más bien de divertirse tranquilamente en el popular salón de baile Moulin de la Galette, cuyo animado ambiente bañó de luz impresionista Auguste Renoir (1841-1919) en su obra maestra de 1876 y una década más tarde inspiró a Lautrec algunos de sus primeros cuadros posimpresionistas. A su vez la sociedad más refinada venía reuniéndose desde 1881 en el Chat Noir de Rodolphe Salis. Caballeros con sombrero de copa, guantes y monóculo, damas elegantemente vestidas y escritores como Paul Verlaine o Jean Lorrain asistían divertidos a las chispeantes funciones de aquel cabaré de nuevo cuño. No obstante, la atracción más famosa de la época, como todavía lo sigue siendo hoy, era el Moulin Rouge, con su reproducción de un molino de viento en la entrada. En este establecimiento, propiedad de Charles Zidler, inaugurado en 1889, obtuvieron sus mayores éxitos las estrellas más conocidas de la época, entre ellas las bailarinas La Goulue ('la Tragona') y Jane Avril o la payasa y bailarina desnuda Cha-U-Kao, a todas las cuales inmortalizó en su obra el cliente fijo que fue Lautrec.

La basílica del Sacré Cœur, cuya construcción se prolongó de 1875 a 1914 y fue consagrada en 1919, se alzaba en la cima de Montmartre como una admonición contra los excesos del mundo de la diversión, demostrando que también el catolicismo se recuperaba en la III República. La censura actuó contra los carteles licenciosos en exceso o las ilustraciones frívolas de libros y revistas, y los inspectores de la policía correccional vigilaban para que se observasen las normas de la decencia en los cabarés. En concreto, ni la falda de una bailarina podía alzarse en exceso, ni quedar al descubierto demasiada piel en ninguna de las dos rápidas y frenéticas danzas de moda de la época, la *quadrille naturaliste* y el cancán, con sus acrobáticas contorsiones, sus aberturas de piernas o sus zancadas. En aquel vertiginoso torbellino Lautrec, a quien sus defectos físicos condenaban casi siempre a ser un mero observador, aparecía sentado a una mesa o en un palco cautivado por el incesante movimiento de las excitantes danzas. El pintor supo captar el dinamismo y la vitalidad de las bailarinas mejor que ningún otro artista de su época y con su obra se erigió en el símbolo de la vitalista *belle époque*. Lautrec alcanzó la inconfundiblemente espontánea expresión de sus litografías entre otras cosas por dibujar sus composiciones directamente sobre piedra; solo en contadísimas ocasiones utilizó también papel de reporte. Por el contrario, recurrió constantemente a la fotografía, por ejemplo en el cartel publicitario de la actuación de la compañía de Eglantine Demay en el teatro Palace de Londres en 1896. Sin embargo, lo que en la muestra fotográfica es una postura congelada, en la litografía de Lautrec

se transforma en una briosa danza en rueda que, con sus líneas curvas y sus trazos cortos, pone todo en movimiento, desde las piernas con medias negras de las cuatro bailarinas hasta sus sombreros adornados con plumas. Como sucede tantas veces en su pintura, las mismas tablas de la pista de baile parecen encontrarse aquí en una posición inclinada dinámica.

Ahora bien, en el voluptuoso panorama de Lautrec no faltan los ya aludidos guardianes oficiales de la moral. El pintor caricaturizó en varias ocasiones con su afilada pluma a uno de ellos, Coutelat du Roché, apodado «Père la pudeur» ('el padre pudor'). En definitiva, en su obra está muy presente el instinto de sacar punta irónicamente a todo propio del caricaturista, que lo relaciona con su famoso predecesor Honoré Daumier (1808-1879). Sus frecuentes colaboraciones como ilustrador de diversas publicaciones periódicas de París, tales como el semanario *Le Rire* o la efímera revista mensual de carácter satírico *La Vache Enragée*, estimularon su sagacidad como caricaturista. Dado que sus obras se basaban fundamentalmente en la línea, estaba a un paso del dibujo caricaturesco y de la deformación aguda de los detalles. En el fondo, con su línea simbólica y en sus honestos retratos —sugestivos y a veces también crueles— de lavanderas encorvadas, de apáticos bebedores de absenta o de prostitutas curtidas, trataba de destilar lo esencial, el núcleo real. Desde este punto de vista su trabajo se distingue con claridad de todas las variantes del Modernismo contemporáneo, en las que únicamente interesaban el valor puramente ornamental de la decoración o, como en el caso de Henry van der Velde (1863-1957), la expresión abstracta de la línea.

Sin embargo, las reacciones a la singular forma de concentración de Lautrec fueron con frecuencia discrepantes. Cuando en 1893 ilustró un álbum con dieciséis litografías para una de las estrellas del Moulin Rouge, su venerada recitadora y cupletista Yvette Guilbert, no faltaron quienes aplaudieron la audacia expresiva de los puntos de vista y las poses grotescas, totalmente acordes con su excéntrico estilo de representación. Por el contrario, el 2 de octubre de 1894 se publicaba en *L'Echo de Paris* una dura crítica del escritor Jean Lorrain, quien entendía que en el álbum se llevaba demasiado lejos «el culto a lo feo» y acusaba a la cabaretera de haber aceptado la deformación de mal gusto de sus rasgos «por afán de publicidad». El crítico de arte Gustave Geffroy hubo de convencer más tarde de la excelencia de las ilustraciones a la propia Yvette Guilbert, cuyos signos distintivos —sus largos guantes negros— se deslizaban en la cubierta escaleras abajo del escenario cual ser vivo.

No obstante, aquel álbum de gran formato, que con el texto de Geffroy y las ilustraciones de Lautrec podía adquirirse en una edición de 100 ejemplares a 50 francos cada uno, no fue un

producto extraordinario solo desde el punto de vista estilístico. De hecho, abrió un nuevo capítulo, junto con los carteles de Lautrec, en la historia de la publicidad, pues se dedicó exclusivamente a la promoción de una persona concreta. Mientras que el fundador del cartel publicitario francés moderno, Jules Chéret (1836-1932), se decantaba preferentemente por las bellezas anónimas y estereotipadas, Lautrec presentaba a los personajes de la vida nocturna parisina con sus características inconfundibles, abriendo así el camino en cierto sentido al divismo. El cantante Aristide Bruant, que en ocasiones insultaba a su público en el cabaré Le Mirliton e interpretaba canciones anarquistas en un grosero argot de calle, encargó varios carteles a su amigo Lautrec. Siguiendo el modelo de las xilografías japonesas, todos ellos reducían de manera drástica la composición a unos pocos elementos, marcadamente planos, y mostraban tan solo la imponente silueta del cantante con su sombrero de ala ancha y su capa negra, en la que resplandecía una bufanda roja de amplios vuelos. Si en sus dos versiones de 1892 el pintor todavía reproducía los rasgos faciales característicos de Bruant, un año después bastaba con la vista de perfil del cantante para que probablemente todo París reconociera su retrato. Al final, en la última página, Lautrec promueve un juego irónico con las expectativas del observador, con el rostro de Bruant visto únicamente desde atrás y sus manos hundidas con insolencia en los bolsillos del pantalón.

El efecto publicitario de esta configuración del cartel, tan clara como fácil de retener en la memoria, favoreció a los dos artistas, pues Lautrec también se benefició de la extendida presencia de sus obras con su inconfundible estilo en las calles de la capital. En ocasiones esta omnipresencia pudo haber sido abrumadora, como llegó a decir en 1892 en *La Vie Parisienne*: «¿Quién nos librará del retrato de Aristide Bruant? Imposible dar un paso sin encontrarse con él».

Una de las páginas menos conocidas de su variada creación es la aportación de Lautrec a la ilustración de libros. En 1897, poco antes de que su incesante productividad se redujese en los últimos años previos a su muerte en 1901 como consecuencia del consumo excesivo de alcohol y de su desenfrenada vida nocturna, realizó diez extraordinarias litografías para el libro *Au Pied du Sinaï* ('Al pie del Sinaí') de Georges Clemenceau, político y amigo suyo. En sus hojas Clemenceau reflejaba la vida de los judíos en París, Polonia y Karlsbad en un momento en que Francia estaba consternada por el caso del capitán judío Dreyfus. Lautrec esbozó con trazos gruesos y enérgicos cuadros de ambiente sombríos y deprimentes, para los cuales estudió previamente a fondo a los vecinos del barrio judío de París. Salvo el dibujo propiamente simbólico de la cubierta con Moisés y las Tablas de la Ley por una parte y el becerro de oro arrojado de su pedestal por otra, el sorprendente realismo y la expresividad de estas obras recuerdan a los grabados de Goya (1746-1828), muy apreciado por el francés. Es difícil imaginar un contraste más agudo con sus imágenes habituales del desenfreno nocturno y de las seducciones eróticas de Montmartre. Las impresionantes ilustraciones de este libro demuestran que el espectro de su obra es mucho mayor que el que sugieren algunos tópicos sobre el artista. En definitiva, la vanguardia no solo comporta una renovación estilística y formal y una innovación estética, sino también una variedad asombrosa y hasta sorprendente en ocasiones. Así se podrá descubrir de nuevo en este volumen ilustrado.

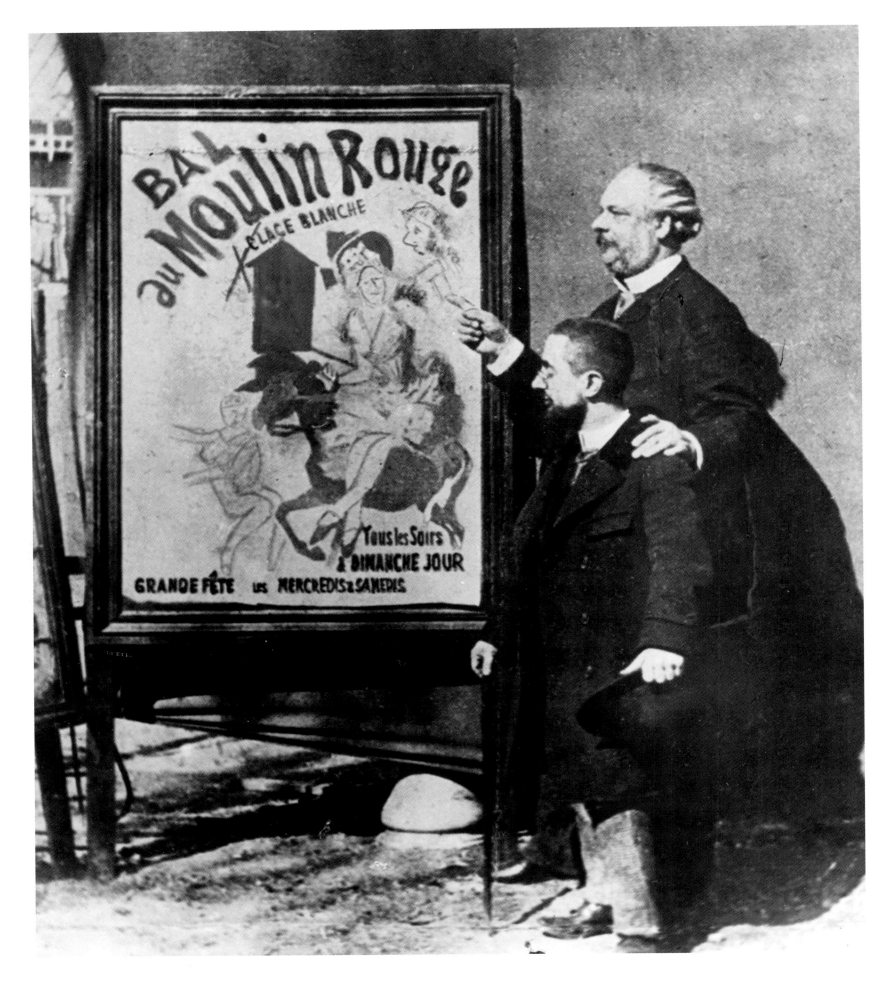

Henri de Toulouse-Lautrec and Tremolada

c. 1892

Toulouse-Lautrec and Tremolada, director of the Moulin Rouge. The poster advertising the famous cabaret was designed by Jules Chéret.

Henri de Toulouse-Lautrec y Tremolada

c 1892

Toulouse-Lautrec y Tremolada, director del Moulin Rouge. El cartel publicitario del famoso cabaré fue diseñado por Jules Chéret.

Henri de Toulouse-Lautrec et Tremolada

vers 1892

Toulouse-Lautrec et Tremolada, directeur du Moulin Rouge. L'affiche faisant de la publicité pour le célèbre cabaret a été dessinée par Jules Chéret.

Henri de Toulouse-Lautrec und Tremolada

um 1892

Toulouse-Lautrec mit Tremolada, dem Direktor des Moulin Rouge. Das Werbeplakat für das berühmte Cabaret gestaltete Jules Chéret.

Introduction

Maria-Christina Boerner

En 1893, même le critique d'art Félix Fénéon, soutien indéfectible des néo-impressionnistes, l'admet dans l'hebdomadaire anarchiste « Le Père Peinard » : « Un qui a un nom de dieu de culot, mille polochons, c'est Lautrec : ni son dessin ni sa couleur ne font des simagrées. Du blanc, du noir, du rouge en grandes plaques, et des formes simplifiées – voilà son fourbi. » Fénéon persiste et signe en assurant que le travail de Toulouse-Lautrec, dont les affiches font sensation depuis deux ans dans la capitale, est « épatant de volonté, de toupet et de rosserie [...] ». Cependant, le jugement sans appel du critique d'art ne se réfère pas seulement aux innovations stylistiques hardies de Lautrec mais aussi à ses sujets, des personnages souvent douteux qui animent les nuits parisiennes. Pour le spectateur d'aujourd'hui, la rébellion artistique antibourgeoise du jeune provincial originaire du sud de la France n'est sans doute plus aussi manifeste qu'elle l'était aux yeux de ses contemporains. De nos jours, si l'on en juge par leurs multiples reproductions, les œuvres de Toulouse-Lautrec font partie de la représentation emblématique de Paris, presque au même titre que la Tour Eiffel inaugurée en 1889.

Pour les historiens d'art, il ne fait cependant aucun doute que Toulouse-Lautrec est l'un des artistes d'avant-garde les plus importants de la fin du XIX^e siècle. Ce sont surtout ses affiches et ses lithographies, avec leurs vastes taches de couleurs claires sans dégradés, leurs contours nets et leurs lignes extrêmement dynamiques, qui sont à l'origine de sa popularité inépuisable ; elles ont contribué au renouveau des arts graphiques.

Il en est de même pour ses dessins dont le trait on-ne-peut-plus sûr, concis, rapide, saisit toujours l'essentiel. Et bien que réalisées avec énormément de soin, ses huiles, dont la réalisation a parfois été longue, possèdent aussi, comme son œuvre graphique, cette spontanéité et cette fraîcheur qui leur assurent non seulement une place dans les plus grands musées du monde mais aussi des prix records sur le marché de l'art.

Pourtant, ni les origines de Toulouse-Lautrec, issu d'une des plus vieilles familles françaises dont la noblesse remonte à Charlemagne, ni sa formation de deux ans dans l'atelier des peintres académiques Léon Bonnat et Fernand Cormon ne laissaient prévoir qu'il ferait une carrière fulgurante en tant que portraitiste de la frivolité parisienne. En tout cas, Henri Marie Raymond de Toulouse-Lautrec-Monfa né à Albi en 1864 et fils aîné du comte Alphonse n'eut pas, à l'instar de nombreux autres peintres, à lutter contre les résistances de ses parents lorsqu'il décida de devenir artiste. Le comte Alphonse, un homme très excentrique, grand amateur de chasse et de fauconnerie – il aimait aussi les vêtements extravagants et se fit volontiers photographier en Turc ou en kilt écossais –, respectait le besoin irrésistible qu'avait son fils de dessiner. Après les premiers rudiments prodigués par son oncle Charles, le jeune garçon prendra à partir de 1872 des cours de peinture et de dessin auprès d'un ami de son père, René Princeteau, peintre animalier grand amateur de chevaux.

Il n'empêche que ses parents, qui vivent séparés depuis 1868, l'incitent à préserver l'honneur de la famille. Comme les œuvres de leur fils donnent un aperçu de la vie parisienne qui risque de le compromettre, ils lui demanderont de n'exposer qu'en signant « Tréclau » (anagramme de Lautrec), « Monfa » (son troisième nom de famille) ou « Tolav-Segroeg ». Il utilisera un pseudonyme jusqu'en 1888, année où il participe à l'importante exposition d'avant-garde des XX à Bruxelles. Plein d'enthousiasme, il se propose de porter « le drapeau rouge de l'impressionnisme » et signe pour la première fois ses œuvres de son nom de famille, Toulouse-Lautrec.

A partir de ce moment, le peintre qui ne mesure qu'un mètre cinquante-deux en raison d'une maladie héréditaire et de deux fractures graves, devra supporter les commentaires souvent railleurs des critiques d'art conservateurs et moralisants qui jugent avec délectation que sa description sans fard du demi-monde parisien est l'expression de la décadence aristocratique.

Toulouse-Lautrec profite quand même des privilèges de l'aristocratie : alors que nombre d'autres peintres, par exemple Vincent van Gogh (1853–1890) dont il a fait le portrait, qui ont tourné le dos à l'académisme officiel et mènent une vie de bohème à Montmartre, paient leur liberté en ne mangeant pas toujours à leur faim, Toulouse-Lautrec touche une rente et sait pouvoir compter sur l'aide financière de sa mère. Cela lui permet de mener une vie d'artiste sans dépendre de commanditaires. En outre, quelques galeristes habiles sauront exploiter de bonne heure la valeur marchande du descendant des célèbres comtes de Toulouse pour vendre ses œuvres.

Mais pour quelle raison Lautrec, habitué aux commodités de son état, est-il si attiré par la vie sur la butte Montmartre, au point de s'y installer à l'âge de vingt ans et de consacrer son art, seize ans durant jusqu'à sa mort précoce, quasi exclusivement aux célébrités ambiguës et aux visiteurs avides de plaisir des théâtres, des cabarets, des cafés-concerts et des bordels ?

Ce sont probablement les facettes multiples et contradictoires de Montmartre qui le fascinent, comme tant d'autres artistes, et sont pour lui une source d'inspiration. Le quartier, situé au nord de Paris et qui ne sera rattaché à la capitale qu'en 1860, a

conservé son caractère champêtre avec ses vignes, ses moulins et ses jardins, mais en l'espace de quelques années, d'innombrables établissements y ont vu le jour. Des badauds et oisifs de toutes les classes sociales s'y croisent et s'y amusent.

Les petites gens recherchent plutôt les plaisirs innocents du bal populaire au « Moulin de la Galette », dont l'ambiance bon-enfant sera immortalisée par Auguste Renoir (1841–1919) en 1876. Dix ans plus tard, l'établissement inspirera aussi à Toulouse-Lautrec quelques-uns de ses premiers tableaux post-impressionnistes. Quant au Tout-Paris, il a ses habitudes au cabaret du « Chat Noir », ouvert en 1881 par Rodolphe Salis. Des dandys portant haut-de-forme, gants et monocle, des dames en toilette élégante et des poètes et écrivains comme Paul Verlaine et Jean Lorrain assistent, amusés, aux spectacles pleins d'esprit.

Mais l'attraction la plus célèbre est le « Moulin Rouge », apprécié aujourd'hui encore, avec ses ailes de moulin qui surplombent l'entrée. C'est dans cet établissement, ouvert en 1889 par Charles Zidler, que les vedettes les plus populaires de ces années-là, telles La Goulue et Jane Avril ou la clownesse Cha-U-Kao qui danse nue, fêtent leurs plus grands succès – et Toulouse-Lautrec, un habitué des lieux, les a toutes immortalisées dans son œuvre.

Sur les hauteurs de la Butte, comme pour exhorter les libertins à la retenue, trône aujourd'hui encore la basilique du Sacré-Cœur. Commencée en 1875 et achevée en 1914, la basilique qui ne sera consacrée qu'en 1919, rappelle que le catholicisme reprend aussi des forces sous la IIIe république. La censure frappe les affiches trop libertines ou les illustrations frivoles des livres et revues ; des inspecteurs de la police des mœurs veillent sur le respect des règles de décence dans les cabarets. Ainsi la jupe d'une danseuse de « quadrille naturaliste » ou de « cancan », ainsi que l'on nomme les danses à la mode, avec leurs contorsions quasi acrobatiques, leurs levés de jambes et leurs grands écarts, ne doit pas être relevée trop haut et il ne faut pas non plus que l'on voir trop de chair sous les jupons.

Au milieu du tourbillon, ses infirmités le condamnant le plus souvent à n'être qu'un spectateur, Toulouse-Lautrec est assis à une table ou dans une loge, subjugué par la turbulence de ces danses provocantes. Et c'est lui qui réussira, en cela l'un des rares artistes de cette époque, à capter le caractère dynamique et la vitalité des danseuses, les transformant en symbole de la Belle Epoque. L'expression incomparablement spontanée des lithographies de Lautrec est aussi due au fait qu'il exécute presque toujours le tracé directement sur la pierre, n'utilisant que rarement un papier-report.

En revanche, il n'hésite pas à se servir de la photographie ; c'est notamment le cas lorsqu'il réalise l'affiche publicitaire qui annonce le spectacle de la « Troupe de Mademoiselle Eglantine » au Palace Theatre de Londres en 1896. Mais sur la lithographie de Toulouse-Lautrec, la pose figée des danseuses devient une ronde pleine de fougue qui, à l'aide de courbes et de traits brefs, met tout en branle, des jambes gainées de noir des quatre danseuses à leur chapeau à plumes. Même le plancher de la salle – on l'observe souvent dans ses œuvres – semble se retrouver en position inclinée et dynamique.

Mais la galerie de portraits créés par Toulouse-Lautrec n'est pas réservée aux seuls plaisirs des sens, on y trouve aussi les gardiens des bonnes mœurs mentionnés précédemment. L'artiste a fait plusieurs fois, d'un trait acéré, la caricature de l'un d'eux, Coutelat du Roché, plus connu sous le nom de « Père la pudeur ». Il faut dire que l'instinct du caricaturiste, le sens de l'exagération comique ou féroce qui relie étroitement Toulouse-Lautrec à son célèbre prédécesseur Honoré Daumier (1808–1879), est très présent dans son œuvre. Et son travail d'illustrateur des innombrables périodiques parisiens, tels l'hebdomadaire « Le Rire » ou le mensuel satirique « La Vache Enragée », dont la vie sera éphémère, aiguise encore sa perspicacité. Comme la force de ses œuvres se concentre dans ses lignes, elle pousse à l'exagération caricaturiste et à la déformation outrée des détails. Au fond, comme dans ses portraits pleins de sensibilité et parfois cruellement honnêtes de lavandières courbées sur leur tâche, de buveurs d'absinthe hébétés ou de prostituées aux traits tirés, il tente ici de faire ressortir l'essentiel, d'aller au cœur du sujet. A cet égard, son œuvre se distingue de manière significative de l'Art Nouveau de l'époque, style essentiellement décoratif ou, comme chez Henry van de Velde (1863–1957), centré sur l'expression abstraite de la ligne.

Cette manière qu'a Toulouse-Lautrec de forcer le trait pour trouver l'essentiel éveille cependant souvent des réactions mitigées. En 1893, lorsqu'il réalise seize lithographies pour illustrer un album destiné à l'une des vedettes du « Moulin Rouge », la parolière et chanteuse Yvette Guilbert qu'il vénère, certains louent la hardiesse expressive des perspectives et des poses grotesques qui correspondent parfaitement au style excentrique de celle-ci. En revanche, on peut lire le 2 octobre 1894 dans « L'Echo de Paris » une critique acerbe de l'écrivain Jean Lorrain qui trouve ici « le culte du laid » poussé trop loin et reproche à la chanteuse d'avoir accepté de se voir enlaidir avec un tel mauvais goût par « amour de la réclame ». Quant à Yvette Guilbert dont les longs gants noirs en guise d'attribut semblent, sur la couverture, glisser sur la scène comme des êtres vivants, il faudra, pour surmonter ses réticences, que le critique d'art Gustave Geffroy la convainque de l'excellence des illustrations. L'album en grand format avec un texte de Geffroy et des illustrations de Toulouse-Lautrec, édité à cent exemplaires, coûtait 50 Francs, ce qui était vraiment abordable. En fait, il ne sort pas seulement de

l'ordinaire sur le plan stylistique : l'album ouvre, avec les affiches de Toulouse-Lautrec, un nouveau chapitre de l'histoire de la publicité car il est consacré à une personne définie. Alors que le fondateur de l'affiche publicitaire moderne française Jules Chéret (1836–1932) choisit la plupart du temps des beautés stéréotypées anonymes, Lautrec présente les personnalités du Paris nocturne avec leurs attributs caractéristiques, ouvrant en quelque sorte la voie au culte de la star. L'artiste réalise, dans la même veine, des affiches pour son ami Aristide Bruant qui, dans son cabaret « Le Mirliton », injuriait parfois son public et entonnait des chansons anarchistes en argot. S'inspirant des estampes japonaises, Toulouse-Lautrec en réduit radicalement la composition, ne laissant que quelques éléments dont l'aplat est accentué et qui mettent en valeur la carrure imposante du chanteur portant son feutre à larges bords et sa cape noire sur laquelle resplendit une écharpe rouge.

Si Toulouse-Lautrec dépeint encore les traits marquants d'Aristide Bruant dans les deux versions de 1892, une vue de profil suffit déjà, un an plus tard ; entre-temps tous les Parisiens connaissent son portrait. Et finalement, sur la dernière affiche, l'artiste se joue ironiquement des espérances du spectateur : la silhouette du chansonnier n'apparaît plus ici que de dos, jambes écartées, les mains enfoncées dans les poches de sa veste.

L'effet sur le public du graphisme clair et facilement mémorisable de ces affiches profite pareillement aux deux artistes ; l'omniprésence de ses œuvres dans les rues de la capitale fait croître le prestige dont est auréolé Toulouse-Lautrec. Il n'empêche que ce matraquage publicitaire génère parfois un sentiment de lassitude qui s'exprime dans « La Vie Parisienne » en 1892 :

« Qui nous délivrera des effigies d'Aristide Bruant ? On ne peut plus faire un pas sans se trouver en face de lui. »

Un aspect moins connu de l'œuvre de Toulouse-Lautrec est son activité d'illustrateur de livres. Peu de temps avant que sa productivité fébrile ne commence à décliner en raison de sa consommation immodérée d'alcool et de la vie dissolue qu'il mène au cours des années précédant sa mort en 1901, il réalise dix lithographies exceptionnelles pour le livre de son ami, le politicien Georges Clemenceau. Dans cet ouvrage intitulé « Au Pied du Sinaï », Clemenceau décrit la vie des Juifs à Paris, en Pologne et à Karlsbad à une époque où la France est secouée par l'affaire Dreyfus. En traits épais et vigoureux, Toulouse-Lautrec esquisse des scènes sombres et oppressantes pour lesquelles il a auparavant étudié minutieusement les habitants du quartier juif de Paris. Hormis l'illustration de couverture au symbolisme évident puisqu'elle montre Moïse et les Tables de la loi ainsi que le Veau d'or renversé de son socle, ces dessins, de par leur réalisme étonnant et leur expressivité, évoquent ceux de Goya (1746–1828), un artiste que Toulouse-Lautrec vénère. On ne saurait imaginer un contraste plus accusé avec les travaux dont il est coutumier, qui montrent l'exubérance et les attraits érotiques de la nuit montmartroise. Ces illustrations livresques impressionnantes prouvent que son œuvre est bien plus riche que ne veulent le faire croire les idées reçues. Car, en fin de compte, le terme d'avant-garde n'implique pas seulement une rénovation stylistique et formelle et une innovation esthétique mais aussi une diversité stupéfiante et parfois dérangeante. Nous vous invitons à redécouvrir cette fabuleuse diversité au fil des pages qui suivent.

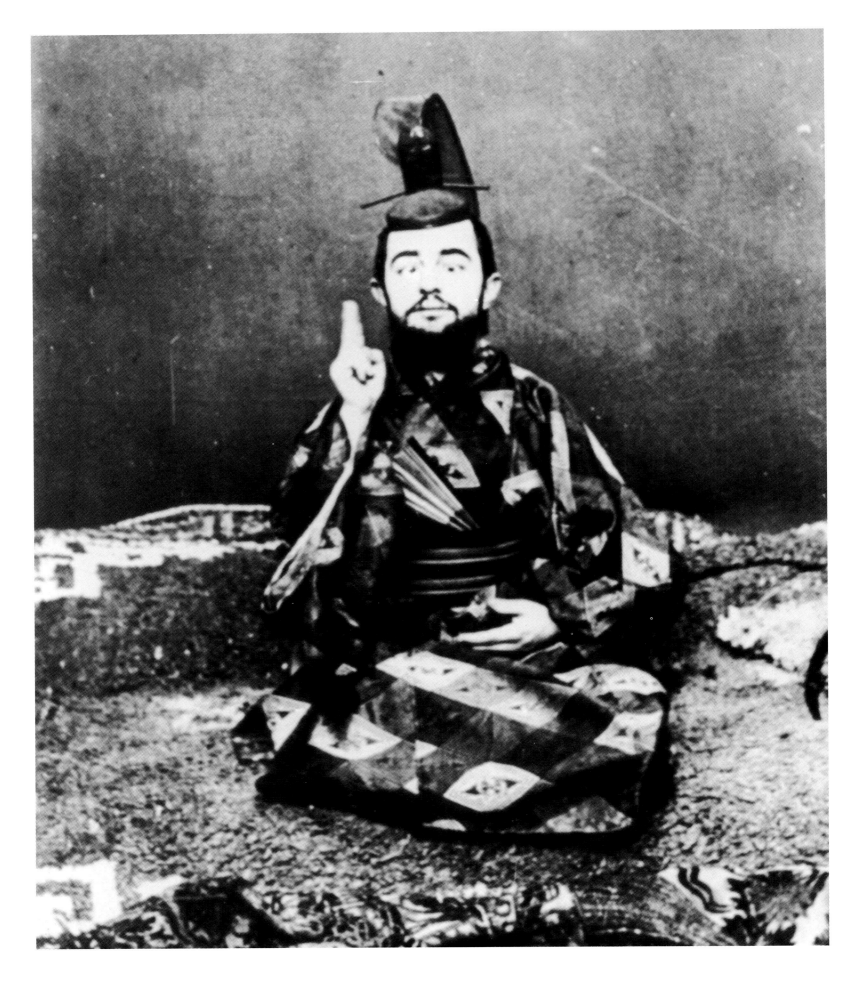

Henri de Toulouse-Lautrec

1892, photograph by Maurice Guibert

Portrait of Toulouse-Lautrec posing as a Japanese emperor while sitting cross-legged and cross-eyed on an Oriental rug. He is wearing a cap, a silk robe, and a fan tucked into his obi.

Henri de Toulouse-Lautrec

1892, fotografía de Maurice Guibert

Retrato de Toulouse-Lautrec posando vestido de emperador japonés, sentado con las piernas cruzadas y los ojos bizcos sobre una alfombra oriental. Lleva un sombrero, un quimono de seda y un abanico insertado en el *obi*.

Henri de Toulouse-Lautrec

1892, photographie de Maurice Guibert

Portrait de Toulouse-Lautrec en empereur du Japon. Louchant et assis en tailleur sur un tapis d'orient, il est coiffé d'un kammuri, porte une robe de soie et un éventail fiché dans son obi.

Henri de Toulouse-Lautrec

1892, Fotografie von Maurice Guibert

Porträt von Toulouse-Lautrec als schielender japanischer Kaiser im Schneidersitz auf einem Orientteppich. Er trägt ein Seidengewand, und im Obi steckt ein Fächer.

Einleitung

Maria-Christina Boerner

Selbst der vehemente Fürsprecher der Neoimpressionisten, Félix Fénéon, musste 1893 in der anarchistischen Wochenzeitschrift „Le Père Peinard" anerkennen: „Tausend Teufel, ist der unverschämt, dieser Lautrec; er ziert sich nicht, weder was seine Zeichnung, noch was seine Farben angeht. Weiß, Schwarz, Rot in großen Flecken und einfachen Formen, das ist seine Art." Weiterhin attestierte Fénéon dem Künstler Henri de Toulouse-Lautrec, dessen Plakate seit zwei Jahren in der französischen Hauptstadt für großes Aufsehen sorgten, „Willen, Frechheit und Boshaftigkeit". Dieses prägnante Urteil des Kunstkritikers bezieht sich freilich nicht nur auf die gewagten stilistischen Innovationen Lautrecs, sondern auch auf seine oftmals anzüglichen Sujets aus dem Pariser Nachtleben. Dem heutigen Betrachter erscheint die antibourgeoise Kunstrebellion des jungen Mannes aus der südfranzösischen Provinz wohl nicht mehr so offenkundig wie den meisten seiner Zeitgenossen. Mittlerweile gehören die Werke Lautrecs nicht zuletzt dank vielfältiger Reproduktionsformen fast genauso zum vertrauten und liebgewonnenen Sinnbild der mondänen Metropole wie der 1889 eingeweihte Eiffelturm. In der kunsthistorischen Bewertung seines Werkes steht dennoch außer Zweifel, dass Lautrec zu den wichtigsten Avantgarde-Künstlern des ausgehenden 19. Jahrhunderts zählt. Vor allem seine Plakate und Lithografien mit ihren großen, hellen Farbflächen ohne Schattierungen sowie den scharfen Konturen und überaus dynamischen Linien begründen seine anhaltende Popularität ebenso wie seinen Ruf als Erneuerer der grafischen Künste. Ähnliches gilt für seine ungemein treffsicheren Zeichnungen, die mit sparsamen, rasch hingeworfenen Strichen stets das Wesentliche erfassen. Und auch seine Ölgemälde besitzen trotz höchst sorgfältiger und meist langwieriger Herstellung genau wie die Grafik jene Spontaneität und Frische, die ihnen nicht nur einen Platz in den großen Museen der Welt sichern, sondern zugleich für Rekordpreise auf dem Kunstmarkt sorgen.

Dabei deuteten weder Lautrecs Herkunft aus dem französischen Hochadel mit Wurzeln bis in die Zeit Karls des Großen noch seine etwa zwei Jahre währende Ausbildung in den Ateliers der biederen akademischen Maler Léon Bonnat und Fernand Cormon ausgerechnet auf eine rasante Karriere als gefeierter Porträtist des leichtlebigen Paris. Immerhin musste der 1864 als Henri Marie Raymond de Toulouse-Lautrec-Monfa im südfranzösischen Albi geborene älteste Spross des Grafen Alphonse nicht wie viele seiner Kollegen gegen allzu starke elterliche Widerstände ankämpfen, als er sich für eine Künstlerlaufbahn entschied.

Der recht exzentrische Graf, der neben der standesgemäßen Jagd und Falkenzucht auch extravagante Verkleidungen liebte und sich gern einmal als Türke oder Highlander im Kilt fotografieren ließ, respektierte den unwiderstehlichen Drang seines Sohnes zu zeichnen. So erhielt bereits der Knabe nach ersten Unterweisungen seitens seines Onkels Charles ab 1872 Mal- und Zeichenunterricht bei dem mit dem Vater befreundeten Pferdeliebhaber und Tiermaler René Princeteau. Gleichwohl drängten die schon seit 1868 getrennt lebenden Eltern Lautrecs auf die Wahrung der Familienehre. Sie verlangten daher von ihrem Sohn, dass er seine Werke mit den kompromittierenden Einblicken in das Nachtleben von Montmartre nur unter Pseudonymen wie „Tréclau" (ein Anagramm von Lautrec), „Monfa" (sein dritter Familienname) oder „Tolav-Segroeg" ausstellen durfte. Das änderte sich erst 1888, als er an der bedeutenden Avantgarde-Ausstellung der „Société des XX" (Gesellschaft der Zwanzig) in Brüssel teilnahm, wo er enthusiastisch „die rote Fahne des Impressionismus" zu tragen beabsichtigte und erstmalig seine Werke mit seinem Familiennamen Toulouse-Lautrec signierte.

Von nun an musste sich der aufgrund einer Erbkrankheit und zweier schwerer Beinbrüche nur 1,52 m große Maler die oftmals höhnischen Kommentare einer konservativen und moralisierenden Kunstkritik gefallen lassen, die seine ungeschminkte Wiedergabe der Pariser Halbwelt genüsslich als Ausdruck adliger Dekadenz verurteilte. Gleichzeitig aber profitierte Lautrec von den Privilegien seiner Klasse: Während viele Künstlerkollegen wie der 1887 von ihm porträtierte Vincent van Gogh (1853 – 1890) das Bohème-Leben auf dem Montmartre und ihre Abkehr vom offiziellen akademischen Kunstgeschmack meist mit einem leeren Magen bezahlten, erhielt Lautrec von seiner Familie eine Rente und konnte stets auf die finanzielle Unterstützung seiner Mutter zählen. Sie ermöglichte ihm eine Künstlerexistenz ohne die beengende Abhängigkeit von Auftraggebern. Zudem wussten einige geschäftstüchtige Galeristen schon früh den Marktwert des Abkömmlings aus dem berühmten Adelsgeschlecht für den Verkauf seiner Werke zu nutzen.

Was aber reizte den an die Annehmlichkeiten seines Stands gewöhnten Lautrec so sehr am Leben auf der „Butte", dem Hügel von Montmartre, dass sich der zwanzigjährige Aristokrat hier installierte und seine Kunst sechzehn Jahre lang bis zu seinem frühen Tod fast ausnahmslos den bizarren Berühmtheiten und vergnügungssüchtigen Besuchern der Theater, Cabarets, Café-Concerts und Bordelle widmete? Es waren wohl die vielen, gerade auch widersprüchlichen Facetten des erst 1860 eingemeindeten Bezirks im Pariser Norden, die ihn wie viele andere Künstler

faszinierten und seine Kunst inspirierten. Einerseits hatte sich das Quartier mit seinen Weinbergen, Windmühlen und Gärten noch viel von seinem ländlichen Charme bewahrt, andererseits entstanden hier innerhalb weniger Jahre unzählige Etablissements, in denen sich die Bevölkerung und Touristen verschiedener sozialer Klassen trafen und dem Amüsement hingaben. Das einfache Volk suchte eher den harmlosen Zeitvertreib im populären Tanzlokal „Moulin de la Galette", dessen beschwingte Atmosphäre bereits Auguste Renoir (1841 – 1919) auf seinem Meisterwerk von 1876 in ein impressionistisches Licht getaucht hatte und auch Lautrec ein Jahrzehnt später zu einigen seiner frühen postimpressionistischen Gemälde anregte. Dagegen traf sich die feinere Gesellschaft seit 1881 im „Chat Noir" von Rodolphe Salis. Dandys mit Zylinder, Handschuhen und Monokel, Damen in ihren eleganten Roben und Literaten wie Paul Verlaine oder Jean Lorrain – sie alle verfolgten amüsiert die geistvollen Darbietungen in diesem neuartigen Cabaret. Die damals berühmteste Attraktion allerdings war das auch heute noch beliebte „Moulin Rouge" mit seiner roten Windmühlenattrappe über dem Eingang. In dem 1889 eröffneten Etablissement von Charles Zidler feierten die bekanntesten Stars jener Jahre wie die Tänzerinnen La Goulue (die Gefräßige) und Jane Avril oder die clowneske Nackttänzerin Cha-U-Kao ihre größten Erfolge, und der Dauergast Lautrec hat sie alle in seinem Werk verewigt.

Wie ein Mahnmal gegen all diese Ausschweifungen des Amüsierbetriebs thront noch heute die 1875 begonnene, 1914 vollendete, aber erst 1919 geweihte Basilika Sacré Cœur auf der Anhöhe von Montmartre und bezeugt, dass in der Dritten Republik auch der Katholizismus wieder erstarkte. Gegen allzu freizügige Plakate oder frivole Illustrationen in Büchern und Zeitschriften schritt eine Zensurbehörde ein, und Inspektoren der Sittenpolizei wachten über die Einhaltung der Anstandsgesetze in den Cabarets. Insbesondere der Rock einer Tänzerin durfte bei den beiden feurig-ekstatischen Modetänzen, der „Quadrille naturaliste" oder dem Cancan mit ihren geradezu akrobatischen Verrenkungen, Beinwürfen und Spagatsprüngen, nicht zu hoch fliegen noch gar zu viel Haut sichtbar werden. Inmitten des wirbelnden Trubels saß der wegen seiner körperlichen Gebrechen meist zum Beobachter verurteilte Lautrec an einem Tisch oder in einer Loge, gefesselt von der rastlosen Bewegung dieser aufreizenden Tänze. Gerade ihm gelang es wie kaum einem anderen Künstler seiner Zeit, die Dynamik und Vitalität der Tänzerinnen einzufangen, und er hat sie mit seinem Werk zum Sinnbild der lebenslustigen Belle Époque gemacht. Den unverwechselbar spontanen Ausdruck seiner Lithografien erzielte Lautrec nicht zuletzt, weil er seine Kompositionen fast immer direkt auf den Stein zeichnete und nur selten zusätzlich Umdruckpapiere benutzte.

Hingegen bediente er sich immer wieder auch der Fotografie, etwa bei dem Werbeplakat für die Auftritte der Truppe um Eglantine Demay im Londoner Palace Theatre 1896. Was auf der erhaltenen Fotovorlage jedoch eine eingefrorene Pose ist, das verwandelt sich auf Lautrecs Lithografie zu einem einzigen schwungvollen Reigen, der mit kurvigen Linien und kurzen Strichen von den schwarz bestrumpften Beinen der vier Tänzerinnen bis zu ihren federgeschmückten Hüten alles in Bewegung versetzt. Selbst die Dielen des Tanzbodens scheinen hier, wie oft bei Lautrec, in eine dynamische Schräglage geraten zu sein.

In Lautrecs sinnenfreudigem Panorama fehlen aber auch die bereits erwähnten staatlichen Sittenwächter nicht. Einen von ihnen, Coutelat du Roché mit dem Spottnamen „Père la pudeur" (Keuschheitsvater), hat Lautrec mehrfach mit spitzer Feder karikiert. Überhaupt ist der Instinkt des Karikaturisten für die ironische Zuspitzung, die Lautrec eng mit seinem berühmten Vorläufer Honoré Daumier (1808 – 1879) verbindet, in seinem Werk sehr präsent. Seine häufige Arbeit als Illustrator für die unzähligen Pariser Periodika wie die Wochenzeitschrift „Le Rire" oder die kurzlebige satirische Monatsschrift „La Vache Enragée" stimulierte seinen Scharfsinn als Karikaturist. Da er seine Werke hauptsächlich über die Linie gestaltete, war der Schritt zur karikierenden Überzeichnung und pointierten Verzerrung von Details nicht weit. Im Grunde versuchte er hier mit dem Zeichenstrich ebenso wie in seinen einfühlsamen, manchmal auch grausam ehrlichen Porträts von gebeugten Wäscherinnen, abgestumpften Absinth-Trinkern oder abgehärmten Prostituierten das Wesentliche, den realen Kern herauszudestillieren. In dieser Hinsicht unterscheidet sich sein Werk markant von jenen Spielarten des zeitgenössischen Jugendstils (Art Nouveau), in denen es entweder um den rein ornamentalen Dekorationswert oder – wie bei Henry van der Velde (1863 –1957) – um den abstrakten Ausdruck der Linie ging.

Oftmals waren die Reaktionen auf Lautrecs spezielle Form der Verdichtung allerdings recht zwiespältig. Als er 1893 für einen der Stars des „Moulin Rouge", die von ihm verehrte Diseuse und Chansonnette Yvette Guilbert, ein Album mit sechzehn Lithografien illustrierte, lobten einige die expressive Kühnheit der Ansichten und grotesken Posen, die ihrem exzentrischen Darstellungsstil vollkommen entsprachen. Dagegen erschien am 2. Oktober 1894 eine scharfe Kritik des Schriftstellers Jean Lorrain in „L'Echo de Paris", der in dem Album den „Kult des Hässlichen" zu weit getrieben fand und der Kabarettistin vorwarf, in ihrer „Sucht nach Reklame" die geschmacklose Verzerrung ihrer Züge akzeptiert zu haben. Yvette Guilbert selbst, deren lange schwarzen Handschuhe, ihr Markenzeichen, auf dem Umschlag wie ein lebendiges Wesen die Stufen der Bühne hinab gleiten, musste sich

erst vom Kunstkritiker Gustave Geffroy von der Vortrefflichkeit der Illustrationen überzeugen lassen.

Das großformatige Album, das mit dem Text von Geffroy und den Abbildungen Lautrecs in einer Auflage von 100 Stück für jeweils 50 Francs recht erschwinglich war, ist aber nicht nur in stilistischer Hinsicht ein außergewöhnliches Produkt. Vielmehr markiert es zusammen mit den Plakaten Lautrecs einen neuen Abschnitt in der Geschichte der Werbung, denn es widmet sich ausschließlich der Publicity einer bestimmten Person. Bevorzugte der Begründer des modernen französischen Werbeplakats Jules Chéret (1836 – 1932) überwiegend anonyme und stereotype Schönheiten, präsentierte Lautrec die Persönlichkeiten des Pariser Nachtlebens mit ihren unverwechselbaren Attributen und ebnete damit in gewisser Weise dem Starkult den Weg. Im Auftrag des Sängers Aristide Bruant, der in seinem Cabaret „Le Mirliton" gelegentlich sein Publikum beschimpfte und anarchistische Chansons im derben Straßenslang vortrug, fertigte sein Freund Lautrec mehrere Plakate an. Nach dem Vorbild japanischer Holzschnitte reduzieren sie alle in radikaler Weise die gesamte Komposition auf wenige, betont flächige Elemente und zeigen nur die imposante Silhouette des Sängers mit dem großen Schlapphut und dem schwarzen Umhang, auf dem der schwungvoll drapierte rote Schal leuchtet. Gibt Lautrec auf den beiden Versionen von 1892 noch die markanten Gesichtszüge Bruants wieder, genügt ein Jahr später bereits dessen Profilansicht, kannte vermutlich doch inzwischen ganz Paris dessen Konterfei. Auf dem letzten Blatt schließlich betreibt Lautrec geradezu ein ironisches Spiel mit den Erwartungen des Betrachters: Die Gestalt Bruants erscheint hier nur noch von hinten, die Hände trotzig in die Hosentaschen gestemmt.

Die Werbewirkung dieser ebenso klaren wie einprägsamen Plakatgestaltung kam wohl beiden Künstlern gleichermaßen zugute, da auch Lautrec von der massiven Präsenz seiner Werke mit dem unverwechselbaren Stil in den Straßen der Hauptstadt profitierte. Freilich sorgte diese Allgegenwärtigkeit bisweilen für Überdruss, wie er in „La Vie Parisienne" 1892 zum Ausdruck kam: „Wer befreit uns vom Konterfei Aristide Bruants? Man kann keinen Schritt mehr tun, schon ist er wieder da."

Zu den weniger bekannten Seiten seines vielfältigen Werkes gehört indes Lautrecs Arbeit als Illustrator von Büchern. Kurz bevor seine rastlose Produktivität infolge seines übermäßigen Alkoholkonsums und ausschweifenden Nachtlebens in den letzten Jahren bis zu seinem Tod 1901 nachzulassen begann, fertigte er 1897 für den Politiker und Freund Georges Clemenceau zehn außergewöhnliche Lithografien für dessen Buch „Au Pied du Sinaï" („Am Fuß des Sinai") an. Darin schildert Clemenceau das Leben der Juden in Paris, Polen und Karlsbad zu einem Zeitpunkt, als Frankreich von der Affäre um den jüdischen Hauptmann Dreyfus erschüttert wird. Mit dicken, heftigen Strichen skizzierte Lautrec düstere und bedrückend wirkende Milieubilder, für die er zuvor eingehend die Einwohner des jüdischen Viertels in Paris studiert hatte. Abgesehen von der eigentümlich symbolischen Umschlagzeichnung mit Moses und den Gesetzestafeln sowie dem vom Sockel gestürzten Goldenen Kalb, erinnert die erstaunliche Wirklichkeitsnähe und Expressivität dieser Arbeiten an die Druckgrafik Goyas (1746 – 1828), den Lautrec sehr verehrte. Ein schärferer Kontrast zu seinen gewohnten Bildern nächtlicher Ausgelassenheit und erotischer Verführungen in Montmartre lässt sich kaum denken. Diese eindrucksvollen Buchillustrationen belegen, dass das Spektrum seines Werkes wesentlich größer ist als es manch verbreitete Gemeinplätze über den Künstler glauben machen wollen. Schließlich bedeutet Avantgarde nicht nur stilistisch-formale Erneuerung und ästhetische Innovation, sondern ebenso verblüffende, manchmal auch befremdende Vielfalt. Sie kann im vorliegenden Bildband aufs Neue entdeckt werden.

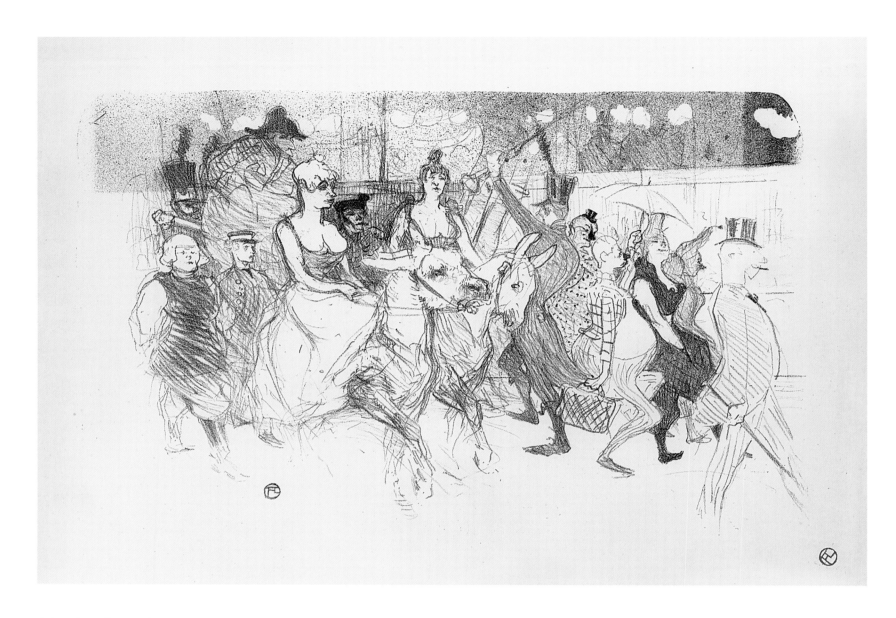

A Parade at the Moulin Rouge

1893, lithograph, 29.6 x 47 cm

Every Saturday at the Moulin Rouge there would be parades, with floats decorated with flowers, followed by an orchestra delivering a cacophony of trumpet sounds. All Montmartrois would come out to gaze at the spectacle. It was not uncommon to see among the participants naked women covered with a transparent veil. Not everybody enjoyed these 'redoutes'. In 1893, Senator Béranger filed a complaint on behalf of the 'Society for the Protection from Street Lawlessness', in which he deplored the sight of "naked women wearing transparent clothing during the parade and then mixing with the people in the dance hall".

Desfile en el Moulin Rouge

1893, litografía, 29,6 x 47 cm

Cada sábado se celebraban en el Moulin Rouge desfiles con carrozas decoradas con flores y acompañadas por una orquesta que producía una cacofonía de sonidos de trompeta. Todos los habitantes de Montmartre salían a contemplar el espectáculo. No era raro ver entre los participantes a mujeres desnudas cubiertas por velos transparentes. No todo el mundo disfrutaba de estos eventos. En 1893 el senador Béranger presentó una queja de la Sociedad para la Vigilancia del Desorden Público en la cual deploraba la vista de «mujeres desnudas cubiertas con ropas transparentes durante el desfile y que luego se mezclan con la gente en el salón de baile».

Une Redoute au Moulin Rouge

1893, lithographie, 29,6 x 47 cm

Il y avait des parades tous les samedis au Moulin Rouge, avec des chars fleuris suivis par un orchestre émettant une cacophonie de sons de trompette. Tous les Montmartrois sortaient pour contempler le spectacle. Il n'était pas rare de voir parmi les participants des femmes nues couvertes d'un voile transparent. Tout le monde n'appréciait pas ces redoutes. En 1893, le sénateur Béranger déposa une plainte au nom de la « Ligue contre la licence des rues », déplorant la présence de « femmes nues portant des vêtements transparents durant la parade et se mêlant ensuite aux gens dans la salle de danse ».

Umzug im Moulin Rouge

1893, Lithografie, 29,6 x 47 cm

Jeden Samstag fanden am Moulin Rouge Umzüge mit blumengeschmückten Wagen statt samt einem Orchester, das für schallende Trompetenklänge sorgte. Alle Bewohner des Montmartre verfolgten das Spektakel. Nicht selten zogen dort auch Frauen mit, die bis auf einen durchsichtigen Schleier unbekleidet waren. Doch diese „Redoutes" gefielen nicht jedem. 1893 beschwerte sich Senator Béranger im Namen der „Gesellschaft zum Schutz vor Gesetzlosigkeit auf der Straße" über den Anblick von „nackten Frauen mit transparenter Kleidung, die am Umzug teilnehmen und sich anschließend im Tanzlokal unter das Volk mischen".

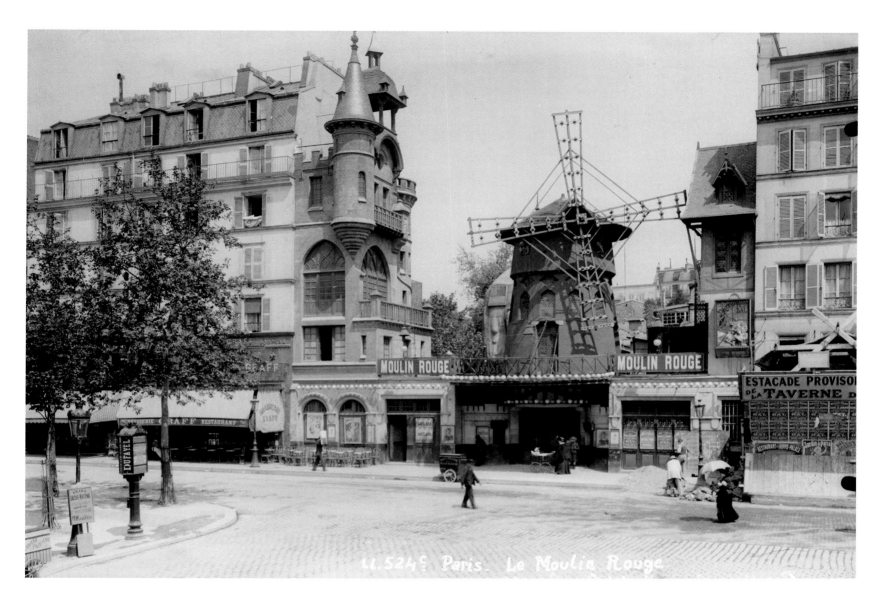

11.524ᶜ Paris. Le Moulin Rouge

The Moulin Rouge

c. 1895

The Moulin Rouge (Red Mill) was built in 1889 by Joseph Oller and Charles Zidler and opened on 6 October the same year. It is located near Montmartre in the eighteenth district of Paris. 'The First Palace of Women', as it was nicknamed by owner Oller, quickly became a great success thanks to the extravagant shows staged in the cabaret. The cancan, danced to the furious rhythms of Offenbach's music made the Moulin Rouge a special attraction for people from all classes. Performers such as Jane Avril, Yvette Guilbert or La Goulue started their career in the establishment, and it was Toulouse-Lautrec, through his paintings and publicity posters, who made the stars of the Moulin Rouge immortal to this day.

El Moulin Rouge

c 1895

El Moulin Rouge fue construido en 1889 por Joseph Oller y Charles Zidler e inaugurado el 6 de octubre del mismo año. Está situado cerca de Montmartre, en el distrito 18 de París. «El primer palacio de las mujeres», como lo llamaba Oller, su propietario, se convirtió en un éxito rápidamente gracias a los extravagantes espectáculos que se presentaban en el cabaré. Sobre todo el cancán bailado al ritmo frenético de la música de Offenbach hizo del Moulin Rouge una atracción para gente de toda clase social. Artistas como Jane Avril, Yvette Guilbert o La Goulue comenzaron sus carreras en el establecimiento y, a través de sus pinturas y carteles publicitarios, Toulouse-Lautrec las hizo estrellas inmortales hasta el día de hoy.

Le Moulin Rouge

vers 1895

Construit par Joseph Oller et Charles Zidler en 1889 au pied de Montmartre, dans le dix-huitième arrondissement, le Moulin Rouge a ouvert ses portes le 6 octobre de la même année. « Le premier palais des femmes » ainsi que le surnommaient ses propriétaires, connut rapidement le succès grâce à ses spectacles extravagants. Le cancan surtout, dansé sur les rythmes endiablés de la musique d'Offenbach, a fait du Moulin Rouge un lieu où se côtoyaient toutes les classes sociales. C'est dans cet établissement que des artistes comme Jane Avril, Yvette Guilbert ou La Goulue ont commencé leur carrière. Toulouse-Lautrec a immortalisé les vedettes du Moulin Rouge sur ses peintures et ses affiches publicitaires.

Das Moulin Rouge

um 1895

Das Moulin Rouge (Rote Mühle) wurde 1889 von Joseph Oller und Charles Zidler erbaut und öffnete seine Türen noch im selben Jahr am 6. Oktober. Es liegt nahe Montmartre im 18. Pariser Arrondissement. Der „erste Palast der Frauen" wurde dank der extravaganten Revuen im Cabaret schnell ein großer Erfolg. Vor allem der zu den furiosen Rhythmen von Offenbachs Musik getanzte Cancan ließ das Moulin Rouge bald zu einer Attraktion für die Angehörigen aller Schichten werden. Darstellerinnen wie Jane Avril, Yvette Guilbert oder La Goulue begannen ihre Laufbahn in dem Etablissement, und Toulouse-Lautrec machte die Stars des Moulin Rouge in seinen Gemälden und Werbeplakaten unsterblich.

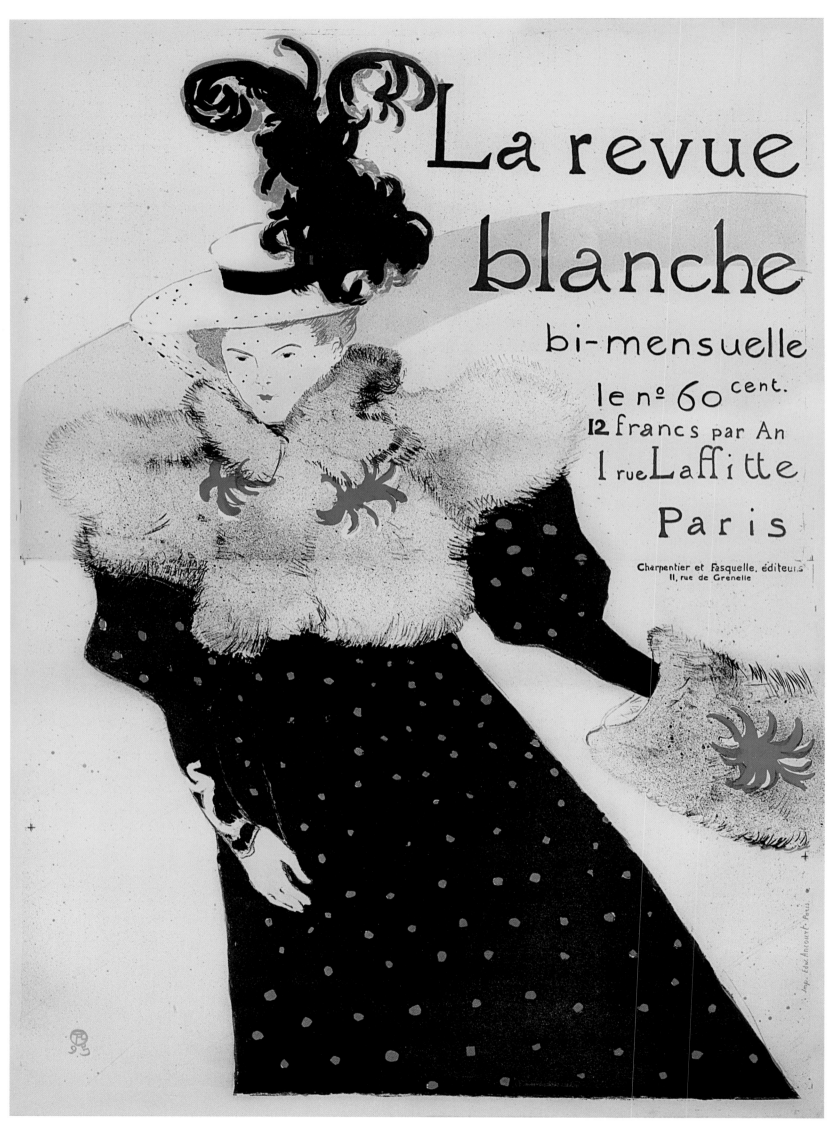

La Revue Blanche

1895, colour lithograph, 125.5 x 91.2 cm

This beautifully preserved copy of the advertisement for the bimonthly literary magazine *La Revue Blanche* shows Misia Sert the elegant wife of Thadée Natanson, publisher of the magazine, skating on an ice rink. Although one does not see the skates or other skaters around her, her body movement is unmistakable. This is one of the few copies of this poster printed on a single sheet of paper from two stones.

La Revue Blanche

1895, litografía en color, 125,5 x 91,2 cm

Esta copia tan bien conservada de la revista literaria bimensual *La Revue Blanche* muestra a Misia Sert, la elegante esposa de Thadée Natanson, editor de la revista, patinando en una pista de hielo. A pesar de que no se ven sus patines ni otros patinadores a su alrededor, sus movimientos corporales resultan inconfundibles. Esta es una de las pocas copias de este cartel impreso en una sola hoja de papel de dos placas.

La Revue Blanche

1895, lithographie en couleur, 125,5 x 91,2 cm

Cette copie bien conservée de la publicité pour le magazine littéraire bimensuel *La Revue Blanche* montre Misia Sert, l'élégante épouse de Thadée Natanson, directeur de la revue, en train de patiner sur glace. Même si l'on ne voit ni ses patins ni d'autres patineurs, le mouvement de son corps est caractéristique. C'est l'une des rares copies de cette affiche imprimée à partir de deux pierres lithographiques sur une simple feuille de papier.

La Revue Blanche

1895, Farblithografie, 125,5 x 91,2 cm

Diese gut erhaltene Werbung für die halbmonatlich erscheinende Literaturzeitschrift *La Revue Blanche* stellt Misia Sert, die elegante Frau des Verlegers Thadée Natanson, beim Eislaufen dar. Auch wenn keine Schlittschuhe oder anderen Eisläufer zu sehen sind, ist die Bewegung des Körpers doch unverkennbar. Es handelt sich hier um eine seltene, von zwei Steinen gedruckte Fassung des Plakats.

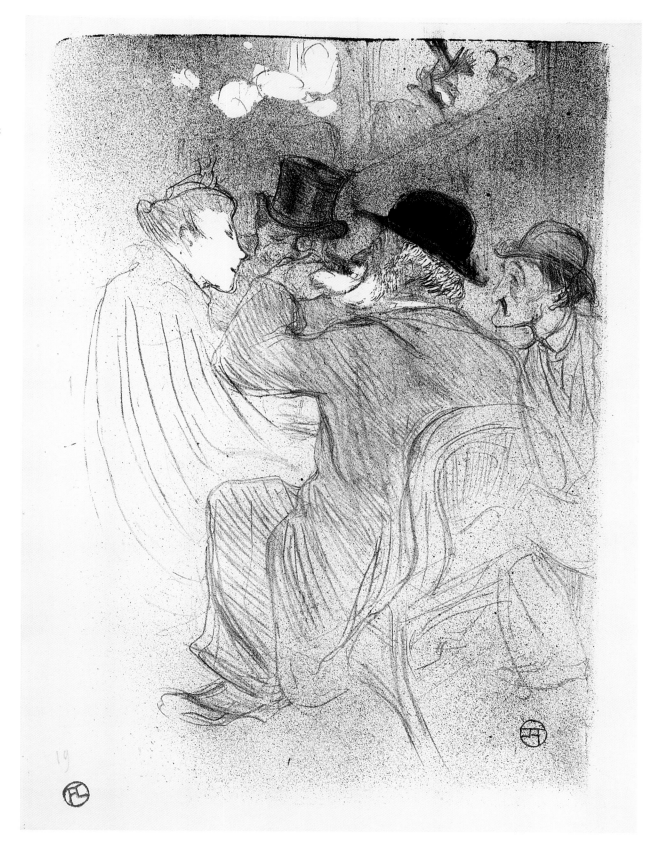

A Rude! A Real Rude!

1893, lithograph, 35.6 x 25.5 cm

According to Loys Delteil, who compiled a complete catalogue of Toulouse-Lautrec's prints, the artist's father, the Count Alphonse de Toulouse-Lautrec, is the man eating a sandwich in the foreground.

¡Un grosero! ¡Un verdadero grosero!

1893, litografía, 35,6 x 25,5 cm

Según Loys Delteil, que recopiló un catálogo completo de grabados de Toulouse-Lautrec, el padre del artista, el conde Alphonse de Toulouse-Lautrec, es el hombre que se ve en primer plano comiendo un bocadillo.

Un Rude ! Un Vrai Rude !

1893, lithographie, 35,6 x 25,5 cm

Selon Loys Delteil, qui a établi un catalogue complet des gravures de Toulouse-Lautrec, l'homme qui mange un sandwich au premier plan est le père de l'artiste, le comte Alphonse de Toulouse-Lautrec.

Ein Grobian! Ein richtiger Grobian!

1893, Lithografie, 35,6 x 25,5 cm

Laut Loys Delteil, der ein Werkverzeichnis zu den Grafiken Toulouse-Lautrecs erstellt hat, handelt es sich bei dem Mann vorn mit dem Sandwich um den Vater des Künstlers, Graf Alphonse de Toulouse-Lautrec.

Luce Myrès, front view

1895, lithograph, 36.5 x 24.5 cm

The popular café singer in a revival of
Offenbach's operetta *La Périchole* at the
'Théâtre des Variétés'.

Luce Myrès, de cara

1895, litografía, 36,5 x 24,5 cm

La popular cantante de cabaré en un
reestreno de la opereta de Offenbach
La Périchole en el Théâtre des Variétés.

Luce Myrès, de face

1895, lithographie, 36,5 x 24,5 cm

La chanteuse populaire dans une reprise
de *La Périchole*, l'opéra-bouffe d'Offenbach,
au Théâtre des Variétés.

Luce Myrès, von vorn

1895, Lithografie, 36,5 x 24,5 cm

Die beliebte Caféhaussängerin in einer
Wiederaufführung von Offenbachs Operette
La Périchole im „Théâtre des Variétés".

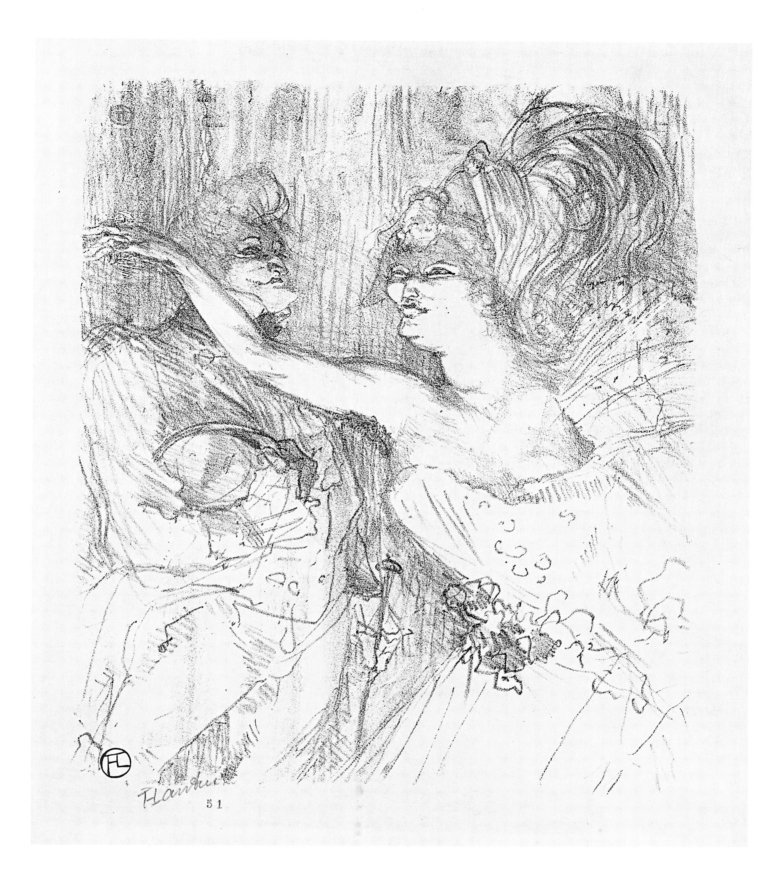

Guy and Mealy

1898, lithograph, 27.7 x 23.2 cm

The actress Juliette Samany (Mealy) and the actor Georges Guillaume (Guy) performing *Paris qui marche* in the 'Théâtre des Variétés'.

Guy y Mealy

1898, litografía, 27,7 x 23,2 cm

La actriz Juliette Samany (Mealy) y el actor Georges Guillaume (Guy) interpretando *Paris qui marche* en el Théâtre des Variétés.

Guy et Mealy

1898, lithographie, 27,7 x 23,2 cm

La comédienne Juliette Samany (Mealy) et le comédien Georges Guillaume (Guy) dans *Paris qui marche* au Théâtre des Variétés.

Guy und Mealy

1898, Lithografie, 27,7 x 23,2 cm

Die Schauspieler Juliette Samany (Mealy) und Georges Guillaume (Guy) führen *Paris qui marche* im „Théâtre des Variétés" auf.

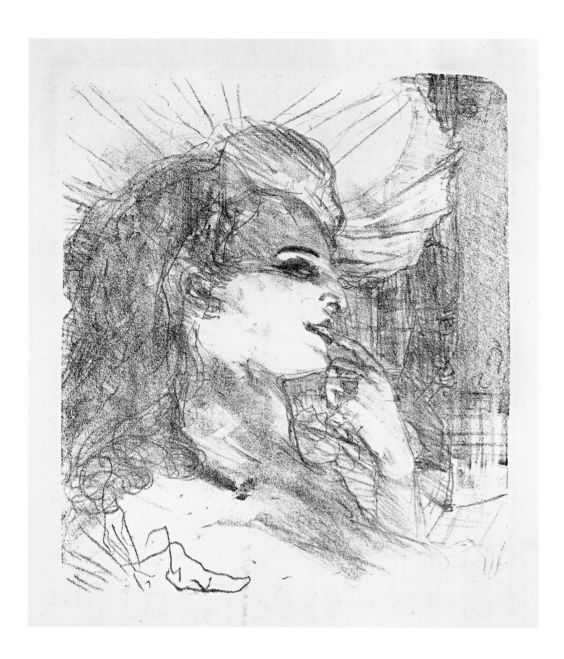

Wisdom

1893, lithograph, 25.5 x 19 cm

The cover for a song included in the book *Les Vieilles Histoires* ('The Old Stories'). Several versions of all songbook covers were printed: a limited edition, without text, for sale to collectors, one with text, another with the book title on the upper margin, and sometimes yet another with additional colours. The names of many composers are known thanks to the artwork on the music sheets rather than their music. The reputation of artists such as Toulouse-Lautrec made it possible for these songs to survive to this day.

Sabiduría

1893, litografía, 25,5 x 19 cm

Cubierta para una canción incluida en el libro *Les Vieilles Histoires* ('Las viejas historias'). Se imprimieron varias versiones de las cubiertas de todo el cancionero: una edición limitada sin texto para coleccionistas, una con texto, otra con el título del libro en el margen superior, y a veces otra con colores adicionales. Los nombres de muchos compositores se conocen más gracias a las ilustraciones de las partituras que a su música. La reputación de artistas como Toulouse-Lautrec hizo posible que estas canciones sobreviviesen hasta nuestros días.

Sagesse

1893, lithographie, 25,5 x 19 cm

Couverture d'une partition de chanson, inclue dans *Les Vieilles Histoires*. On imprimait plusieurs versions de toutes les couvertures de recueils de chansons : une édition limitée, sans texte, vendue aux collectionneurs, une autre avec un texte, une autre avec le titre du recueil dans la marge supérieure et quelquefois une autre encore coloriée. Les noms de nombreux compositeurs sont plus connus grâce aux œuvres d'art ornant les partitions que par leur musique. Si ces chansons ont survécu jusqu'à ce jour, elles le doivent à la réputation d'artistes comme Toulouse-Lautrec.

Weisheit

1893, Lithografie, 25,5 x 19 cm

Notentitel aus dem Band *Les Vieilles Histoires* („Die alten Geschichten"). Es wurden diverse Fassungen der Notentitel gedruckt: eine Sammleredition in limitierter Auflage ohne Text, eine Version mit Text, eine andere mit dem Buchtitel am oberen Rand und manchmal noch eine kolorierte. Die Namen vieler Komponisten kennt man heute nur dank der Illustrationen in den Notenheften. So hat das Renommee von Künstlern wie Toulouse-Lautrec ein Überdauern ihrer Lieder bis in unsere Zeit ermöglicht.

Anna Held

1898, lithograph, 29.2 x 24.3 cm

Anna Held was a highly successful Polish-born music hall singer.

Anna Held

1898, litografía, 29,2 x 24,3 cm

Anna Held fue una cantante de cabaré polaca de gran éxito.

Anna Held

1898, lithographie, 29,2 x 24,3 cm

Née en Pologne, Anna Held était une chanteuse de music-hall très populaire.

Anna Held

1898, Lithografie, 29,2 x 24,3 cm

Die in Polen geborene Anna Held war eine höchst erfolgreiche Varietésängerin.

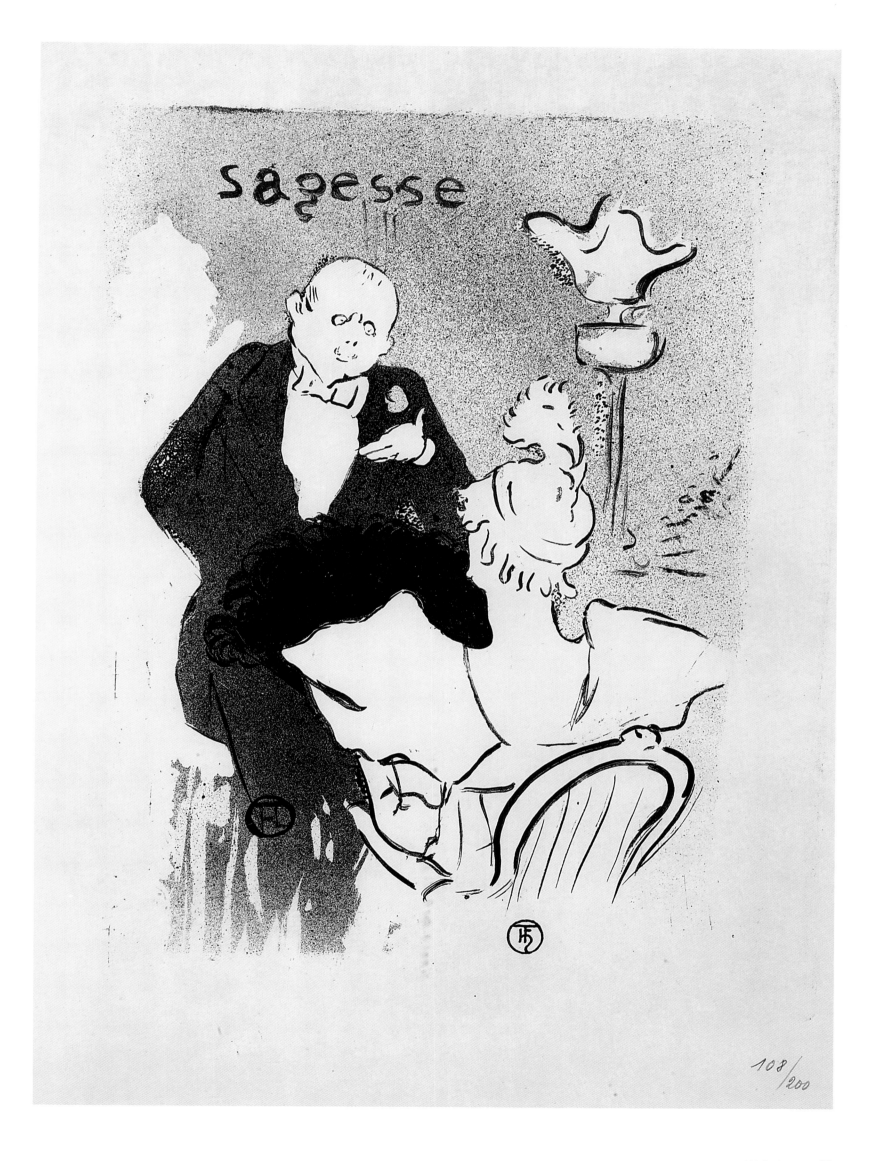

108/200

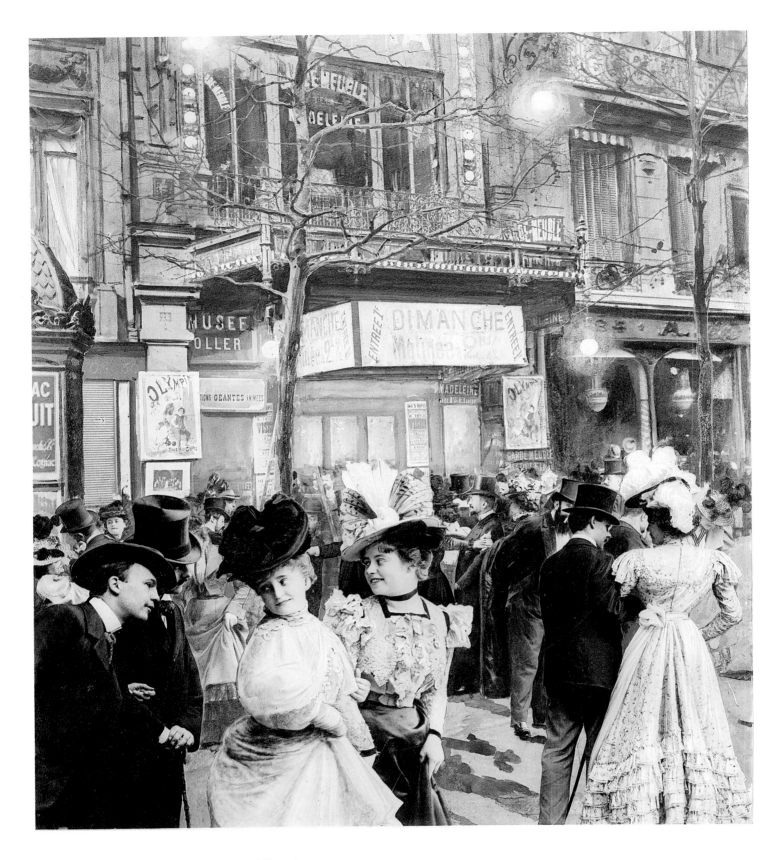

The Olympia

The photograph shows patrons as they exit the famed Paris 'Olympia' music hall after an evening performance in the late 1880s.

El Olympia

La fotografía muestra a los espectadores saliendo del famoso teatro Olympia de París después de una noche de actuación a finales de la década de 1880.

L'Olympia

La photographie montre les clients quittant le célèbre music-hall parisien après un spectacle en soirée à la fin des années 1880.

Das Olympia

Die Fotografie zeigt Besucher beim Verlassen des berühmten Pariser Varietés „Olympia" nach einer Abendvorstellung in den späten 1880er-Jahren.

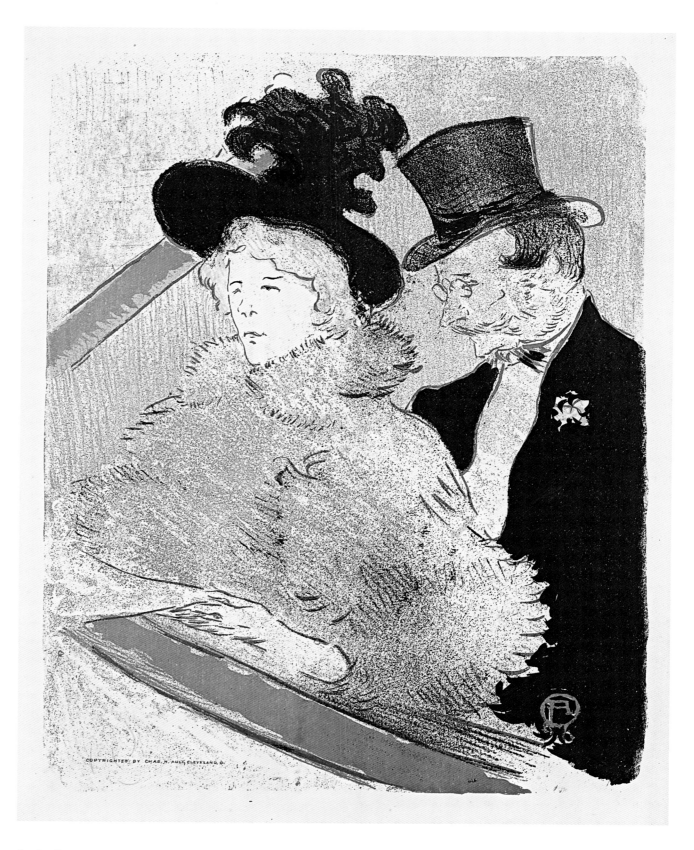

At the Concert

1896, colour lithograph, 32 x 25.2 cm

Toulouse-Lautrec was commissioned to design this poster for the American company Ault & Wiborg Co., which manufactured lithographic inks. It depicts Emilienne d'Alençon in a theatre loge, together with the artist's first cousin, Gabriel Tapié de Céleyran.

En el concierto

1896, litografía en color, 32 x 25,2 cm

Se encargó a Toulouse-Lautrec diseñar este cartel para la compañía americana Ault & Wiborg Co., que fabricaba tintas litográficas. Representa a Emilienne d'Alençon en un palco, junto con el primo hermano del artista, Gabriel Tapié de Céleyran.

Au Concert

1896, lithographie en couleur, 32 x 25,2 cm

La compagnie américaine Ault & Wiborg Co. qui fabriquait des encres lithographiques commanda cette affiche à Toulouse-Lautrec. Elle montre Emilienne d'Alençon dans une loge de théâtre avec le cousin germain de l'artiste, Gabriel Tapié de Céleyran.

Im Konzert

1896, Farblithografie, 32 x 25,2 cm

Den Auftrag für dieses Plakat erhielt Toulouse-Lautrec von dem amerikanischen Unternehmen Ault & Wiborg Co., das lithografische Tinten herstellte. Es zeigt Emilienne d'Alençon in einer Theaterloge mit dem Cousin des Künstlers, Gabriel Tapié de Céleyran.

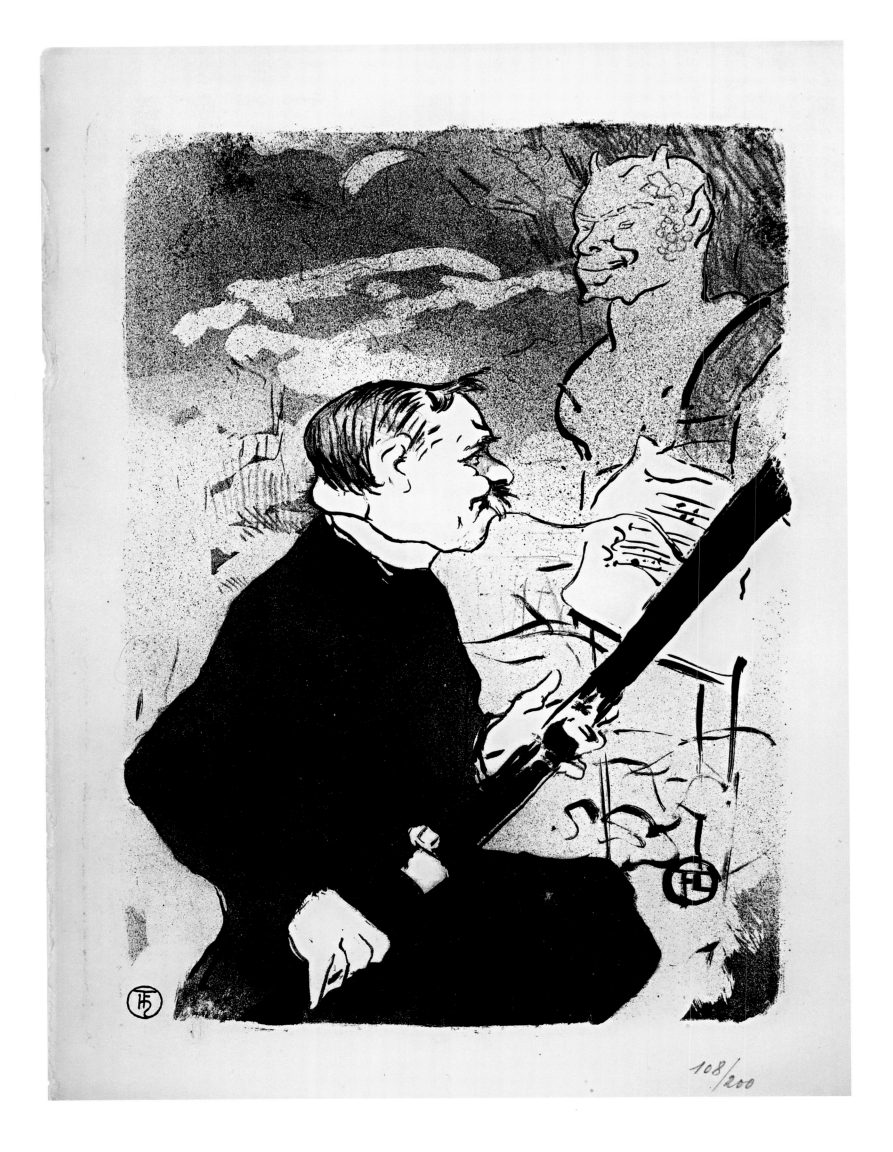

108/200

For You!...

1893, lithograph, 27.5 x 19.5 cm

The cover for one of the songs composed by Désiré Dihau. It was included in a songbook entitled *Les Vieilles Histoires* ('The Old Stories'), for which Toulouse-Lautrec also designed the cover. Dihau, a cousin of Toulouse-Lautrec, was a bassoonist at the Paris Opera.

¡Para ti...!

1893, litografía, 27,5 x 19,5 cm

Cubierta de una de las canciones compuestas por Désiré Dihau. Estaba incluida en un cancionero titulado *Les Vieilles Histoires* ('Las viejas historias'), para el que Toulouse-Lautrec también diseñó la cubierta. Dihau, primo del pintor, era fagotista de la Ópera de París.

Pour Toi !...

1893, lithographie, 27,5 x 19,5 cm

Couverture réalisée pour la partition d'une des chansons composées par Désiré Dihau. Elle est inclue dans le recueil intitulé *Les Vieilles Histoires* dont Toulouse-Lautrec a aussi dessiné la couverture. Dihau, un cousin de Toulouse-Lautrec, était basson de l'Opéra de Paris.

Für Dich! ...

1893, Lithografie, 27,5 x 19,5 cm

Notentitel für ein von Désiré Dihau komponiertes Lied. Er stammt aus dem Liederbuch *Les Vieilles Histoires* („Die alten Geschichten"), für das Toulouse-Lautrec ebenfalls das Titelbild gestaltete. Dihau war ein Verwandter des Künstlers und Fagottist an der Pariser Oper.

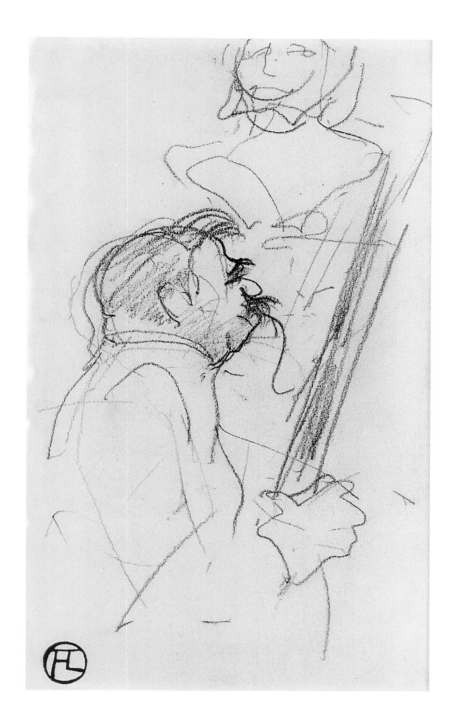

Portrait of Dihau

1893, pencil on paper, 17.5 x 10.5 cm

This is a pencil drawing Toulouse-Lautrec created in preparation for the *For You!* lithograph. Although the bassoonist kept his original position in the print, the marble bust has been relegated to the background in a less prominent position.

Retrato de Dihau

1893, lápiz sobre papel, 17,5 x 10,5 cm

Dibujo a lápiz realizado por Toulouse-Lautrec como preparación para la litografía *¡Para ti...!* Aunque el fagotista mantuvo su postura original en el grabado, el busto de mármol ha sido relegado al fondo, a una posición menos destacada.

Portrait de Dihau

1893, mine de plomb sur papier, 17,5 x 10,5 cm

Toulouse-Lautrec a créé ce dessin à la mine de plomb en préparant la lithographie de *Pour Toi !* Si le basson conserve sa position d'origine sur l'estampe, le buste de marbre a été relégué à l'arrière-plan où il est moins visible.

Bildnis Dihau

1893, Bleistift auf Papier, 17,5 x 10,5 cm

Diese Bleistiftzeichnung schuf Toulouse-Lautrec in Vorbereitung der Lithografie *Für Dich!*. In der Grafik behält der Fagottist seine ursprüngliche Position bei, während die Marmorbüste an eine weniger auffällige Stelle in den Hintergrund rückt.

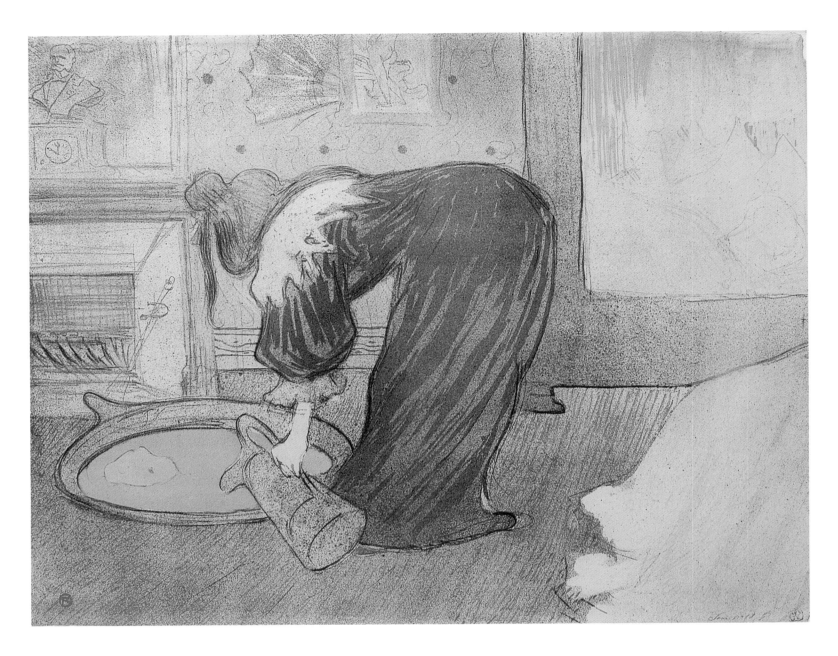

Woman with a Tub

1896, colour lithograph, 40 x 52.5 cm

One of ten lithographs in colour from the album *Elles* published in 1896. Hoping to boost sales, Gustave Pellet asked Toulouse-Lautrec to create a series of works depicting life in the brothels, which was not an unusual subject at the time. The artist had lived in brothels periodically. In these lithographs he chose to show the private, sometimes intimate lives of the women in a series of mundane scenes instead of emphasizing the erotic side of the subject. He thus made the women more human and somehow restored their dignity. Of the ten prints only two have an erotic theme. Perhaps for this reason the book was a flop. Today they are considered masterpieces of late nineteenth century French lithography.

Mujer con barreño

1896, litografía en color, 40 x 52,5 cm

Una de las diez litografías en color del álbum *Elles*, publicado en 1896. Con la esperanza de aumentar las ventas, Gustave Pellet pidió a Toulouse-Lautrec que crease una serie de trabajos que representaran la vida en los burdeles, un tema nada extraño entonces. El artista había vivido en burdeles en distintas ocasiones. En estas litografías decidió mostrar la parte privada, a veces íntima, de la vida de las mujeres en una serie de escenas muy mundanas, en vez de poner énfasis en lo erótico del tema. Así presenta a las mujeres de manera más humana y de algún modo les devuelve su dignidad. De los diez grabados solo dos describen un tema erótico (tal vez por este motivo el libro fue un fracaso). Hoy están considerados como obras maestras de la litografía francesa de finales del siglo XIX.

Femme au Tub

1896, lithographie en couleur, 40 x 52,5 cm

L'une des dix lithographies en couleur de l'album *Elles*, publié en 1896. Espérant stimuler les ventes, Gustave Pellet avait demandé à Toulouse-Lautrec de créer une série de dessins montrant la vie dans les bordels, un sujet qui n'avait rien d'insolite à l'époque. L'artiste avait périodiquement vécu dans des maisons closes. Il choisit ici de décrire la vie privée, parfois intime, des femmes dans une série de scènes très prosaïques au lieu d'insister sur le côté érotique du sujet. Il rend ainsi ces femmes plus humaines et leur restitue en quelque sorte leur dignité. Deux d'entre elles seulement ont un thème érotique, d'où la mévente du livre. Elles font désormais figure de chefs-d'œuvre de la lithographie française du XIXᵉ siècle.

Frau am Waschzuber

1896, Farblithografie, 40 x 52,5 cm

Eine von zehn Farblithografien aus dem Album *Elles*, das 1896 erschien. In der Hoffnung auf Umsatzsteigerungen gab Gustave Pellet bei Toulouse-Lautrec eine Folge von Bordellszenen in Auftrag, die damals als Sujet nicht unüblich waren. Der Künstler hatte zeitweise auch im Freudenhaus gelebt. In diesen Arbeiten schildert er nun das private, mitunter intime Leben der Frauen in ihrem ganz normalen Alltag, anstatt den erotischen Aspekt zu betonen, und gibt ihnen so ihre Würde zurück. Von den zehn Grafiken weisen nur zwei ein erotisches Thema auf – eventuell liegt darin auch der Grund für ihren damaligen Misserfolg. Heute gelten sie hingegen als Meisterwerke der französischen Lithografie des ausgehenden 19. Jahrhunderts.

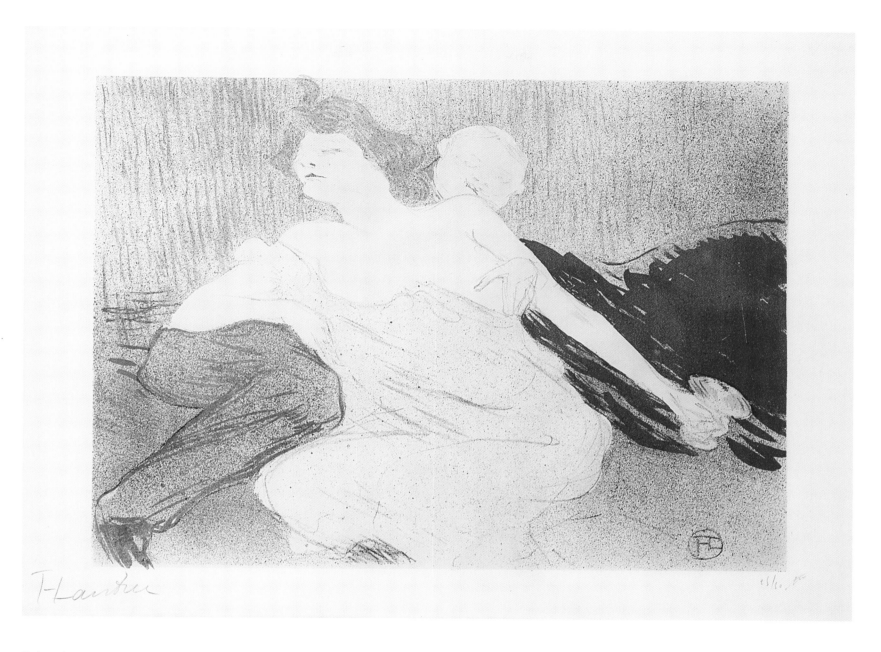

Debauchery

1896, colour lithograph, 23.9 x 32 cm

Toulouse-Lautrec designed this print as the cover for a sales catalogue of posters by French and foreign artists. It is a rare print as the text has not yet been added. The woman is one of the many brothel residents of Paris. However, the eager gentleman is Maxime Dethomas, one of Toulouse-Lautrec's friends, a painter-engraver and stage designer. The title *Debauchery* ('La Débauche') conjures up images of the laissez-faire spirit of the late nineteenth century in Paris.

Libertinaje

1896, litografía en color, 23,9 x 32 cm

Toulouse-Lautrec diseñó este grabado como cubierta para un catálogo de venta de carteles de artistas franceses y extranjeros. Se trata de un grabado poco corriente, pues el texto aún no se ha añadido. La mujer es una de las muchas residentes de los burdeles de París. Sin embargo, el ansioso caballero es Maxime Dethomas, uno de los amigos de Toulouse-Lautrec, grabador, pintor y escenógrafo. El título *Libertinaje*, evoca imágenes del espíritu no intervencionista, el *laissez-faire*, de finales siglo XIX en la capital gala.

La Débauche

1896, lithographie en couleur, 23,9 x 32 cm

Toulouse-Lautrec a dessiné cette scène pour la couverture d'un catalogue de vente d'affiches réalisées par des artistes français et étrangers. C'est une pièce rare, vu que le texte n'a pas encore été ajouté. La femme est une pensionnaire d'une des nombreuses maisons closes de Paris. Quant au monsieur empressé, il s'agit de Maxime Dethomas, l'un des amis de Toulouse-Lautrec, peintre-graveur et décorateur de théâtre. Le titre *La Débauche* évoque l'esprit de licence qui régnait à Paris à la fin du dix-neuvième siècle.

Ausschweifung

1896, Farblithografie, 23,9 x 32 cm

Diese Grafik entstand als Titelillustration für einen Verkaufskatalog von Plakaten französischer und ausländischer Künstler. Es handelt sich um einen seltenen Zustandsdruck, bei dem der Text noch fehlt. Die Frau gehört zu den zahlreichen Pariser Bordellbewohnerinnen, der eifrige Herr ist hingegen Toulouse-Lautrecs Freund, der Maler und Bühnenbildner Maxime Dethomas. Der Werktitel *Ausschweifung* („La Débauche") beschwört den Geist des Laisser-faire im Paris des späten 19. Jahrhunderts.

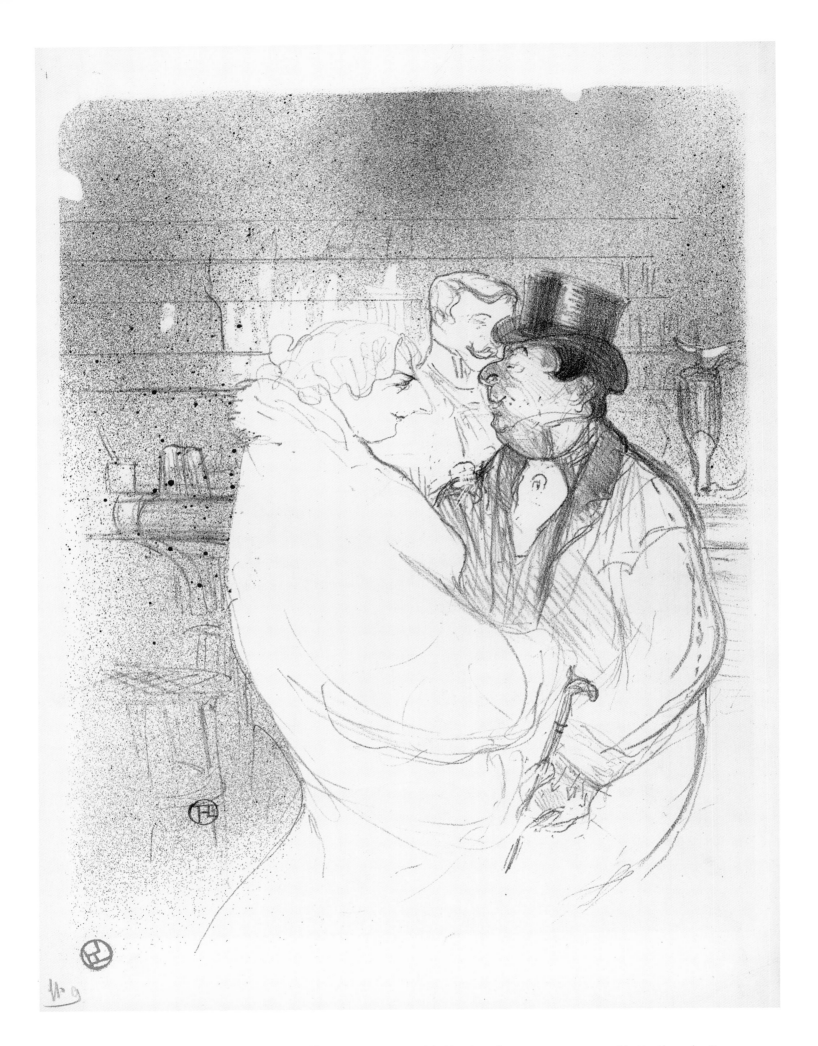

Ida Heath at the Bar

1894, lithograph, 33.5 x 25.5 cm

An English dancer portrayed by Toulouse-Lautrec in two lithographs.

Ida Heath en el bar

1894, litografía, 33,5 x 25,5 cm

Una bailarina inglesa retratada por Toulouse-Lautrec en dos litografías.

Ida Heath au Bar

1894, lithographie, 33,5 x 25,5 cm

Une danseuse anglaise, objet de deux lithographies.

Ida Heath an der Bar

1894, Lithografie, 33,5 x 25,5 cm

Die englische Tänzerin bildete Toulouse-Lautrec auf zwei Lithografien ab.

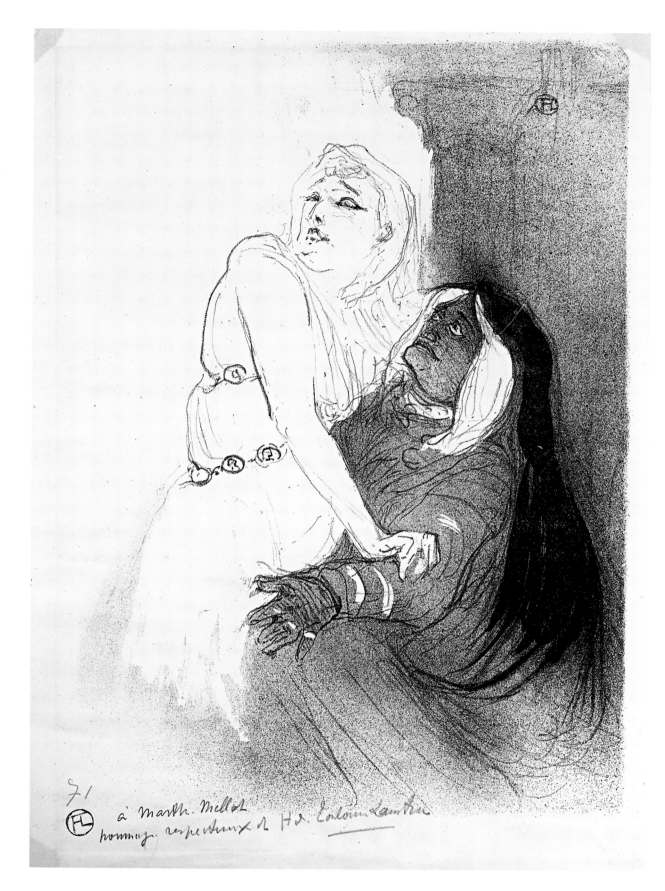

Sarah Bernhardt in *Phèdre*

1893, lithograph, 34.2 x 23.5 cm

Marie Henriette Bernhardt studied theatre at the 'Conservatoire de Musique et Déclamation'. She had an illustrious career as an actress, both on stage and in the early silent movies. Toulouse-Lautrec frequently attended the theatre, which offered quite a different entertainment to that found in a café-concert, in order to draw inspiration for his work. There he 'discovered' Sarah Bernhardt, who was already 50 years old when he drew this poignant scene from *Phèdre*.

Sarah Bernhardt en *Phèdre*

1893, litografía, 34,2 x 23,5 cm

Marie Henriette Bernhardt estudió teatro en el Conservatorio de Música y Declamación. Tuvo una próspera carrera como actriz, tanto sobre el escenario como en las primeras películas mudas. Toulouse-Lautrec asistía con frecuencia al teatro, que ofrecía un entretenimiento bien distinto al de un café-cantante, para obtener inspiración para su trabajo. Allí «descubrió» a Sarah Bernhardt, que tenía ya 50 años cuando la dibujó en esta conmovedora escena de *Phèdre*.

Sarah Bernhardt dans *Phèdre*

1893, lithographie, 34,2 x 23,5 cm

Marie Henriette Bernhardt avait étudié le théâtre au Conservatoire de Musique et Déclamation. Elle a fait une carrière illustre sur les planches et dans les premiers films muets. En quête d'inspiration, Toulouse-Lautrec allait souvent au théâtre qui offrait un autre genre de divertissement que le café-concert. C'est là qu'il découvrit Sarah Bernhardt qui avait déjà 50 ans lorsqu'il a dessiné cette scène poignante de *Phèdre*.

Sarah Bernhardt in *Phèdre*

1893, Lithografie, 34,2 x 23,5 cm

Marie Henriette Bernhardt studierte am „Conservatoire de Musique et Déclamation" und absolvierte eine glänzende Karriere als Schauspielerin, auf der Bühne wie auch im frühen Stummfilm. Zur Inspiration besuchte Toulouse-Lautrec häufig das Theater, das eine ganz andere Unterhaltung als die Cafés-Concerts bot. Dort „entdeckte" er auch Sarah Bernhardt und hielt sie in dieser packenden Szene aus der *Phèdre* fest. Bei Entstehen der Zeichnung war sie schon 50 Jahre alt.

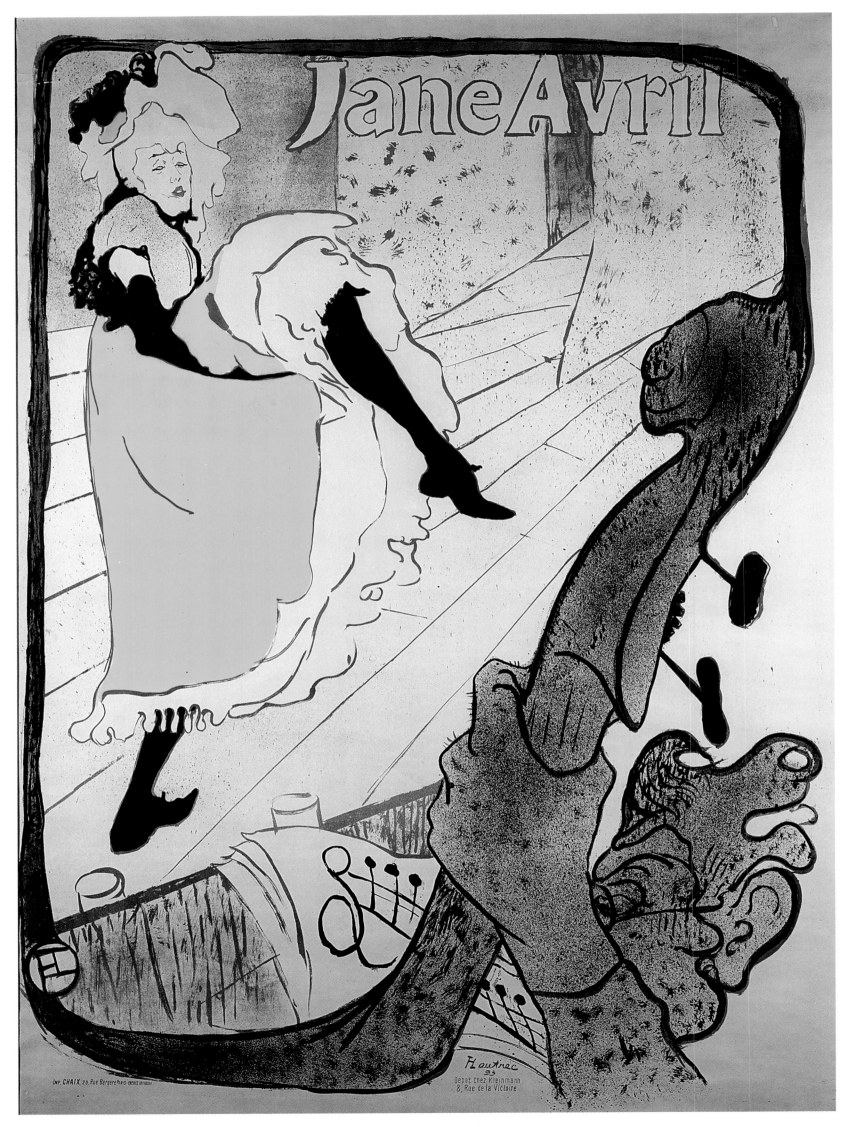

Jane Avril

1893, colour lithograph, 124 x 91.5 cm
Toulouse-Lautrec was very fond of Jane Avril (1868 – 1943) and created four publicity posters for the entertainer. Two of these show her dancing the French cancan. This large poster is the sixth he produced and has a similar composition to the first he created for La Goulue.

Jane Avril

1893, litografía en color, 124 x 91,5 cm
Toulouse-Lautrec fue un gran admirador de Jane Avril (1868-1943) y firmó cuatro carteles publicitarios para esta actriz. En dos de ellos aparece bailando el cancán. Este gran cartel es el sexto que creó y tiene una composición similar al primero que hizo para La Goulue.

Jane Avril

1893, lithographie en couleur, 124 x 91,5 cm
Toulouse-Lautrec aimait beaucoup Jane Avril (1868 – 1943) et a créé quatre affiches publicitaires pour cette artiste. Deux d'entre elles la montrent dansant le French cancan. Cette grande affiche, la sixième qu'il ait réalisée, présente une composition similaire à celle de la toute première, créée pour La Goulue.

Jane Avril

1893, Farblithografie, 124 x 91,5 cm
Toulouse-Lautrec war Jane Avril (1868 – 1943) sehr zugetan und schuf vier Werbeplakate für die Unterhaltungskünstlerin. Zwei zeigen sie beim Cancantanzen. Dieses große Plakat, sein sechstes, weist eine ganz ähnliche Komposition auf wie das erste, das er für La Goulue gestaltet hatte.

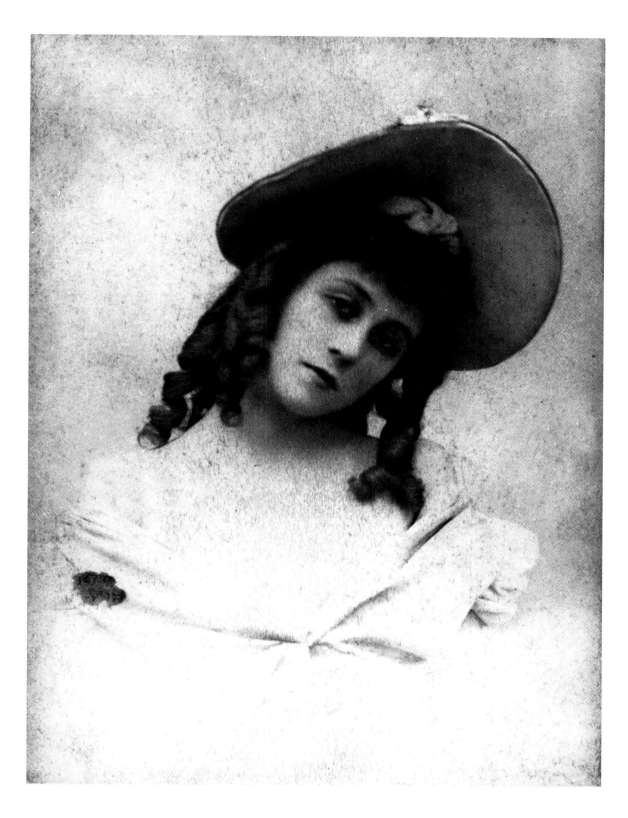

Jane Avril

The French art critic Arsène Alexandre wrote in 1893 about Toulouse-Lautrec and Jane Avril: "Painter and model, together, have created a true art of our time, one through movement, one through representation."

Jane Avril

El crítico de arte francés Arsène Alexandre escribió en 1893 sobre Toulouse-Lautrec y Jane Avril: «El pintor y la modelo, juntos, han creado un verdadero arte de nuestro tiempo, una a través del movimiento y el otro a través de la representación».

Jane Avril

Le critique d'art français Arsène Alexandre a écrit en 1893 à propose de Toulouse-Lautrec et Jane Avril : « Ensemble, le peintre et le modèle ont créé un art vraiment de notre temps, l'une par le mouvement, l'autre par la représentation. »

Jane Avril

Der französische Kunstkritiker Arsène Alexandre schrieb 1893 über Toulouse-Lautrec und Jane Avril: „Maler und Modell schufen gemeinsam eine wahre Kunst unserer Zeit, sie durch Bewegung, er durch die Wiedergabe."

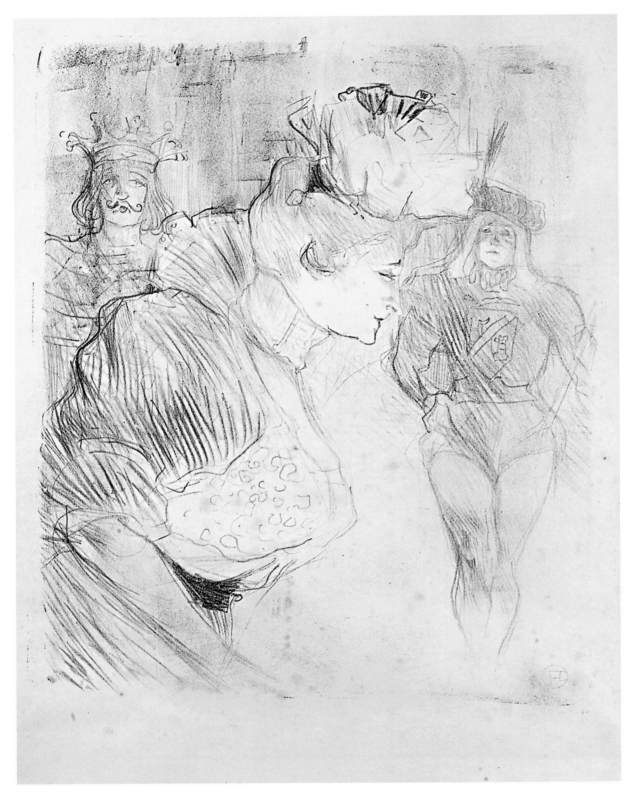

Lender bowing to the Audience

1895, lithograph, 32 x 26.4 cm

Toulouse-Lautrec would develop an intense obsession, which he called a 'furia', with a particular performer. He would watch the performer night after night, hastily sketching whatever fascinated him. He would do this in notebooks, on napkins or even on tablecloths. These sketches then became the basis for some of his best-known works. One such 'furia' involved the actress Marcelle Lender. He would arrive at the theatre just in time to see her dance the final bolero.

Lender saludando al público

1895, litografía, 32 x 26,4 cm

Toulouse-Lautrec desarrollaba una intensa obsesión, que él llamaba «furia», por algún artista en particular. Iba a verlo actuar noche tras noche y realizaba bocetos a toda prisa de cualquier cosa que lo fascinase. Dibujaba en cuadernos, en servilletas o incluso sobre los manteles. Estos bosquejos sirvieron como base para algunos de sus trabajos más conocidos. Una «furia» así sintió por la actriz Marcelle Lender. Solía llegar al teatro justo a tiempo para verla bailar el bolero final.

Lender Saluant le Public

1895, lithographie, 32 x 26,4 cm

Toulouse-Lautrec développait une véritable « furia » pour certains artistes. Il regardait alors, nuit après nuit, l'artiste en question, croquant tout ce qui le fascinait sur des carnets, des serviettes de table et même des nappes. Ces ébauches devinrent la base de quelques-uns de ses travaux les plus connus. L'une de ces « furias » concernait la comédienne Marcelle Lender. Il arrivait au théâtre juste à temps pour la voir danser le boléro final.

Lender grüßt das Publikum

1895, Lithografie, 32 x 26,4 cm

Toulouse-Lautrec entwickelte Obsessionen für eine bestimmte Darstellerin, was er als „furia" bezeichnete. Abend für Abend beobachtete er dann eine dergestalt Auserwählte und zeichnete hastig, was immer ihn faszinierte, in Notizbücher, auf Servietten oder sogar auf die Tischdecke. Diese Skizzen waren Ausgangspunkt für seine bekanntesten Werke. Eine solche „furia" galt der Schauspielerin Marcelle Lender, und im Theater tauchte er immer gerade noch rechtzeitig zu ihrem Abschlussbolero auf.

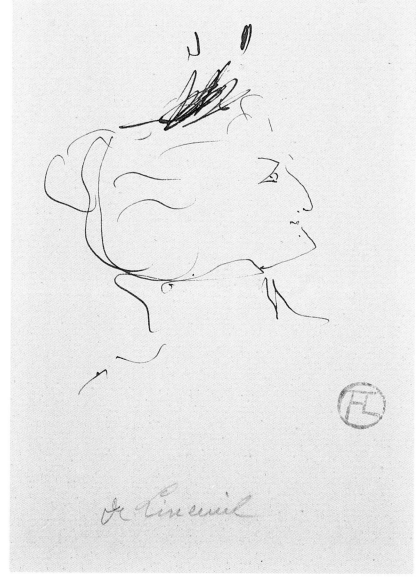

Marcelle Lender
1896, pen and ink on paper, 13.7 x 8.8 cm

Marcelle Lender
1896, pluma y tinta sobre papel, 13,7 x 8,8 cm

Marcelle Lender
1896, plume et encre sur papier, 13,7 x 8,8 cm

Marcelle Lender
1896, Feder und Tinte auf Papier, 13,7 x 8,8 cm

Madame Lineuil
1896, pen and ink on paper, 12.2 x 8.1 cm

Madame Lineuil
1896, pluma y tinta sobre papel, 12,2 x 8,1 cm

Madame Lineuil
1896, plume et encre sur papier, 12,2 x 8,1 cm

Madame Lineuil
1896, Feder und Tinte auf Papier, 12,2 x 8,1 cm

Aristide Bruant in his Cabaret

1893, colour lithograph, 127.3 x 95 cm

Bruant commissioned this poster, the third and possibly the most memorable of the four posters the artist created for the singer. Bruant's trademark black hat, black cape and red scarf thrown over his shoulder are immediately recognizable. The bold coloured shapes bring to mind the Japanese woodblock prints that were popular at the time and which Toulouse-Lautrec collected. The artist designed the image so that it could be overprinted by different texts for different occasions. A very rare copy of this poster, it was printed on a single sheet of paper, rather than the usual two, and without text. It allows us to see Toulouse-Lautrec's creation as the artist conceived it.

Aristide Bruant en su cabaré

1893, litografía en color, 127,3 x 95 cm

Bruant encargó este cartel, el tercero y posiblemente el más famoso de los cuatro que el artista creó para el cantante. Las señas de identidad de Bruant, sombrero negro, capa negra y bufanda roja cayendo sobre su hombro, son reconocibles de inmediato. Las formas de intensos colores recuerdan a las impresiones xilográficas japonesas muy populares en aquella época y que el mismo Toulouse-Lautrec coleccionaba. El artista diseñó la imagen de modo que pudiera ser sobreimpresa con diferentes textos en distintas ocasiones. Se trata de una copia muy rara de este cartel, ya que está impreso sobre una sola hoja de papel (lo habitual eran dos) y sin texto. Esto nos permite ver la creación de Toulouse-Lautrec tal como el artista la concibió.

Aristide Bruant dans son Cabaret

1893, lithographie en couleur, 127,3 x 95 cm

Bruant a commandé cette affiche, la troisième et peut-être la plus remarquable des quatre réalisées par l'artiste pour le chanteur. On reconnaît immédiatement les signes distinctifs de Bruant, le feutre noir, la cape noire et l'écharpe rouge jetée sur son épaule. Les blocs de couleurs vives évoquent les estampes japonaises populaires à cette époque et que collectionnait Toulouse-Lautrec. L'artiste a conçu l'image de telle manière que l'on peut y imprimer différents textes selon l'occasion. Cette copie très rare de cette affiche, imprimée sur une simple feuille de papier au lieu des deux habituelles et sans texte, nous permet de voir la création de Toulouse-Lautrec telle que l'artiste l'a pensée.

Aristide Bruant in seinem Cabaret

1893, Farblithografie, 127,3 x 95 cm

Diese Auftragsarbeit für Bruant ist das dritte und wohl bemerkenswerteste der vier Plakate, die der Künstler für ihn schuf. Die Markenzeichen des Sängers – schwarzer Hut, schwarzer Umhang und ein über die Schulter geworfener roter Schal – sind sofort zu erkennen. Die kühnen Farbflächen erinnern an die damals beliebten japanischen Holzschnitte, die Toulouse-Lautrec auch sammelte. Das Bild hat der Künstler so gestaltet, dass ein Überdrucken mit wechselnden Texten zu unterschiedlichen Anlässen möglich war. Diese sehr seltene Fassung des Plakats wurde ohne Text auf ein Einzelblatt statt die üblichen zwei Blätter gedruckt und gibt uns Einblick in den Schaffensprozess von Toulouse-Lautrec.

Aristide Bruant

This photo of Bruant was the frontispiece of a collection of his poems and songs called *Dans la Rue*. The book was illustrated by Steinlen, Poulbot and Borgex and was published in 1924.

Aristide Bruant

Esta fotografía de Bruant se utilizó como portada de una colección de sus poemas y canciones titulada *Dans la Rue*. El libro fue ilustrado por Steinlen, Poulbot y Borgex y se publicó en 1924.

Aristide Bruant

Cette photo de Bruant orne le frontispice d'un recueil de ses poèmes et chansons intitulé *Dans la Rue*. Illustré par Steinlen, Poulbot et Borgex, l'ouvrage a été publié en 1924.

Aristide Bruant

Dieses Foto von Bruant war das Frontispiz für seine Gedicht- und Liedersammlung *Dans la Rue*. Der Band wurde von Steinlen, Poulbot und Borgex illustriert und erschien 1924.

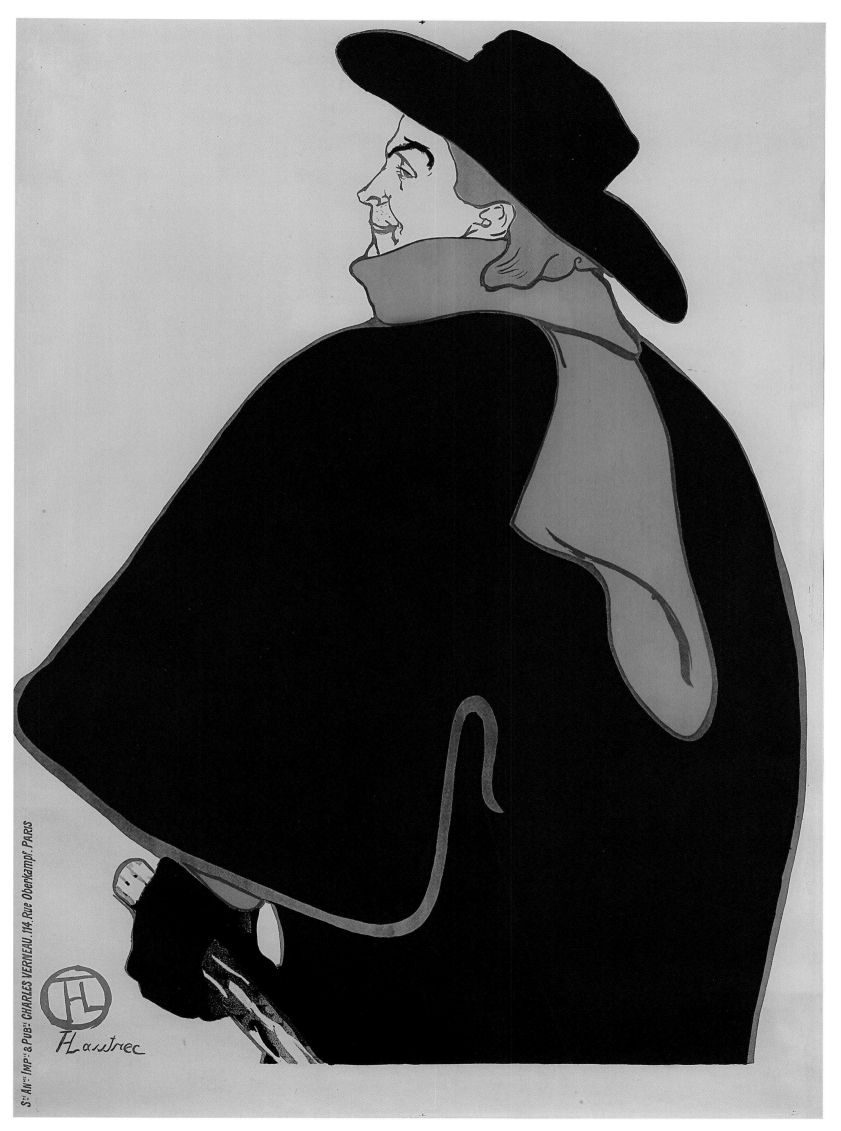

Café de la Paix

c. 1900

Opened in May 1862, the Café de la Paix was one of the most fashionable café-restaurants in nineteenth-century Paris. It was a favourite meeting place for artists, writers and journalists.

Café de la Paix

c 1900

Abierto en mayo de 1862, el Café de la Paix fue uno de los cafés-restaurantes más de moda de París en el siglo XIX. Era uno de los lugares de encuentro preferidos por artistas, escritores y periodistas.

Café de la Paix

vers 1900

Ouvert en 1862, le Café de la Paix était l'un des cafés-restaurants parisiens à la mode au dix-neuvième siècle ; les artistes, les écrivains et les journalistes aimaient s'y retrouver.

Café de la Paix

um 1900

Das im Mai 1862 eröffnete Café de la Paix gehörte zu den angesagten Cafés-Restaurants im Paris des späten 19. Jahrhunderts und war beliebter Treffpunkt von Künstlern, Schriftstellern und Journalisten.

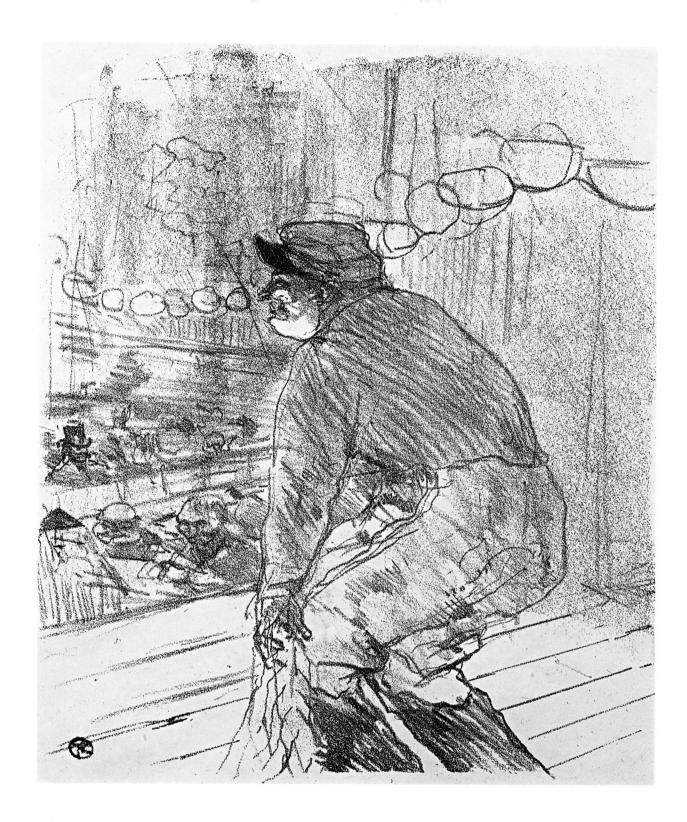

Polin

1898, lithograph, 29.2 x 23.7 cm

Polin had a round face and seemed of limited intelligence. He captivated his audiences with simple, everyday remarks, with which everybody in the audience could identify. He would sometimes compose little poems while on stage and was very popular with the café-concert crowds.

Polin

1898, litografía, 29,2 x 23,7 cm

Polin tenía la cara redonda y aspecto de ser poco inteligente. Cautivaba a su público con comentarios sencillos, cotidianos, con los que todo espectador podía identificarse. A veces componía breves poemas sobre el escenario y era muy popular entre los asistentes a los cafés-cantantes.

Polin

1898, lithographie, 29,2 x 23,7 cm

Polin avait un visage rond qui ne semblait pas briller d'intelligence. Il captivait son auditoire en lançant des remarques tout à fait ordinaires que chacun pouvait reprendre à son compte. Il composait parfois de petits poèmes sur scène et était très populaire auprès du public de café-concert.

Polin

1898, Lithografie, 29,2 x 23,7 cm

Polin mit dem runden Gesicht schien nicht sehr intelligent. Sein Publikum fesselte er mit Stammtischweisheiten, mit denen sich jeder identifizieren konnte, und bisweilen improvisierte er auch Kurzgedichte auf der Bühne. Bei den Zuschauermassen der Cafés-Concerts war er sehr beliebt.

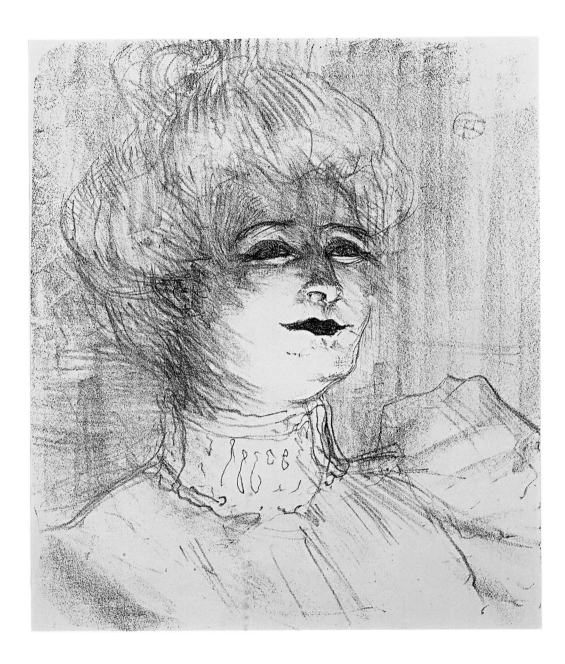

At the Ambassadeurs – Singer at the Café-Concert

1894, colour lithograph, 30.5 x 24.7 cm

This is one of the few lithographs in colour that Toulouse-Lautrec produced. Its simple composition and forceful imagery convey the spirit of the café-concert. 'Les Ambassadeurs' was an elegant establishment on the Champs-Elysées with outdoor seating in the summer months. Here an anonymous singer is captured from behind the scenes as she stands on the covered stage looking out at the audience and the night sky.

En Les Ambassadeurs – Artista en el café-cantante

1894, litografía en color, 30,5 x 24,7 cm

Esta es una de las pocas litografías en color que realizó Toulouse-Lautrec. Su composición simple de imágenes poderosas transmite el espíritu del café-cantante. Les Ambassadeurs era un elegante establecimiento situado en los Campos Elíseos con terraza en los meses de verano. Aquí se ve a una cantante anónima desde atrás. Está de pie en la zona cubierta del escenario mirando al público y al cielo nocturno.

Aux Ambassadeurs – Chanteuse au Café-Concert

1894, lithographie en couleur, 30,5 x 24,7 cm

L'une des quelques rares lithographies en couleur réalisées par Toulouse-Lautrec. Sa composition simple et ses traits et couleurs vigoureux traduisent l'esprit du café-concert. Situé sur les Champs-Elysées, Les Ambassadeurs était un établissement élégant disposant d'une terrasse en été. Une chanteuse anonyme est représentée ici des coulisses alors qu'elle se trouve sur la scène couverte, regardant le public et le ciel nocturne.

Im Ambassadeurs – Sängerin im Café-Concert

1894, Farblithografie, 30,5 x 24,7 cm

Dies ist eine der wenigen farbigen Lithografien, die Toulouse-Lautrec anfertigte. Die einfache Komposition und kraftvolle Bildsprache bannen den Geist des Café-Concert. „Les Ambassadeurs" war ein elegantes Etablissement auf den Champs-Elysées mit Außenterrasse in den Sommermonaten. Hier sieht man den Blick aus der Kulisse auf die namenlose Sängerin, die von der überdachten Bühne ins Publikum und in den Nachthimmel blickt.

Marie-Louise Marsy

1898, lithograph, 29.4 x 24.3 cm

Marie-Louise Marsy was a comedic actress famous for her beauty as well as for her acting.

Marie-Louise Marsy

1898, litografía, 29,4 x 24,3 cm

Marie-Louise Marsy era una actriz de comedia, famosa tanto por su belleza como por sus dotes interpretativas.

Marie-Louise Marsy

1898, lithographie, 29,4 x 24,3 cm

Marie-Louise Marsy était une comédienne aussi célèbre pour sa beauté que pour son talent.

Marie-Louise Marsy

1898, Lithografie, 29,4 x 24,3 cm

Die Komödienschauspielerin Marie-Louise Marsy war berühmt für ihre Schönheit und Schauspielkünste.

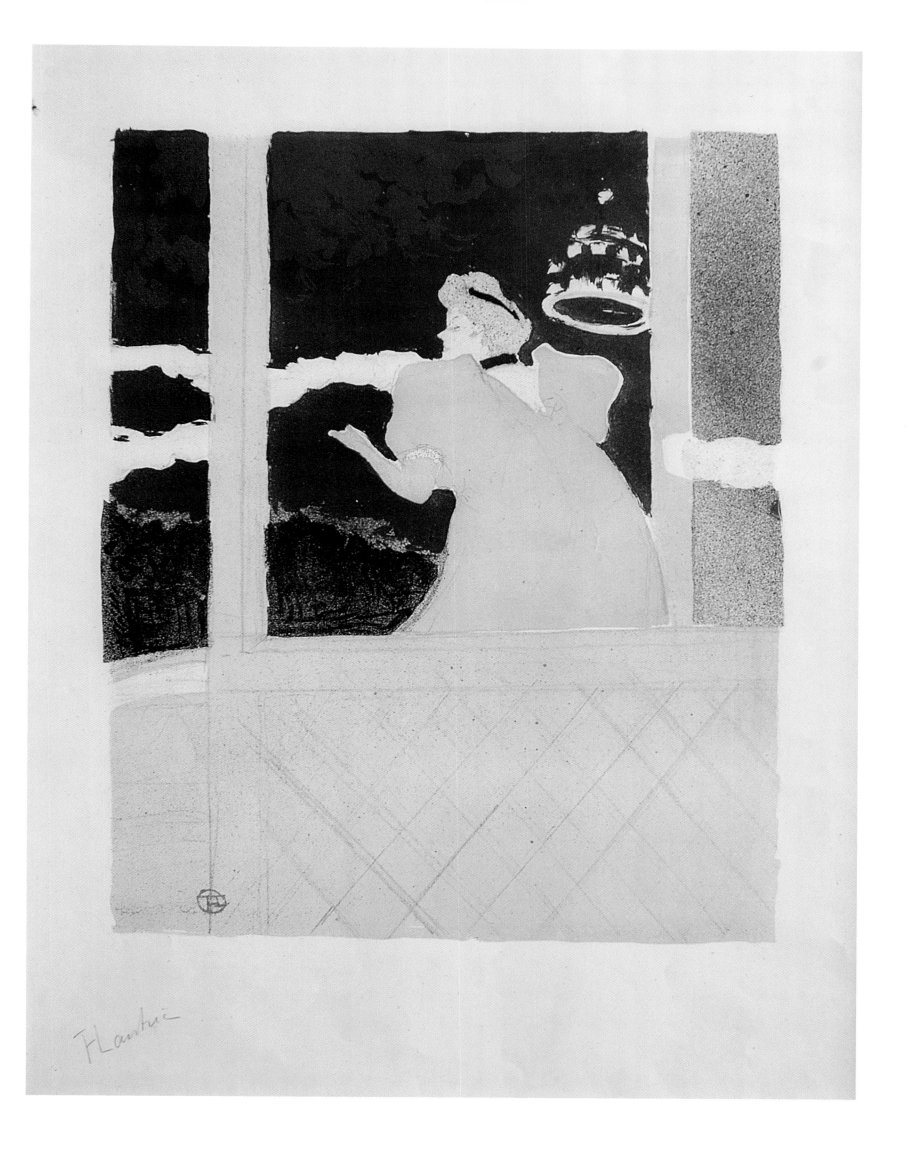

Flantrec

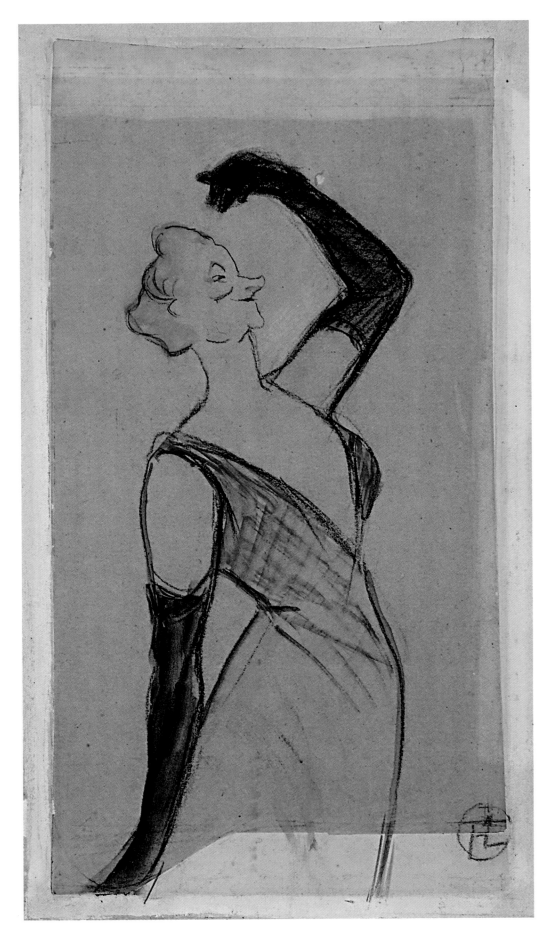

Yvette Guilbert
1893, watercolour, 23 x 12.6 cm

Toulouse-Lautrec painted Yvette Guilbert in several poses in preparation for the album he eventually produced in 1893 to honour his beloved singer and actress. This unique watercolour captures Yvette Guilbert with her trademark long black gloves waving to the public. The artist painted mostly with oils on canvas. The watercolours were usually studies of a subject, which he painted on various materials. Sometimes, as is the case with this watercolour, he would add an extra piece of paper or carton to enlarge the surface and achieve the result he was looking for.

Yvette Guilbert
1893, acuarela, 23 x 12,6 cm

Toulouse-Lautrec pintó a Yvette Guilbert en varias posturas como preparación para el álbum que produjo en 1893 en honor a su querida cantante y actriz. Esta acuarela única muestra a Yvette Guilbert con sus característicos guantes largos negros saludando al público. El artista pintó sobre todo óleos sobre lienzo. Las acuarelas constituían por lo general los estudios de un tema, que pintaba sobre varios materiales. A veces, tal es el caso de esta acuarela, añadía un trozo adicional de papel o cartón para ampliar la superficie y lograr el resultado que buscaba.

Yvette Guilbert
1893, aquarelle, 23 x 12,6 cm

Toulouse-Lautrec a représenté Yvette Guilbert dans différentes poses pour préparer l'album qu'il réalisa finalement en 1893 pour rendre hommage à la chanteuse et comédienne qu'il aimait. Cette aquarelle unique en son genre montre Yvette Guilbert reconnaissable à ses longs gants noirs, faisant un signe de la main au public. L'artiste peignait surtout à l'huile sur de la toile. Les aquarelles étaient habituellement réservées aux études de sujet, peintes sur des matériaux variés. Quelquefois, c'est le cas de cette aquarelle, il ajoutait un morceau de papier ou de carton pour agrandir la surface et atteindre l'effet désiré.

Yvette Guilbert
1893, Aquarell, 23 x 12,6 cm

Toulouse-Lautrec malte Yvette Guilbert in mehreren Posen als Vorbereitung auf das Album, das er dann 1893 zu Ehren seiner geliebten Sängerin und Schauspielerin schuf. Das einzigartige Aquarell zeigt sie mit den charakteristischen langen schwarzen Handschuhen, wie sie dem Publikum zuwinkt. Meist arbeitete der Künstler in Öl auf Leinwand, während die Aquarelle eher als Motivstudien auf diversen Materialien entstanden. Um das gewünschte Resultat zu erzielen, setzte er mitunter, so auch hier, ein Stück Papier oder Karton zur Vergrößerung der Malfläche an.

Judic

1894, lithograph, 36.5 x 26.3 cm

Judic was a waitress at a brasserie when she was spotted for her beauty and elegance. Having a nice singing voice helped her become a favourite of the café-concerts. Instead of asking "Have you heard her sing?" people would say, "Have you seen her sing?"

Judic

1894, litografía, 36,5 x 26,3 cm

Judic era camarera en una cervecería cuando fue descubierta por su belleza y elegancia. Tener una voz agradable la ayudó a convertirse en la favorita de los cafés-cantantes. En lugar de preguntar «¿La has oído cantar?», la gente solía decir «¿La has visto cantar?».

Judic

1894, lithographie, 36,5 x 26,3 cm

Judic était serveuse dans une brasserie où elle se fit remarquer pour sa beauté et son élégance. Comme elle avait une jolie voix, elle devint une des chanteuses préférées du café-concert. Au lieu de demander « L'avez-vous entendue chanter ? », les gens disaient « L'avez-vous vue chanter ? »

Judic

1894, Lithografie, 36,5 x 26,3 cm

Judic war Kellnerin in einer Brasserie, wo sie wegen ihrer Schönheit und Eleganz auffiel. Dank einer angenehmen Singstimme avancierte sie zur Favoritin in den Cafés-Concerts. Statt der Frage „Haben Sie sie singen gehört?" hieß es: „Haben Sie sie singen gesehen?"

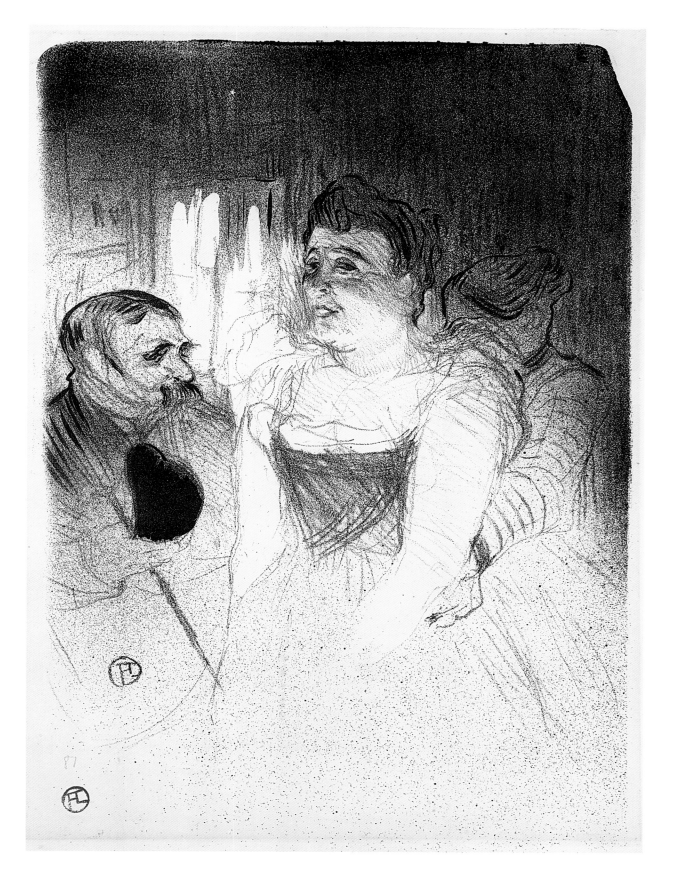

Yvette Guilbert bowing to the Audience

1898, lithograph, 29.4 x 23.8 cm

No music hall performer made a bigger impression on Toulouse-Lautrec than Yvette Guilbert. She wore dresses that accentuated her unfashionably slender figure and long black gloves. Standing motionless on stage, only gesturing with her arms, she performed bold lyrics in a way that resembled a monologue, hence she was often called a 'diseuse' ('sayer').

Yvette Guilbert saludando al público

1898, litografía, 29,4 x 23,8 cm

Ningún artista de café-cantante dejó una impresión tan profunda en Toulouse-Lautrec como Yvette Guilbert. Llevaba vestidos que acentuaban su delgada figura pasada de moda y guantes largos negros. De pie, inmóvil sobre el escenario, gesticulando únicamente con los brazos, cantaba letras atrevidas de manera que parecían un monólogo, por esa razón a menudo la llamaban *diseuse* ('decidora').

Yvette Guilbert Saluant le Public

1898, lithographie, 29,4 x 23,8 cm

Aucun artiste de music-hall ne fit plus grande impression sur Toulouse-Lautrec qu'Yvette Guilbert. Elle portait des robes accentuant sa silhouette mince qui n'était guère à la mode et de longs gants noirs. Ne faisant bouger que ses bras sur scène, elle présentait ses chansons sur le mode d'un long monologue, ce qui lui valut d'être surnommée la « diseuse ».

Yvette Guilbert grüßt das Publikum

1898, Lithografie, 29,4 x 23,8 cm

Keine Varietédarstellerin machte größeren Eindruck auf Toulouse-Lautrec als Yvette Guilbert. Sie trug figurbetonte Kleider, die ihre – damals unmoderne – Schlankheit betonten, und lange schwarze Handschuhe. Bewegungslos auf der Bühne stehend und nur mit Gesten trug sie gewagte Liedtexte im Monologstil vor, weshalb sie häufig auch als „Diseuse" bezeichnet wurde.

Caudieux with artist's comment:
"Caudieux in St. Jean les 2 jumeaux"

1894, pen and ink on paper, 19.7 x 11.5 cm

Caudieux con comentario del artista:
«Caudieux en St. Jean les 2 jumeaux»

1894, pluma y tinta sobre papel, 19,7 x 11,5 cm

Caudieux avec le commentaire de l'artiste:
« Caudieux à St. Jean les 2 jumeaux »

1894, plume et encre sur papier, 19,7 x 11,5 cm

Caudieux mit Anmerkung des Künstlers:
„Caudieux in St. Jean les 2 jumeaux"

1894, Feder und Tinte auf Papier, 19,7 x 11,5 cm

Le Café Concert

LITHOGRAPHIES

DE

H.-G. Ibels

ET DE

H. de Toulouse-Lautrec

TEXTE DE GEORGES MONTORGUEIL

Édité par « l'Estampe originale », 17, rue de Rome. — Paris.

The Album *Le Café Concert*

The Café-Concerts

The café-concerts made their appearance in Paris during the 1840s and immediately became popular, not only with Parisians but also with the many visitors to the capital. A few ordinary cafés began adding simple shows, usually solo performances by attractive young women from the lower classes who would sing and joke about love and everyday life.

Toulouse-Lautrec was a dedicated patron of the café-concerts and was actively involved in the production of the publicity material for the stars of these establishments, designing what have become his best-recognized works. His posters were instrumental in bringing the café-concerts and their stars to the attention of the public.

In 1893 the album *Le Café Concert* was published. It contained 11 prints created by Toulouse-Lautrec (pp. 54 – 63) and 11 by Henri-Gabriel Ibels. Ibels designed the portfolio cover and George Montorgueil wrote the accompanying text.

Los cafés-cantantes

Los cafés-cantantes hicieron su aparición en París durante la década de 1840 y fueron un éxito inmediato, no solo entre los parisinos, sino también entre los muchos visitantes de la capital. Algunos cafés ordinarios comenzaron a añadir espectáculos sencillos, por lo general actuaciones de mujeres jóvenes y atractivas de clase baja, que cantaban y bromeaban sobre el amor y la vida cotidiana.

Toulouse-Lautrec era un dedicado cliente de los cafés-cantantes y tomaba parte activa en la producción de material publicitario para las estrellas de estos establecimientos, diseñando los que se convertirían en sus trabajos más reconocidos. Sus carteles contribuyeron de forma decisiva a dirigir la atención del público hacia los cafés-cantantes y sus estrellas.

En 1893 se publicó el álbum *Le Café Concert*, que contenía once grabados de Toulouse-Lautrec (págs. 54-63) y once de Henri-Gabriel Ibels. Ibels diseñó la cubierta y George Montorgueil escribió los textos que los acompañaban.

Les Cafés-Concerts

Apparus dans la capitale entre 1840 et 1850, les cafés-concerts ont immédiatement connu le succès, auprès des Parisiens mais aussi auprès des nombreux touristes. Quelques propriétaires de cafés ordinaires commencèrent à offrir à leurs clients des spectacles simples, souvent en solo, dans lesquels se produisaient des jeunes femmes séduisantes issues des milieux populaires, qui pouvaient chanter et plaisanter, parler d'amour et de la vie quotidienne.

Spectateur enthousiaste, Toulouse-Lautrec collabora activement à la production du matériel publicitaire destiné aux vedettes de ces établissements, créant ici ses œuvres les plus caractéristiques. Ses affiches ont contribué à faire connaître le café-concert et ses stars.

L'album *Le Café Concert* a été publié en 1893. Il contenait onze lithographies de Toulouse-Lautrec (p. 54 – 63) et onze d'Henry-Gabriel Ibels. Ibels dessina la couverture du portfolio et Georges Montorgueil écrivit les textes d'accompagnement.

Die Cafés-Concerts

Die Cafés-Concerts kamen in den 1840er-Jahren in Paris auf und fanden sofort Anklang, nicht nur bei den Parisern selbst, sondern auch bei den zahlreichen Besuchern der französischen Hauptstadt. Ein paar Cafés boten nun ein einfaches Unterhaltungsprogramm, meist Soloauftritte attraktiver junger Frauen aus der Unterschicht, die Lieder und Scherzhaftes über Liebe und Alltag vortrugen.

Toulouse-Lautrec war Stammgast in diesen Etablissements und beteiligte sich aktiv an der Herstellung von Werbematerialien für ihre Stars; dabei entstanden seine angesehensten Werke. Mit seinen Plakaten gelang es ihm, das Interesse der Öffentlichkeit an den Cafés-Concerts und ihren Darstellern zu wecken.

1893 erschien dann das Album *Le Café Concert*. Es enthielt elf Grafiken von der Hand Toulouse-Lautrecs (S. 54 – 63) und elf weitere von Henri-Gabriel Ibels. Ibels gestaltete ebenfalls die Titelillustration, und George Montorgueil verfasste die begleitenden Texte.

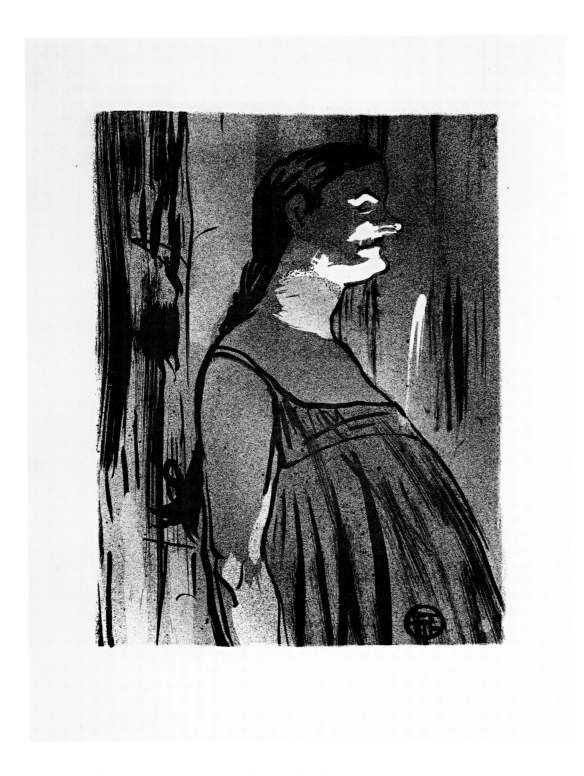

Madame Abdala

(from the album *Le Café Concert*)
1893, lithograph, 27 x 20 cm

Madame Abdala was a natural performer, famous for her constantly changing facial expressions and comical interpretations of popular songs.

Madame Abdala

(del álbum *Le Café Concert*)
1893, litografía, 27 x 20 cm

Madame Abdala fue una artista nata, famosa por su constante cambio de expresiones faciales y por sus cómicas interpretaciones de canciones populares.

Madame Abdala

(de l'album *Le Café Concert*)
1893, lithographie, 27 x 20 cm

Madame Abdala, une artiste née, était connue pour ses jeux de physionomie et ses interprétations comiques de chansons populaires.

Madame Abdala

(aus dem Album *Le Café Concert*)
1893, Lithografie, 27 x 20 cm

Madame Abdala war eine Naturbegabung und berühmt für ihr schnelles Minenspiel und ihre komischen Interpretationen von populären Liedern.

Caudieux at the Petit Casino

(from the album *Le Café Concert*)
1893, lithograph, 27.2 x 21.4 cm

Known as 'Cannon Man', Caudieux was a performer who delighted his audiences with jokes, stories and comments, all delivered with verve and never-ending movement on stage. Toulouse-Lautrec designed this lithograph and a large poster of Caudieux, both capturing the performer in the middle of his on-stage antics. Here, with the hands and feet of Caudieux in the air, and his coat-tails flying, the artist definitely conveys the sense of movement, which is highlighted by the stage lights.

Caudieux en el Petit Casino

(del álbum *Le Café Concert*)
1893, litografía, 27,2 x 21,4 cm

Conocido como «el hombre cañón», Caudieux fue un artista que deleitaba a su público con bromas, historias y comentarios, todo ejecutado con un vigor y un movimiento interminable sobre el escenario. Toulouse-Lautrec diseñó esta litografía y un gran cartel de Caudieux, ambos representaban al artista en medio de sus payasadas teatrales. Aquí, con las manos y los pies de Caudieux en el aire y el vuelo de sus faldones, el artista transmite la sensación de movimiento, destacada por las luces del escenario.

Caudieux – Petit Casino

(de l'album *Le Café Concert*)
1893, lithographie, 27,2 x 21,4 cm

Caudieux, surnommé l'homme-canon, réjouissait son public avec les plaisanteries, les histoires et les commentaires qu'il présentait, remuant sans cesse, avec une verve intarissable. Toulouse-Lautrec a réalisé cette lithographie et une grande affiche de Caudieux, qui saisissent l'artiste sur scène alors qu'il est en train de faire des pitreries. Ici, en montrant s'envoler les mains et le pied de Caudieux et voleter ses basques, l'artiste traduit définitivement le sens du mouvement mis en valeur par les feux de la scène.

Caudieux – Petit Casino

(aus dem Album *Le Café Concert*)
1893, Lithografie, 27,2 x 21,4 cm

Der als „Kanonenmann" bekannte Caudieux begeisterte sein Publikum mit Witzen, Anekdoten und Kommentaren, die er mit viel Schwung und in unablässiger Bewegung vortrug. Neben dieser Lithografie hielt Toulouse-Lautrec ihn auch auf einem großformatigen Plakat mitten in seinen Bühnenpossen fest. Mit Händen und Beinen in der Luft und fliegenden Rockschößen vermittelt der Künstler hier sehr gut den Eindruck von Dynamik, was die Bühnenbeleuchtung noch unterstreicht.

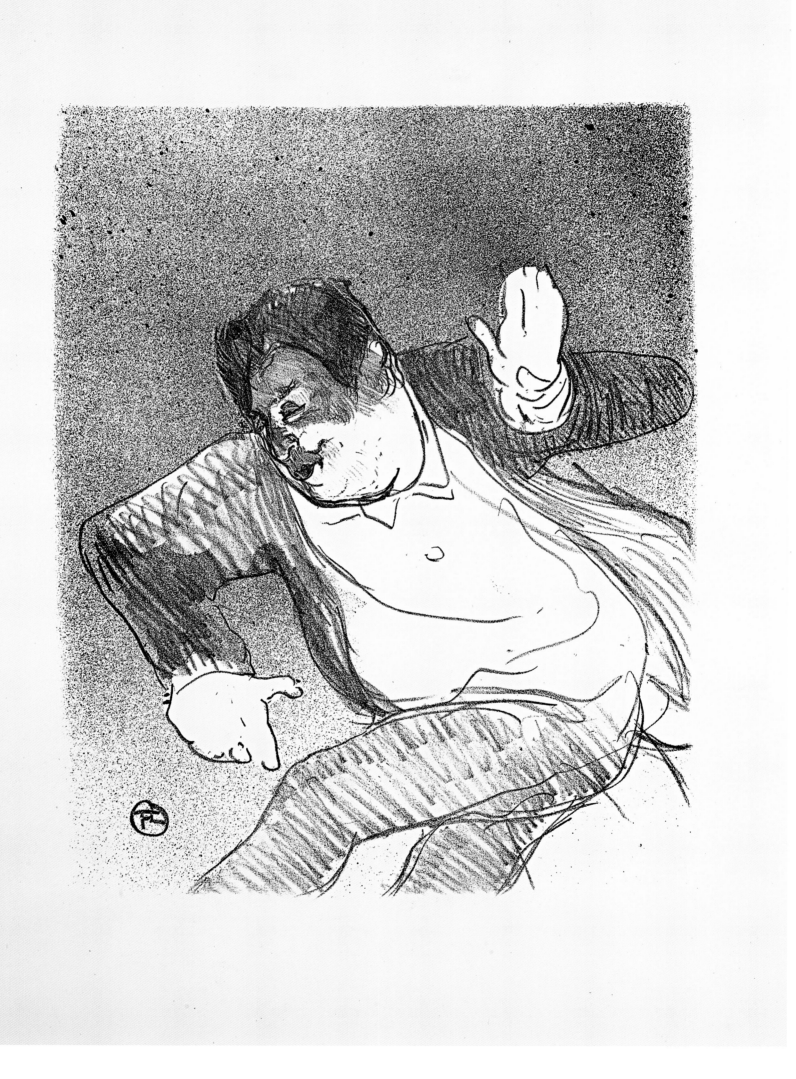

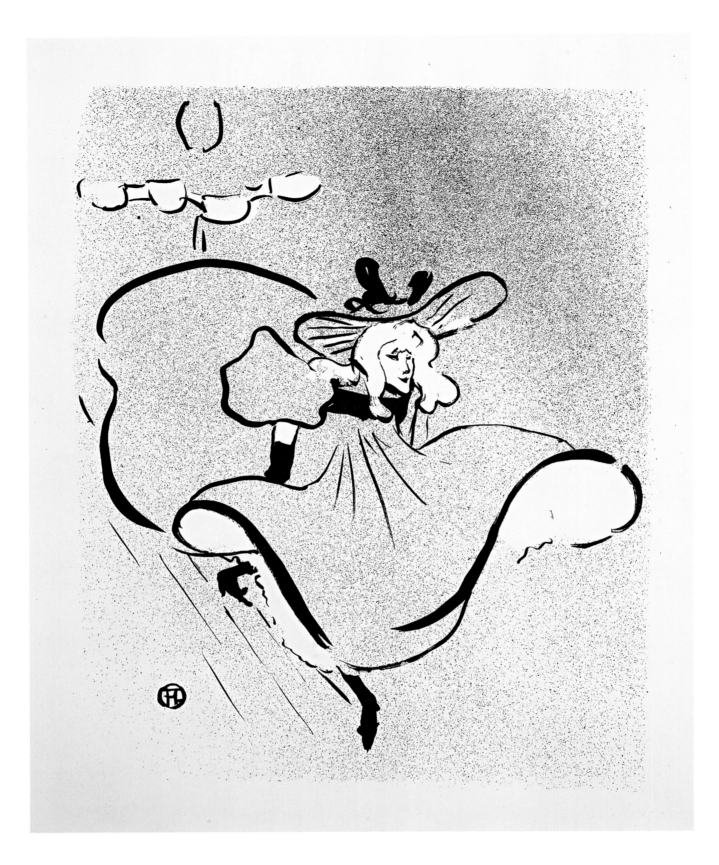

Jane Avril

(from the album *Le Café Concert*)
1893, lithograph, 26.6 x 21.5 cm

Jane Avril was a talented dancer and personifies the Belle Époque as much as her contemporaries Yvette Guilbert, May Belfort and others. She asked Toulouse-Lautrec to create a poster for her when she was to appear at the 'Jardin de Paris' and he later made her the subject of many of his lithographs and paintings, several of which she gave as gifts to her friends and lovers. She and Toulouse-Lautrec were close friends until he died. In her memoirs she says about him: "It is more than certain that I owe him the celebrity I have enjoyed since his first poster of me."

Jane Avril

(del álbum *Le Café Concert*)
1893, litografía, 26,6 x 21,5 cm

Jane Avril fue una talentosa bailarina y personificó la *belle époque* tanto como sus contemporáneas Yvette Guilbert y May Belfort, entre otras. Ella encargó a Toulouse-Lautrec un cartel para su aparición en el Jardin de Paris y él, más tarde, la convirtió en el tema de muchas de sus litografías y pinturas, varias de las cuales ella dio como regalo a sus amigos y amantes. Jane y Toulouse-Lautrec fueron amigos íntimos hasta la muerte del artista. En sus memorias ella dice sobre él: «Es más que cierto que le debo la fama que he disfrutado desde que hizo el primer cartel sobre mí».

Jane Avril

(de l'album *Le Café Concert*)
1893, lithographie, 26,6 x 21,5 cm

Jane Avril était une très bonne danseuse et personnifie la Belle Epoque autant que ses contemporaines Yvette Guilbert, May Belfort et d'autres encore. Alors qu'elle allait se produire au Jardin de Paris, elle demanda à Toulouse-Lautrec de créer une affiche pour elle. Plus tard il la représenta sur nombre de lithographies et peintures, dont elle offrit certaines à ses amis ou amants. Elle resta très liée à Toulouse-Lautrec jusqu'à la mort de celui-ci. Elle dit de lui dans ses mémoires : « Il est plus que certain qu'à lui je dois la célébrité dont j'ai joui dès sa première affiche de moi. »

Jane Avril

(aus dem Album *Le Café Concert*)
1893, Lithografie, 26,6 x 21,5 cm

Jane Avril war eine begabte Tänzerin und verkörperte die Belle Époque ebenso wie Yvette Guilbert, May Belfort und weitere Zeitgenössinnen. Vor ihrem Auftritt im „Jardin de Paris" bat sie Toulouse-Lautrec um ein Plakat für sich, und später widmete er ihr zahlreiche Lithografien und Gemälde, die sie ihren Freunden und Liebhabern teilweise schenkte. Mit Toulouse-Lautrec blieb sie bis zu seinem Tod eng befreundet. In ihren Memoiren sagt sie über ihn: „Es ist mehr als gewiss, dass ich ihm den Ruhm zu verdanken habe, den ich seit seinem ersten Plakat von mir genieße."

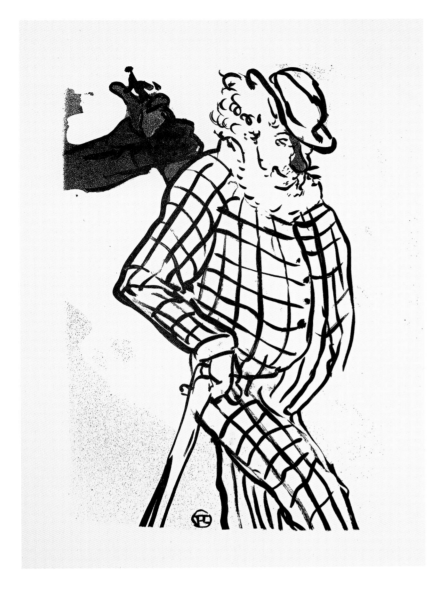

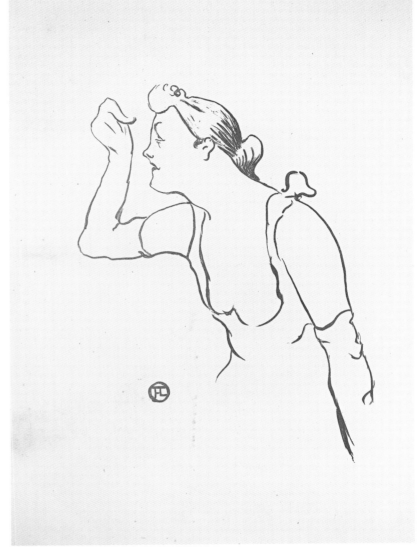

American Singer

(from the album *Le Café Concert*)
1893, lithograph, 27.3 x 20 cm

Toulouse-Lautrec decided to show this American singer's transatlantic haute couture instead of portraying his face. The singer's name did not survive, but his unusual appearance will be forever visible.

Cantante americano

(del álbum *Le Café Concert*)
1893, litografía, 27,3 x 20 cm

Toulouse-Lautrec decidió mostrar la alta costura transatlántica de este cantante americano, en lugar de retratar su rostro. El nombre del cantante no ha llegado hasta nuestros días, pero su extravagante aspecto ha quedado inmortalizado.

Chanteur Américain

(de l'album *Le Café Concert*)
1893, lithographie, 27,3 x 20 cm

Toulouse-Lautrec décida de montrer les vêtements, fruits de la haute couture transatlantique, de ce chanteur américain au lieu de montrer son visage. Le nom du chanteur ne nous est pas parvenu mais l'artiste a immortalisé son aspect insolite.

Amerikanischer Sänger

(aus dem Album *Le Café Concert*)
1893, Lithografie, 27,3 x 20 cm

Hier konzentriert sich Toulouse-Lautrec auf die transatlantische Haute Couture, anstatt das Gesicht des Sängers wiederzugeben. Seinen Namen kennen wir nicht mehr, während seine ungewöhnliche Aufmachung unvergessen bleibt.

Paula Brébion

(from the album *Le Café Concert*)
1893, lithograph, 26.2 x 19.3 cm

This singer with a nasal voice and a penchant for good food was so enamoured with the military that most of her repertoire was devoted to them, sometimes with risqué overtones.

Paula Brébion

(del álbum *Le Café Concert*)
1893, litografía, 26,2 x 19,3 cm

Esta cantante de voz nasal y una inclinación por la buena comida sentía tal debilidad por los militares que la mayor parte de su repertorio estaba dedicado a ellos, a veces con arriesgadas connotaciones.

Paula Brébion

(de l'album *Le Café Concert*)
1893, lithographie, 26,2 x 19,3 cm

Cette chanteuse à la voix nasale, connue pour apprécier les bons petits plats, aimait tellement les militares qu'elle leur a consacré la plus grande partie de son répertoire, ne dédaignant pas les sous-entendus osés.

Paula Brébion

(aus dem Album *Le Café Concert*)
1893, Lithografie, 26,2 x 19,3 cm

Die Sängerin mit der nasalen Stimme und einer Vorliebe für gutes Essen war so angetan vom Militär, dass sie ihm den Großteil ihres Repertoires widmete, gern mal mit pikanten Untertönen.

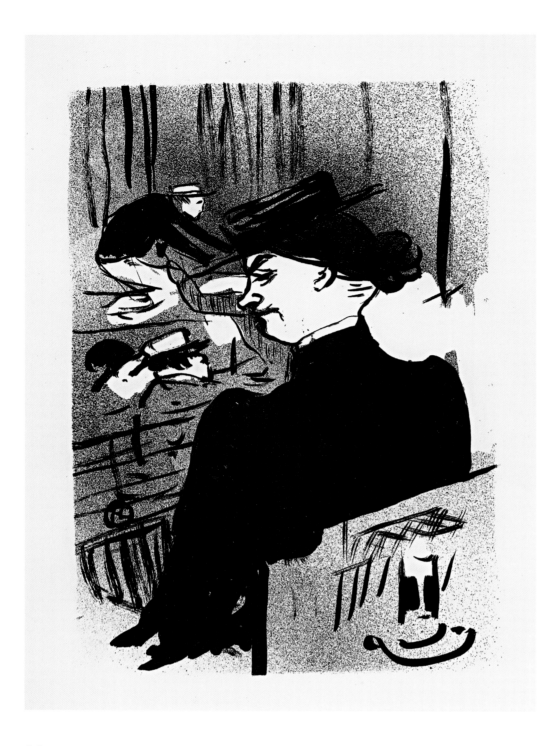

Edmée Lescot

(from the album *Le Café Concert*)
1893, lithograph, 27 x 19 cm

Toulouse-Lautrec shows Edmée Lescot as a Spanish dancer. She was known for her performances of all forms of Spanish dance, such as the tango, the bolero, and the fandango. It was said that she was as good as any gypsy dancer from Granada, and an even better singer.

Edmée Lescot

(del álbum *Le Café Concert*)
1893, litografía, 27 x 19 cm

Toulouse-Lautrec muestra Edmée Lescot como una bailarina española. Era conocida por sus actuaciones de todas las formas de baile español, tales como el tango, el bolero, y el fandango. Se decía que era tan buena como cualquier bailarín gitano de Granada, y mejor cantante.

Edmée Lescot

(de l'album *Le Café Concert*)
1893, lithographie, 27 x 19 cm

Toulouse-Lautrec représente Edmée Lescot en danseuse espagnole. Elle était connue pour exécuter toutes les formes de danse espagnole comme le tango, le boléro et le fandango. On a dit d'elle qu'elle valait n'importe qu'elle danseuse tzigane de Grenade et qu'elle chantait mieux.

Edmée Lescot

(aus dem Album *Le Café Concert*)
1893, Lithografie, 27 x 19 cm

Toulouse-Lautrec stellt Edmée Lescot als spanische Tänzerin dar. Sie war bekannt für ihre Darbietungen aller spanischen Tanzstile wie Tango, Bolero und Fandango. Den Zigeunerinnen von Granada, so hieß es, war sie ebenbürtig und obendrein eine bessere Sängerin.

A Spectator

(from the album *Le Café Concert*)
1893, lithograph, 26.5 x 18.5 cm

The album *Le Café Concert* depicted the people and actors who participated in this form of entertainment. How could one ignore the 'spectator' for whom the shows were intended! This lady is watching a performance by Polin, who can be seen on stage in the background.

Espectadora

(del álbum *Le Café Concert*)
1893, litografía, 26,5 x 18,5 cm

El álbum *Le Café Concert* representaba a la gente y los actores que participaban en esta forma de entretenimiento. ¿Cómo podía ignorarse el público al que estaba dirigido el espectáculo? Esta mujer contempla una función de Polin, a quien puede distinguirse al fondo sobre el escenario.

Une Spectatrice

(de l'album *Le Café Concert*)
1893, lithographie, 26,5 x 18,5 cm

L'album *Le Café Concert* représente les personnes qui participaient à cette forme de divertissement. Impossible d'ignorer le public à qui les spectacles étaient destinés ! Ici, une dame regarde Polin que l'on peut distinguer sur scène à l'arrière-plan.

Eine Zuschauerin

(aus dem Album *Le Café Concert*)
1893, Lithografie, 26,5 x 18,5 cm

Die Mappe *Le Café Concert* bildet den Amüsierbetrieb mit seinem Personen- und Künstlerkreis ab. Wie könnte man da den „Zuschauer" vergessen, an den sich die Darbietungen ja richteten! Diese Dame verfolgt einen Auftritt von Polin, der hinten auf der Bühne auszumachen ist.

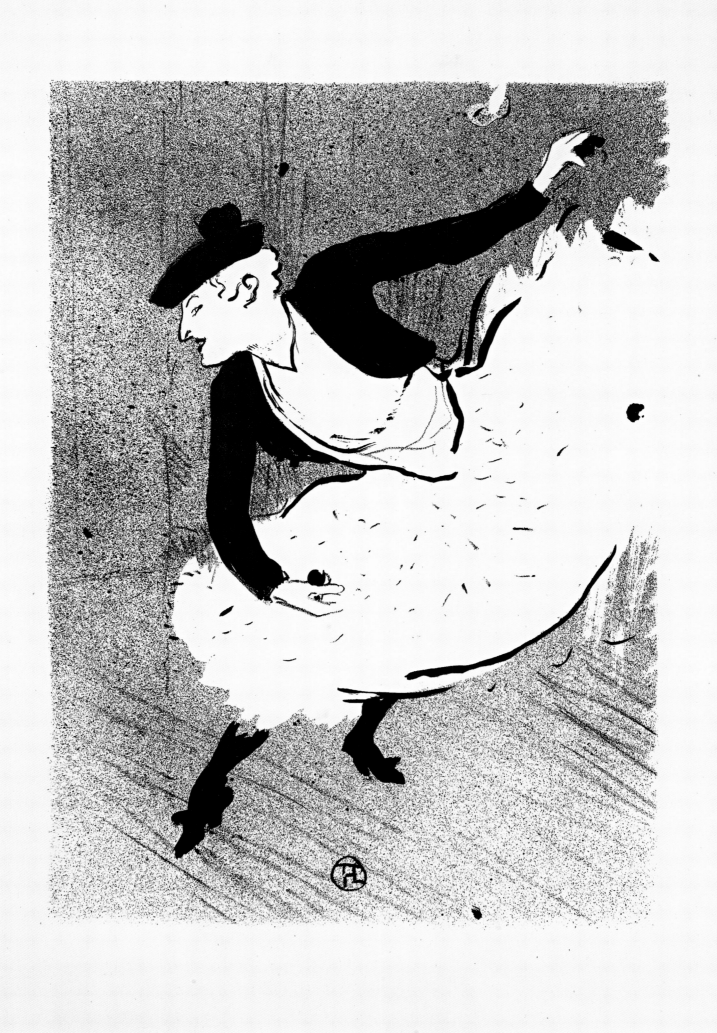

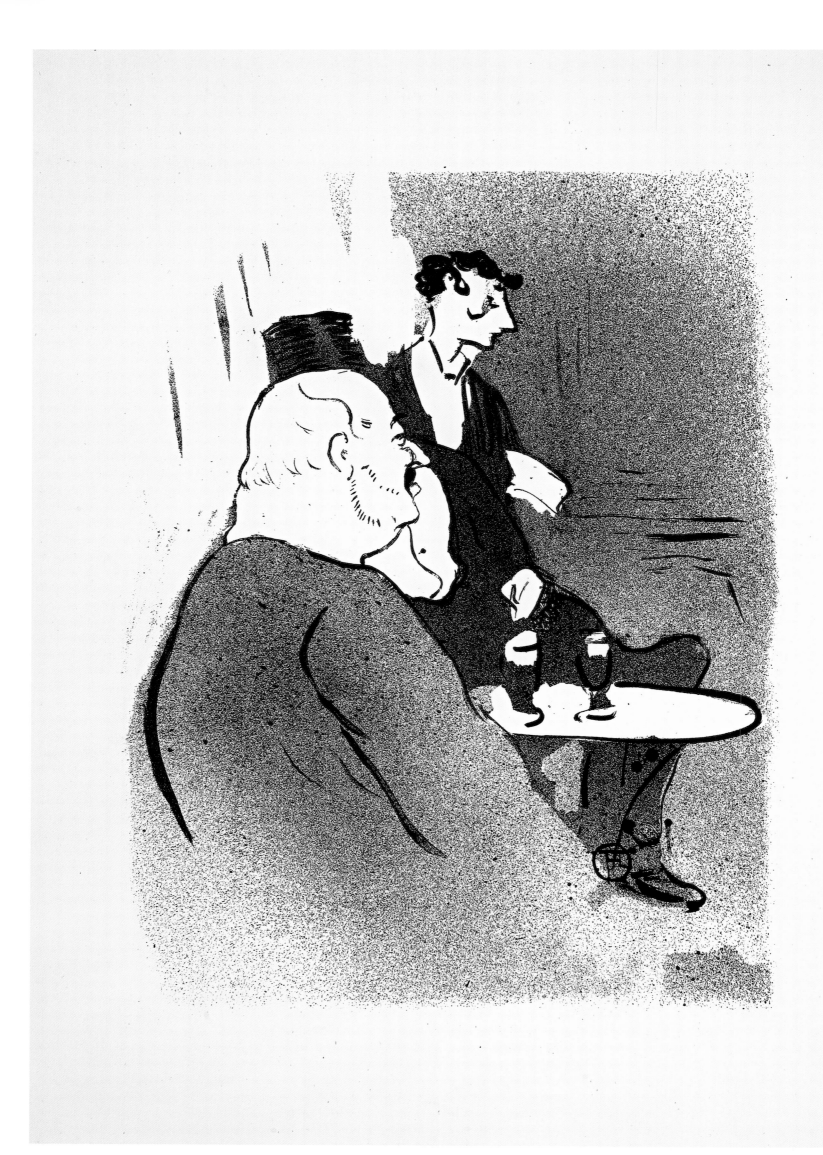

Ducarre at Les Ambassadeurs

(from the album *Le Café Concert*)
1893, lithograph, 26 x 19.9 cm

Ducarre was the manager of the café-concert 'Les Ambassadeurs', on the Champs-Elysées, where Aristide Bruant was invited to perform after he had become popular with his own cabaret.

Ducarre en Les Ambassadeurs

(del álbum *Le Café Concert*)
1893, litografía, 26 x 19,9 cm

Ducarre era el director del café-cantante Les Ambassadeurs, situado en los Campos Elíseos, donde se invitó a actuar a Aristide Bruant después de alcanzar la fama en su propio cabaré.

Ducarre aux Ambassadeurs

(de l'album *Le Café Concert*)
1893, lithographie, 26 x 19,9 cm

Ducarre était le directeur du café-concert Les Ambassadeurs, sur les Champs-Elysées, où Aristide Bruant fut invité à se produire après être devenu populaire avec son propre cabaret.

Ducarre im Les Ambassadeurs

(aus dem Album *Le Café Concert*)
1893, Lithografie, 26 x 19,9 cm

Ducarre war Geschäftsführer des Café-Concert „Les Ambassadeurs" auf den Champs-Elysées, wo Aristide Bruant auf Einladung auftrat, nachdem er mit dem eigenen Cabaret Bekanntheit erlangt hatte.

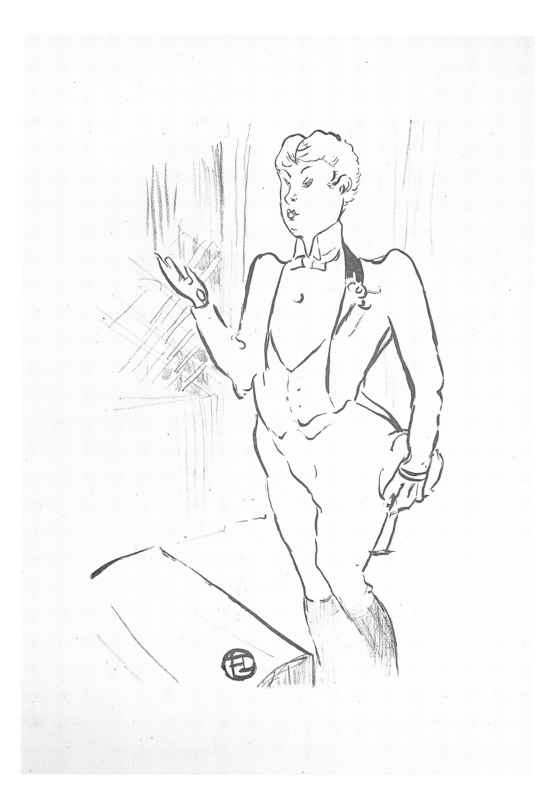

Mary Hamilton

(from the album *Le Café Concert*)
1893, lithograph, 26.8 x 16.2 cm

It was 'chic' for English women entertainers to dress up like men with trousers and coats. This lithograph depicts Mary Hamilton as she would dress to appear on stage, to the delight of the not-so-shocked patrons of the café-concerts.

Mary Hamilton

(del álbum *Le Café Concert*)
1893, litografía, 26,8 x 16,2 cm

Las artistas inglesas encontraban *chic* vestirse de hombre con pantalones y abrigos. Esta litografía representa a Mary Hamilton ataviada como aparecía sobre el escenario para deleite de los clientes habituales de los cafés-cantantes, a los que no les resultaba tan escandaloso.

Mary Hamilton

(de l'album *Le Café Concert*)
1893, lithographie, 26,8 x 16,2 cm

Les artistes femmes anglaises trouvaient chic de s'habiller comme des hommes, en veste et pantalon. Cette lithographie montre Mary Hamilton en habits de scène pour le bonheur du public des cafés-concerts, pas si choqué que cela.

Mary Hamilton

(aus dem Album *Le Café Concert*)
1893, Lithografie, 26,8 x 16,2 cm

Bei englischen Unterhaltungskünstlerinnen galt Männerkleidung mit Jacke und Hose als „chic". Diese Lithografie zeigt Mary Hamilton in der Aufmachung, in der sie zur Freude der nur wenig schockierten Zuschauer auf der Bühne der Cafés-Concerts auftrat.

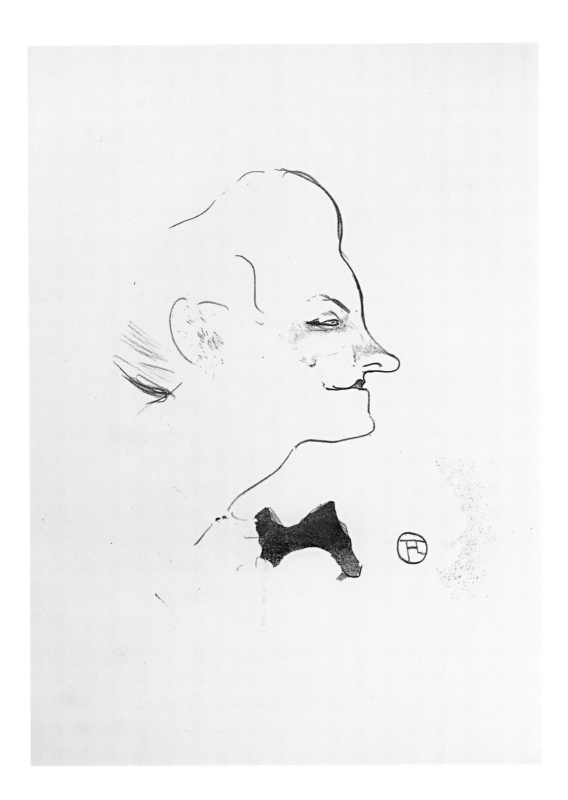

Aristide Bruant

(from the album *Le Café Concert*)
1893, lithograph, 26.4 x 21 cm

Aristide Bruant, singer and songwriter, was the embodiment of Montmartre and the cabaret lifestyle of the late nineteenth century. Many of his songs were recorded during his lifetime and his voice survives to this day.

Aristide Bruant

(del álbum *Le Café Concert*)
1893, litografía, 26,4 x 21 cm

Aristide Bruant, cantante y compositor de canciones, era la encarnación de Montmartre y el estilo de vida del cabaré de finales del siglo XIX. Muchas de sus canciones fueron grabadas en vida del artista, así su voz ha sobrevivido hasta nuestros días.

Aristide Bruant

(de l'album *Le Café Concert*)
1893, lithographie, 26,4 x 21 cm

Aristide Bruant, chanteur et chansonnier, incarnait la Butte et l'esprit de ses cabarets à la fin du dix-neuvième siècle. Nombre de ses chansons ont été enregistrées de son vivant et sa voix nous est ainsi parvenue.

Aristide Bruant

(aus dem Album *Le Café Concert*)
1893, Lithografie, 26,4 x 21 cm

Der Sänger und Lieddichter Aristide Bruant war Inbegriff für den Montmartre und das Leben in den Cabarets zu Ende des 19. Jahrhunderts. Viele Lieder hat er noch zu Lebzeiten aufgenommen, und so hat seine Stimme bis heute überdauert.

Yvette Guilbert

(from the album *Le Café Concert*)
1893, lithograph, 25.3 x 22.3 cm

Yvette Guilbert was never happy with the way Toulouse-Lautrec depicted her chin, tight lips and prominent nose.

Yvette Guilbert

(del álbum *Le Café Concert*)
1893, litografía, 25,3 x 22,3 cm

Yvette Guilbert nunca estuvo satisfecha con la forma en la que Toulouse-Lautrec dibujó su barbilla, labios apretados y nariz prominente.

Yvette Guilbert

(de l'album *Le Café Concert*)
1893, lithographie, 25,3 x 22,3 cm

Yvette Guilbert n'apprécia jamais la manière dont Toulouse-Lautrec représentait son menton, ses lèvres fines et son grand nez.

Yvette Guilbert

(aus dem Album *Le Café Concert*)
1893, Lithografie, 25,3 x 22,3 cm

Yvette Guilbert war stets unglücklich über die Art, wie Toulouse-Lautrec ihr Kinn, die schmalen Lippen und die auffällige Nase wiedergab.

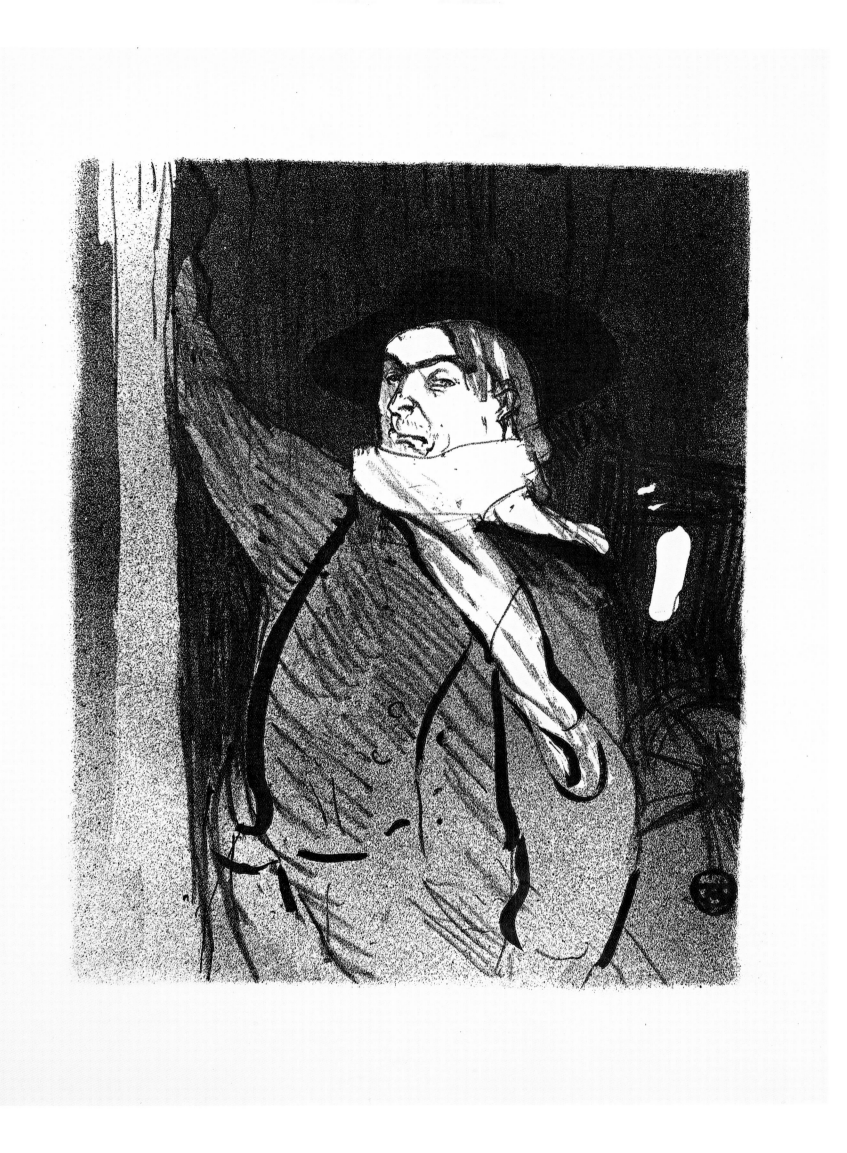

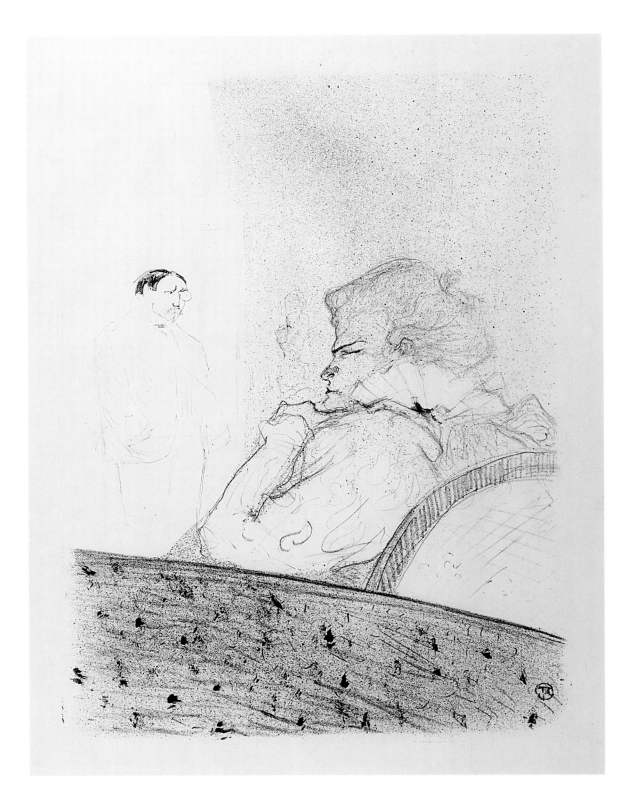

Brandès and Le Bargy

1894, lithograph, 42.8 x 33.5 cm

The two actors are portrayed in a scene from *Cabotins* ('Charlatans'). Marthe Brandès had a ten-year acting career at the 'Comédie Française'. Toulouse-Lautrec was drawn to her unmistakable profile and depicted her in two other lithographs. Charles le Bargy was known for his good looks and elegant clothes. One theatre critic remarked that his acting skills were poor, but he would surely have had success as a diplomat.

Brandès y Le Bargy

1894, litografía, 42,8 x 33,5 cm

Los dos actores están retratados en una escena de *Cabotins* ('Los impostores'). Marthe Brandès tuvo una carrera de interpretación de diez años en la Comédie Française. A Toulouse-Lautrec le atraía su inconfundible perfil y la retrató en dos litografías más. Charles le Bargy era famoso por su atractivo y su elegante ropa. Un crítico de teatro comentó que sus dotes interpretativas eran escasas, pero que muy probablemente habría tenido éxito como diplomático.

Brandès et Le Bargy

1894, lithographie, 42,8 x 33,5 cm

Les deux acteurs sont représentés dans une scène des *Cabotins*. Marthe Brandès avait joué pendant dix ans à la Comédie Française. Fasciné par son profil caractéristique, Toulouse-Lautrec lui a consacré deux autres lithographies. Charles le Bargy était connu pour son physique avantageux et l'élégance de sa mise. Un critique de théâtre fit remarquer que ses talents d'acteur étaient maigres mais qu'il aurait sûrement eu du succès en tant que diplomate.

Brandès und Le Bargy

1894, Lithografie, 42,8 x 33,5 cm

Die beiden Schauspieler erscheinen in einer Szene aus *Cabotins* („Gaukler"). Marthe Brandès stand zehn Jahre lang erfolgreich auf der Bühne der „Comédie Française". Toulouse-Lautrec war fasziniert von ihrem markanten Profil und widmete ihr noch zwei weitere Lithografien. Der gut aussehende Charles le Bargy war bekannt für seine elegante Kleidung. Ein Theaterkritiker bewertete seine Schauspielkünste als eher gering, räumte ihm aber Erfolgschancen als Diplomat ein.

Brandès in her Box

1894, lithograph, 37.5 x 27 cm

Brandès en su camerino

1894, litografía, 37,5 x 27 cm

Brandès dans sa Loge

1894, lithographie, 37,5 x 27 cm

Brandès in ihrer Loge

1894, Lithografie, 37,5 x 27 cm

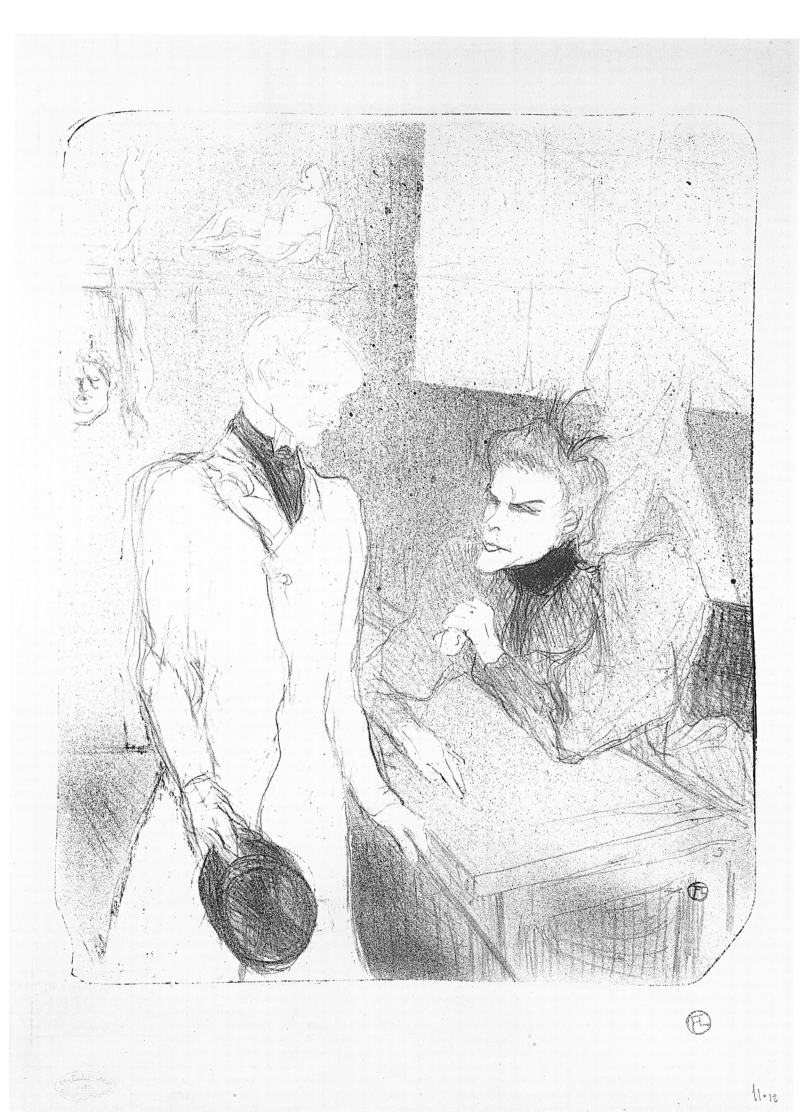

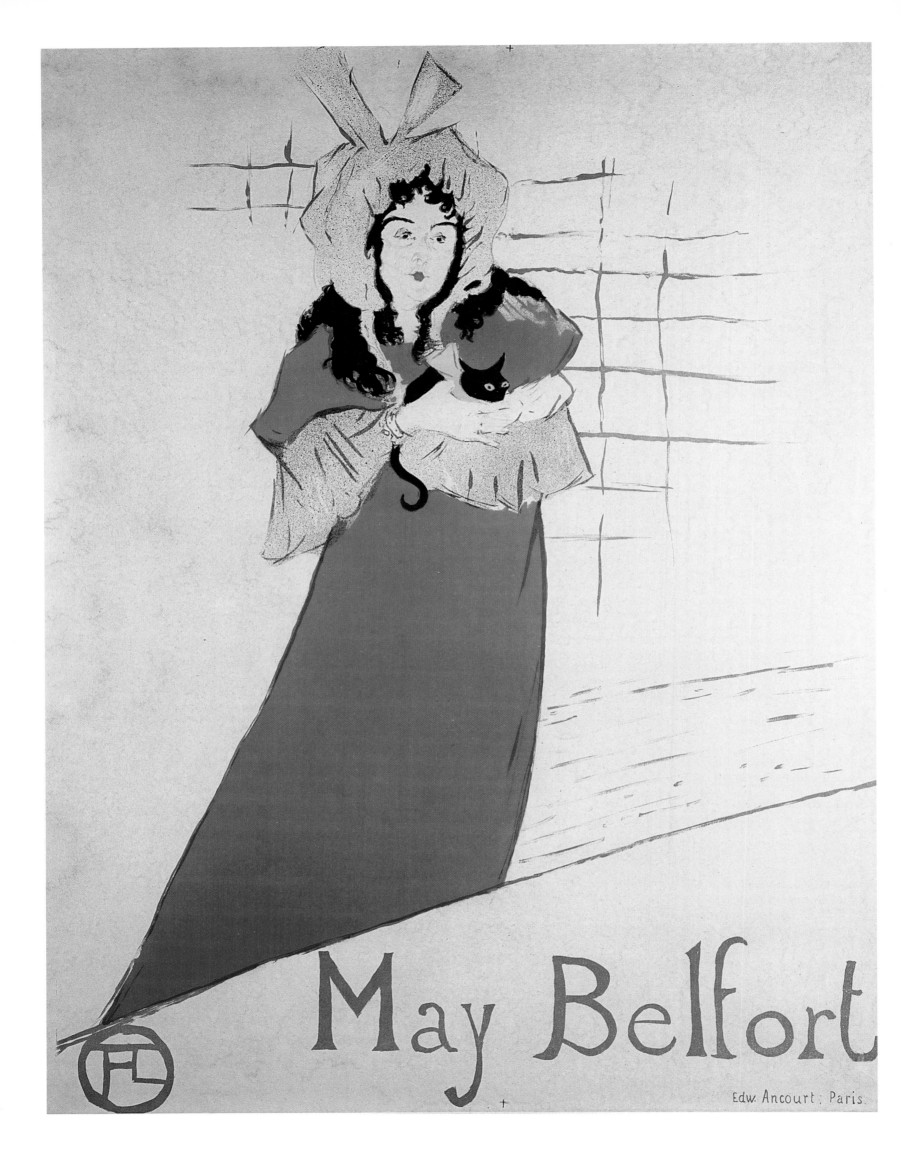

May Belfort

Edw. Ancourt. Paris.

May Belfort

1895, colour lithograph, 79.5 x 61 cm

Always singing with her cat in her arms, this beautiful Irish actress dressed as an English baby wearing a bonnet tied with ribbons and brightly coloured dresses. The singer and performer captivated French audiences everywhere she went. Toulouse-Lautrec portrayed her in several of his lithographs. This poster was commissioned for her entry into the 'Petit Casino', where she would sing "I've got a little cat, I'm very fond of that" in a seductive manner full of innuendo. This poster is remarkably well preserved, particularly the red dress, which over time usually fades and turns orange.

May Belfort

1895, litografía en color, 79,5 x 61 cm

Siempre cantando con su gato en los brazos, esta bella actriz irlandesa vestía como un bebé inglés con un sombrero atado con cintas y vestidos de vivos colores. Esta cantante y artista cautivaba al público francés allá donde iba. Toulouse-Lautrec la retrató en varias de sus litografías. Ella le encargó este cartel para su entrada en el Petit Casino, donde cantaría «Tengo un gatito, y estoy encantada» de una manera seductora llena de insinuaciones. Este cartel se ha conservado notablemente bien, en especial el vestido rojo, que por lo general con el tiempo suele decolorarse y volverse naranja.

May Belfort

1895, lithographie en couleur, 79,5 x 61 cm

Chantant toujours avec son chaton dans les bras, cette belle artiste irlandaise était vêtue comme un poupon anglais avec un bonnet à rubans et des robes aux couleurs vives. Elle captivait le public français où qu'elle se trouvât. Toulouse-Lautrec l'a représentée sur plusieurs lithographies. Cette affiche, commandée pour son entrée au Petit Casino où elle chantait « I've got a little cat, I'm very fond of that » d'une manière aguichante pleine de sous-entendus, est remarquablement bien conservée, surtout le rouge de la robe qui pâlit normalement avec le temps et tourne à l'orange.

May Belfort

1895, Farblithografie, 79,5 x 61 cm

Die schöne irische Schauspielerin, die stets mit ihrer Katze im Arm sang, machte sich als englisches „Baby" mit Häubchen und bunten Kleidern auf. Wo immer sie auftrat, fesselte die Sängerin und Darstellerin ihr französisches Publikum. Toulouse-Lautrec bildete sie auf mehreren Lithografien ab. Dieses Plakat wurde für ihr Debut im „Petit Casino" in Auftrag gegeben, wo sie sehr verführerisch und anspielungsreich „I've got a little cat, I'm very fond of that" sang. Das Blatt ist auffallend gut erhalten, insbesondere die rote Farbe, die sonst mit der Zeit meist verblasst und sich orange verfärbt.

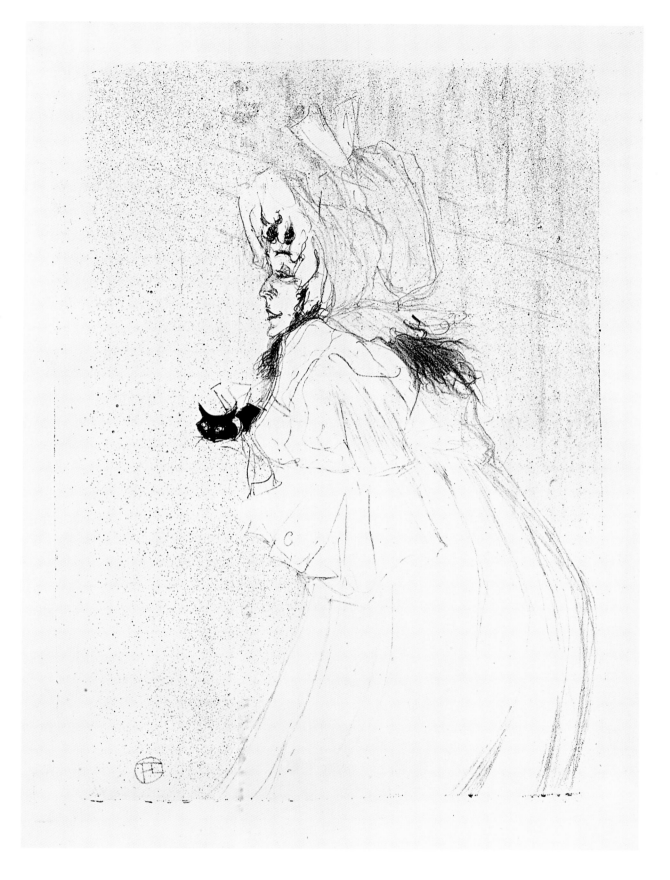

Miss May Belfort bowing
to the Audience

1895, lithograph, 37.5 x 26.5 cm

Miss May Belfort saludando
al público

1895, litografía, 37,5 x 26,5 cm

Miss May Belfort
Saluant le Public

1895, lithographie, 37,5 x 26,5 cm

Miss May Belfort grüßt
das Publikum

1895, Lithografie, 37,5 x 26,5 cm

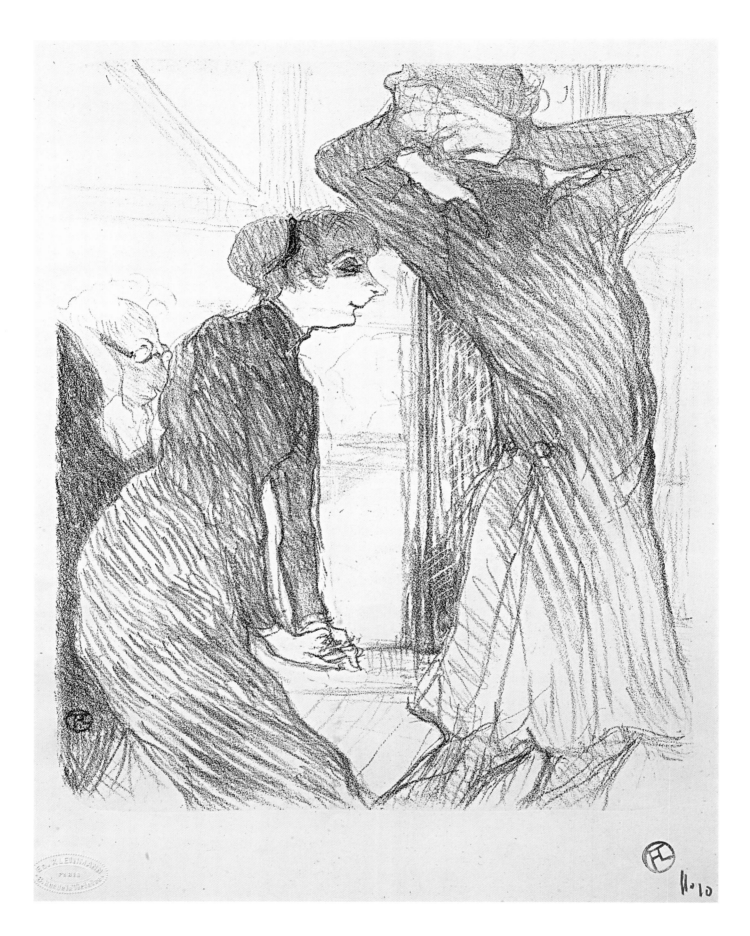

Lugné-Poë and Bady

1894, lithograph, 29 x 24 cm

Aurélien Lugné-Poë started his career as an actor and later founded the 'Théâtre de l'Œuvre', for which Toulouse-Lautrec illustrated the cover of one of its publications. Lugné-Poë started the practice of dimming the house lights during performances. Parisians were enraged, complaining that they were missing half the fun if they could not see each other. Berthe Bady was a Belgian actress who starred several times opposite Lugné-Poë.

Lugné-Poë y Bady

1894, litografía, 29 x 24 cm

Aurélien Lugné-Poë comenzó su carrera como actor y más adelante fundó el Théâtre de l'Œuvre, para el cual Toulouse-Lautrec ilustró la portada de una de sus publicaciones. Lugné-Poë inició la práctica de bajar las luces durante las actuaciones. Los parisinos se enfurecieron y se quejaron de que, si no podían verse los unos a los otros, se perdían la mitad de la diversión. Berthe Bady fue una actriz belga que le dio la réplica en varias ocasiones.

Lugné-Poë et Bady

1894, lithographie, 29 x 24 cm

Aurélien Lugné-Poë a débuté comme acteur avant de fonder le Théâtre de l'Œuvre, dont Toulouse-Lautrec a illustré la couverture d'une des publications. Il a initié la pratique qui consiste à baisser l'éclairage pendant le spectacle. Les Parisiens furieux, se plaignirent qu'ils rataient la moitié de leur plaisir s'ils ne pouvaient pas se voir l'un l'autre. Berthe Bady était une comédienne belge qui donna plusieurs fois la réplique à Lugné-Poë.

Lugné-Poë und Bady

1894, Lithografie, 29 x 24 cm

Aurélien Lugné-Poë begann als Schauspieler und eröffnete später das „Théâtre de l'Œuvre", für das Toulouse-Lautrec eine Titelillustration schuf. Als Erster dunkelte Lugné-Poë die Beleuchtung im Saal ab. Die Pariser waren darüber empört und beschwerten sich, dass ihnen die Hälfte des Spaßes entgehe, wenn sie einander nicht sehen könnten. Berthe Bady war Belgierin und übernahm mehrfach Hauptrollen an der Seite von Lugné-Poë.

Announcement for the Théâtre de l'Œuvre

1895, lithograph, 21.2 x 33.8 cm

The cover of a publication produced in three languages as an advertisement for the 'Théâtre de l'Œuvre' in Paris.

Prospecto para el Théâtre de l'Œuvre

1895, litografía, 21,2 x 33,8 cm

Cubierta de una publicación en tres idiomas como anuncio para el Théâtre de l'Œuvre de París.

Prospectus pour le Théâtre de l'Œuvre

1895, lithographie, 21,2 x 33,8 cm

Couverture d'une publication trilingue faisant de la publicité pour le Théâtre de l'Œuvre à Paris.

Ankündigung für das Théâtre de l'Œuvre

1895, Lithografie, 21,2 x 33,8 cm

Titelbild für einen Werbeprospekt, der in drei Sprachen für das „Théâtre de l'Œuvre" in Paris erstellt wurde.

Women's Heads

c. 1894, pencil on paper, 16 x 22.5 cm

Cabezas de mujeres

c 1894, lápiz sobre papel, 16 x 22,5 cm

Têtes de Femmes

vers 1894, mine de plomb sur papier, 16 x 22,5 cm

Frauenköpfe

um 1894, Bleistift auf Papier, 16 x 22,5 cm

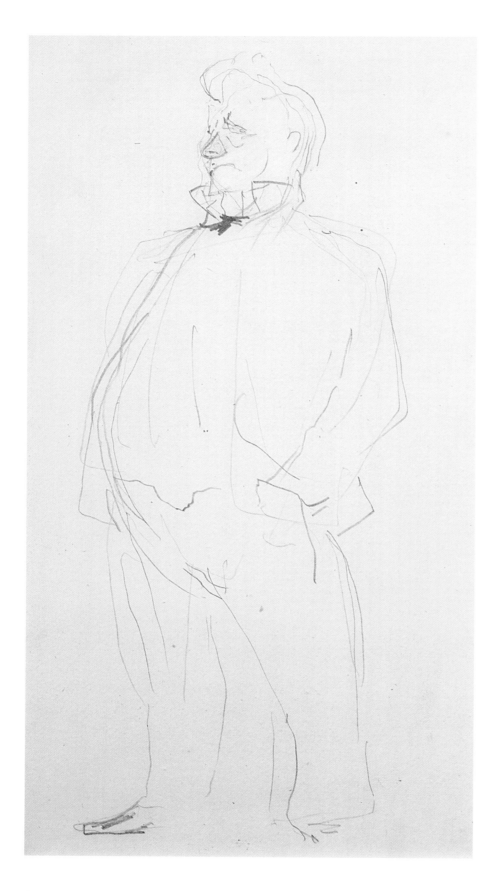

The Little Errand Girl

1901, colour lithograph, 28 x 19 cm

The cover sheet for a song about an errand girl, with words by Achille Melandri and music by Désiré Dihau. The man in checkered pants, top hat and monocle, with obvious money to spare, is casting an interested eye on the coquettish young woman who is presumably running errands for her employer.

La muchacha de los recados

1901, litografía en color, 28 x 19 cm

Portada para una canción sobre una chica de los recados, con texto de Achille Melandri y música de Désiré Dihau. El opulento caballero con pantalones a cuadros, chistera y monóculo mira con interés a la coqueta muchacha que, por lo visto, está haciendo recados para su patrón.

Le Petit Trottin

1901, lithographie en couleur, 28 x 19 cm

Couverture d'une partition de chanson parlant d'une fille de courses, le texte est d'Achille Melandri, la musique de Désiré Dihau. L'homme en pantalons à carreaux, portant haut-de-forme et monocle – il a manifestement de l'argent –, jette un coup d'œil intéressé sur la jeune coquette qui fait probablement des courses pour son employeur.

Das kleine Laufmädchen

1901, Farblithografie, 28 x 19 cm

Notentitel für ein Lied über ein Laufmädchen. Der Text stammt von Achille Melandri, die Musik von Désiré Dihau. Der Mann mit karierter Hose, Zylinder und Monokel, dem es nicht am nötigen Kleingeld fehlt, wirft einen interessierten Blick auf die kokette junge Frau, vermutlich eine Laufbotin.

Artist's Portrait
c. 1893, pencil on paper, 23.5 x 9.5 cm

Retrato de artista
c 1893, lápiz sobre papel, 23,5 x 9,5 cm

Portrait d'Artiste
vers 1893, mine de plomb sur papier, 23,5 x 9,5 cm

Künstlerbildnis
um 1893, Bleistift auf Papier, 23,5 x 9,5 cm

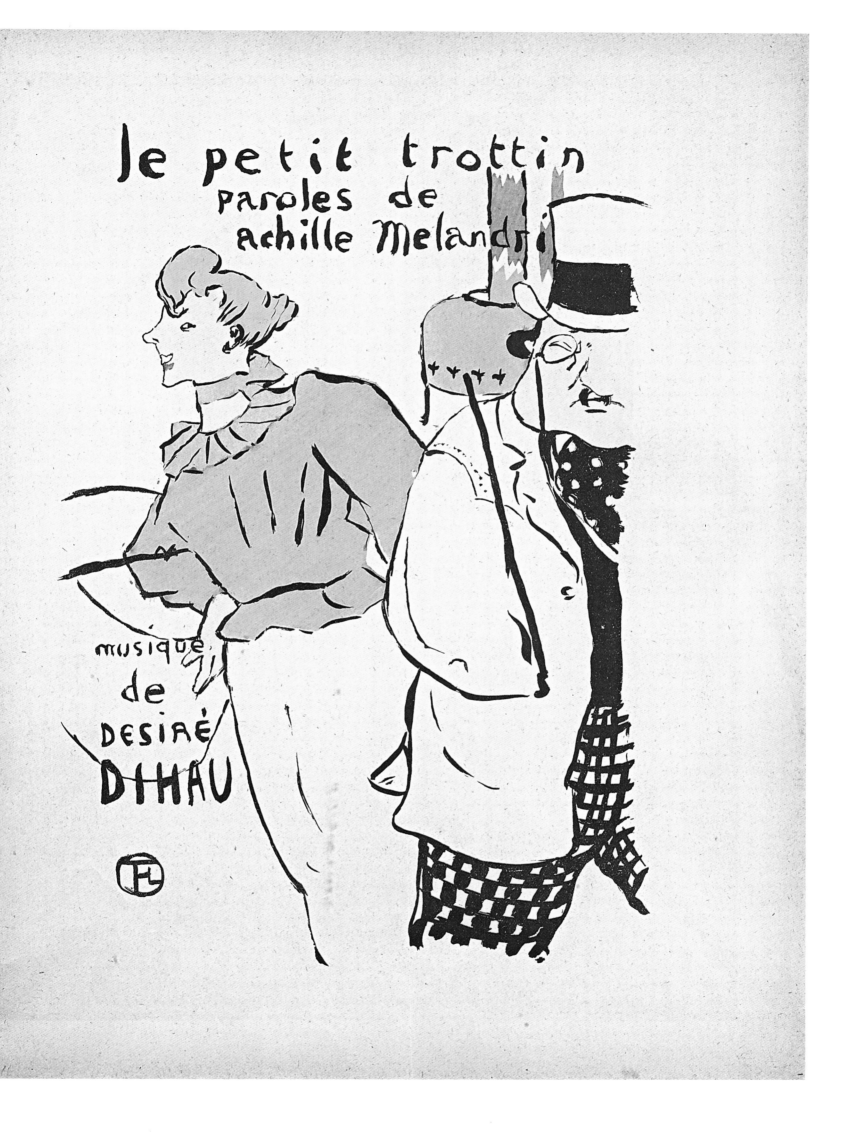

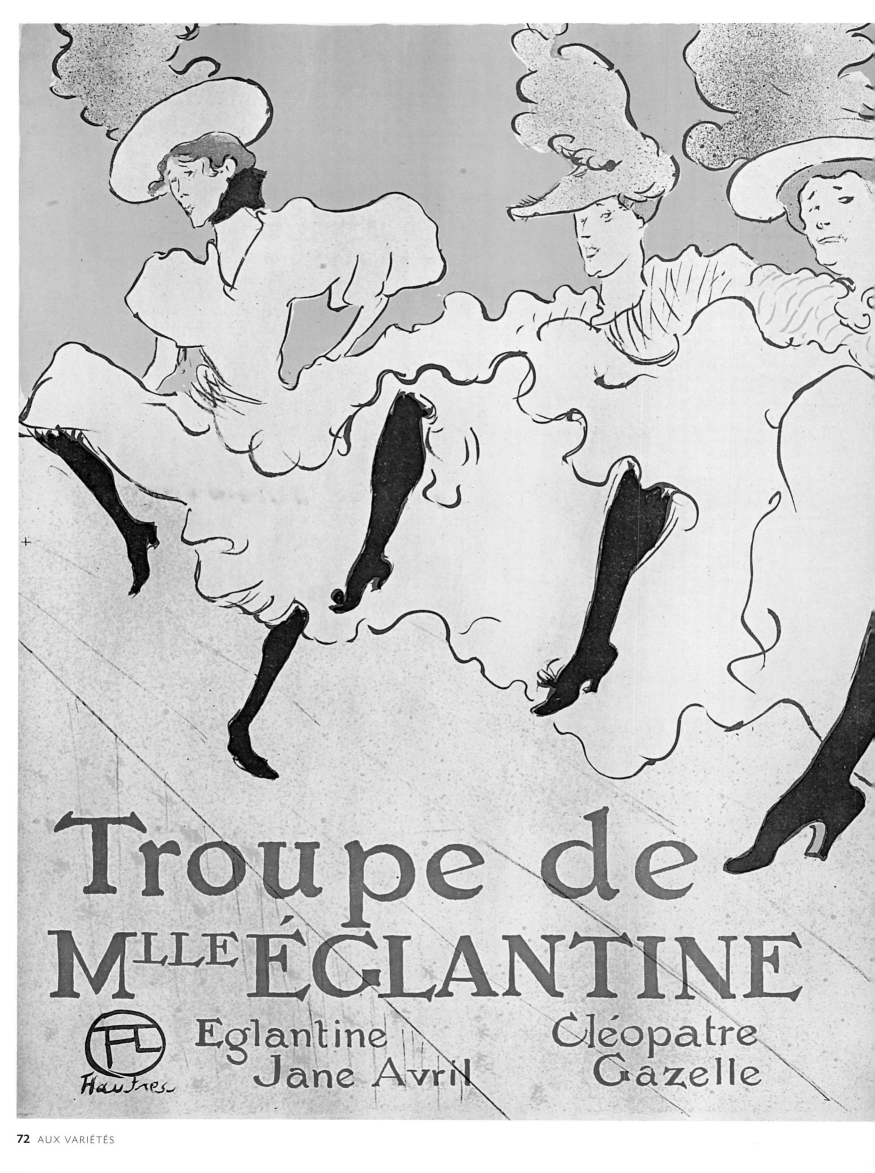

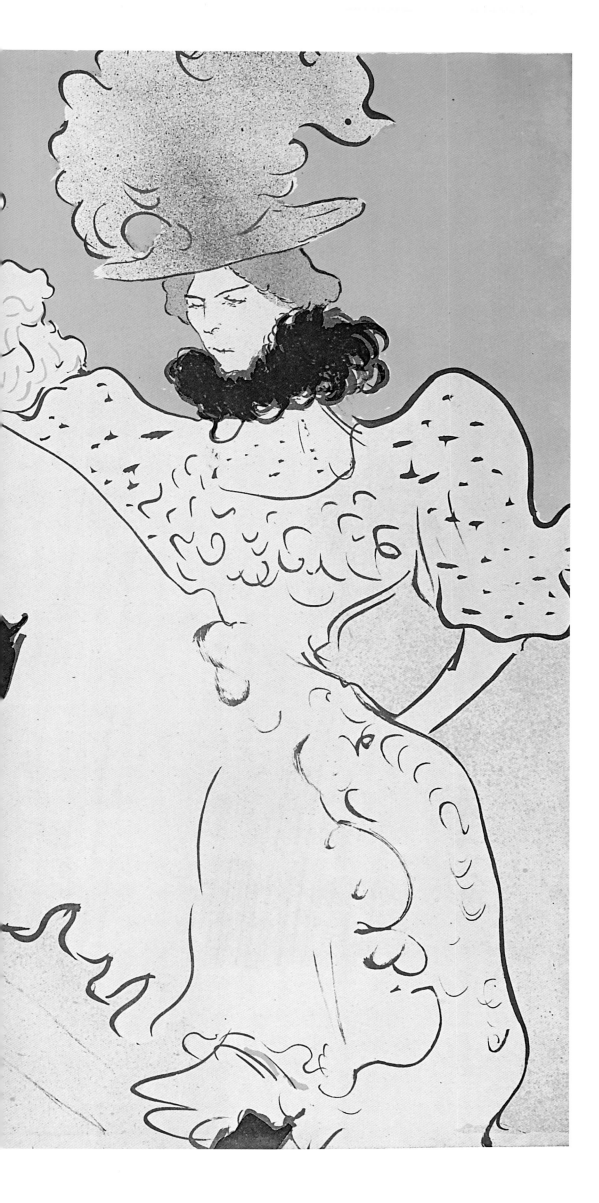

Mademoiselle Eglantine's Troupe

1896, colour lithograph, 61.7 x 80.4 cm

At the height of her career Jane Avril decided that England was ready for the French cancan (the name is thought to derive from Old French *caquehan*, 'tumult'). She went to London with three other dancers, Eglantine, Cléopâtre and Gazelle, and asked Toulouse-Lautrec to make a poster for the troupe. The tour was not a success because the reviews characterized the show as "too tame for French cancan"! It seems the audience expected something much racier. The poster is based on a photograph. Although the artist simplified the lines, the personalities of the dancers come through.

La compañía de mademoiselle Eglantine

1896, litografía en color, 61,7 x 80,4 cm

En el momento cumbre de su carrera, Jane Avril decidió que Inglaterra estaba lista para el cancán francés (se piensa que el nombre deriva del francés antiguo *caquehan* ['tumulto']) y decidió marcharse a Londres con otras tres bailarinas, Eglantine, Cléopâtre y Gazelle. Le pidieron a Toulouse-Lautrec que realizara un cartel para la compañía. El viaje no fue un éxito porque las revistas calificaron el espectáculo de «demasiado soso para el cancán». Al parecer el público esperaba algo mucho más atrevido. El cartel está basado en una fotografía. Aunque el artista simplificó las líneas, se perciben las personalidades de las bailarinas.

La Troupe de Mademoiselle Eglantine

1896, lithographie en couleur, 61,7 x 80,4 cm

Au sommet de sa carrière et décidant que l'Angleterre était prête pour le French cancan (on pense que le nom est dérivé de l'ancien français « caquehan », tumulte), Jane Avril partit pour Londres avec trois autres danseuses, Eglantine, Cléopâtre et Gazelle, et demanda à Toulouse-Lautrec de faire une affiche pour la troupe. La tournée ne fut pas un succès, les critiques jugeant le spectacle « trop timide pour un French cancan » ! Le public semblait s'attendre à quelque chose de plus olé olé. L'affiche est basée sur une photographie. La personnalité des danseuses transparaît malgré l'effort de stylisation.

Die Truppe von Mademoiselle Eglantine

1896, Farblithografie, 61,7 x 80,4 cm

Auf dem Zenit ihrer Laufbahn beschloss Jane Avril, dass England nun bereit sei für den Cancan. (Der Name leitet sich vom altfranzösischen „caquehan", Tumult, ab.) Zusammen mit drei weiteren Tänzerinnen, Eglantine, Cléopâtre und Gazelle, ging sie nach London und bat Toulouse-Lautrec um ein Plakat für die Truppe. Die Tour war kein Erfolg, weil der Auftritt in Kritiken als „zu zahm für den französischen Cancan" bemängelt wurde! Scheinbar erwartete man deutlich Gewagteres. Das Plakat entstand nach einer Fotografie. Trotz reduzierter Linienführung wird die Persönlichkeit der Tänzerinnen doch erkennbar.

Profile of a Woman

c. 1895, pencil on paper, 21 x 17.2 cm

Perfil de mujer

c 1895, lápiz sobre papel, 21 x 17,2 cm

Profil de Femme

vers 1895, mine de plomb sur papier, 21 x 17,2 cm

Frau im Profil

um 1895, Bleistift auf Papier, 21 x 17,2 cm

The Hairdresser

1893, colour lithograph, 31.5 x 23.9 cm

Program of the 'Théâtre Libre' for two plays: *Une Faillite* ('A Bankruptcy') and *Le Poète et le Financier* ('The Poet and the Financier'). Toulouse-Lautrec printed this version before the lettering was added on the upper left corner. He would print a few copies of most of the sheet music covers, theatre programs, and large posters he designed before the text was added. All of his works 'before letters' are coveted by collectors, as they show the artist's work unencumbered by text.

El peluquero

1893, litografía en color, 31,5 x 23,9 cm

Programa del Théâtre Libre para dos obras: *Une Faillite* ('Bancarrota') y *Le Poète et le Financier* ('El poeta y el financiero'). Toulouse-Lautrec grabó esta versión antes de que se añadiera el texto en la esquina superior izquierda. Haría algunas copias de la mayor parte de las cubiertas de partituras, programas de teatro y grandes carteles que diseñó antes de que se añadiera el texto. Todos sus trabajos de «antes de la letra» son muy codiciados por los coleccionistas, pues en ellos el trabajo del artista no está recargado por el texto.

Le Coiffeur

1893, lithographie en couleur, 31,5 x 23,9 cm

Le programme du Théâtre Libre présentant *Une Faillite* et *Le Poète et le Financier*. Toulouse-Lautrec fit imprimer cette version avant que le lettrage ne soit ajouté en haut à gauche. Il faisait tirer quelques épreuves de la plupart des couvertures de partitions de chansons, de programmes de théâtre et de grandes affiches avant que le texte n'y fût inscrit. Toutes ses épreuves « avant la lettre » sont convoitées par les collectionneurs car elles montrent le travail de l'artiste non alourdi par le texte.

Der Friseur

1893, Farblithografie, 31,5 x 23,9 cm

Programm des „Théâtre Libre" für die beiden Stücke *Une Faillite* („Ein Bankrott") und *Le Poète et le Financier* („Der Dichter und der Finanzier"). Diese Fassung druckte Toulouse-Lautrec noch vor Ergänzung der Lettern in der oberen linken Ecke. Bei den meisten von ihm gestalteten Notentiteln, Theaterprogrammen und großformatigen Plakaten ließ er auch ein paar Abzüge ohne Text anfertigen. Sie zeigen das reine Bildmotiv und sind deshalb in Sammlerkreisen sehr begehrt.

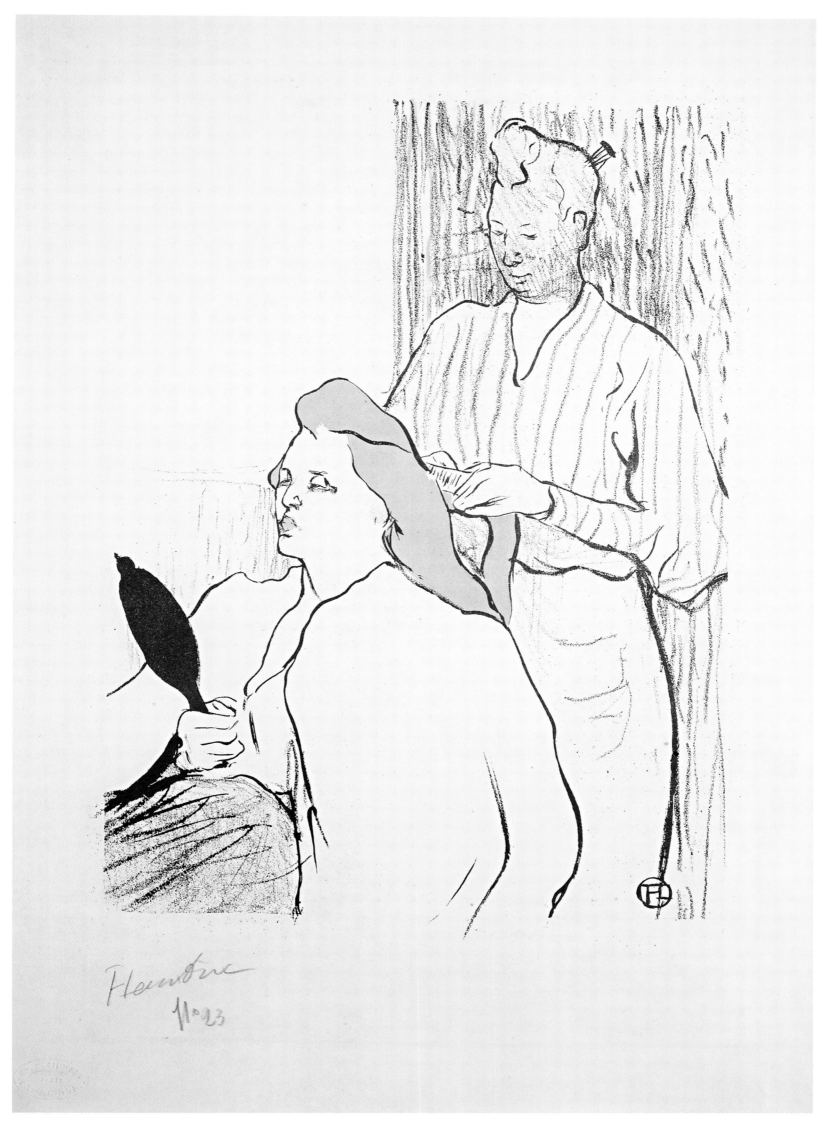

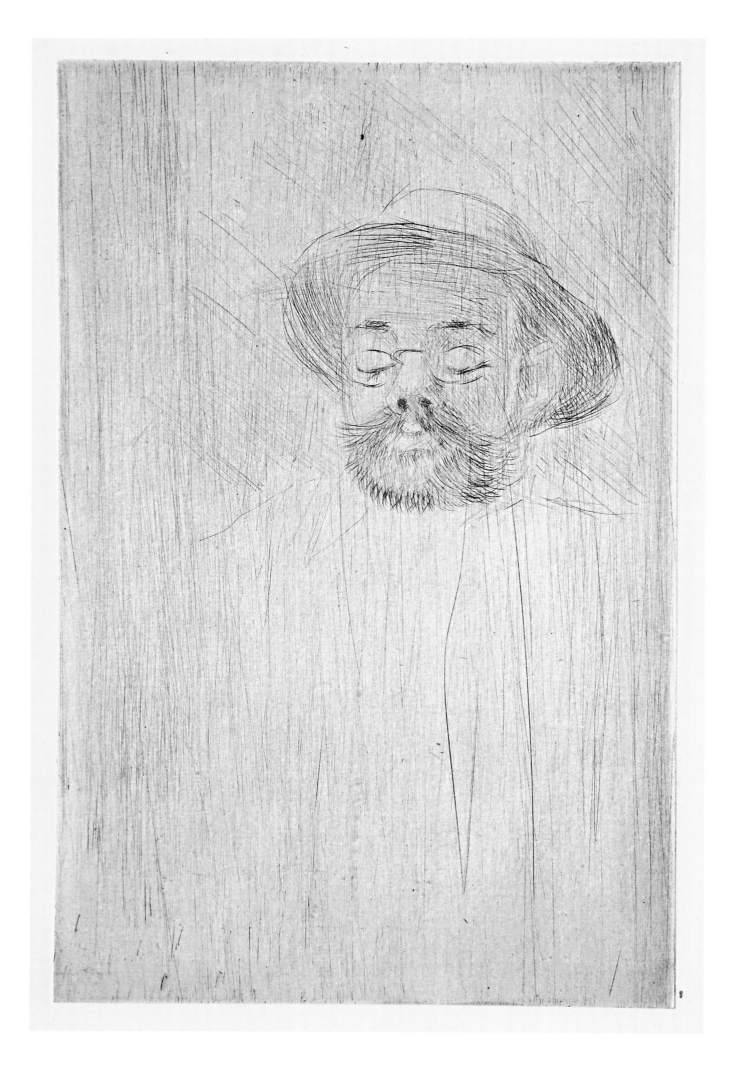

Henri Somm

1898, drypoint, 16.8 x 10.8 cm

French illustrator and printmaker
(1844 – 1907).

Henri Somm

1898, grabado a punta seca, 16,8 x 10,8 cm

Ilustrador francés y grabador
(1844-1907).

Henri Somm

1898, pointe sèche, 16,8 x 10,8 cm

Illustrateur et graveur français
(1844 – 1907).

Henri Somm

1898, Kaltnadel, 16,8 x 10,8 cm

Französischer Illustrator und Grafiker
(1844 – 1907).

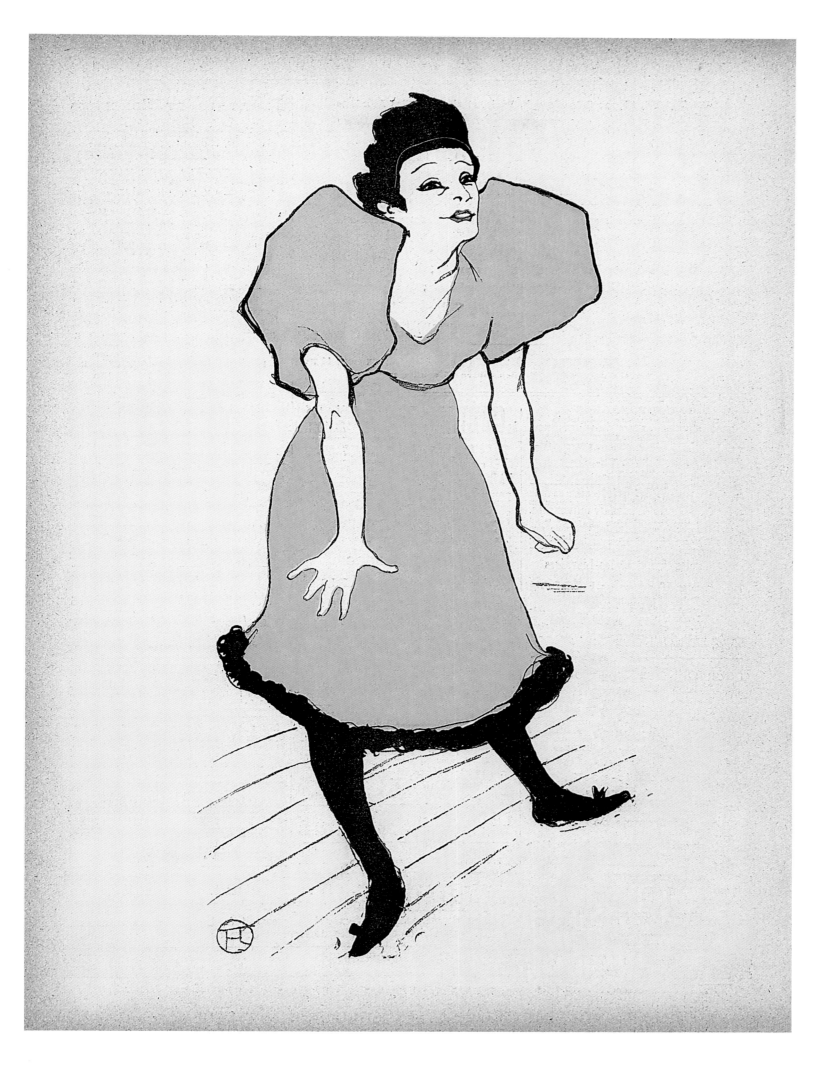

Polaire

1895, colour lithograph, 26.2 x 12.2 cm

Comedy actress and singer.

Polaire

1895, litografía en color, 26,2 x 12,2 cm

Actriz de comedia y cantante.

Polaire

1895, lithographie en couleur, 26,2 x 12,2 cm

Actrice et chanteuse.

Polaire

1895, Farblithografie, 26,2 x 12,2 cm

Komödienschauspielerin und Sängerin.

Yvette Guilbert

The famous singer portrayed around 1890 with her signature black gloves.

Yvette Guilbert

La famosa cantante retratada hacia 1890 con sus característicos guantes negros.

Yvette Guilbert

La célèbre chanteuse photographiée vers 1890 avec son emblème, ses longs gants noirs.

Yvette Guilbert

Die legendäre Sängerin um 1890 mit den für sie typischen schwarzen Handschuhen.

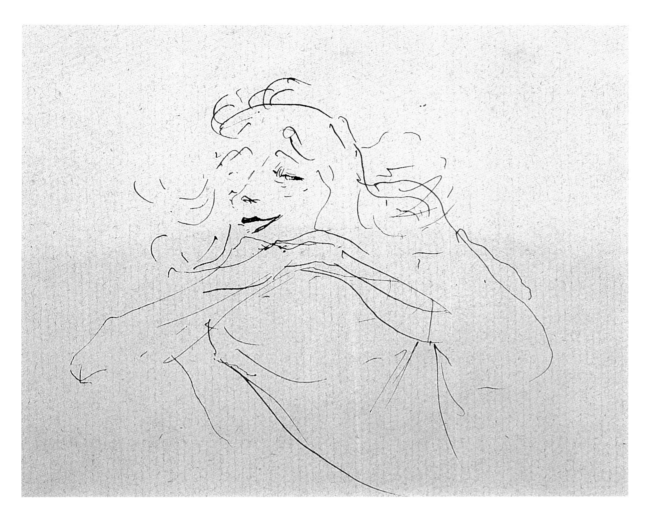

Study of Yvette Guilbert for
"Linger, Longer, Loo!"
1894, pen and ink on paper, 11 x 12 cm

Estudio de Yvette Guilbert para
«Linger, Longer, Loo!»
1894, pluma y tinta sobre papel, 11 x 12 cm

Étude d'Yvette Guilbert pour
« Linger, Longer, Loo ! »
1894, plume et encre sur papier, 11 x 12 cm

Studie von Yvette Guilbert für
„Linger, Longer, Loo!"
1894, Feder und Tinte auf Papier, 11 x 12 cm

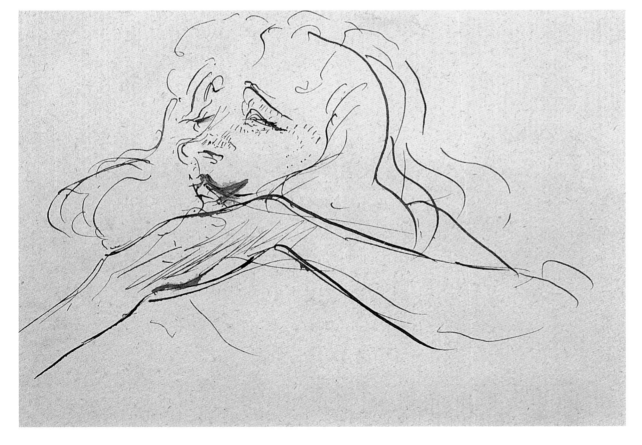

Study of Yvette Guilbert for
"Linger, Longer, Loo!"
1894, pen and ink on paper, 10.7 x 16.3 cm

Estudio de Yvette Guilbert para
«Linger, Longer, Loo!»
1894, pluma y tinta sobre papel, 10,7 x 16,3 cm

Étude d'Yvette Guilbert pour
« Linger, Longer, Loo ! »
1894, plume et encre sur papier, 10,7 x 16,3 cm

Studie von Yvette Guilbert für
„Linger, Longer, Loo!"
1894, Feder und Tinte auf Papier, 10,7 x 16,3 cm

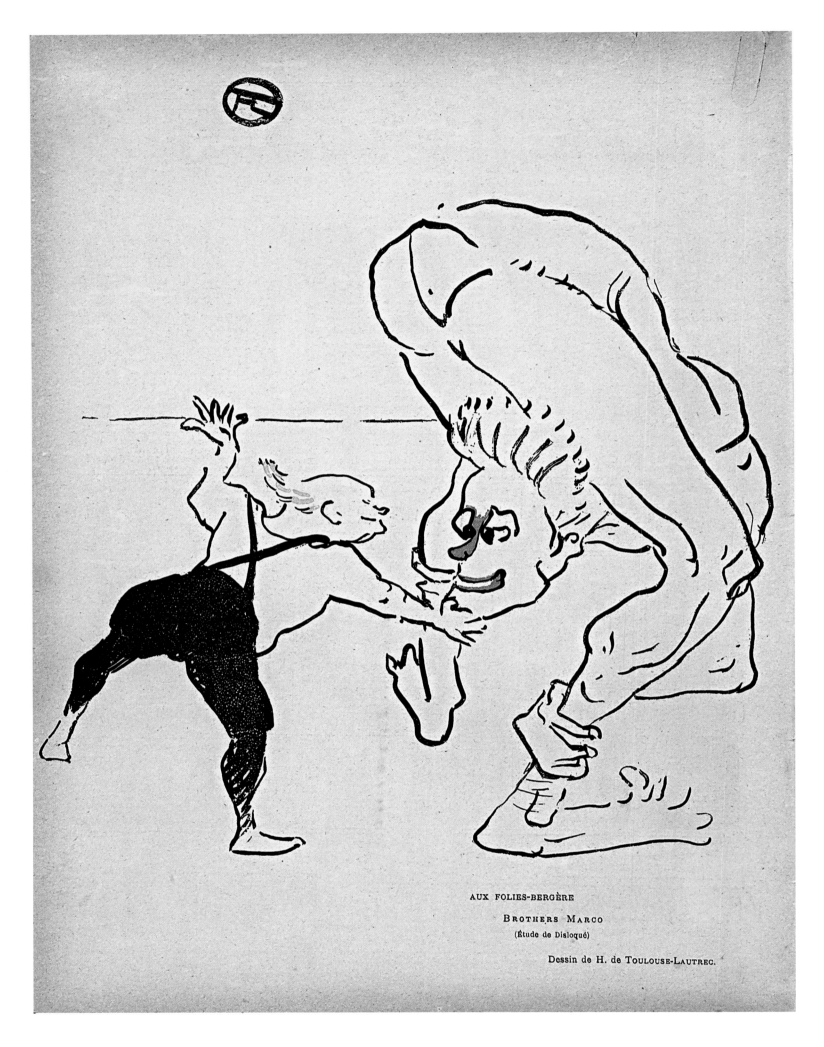

AUX FOLIES-BERGÈRE

BROTHERS MARCO
(Étude de Disloqué)

Dessin de H. de TOULOUSE-LAUTREC.

At the Folies-Bergères:
Brothers Marco

1895, colour lithograph, 23.7 x 21.5 cm

En el Folies-Bergères:
Brothers Marco

1895, litografía en color, 23,7 x 21,5 cm

Aux Folies-Bergères :
Brothers Marco

1895, lithographie en couleur, 23,7 x 21,5 cm

In den Folies-Bergères:
Brothers Marco

1895, Farblithografie, 23,7 x 21,5 cm

Footit

c. 1895, pencil on paper, 20 x 15.3 cm

George Footit (1864 – 1921) was a British equestrian acrobat and clown who performed at the 'Hippodrome du Champ-de-Mars' and at the 'Nouveau Cirque' in Paris from 1889 together with Raphael 'Chocolat' Padilla. In their act Footit played the abusive character with Chocolat as his foolish and lazy victim.

Footit

c 1895, lápiz sobre papel, 20 x 15,3 cm

George Footit (1864-1921) fue un payaso y acróbata ecuestre británico que actúo en el hipódromo del Campo de Marte y en el Nouveau Cirque en París desde 1889 junto a Rafael *Chocolat* Padilla. En su número, Footit hacía de abusón con Chocolat, su víctima tonta y perezosa.

Footit

vers 1895, mine de plomb sur papier, 20 x 15,3 cm

George Footit (1864 – 1921), clown, écuyer et acrobate anglais, se produisit à l'Hippodrome du Champ-de-Mars et au Nouveau Cirque à Paris à partir de 1889 avec Raphael 'Chocolat' Padilla. Dans leur numéro, Footit interprétait un personnage abusant de son autorité et Chocolat, son souffre-douleur, un être stupide et paresseux.

Footit

um 1895, Bleistift auf Papier, 20 x 15,3 cm

George Footit (1864 – 1921) war ein britischer Reitakrobat und Clown, der ab 1889 gemeinsam mit Raphael „Chocolat" Padilla im „Hippodrome du Champ-de-Mars" und dem „Nouveau Cirque" in Paris auftrat. Dabei übernahm er den herrischen Part mit Chocolat als seinem törichten und faulen Prügelknaben.

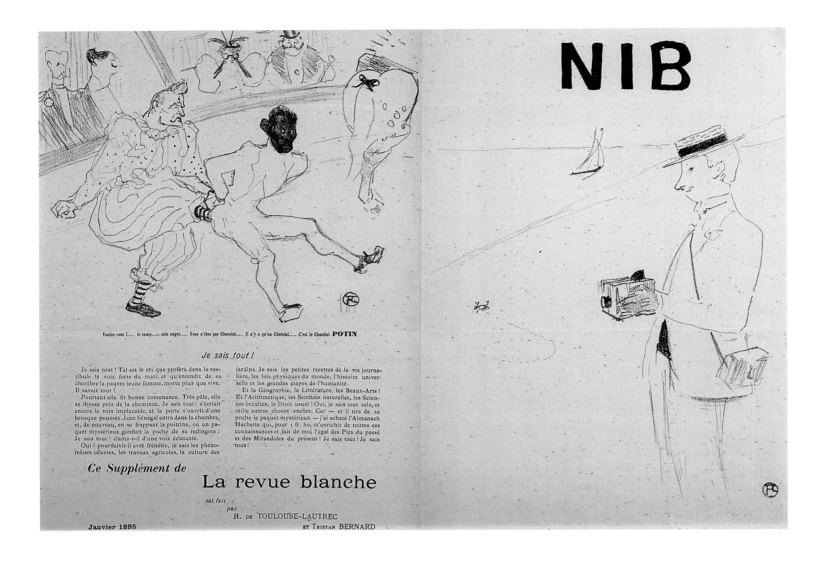

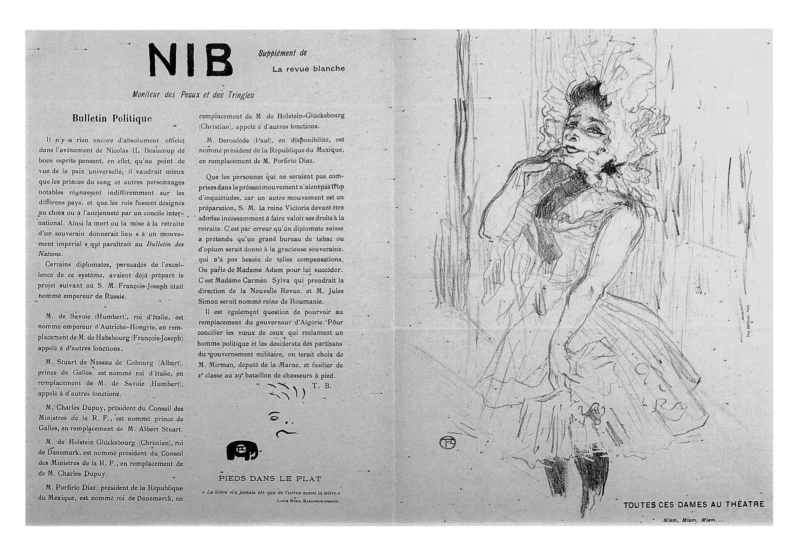

Covers for the Magazine Supplement NIB

1895, lithographs, 35.5 x 50.4 cm
(unfolded covers, left)
1895, lithograph, 25.9 x 24 cm (right)

NIB was published as a supplement to the famous literary revue *La Revue Blanche*. Toulouse-Lautrec contributed two covers for the magazine. The illustrations by Toulouse-Lautrec on both sides of this cover are *The Amateur Photographer, Footit and Chocolat* and *Anna Held* in *Toutes ces Dames au Théâtre*.

Cubiertas del suplemento NIB

1895, litografías, 35,5 x 50,4 cm
(cubiertas desplegadas, izquierda)
1895, litografía, 25,9 x 24 cm (derecha)

NIB fue un suplemento de la famosa revista literaria *La Revue Blanche*. Toulouse-Lautrec contribuyó con dos cubiertas para la publicación. Sus ilustraciones sobre ambos lados de esta cubierta son *El fotógrafo aficionado, Footit y Chocolat y Anna Held*, cantando *Toutes ces Dames au Théâtre*.

Couvertures du supplément NIB

1895, lithographies, 35,5 x 50,4 cm
(couvertures dépliées, à gauche)
1895, lithographie, 25,9 x 24 cm (à droite)

NIB était le supplément de *La Revue Blanche*. Toulouse-Lautrec en illustra deux couvertures. Ici, il a dessiné (devant et dos) *Le Photographe-Amateur, Footit et Chocolat* et *Anna Held*, dans *Toutes ces Dames au Théâtre*.

Titelillustrationen für die Zeitschriftenbeilage NIB

1895, Lithografien, 35,5 x 50,4 cm
(geöffnete Umschläge, links)
1895, Lithografie, 25,9 x 24 cm (rechts)

NIB erschien als Beilage der berühmten Literaturzeitschrift *La Revue Blanche*. Toulouse-Lautrec steuerte zwei Titelentwürfe zu ihr bei. Seine Illustrationen für Vorder- und Rückumschlag zeigen den *Amateurfotografen, Footit und Chocolat* und *Anna Held* in *Toutes ces Dames au Théâtre*.

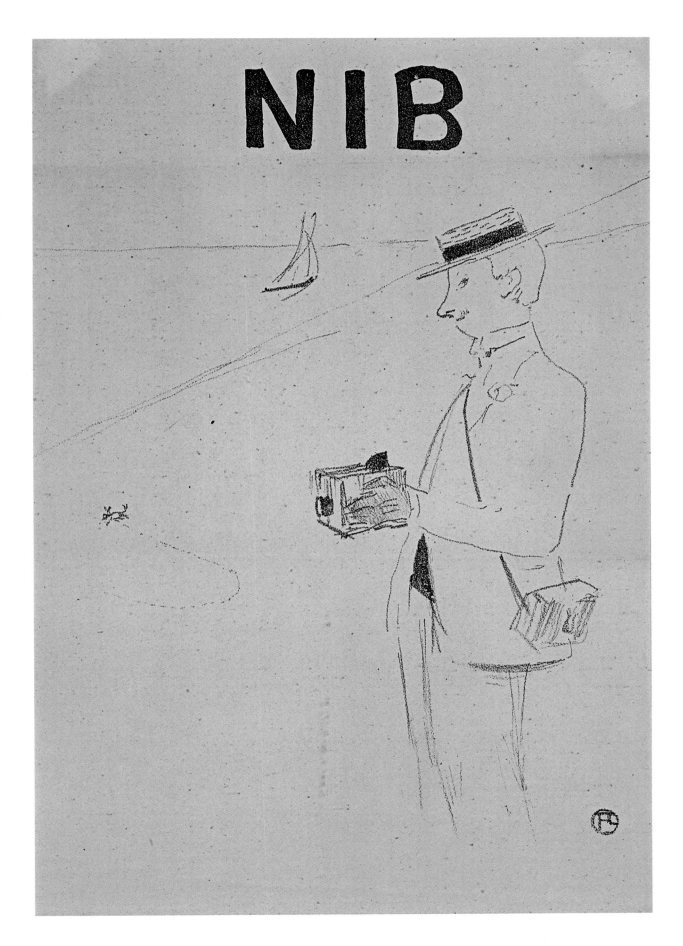

YVETTE GUILBERT

L'Art
de chanter
une
chanson

BERNARD GRASSET
MCMXXVIII

L'Art de Chanter une Chanson

Instructional book about how to sing a song by Yvette Guilbert, published 1928.

L'Art de Chanter une Chanson

Manual de instrucciones sobre cómo cantar una canción escrito por Yvette Guilbert y publicado en 1928.

L'Art de Chanter une Chanson

Un livre écrit par Yvette Guilbert, publié en 1928.

L'Art de Chanter une Chanson

Diese Anleitung von Yvette Guilbert zur Gesangskunst wurde im Jahr 1928 veröffentlicht.

Divan Japonais

1893, colour lithograph, 80.8 x 60.8 cm

A cabaret decorated in a Japanese style is the unusual setting Toulouse-Lautrec chose to depict two of his favourite performers: Yvette Guilbert on stage, recognized only by her signature gloves, and Jane Avril seated as a spectator exuding charm and style. This poster has several hidden messages: first, the blonde man on the right, Edouard Dujardin, was an art critic and appears to be distracted by Jane who was interested in art. Thus the artist enhances Jane's status by associating her with him. Also, Dujardin had written about abstraction in Japanese art. It is, therefore, appropriate that the art critic should appear in this setting in a poster that Toulouse-Lautrec designed using techniques influenced by Japanese printmaking.

Divan Japonais

1893, litografía en color, 80,8 x 60,8 cm

Un cabaré decorado al estilo japonés es el original marco en el que Toulouse-Lautrec decidió situar a dos de sus artistas favoritas: Yvette Guilbert sobre el escenario, reconocible tan solo por sus distintivos guantes, y Jane Avril, sentada como espectadora, desprendiendo encanto y estilo. Este cartel contiene varios mensajes ocultos. Para empezar, Edouard Dujardin, el hombre rubio de la derecha, era un crítico de arte y parece que Jane, aficionada al arte, lo está distrayendo. Así, el artista ensalza la categoría de Jane al asociarla con él. Además, Dujardin había escrito sobre la abstracción en el arte japonés. Por lo tanto, resulta oportuno que el crítico de arte aparezca en este escenario en un cartel que Toulouse-Lautrec diseñó usando técnicas influidas por la impresión japonesa.

Divan Japonais

1893, lithographie en couleur, 80,8 x 60,8 cm

Un cabaret de style japonisant est le décor insolite choisi par Toulouse-Lautrec pour représenter ses deux artistes favorites : Yvette Guilbert sur scène, on la reconnaît grâce à ses gants noirs, et Jane Avril, en spectatrice, rayonnant de charme et d'élégance. L'affiche dissimule plusieurs messages. A droite, l'homme blond, le critique d'art Edouard Dujardin, semble distrait par Jane que l'art intéressait. Ainsi l'artiste rehausse le statut de Jane en l'associant à lui. Dujardin a d'autre part écrit un texte sur l'abstraction dans l'art japonais. Sa présence est donc pertinente dans ce décor, sur une affiche que Toulouse-Lautrec a dessinée en utilisant des techniques influencées par l'estampe japonaise.

Divan Japonais

1893, Farblithografie, 80,8 x 60,8 cm

Ein Cabaret im japanischen Stil bildet hier den ungewöhnlichen Rahmen für zwei Lieblingsdarstellerinnen des Künstlers: auf der Bühne Yvette Guilbert, nur an ihren charakteristischen Handschuhen erkennbar, und als Zuschauerin die Charme und Stil verströmende Jane Avril. Das Plakat enthält mehrere versteckte Botschaften. Zum einen sieht man rechts den blonden Kunstkritiker Edouard Dujardin, der sich hier von der kunstinteressierten Jane ablenken lässt. Durch Dujardins Hinwendung wird Jane also aufgewertet. Da sich Dujardin zudem über die Abstraktion in der japanischen Kunst geäußert hatte, ist sein Erscheinen sehr passend auf einem Plakat, das Toulouse-Lautrec unter dem Einfluss japanischer Drucktechniken gestaltete.

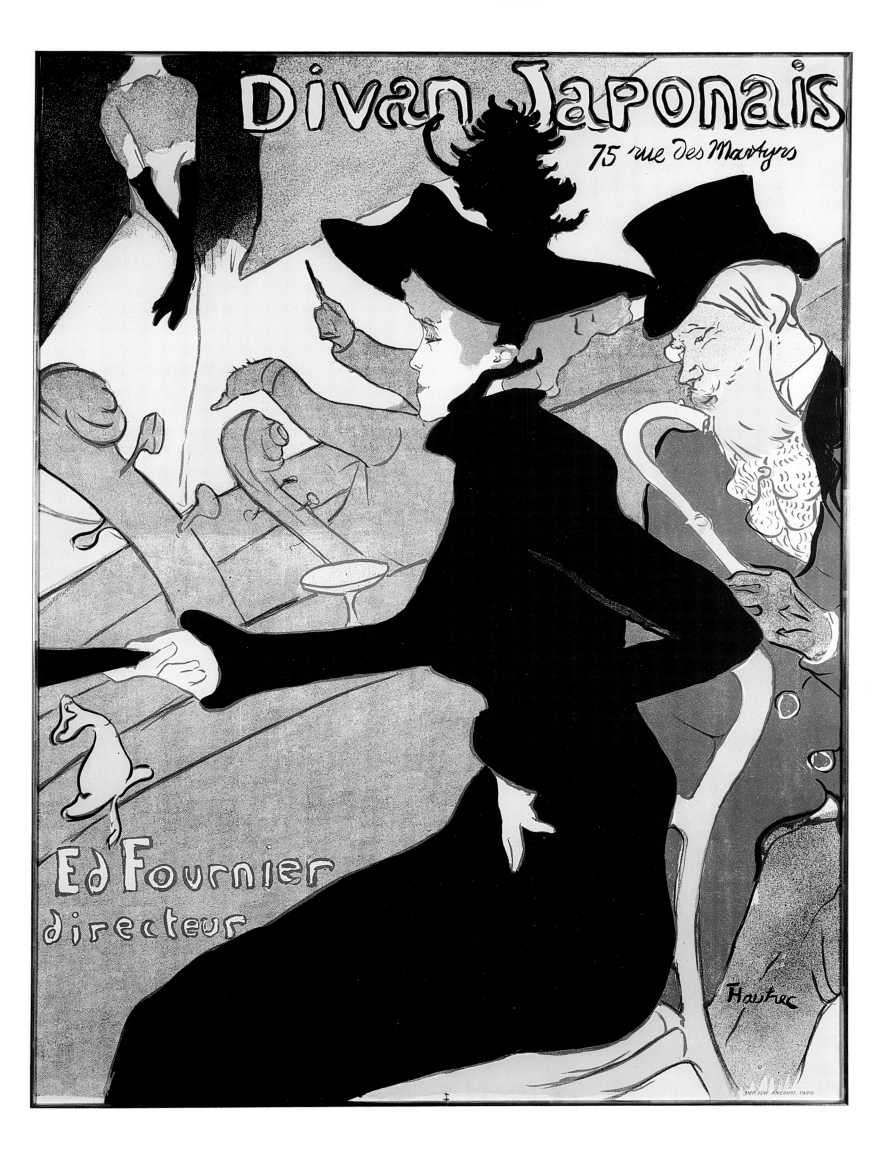

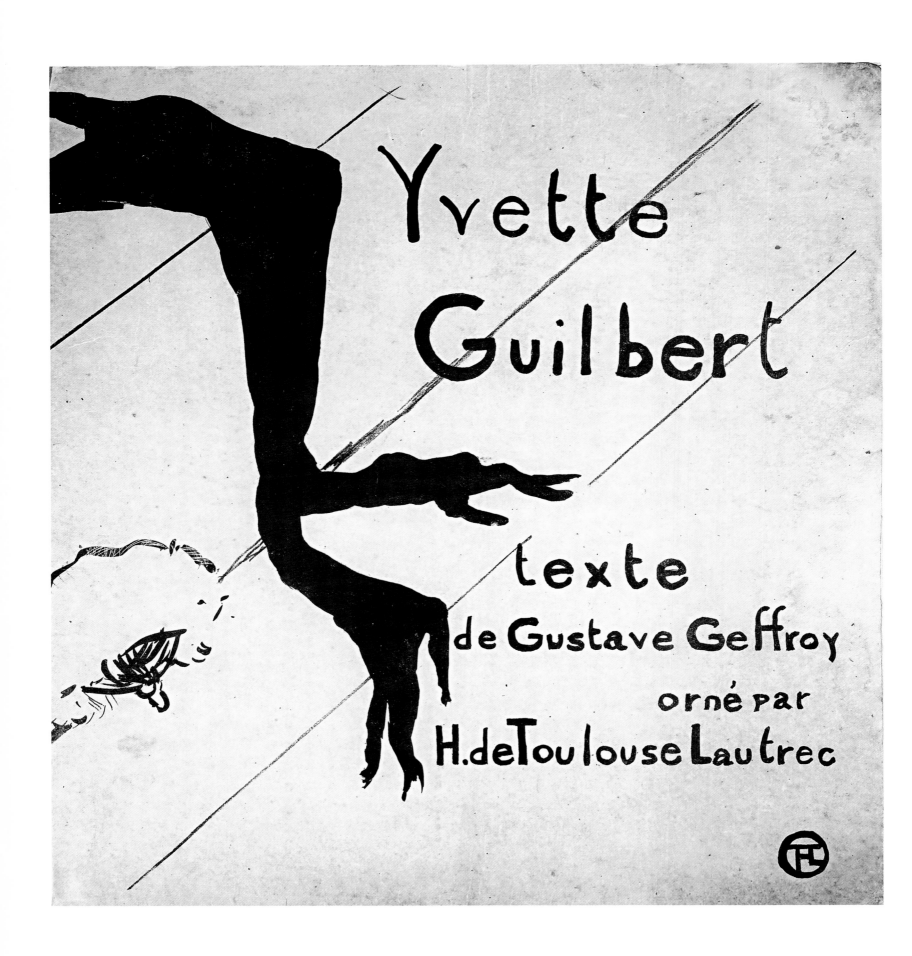

The Album *Yvette Guilbert*

The Album *Yvette Guilbert*

A big fan and friend of Yvette Guilbert, the artist decided to surprise her by producing this limited-edition album (100 copies were produced and signed by the singer) with 16 lithographs depicting Guilbert in various poses on and off stage.

When she first saw the book she was not pleased with the way he depicted her. "I am not that ugly!" she told him, but Toulouse-Lautrec's reputation was guaranteed to make her a big success, which is what happened shortly afterwards.

El álbum *Yvette Guilbert*

Gran admirador y amigo de Yvette Guilbert, el artista decidió sorprenderla produciendo este álbum de edición limitada (cien copias fueron producidas y firmadas por la cantante) con dieciséis litografías de Guilbert en varias posturas sobre y fuera del escenario.

Cuando vio el libro por primera vez, no se sintió satisfecha con la forma en la que la había dibujado. «¡No soy tan fea!», le dijo ella, pero la reputación de Toulouse-Lautrec era garantía de éxito, que, de hecho, logró poco después.

L'album *Yvette Guilbert*

Grand admirateur et ami d'Yvette Guilbert, l'artiste décida de lui faire une surprise en réalisant cet album en édition limitée (100 copies furent produites et signées par la chanteuse). Il comprenait seize lithographies présentant Guilbert dans des poses variées sur scène et en coulisses.

En voyant pour la première fois l'ouvrage, elle s'étonna vivement de se voir ainsi representée car elle s'y trouvait enlaide. Mais la réputation de Toulouse-Lautrec lui assurait le succès.

Das Album *Yvette Guilbert*

Als großer Anhänger und Freund von Yvette Guilbert beschloss der Künstler, sie mit einer limitierten Sondermappe von 16 Lithografien zu überraschen, die sie in wechselnden Posen auf und hinter der Bühne zeigen. Es erschienen 100 von der Sängerin signierte Exemplare.

Als sie das Album das erste Mal zu Gesicht bekam, zeigte sie sich unzufrieden mit ihrer Wiedergabe. „So hässlich bin ich nicht", sagte sie zu ihm, doch der Ruf von Toulouse-Lautrec schien Garant für ihren Durchbruch, und so kam es dann auch kurze Zeit später.

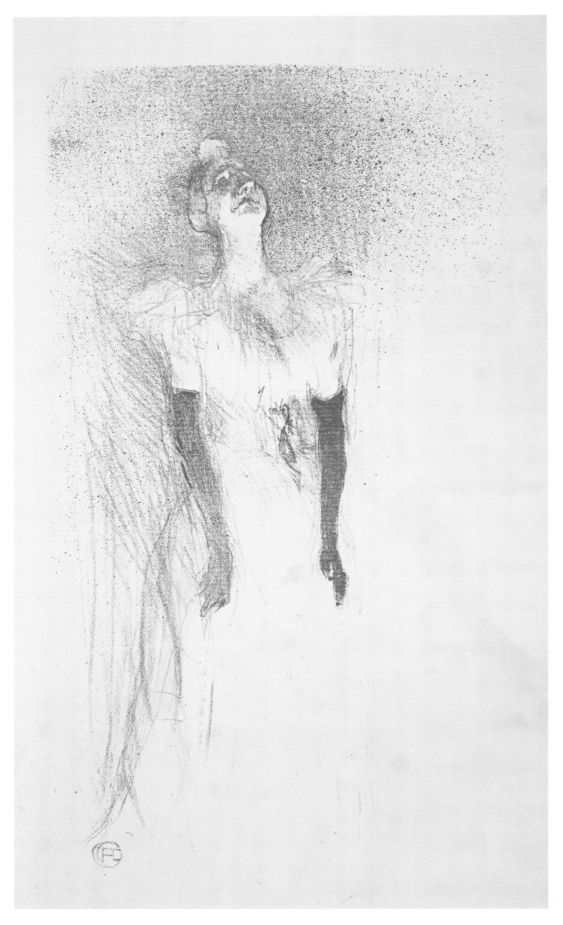

From the album *Yvette Guilbert*

1894, lithograph, 30.7 x 15.6 cm (left)
1894, lithograph, 34.2 x 20.2 cm (right)

Del álbum *Yvette Guilbert*

1894, litografía, 30,7 x 15,6 cm (izquierda)
1894, litografía, 34,2 x 20,2 cm (derecha)

De l'album *Yvette Guilbert*

1894, lithographie, 30,7 x 15,6 cm (à gauche)
1894, lithographie, 34,2 x 20,2 cm (à droite)

Aus dem Album *Yvette Guilbert*

1894, Lithografie, 30,7 x 15,6 cm (links)
1894, Lithografie, 34,2 x 20,2 cm (rechts)

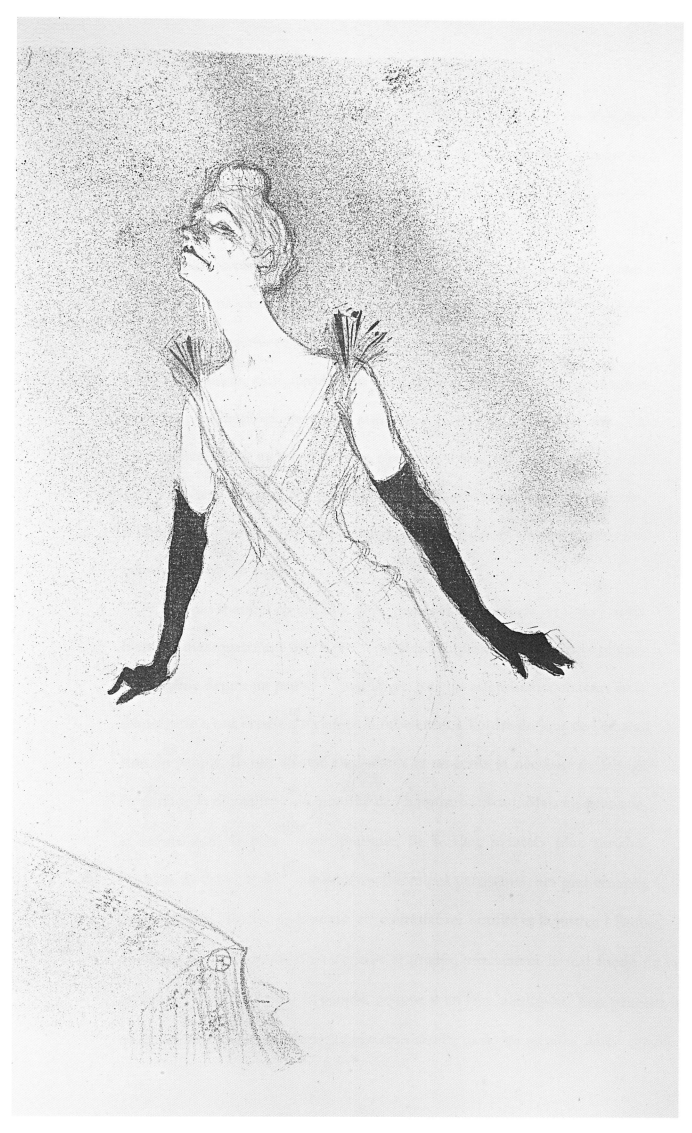

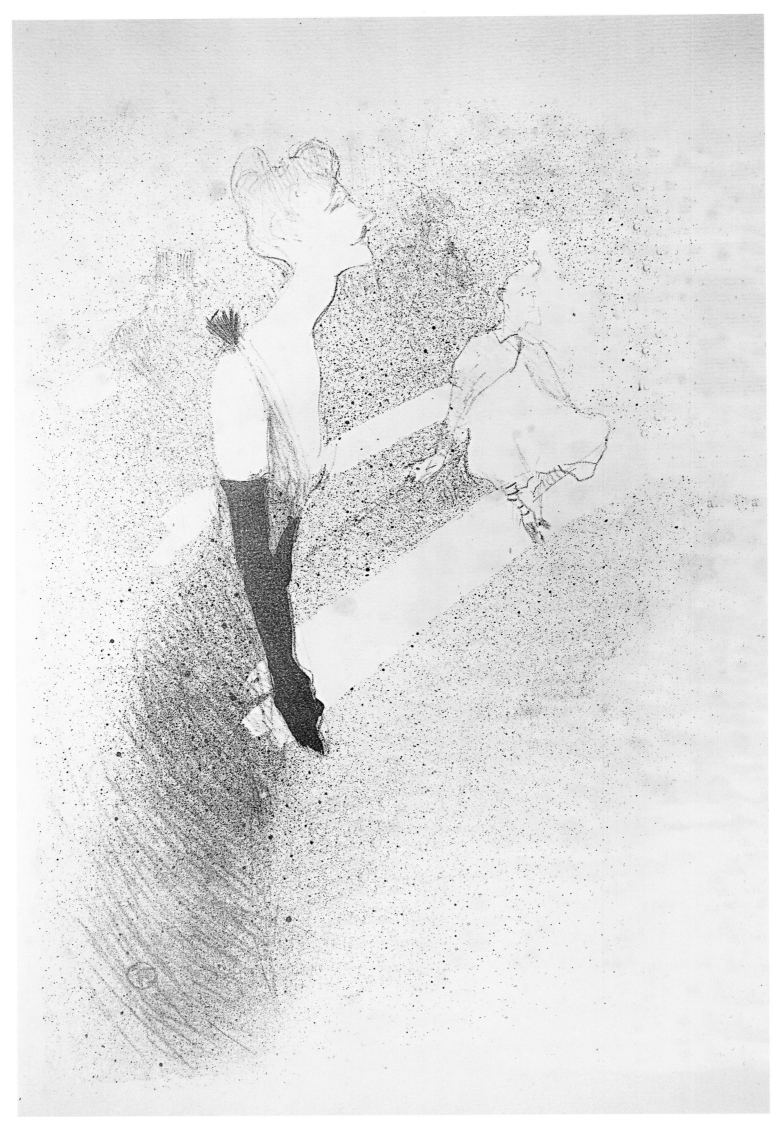

From the album *Yvette Guilbert*

1894, lithograph, 31.7 x 21.5 cm (left)
1894, lithograph, 27 x 18.1 cm (right)

Del álbum *Yvette Guilbert*

1894, litografía, 31,7 x 21,5 cm (izquierda)
1894, litografía, 27 x 18,1 cm (derecha)

De l'album *Yvette Guilbert*

1894, lithographie, 31,7 x 21,5 cm (à gauche)
1894, lithographie, 27 x 18,1 cm (à droite)

Aus dem Album *Yvette Guilbert*

1894, Lithografie, 31,7 x 21,5 cm (links)
1894, Lithografie, 27 x 18,1 cm (rechts)

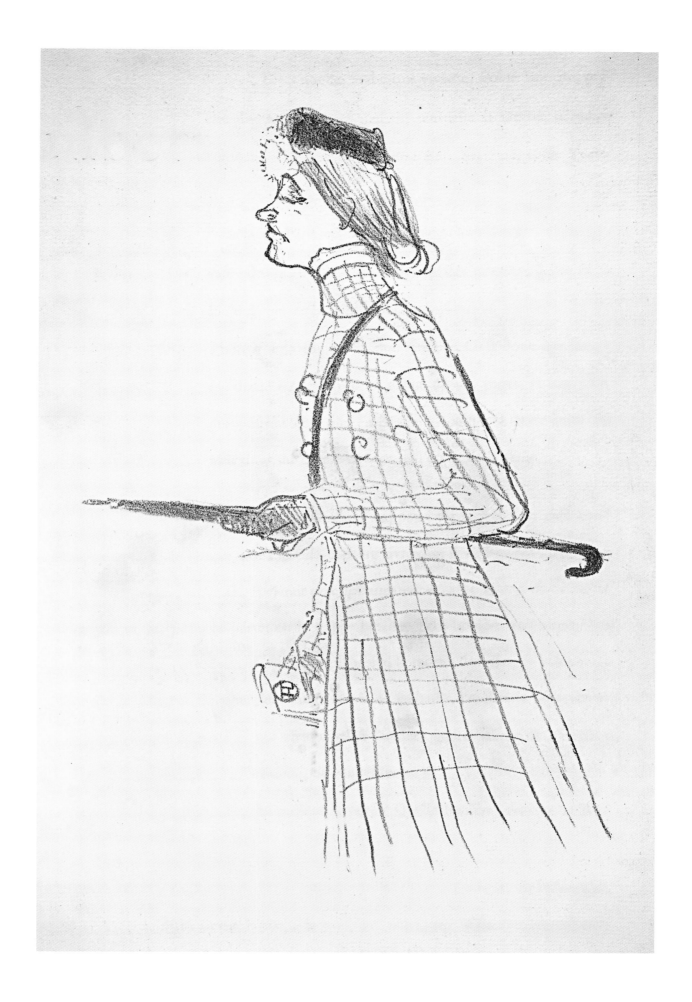

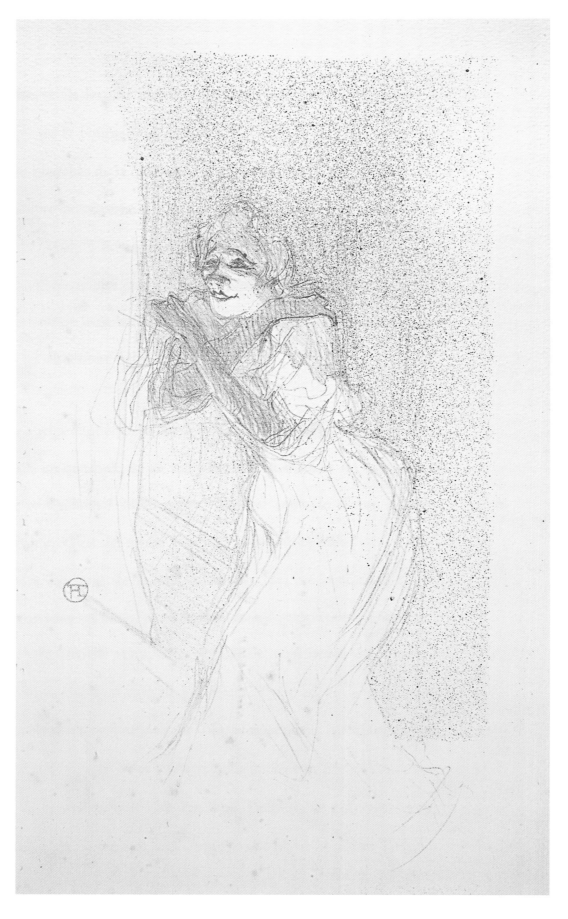

From the album *Yvette Guilbert*

1894, lithograph, 30.7 x 14.2 cm (left)
1894, lithograph, 32.8 x 18.8 cm (right)

Del álbum *Yvette Guilbert*

1894, litografía, 30,7 x 14,2 cm (izquierda)
1894, litografía, 32,8 x 18,8 cm (derecha)

De l'album *Yvette Guilbert*

1894, lithographie, 30,7 x 14,2 cm (à gauche)
1894, lithographie, 32,8 x 18,8 cm (à droite)

Aus dem Album *Yvette Guilbert*

1894, Lithografie, 30,7 x 14,2 cm (links)
1894, Lithografie, 32,8 x 18,8 cm (rechts)

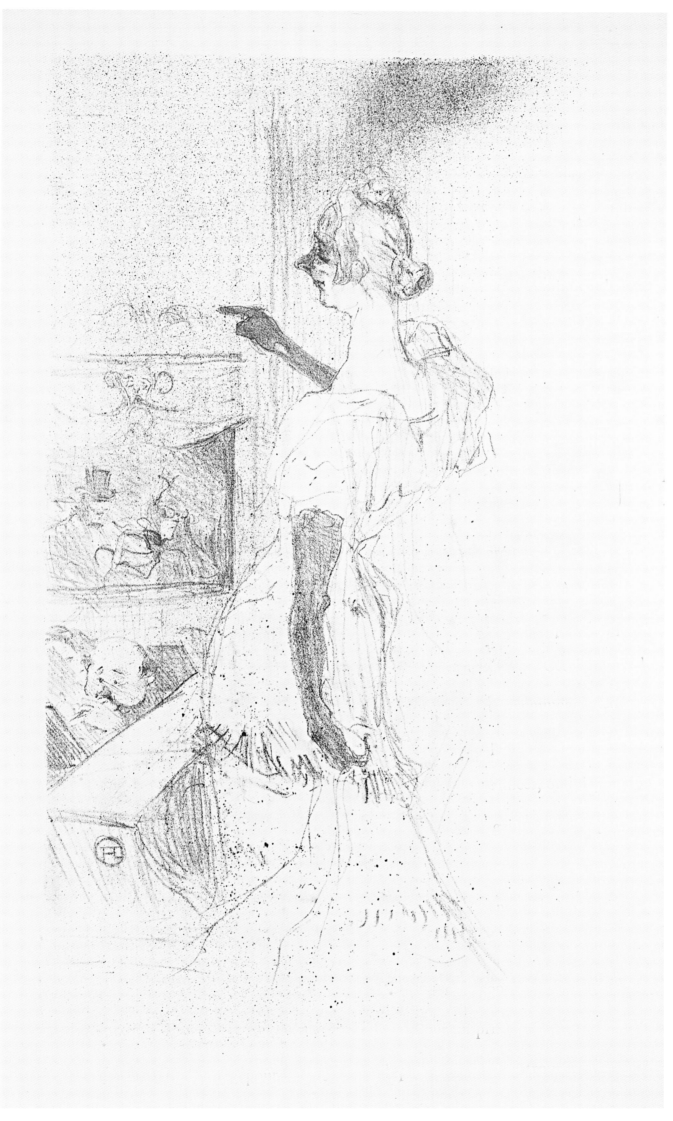

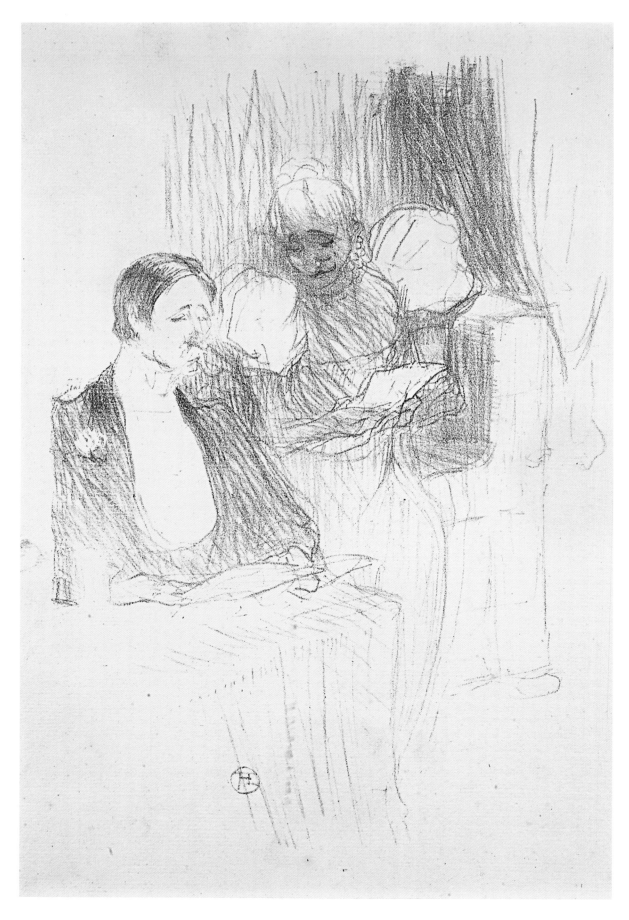

From the album *Yvette Guilbert*

1894, lithograph, 30.3 x 20.7 cm (left)
1894, lithograph, 28.2 x 11.8 cm (right)

Del álbum *Yvette Guilbert*

1894, litografía, 30,3 x 20,7 cm (izquierda)
1894, litografía, 28,2 x 11,8 cm (derecha)

De l'album *Yvette Guilbert*

1894, lithographie, 30,3 x 20,7 cm (à gauche)
1894, lithographie, 28,2 x 11,8 cm (à droite)

Aus dem Album *Yvette Guilbert*

1894, Lithografie, 30,3 x 20,7 cm (links)
1894, Lithografie, 28,2 x 11,8 cm (rechts)

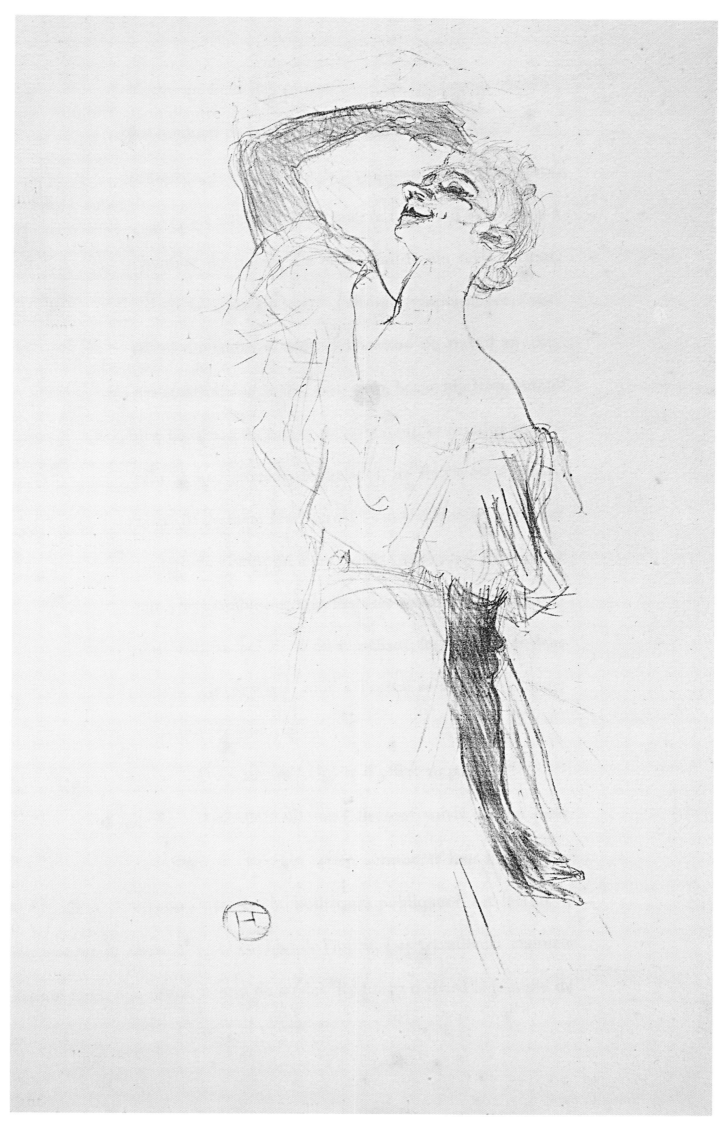

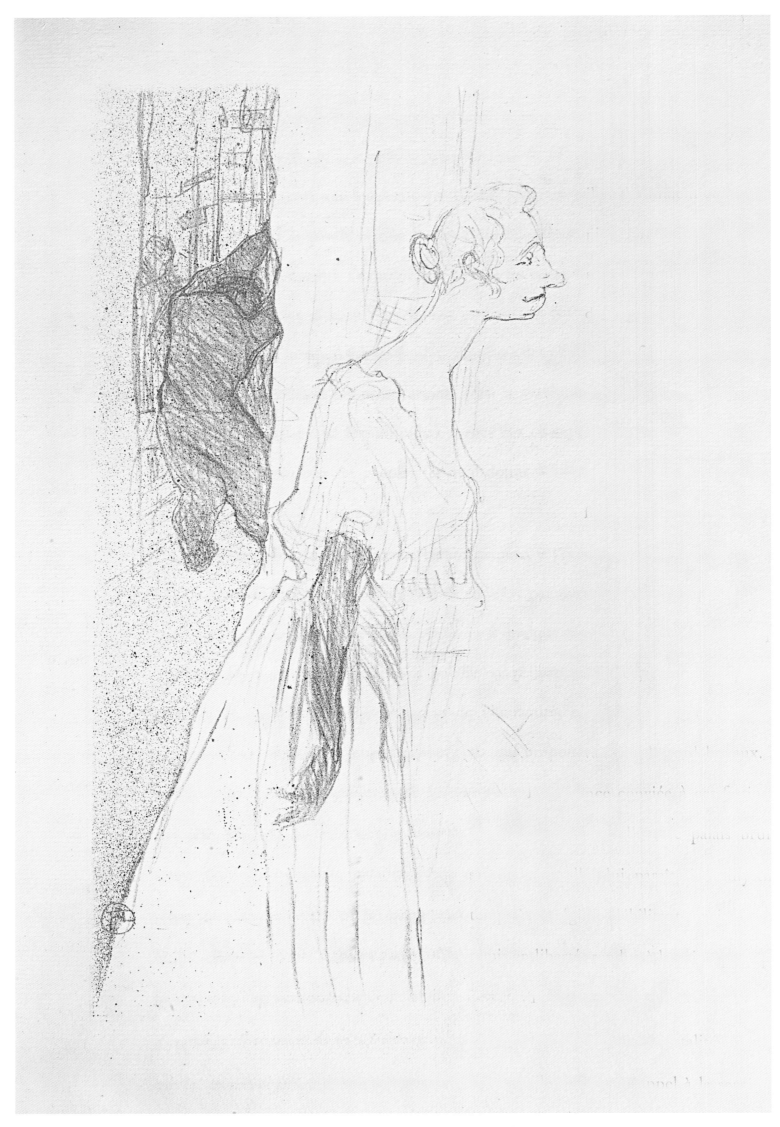

From the album *Yvette Guilbert*

1894, lithograph, 30 x 15 cm (left)
1894, lithograph, 25.5 x 20 cm (right)

Del álbum *Yvette Guilbert*

1894, litografía, 30 x 15 cm (izquierda)
1894, litografía, 25,5 x 20 cm (derecha)

De l'album *Yvette Guilbert*

1894, lithographie, 30 x 15 cm (à gauche)
1894, lithographie, 25,5 x 20 cm (à droite)

Aus dem Album *Yvette Guilbert*

1894, Lithografie, 30 x 15 cm (links)
1894, Lithografie, 25,5 x 20 cm (rechts)

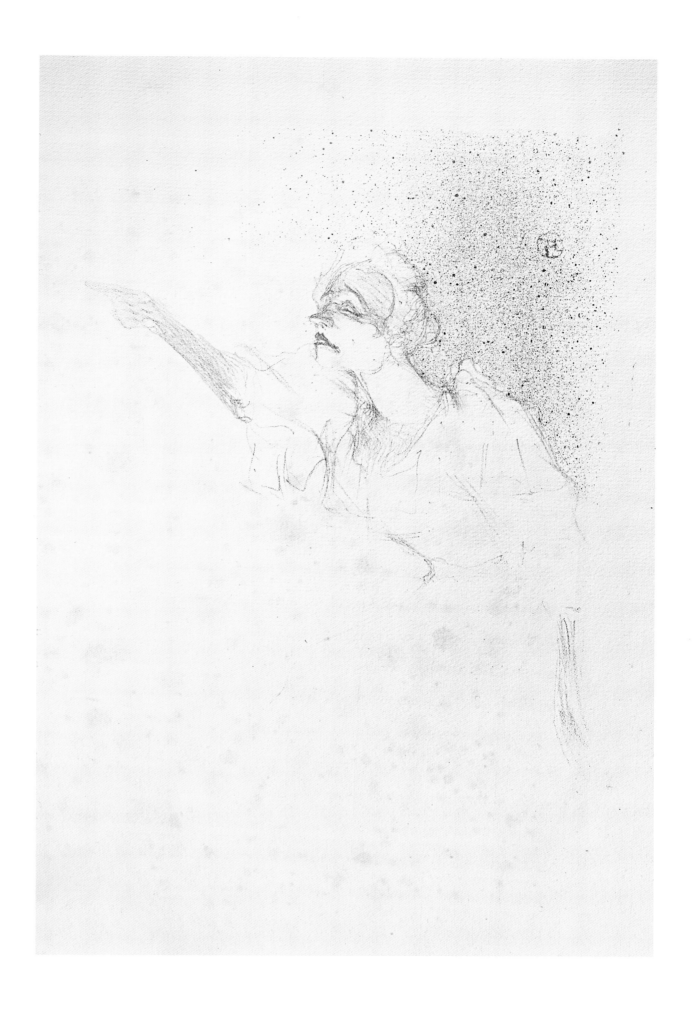

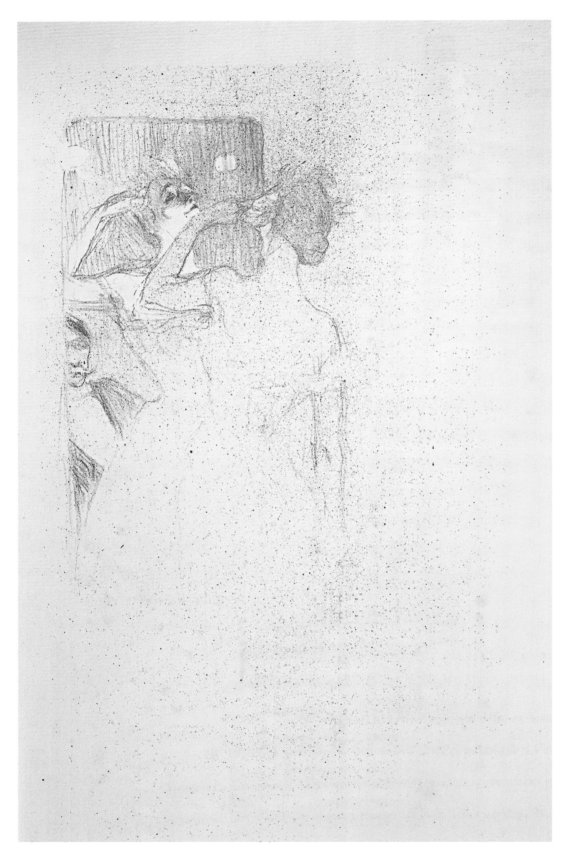

From the album *Yvette Guilbert*

1894, lithograph, 33 x 19 cm (left)
1894, lithograph, 31.5 x 22 cm (right)

Del álbum *Yvette Guilbert*

1894, litografía, 33 x 19 cm (izquierda)
1894, litografía, 31,5 x 22 cm (derecha)

De l'album *Yvette Guilbert*

1894, lithographie, 33 x 19 cm (à gauche)
1894, lithographie, 31,5 x 22 cm (à droite)

Aus dem Album *Yvette Guilbert*

1894, Lithografie, 33 x 19 cm (links)
1894, Lithografie, 31,5 x 22 cm (rechts)

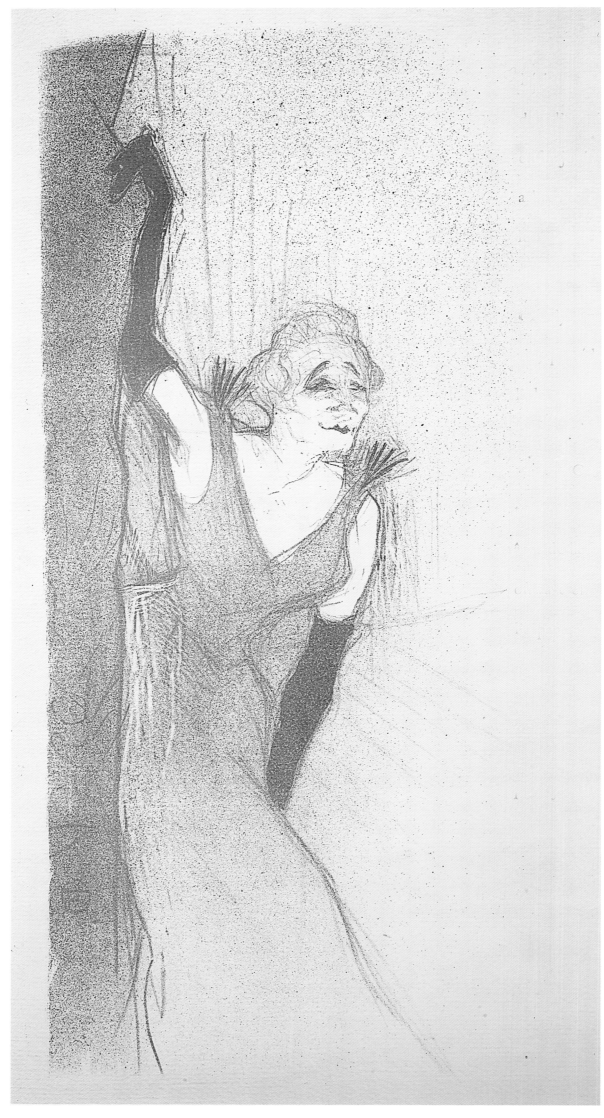

From the album *Yvette Guilbert*

1894, lithograph, 34.1 x 15.5 cm (left)
1894, lithograph, 31.5 x 18.2 cm (right)

Del álbum *Yvette Guilbert*

1894, litografía, 34,1 x 15,5 cm (izquierda)
1894, litografía, 31,5 x 18,2 cm (derecha)

De l'album *Yvette Guilbert*

1894, lithographie, 34,1 x 15,5 cm (à gauche)
1894, lithographie, 31,5 x 18,2 cm (à droite)

Aus dem Album *Yvette Guilbert*

1894, Lithografie, 34,1 x 15,5 cm (links)
1894, Lithografie, 31,5 x 18,2 cm (rechts)

From the album *Yvette Guilbert*

1894, lithograph, 30.4 x 13.9 cm (left)
1894, lithograph, 24.8 x 9 cm (right)

Del álbum *Yvette Guilbert*

1894, litografía, 30,4 x 13,9 cm (izquierda)
1894, litografía, 24,8 x 9 cm (derecha)

De l'album *Yvette Guilbert*

1894, lithographie, 30,4 x 13,9 cm (à gauche)
1894, lithographie, 24,8 x 9 cm (à droite)

Aus dem Album *Yvette Guilbert*

1894, Lithografie, 30,4 x 13,9 cm (links)
1894, Lithografie, 24,8 x 9 cm (rechts)

La Vache Enragée

1896, colour lithograph, 79 x 57.5 cm

La Vache Enragée was an enormously successful monthly illustrated satirical magazine, founded by the artist Adolphe Willette. The name was taken from a novel about a struggling artist in Montmartre. The phrase 'la vache enragée' ('enraged cow') was an idiomatic expression for the hardship and struggles of young artists. The bespectacled old man, yellow-faced with fear, being chased by a cow down the hill out of Montmartre, represents the academic establishment.

La Vache Enragée

1896, litografía en color, 79 x 57,5 cm

La Vache Enragée fue una revista satírica, ilustrada, de tirada mensual y gran éxito, fundada por el artista Adolphe Willette. El nombre fue sacado de una novela sobre un artista en apuros en Montmartre. La locución *la vache enragée* ('la vaca enfurecida') hacía referencia a las dificultades de los jóvenes artistas. El anciano con gafas y la cara amarilla de miedo, al que persigue una vaca colina abajo fuera de Montmartre, representa el estamento académico.

La Vache Enragée

1896, lithographie en couleur, 79 x 57,5 cm

Fondé par l'artiste Adolphe Willette, *La Vache Enragée* était un mensuel satirique illustré qui connaissait un énorme succès. Il devait son nom à une nouvelle évoquant les difficultés d'un artiste pour survivre – il mangeait donc de la vache enragée. Le vieillard à lunettes, la face jaune de peur et poursuivi par une vache jusqu'au pied de la butte Montmartre, représente l'Académie.

La Vache Enragée

1896, Farblithografie, 79 x 57,5 cm

La Vache Enragée war eine monatlich erscheinende und höchst erfolgreiche Satirezeitschrift, die der Künstler Adolphe Willette gegründet hatte. Ihren Namen verdankt sie einem Roman über einen hungerleidenden Künstler vom Montmartre. Der idiomatische Ausdruck („wütende Kuh") bezieht sich auf die Mühen und Nöte junger Kunstschaffender. Der bebrillte alte Mann, der, das Gesicht gelb vor Angst, von einer Kuh vom Montmartre-Hügel vertrieben wird, steht hier für das Kunstestablishment.

The Old Man

c. 1893, pencil on paper, 17 x 11.3 cm

A considerable number of Toulouse-Lautrec's drawings and small sketches are erotic drawings; they are often humorous and have all the characteristics of caricatures.

El viejo

c 1893, lápiz sobre papel, 17 x 11,3 cm

Una considerable cantidad de dibujos de Toulouse-Lautrec y pequeños bocetos son eróticos; a menudo son cómicos y todos tienen características de caricaturas.

Le Vieillard

vers 1893, mine de plomb sur papier, 17 x 11,3 cm

Un grand nombre de dessins et petits croquis réalisés par Toulouse-Lautrec sont érotiques. Souvent pleins d'humour, ils présentent toutes les caractéristiques de la caricature.

Der Greis

um 1893, Bleistift auf Papier, 17 x 11,3 cm

Ein Gutteil von Toulouse-Lautrecs Zeichnungen und Skizzen ist erotischer Natur; sie sind häufig humorvoll und weisen alle Merkmale von Karikaturen auf.

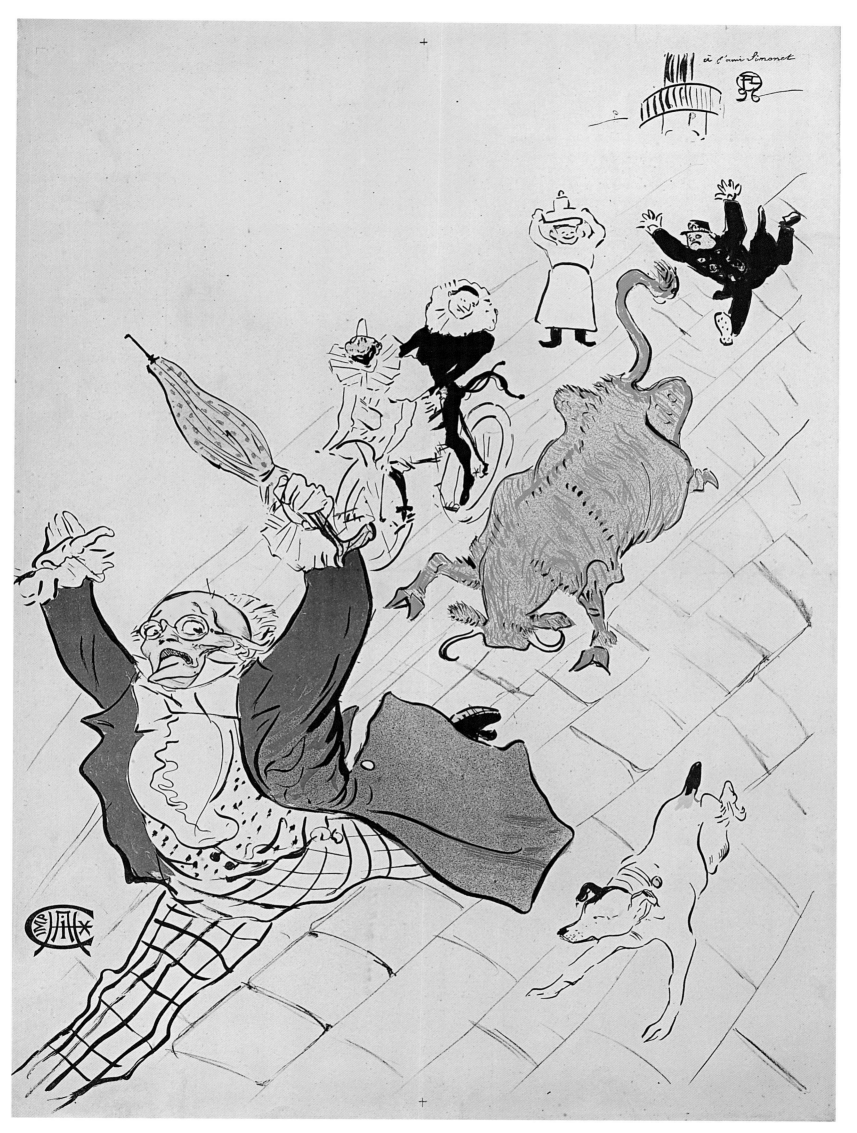

Portrait of Count
Alphonse de Toulouse-Lautrec

c. 1888, pencil on paper, 8.5 x 9.3 cm

Retrato del conde
Alphonse de Toulouse-Lautrec

c 1888, lápiz sobre papel, 8,5 x 9,3 cm

Portrait du Comte
Alphonse de Toulouse-Lautrec

vers 1888, mine de plomb sur papier, 8,5 x 9,3 cm

Bildnis Graf
Alphonse de Toulouse-Lautrec

um 1888, Bleistift auf Papier, 8,5 x 9,3 cm

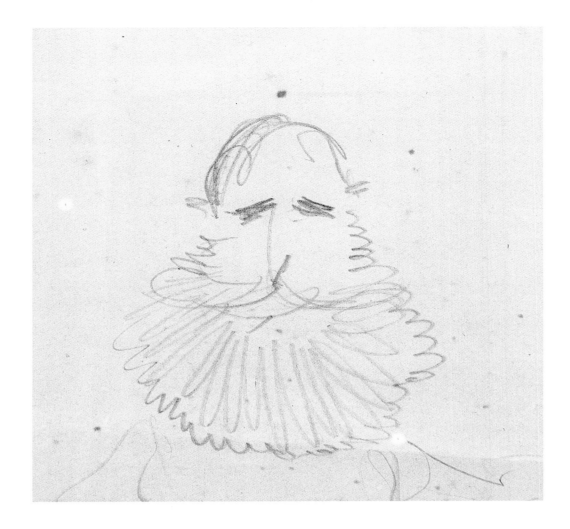

Caricature of a Gentleman
in Arcachon

1896, pencil on paper, 12.3 x 10.5 cm

Caricatura de un caballero
en Arcachon

1896, lápiz sobre papel, 12,3 x 10,5 cm

Charge d'un Monsieur
à Arcachon

1896, mine de plomb sur papier, 12,3 x 10,5 cm

Karikatur eines Herrn
in Arcachon

1896, Bleistift auf Papier, 12,3 x 10,5 cm

Monsieur X.

1896, pencil on paper, 24 x 17.3 cm

Monsieur X.

1896, lápiz sobre papel, 24 x 17,3 cm

Monsieur X.

1896, mine de plomb sur papier, 24 x 17,3 cm

Monsieur X.

1896, Bleistift auf Papier, 24 x 17,3 cm

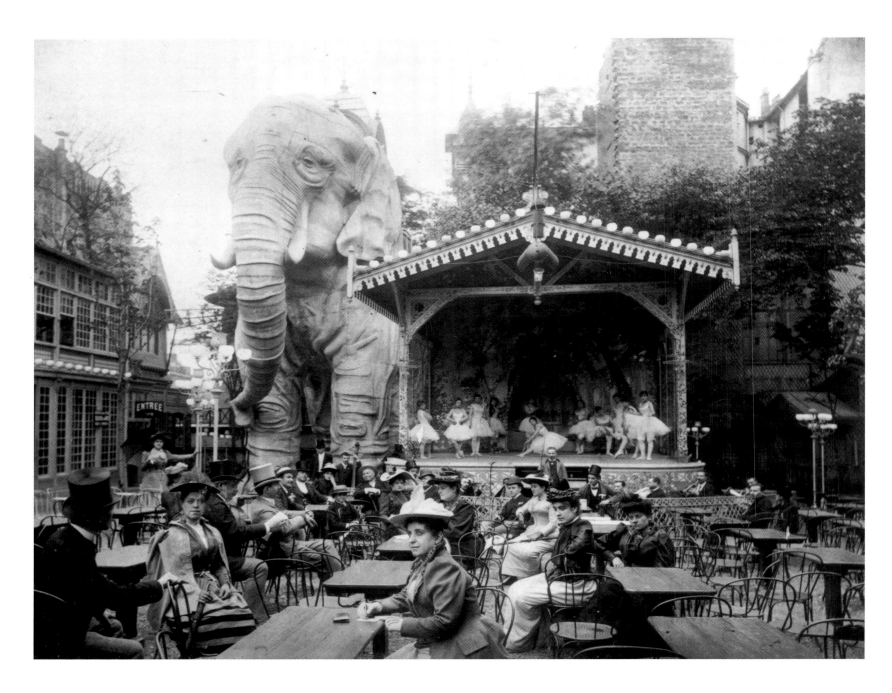

The Elephant at the Moulin Rouge

c. 1900

The Moulin Rouge not only had a windmill on its roof as a landmark, but also a gigantic stucco elephant at the back of the building which was invisible from the street. Men could ascend a spiral staircase inside one of the elephant's legs. When the hollow belly of the beast was reached, a dancer was waiting to provide entertainment. Women were denied permission to climb into the creature.

El elefante del Moulin Rouge

c 1900

El Moulin Rouge tenía no solo un molino de viento sobre su azotea como punto de referencia, sino también un elefante de estuco gigantesco detrás del edificio que no se veía desde la calle. Los hombres podían ascender por una escalera de caracol situada dentro de una de las patas del animal. Una bailarina los esperaba en el vientre hueco de la bestia para entretenerlos. A las mujeres se les negaba la entrada a la criatura.

L'Eléphant du Moulin Rouge

vers 1900

L'établissement n'avait pas seulement un moulin aux ailes rouges sur son toit mais aussi, à l'arrière, un colossal éléphant de stuc invisible de la rue. Des hommes pouvaient monter l'escalier en colimaçon dissimulé dans l'une des jambes de l'éléphant et atteindre le ventre creux du colosse où une danseuse attendait les clients. Les femmes n'avaient pas le droit d'entrer.

Der Elefant des Moulin Rouge

um 1900

Neben der Windmühle auf dem Dach besaß das Moulin Rouge als Wahrzeichen auch einen riesigen Gipselefanten, der an der Gebäuderückseite stand und von der Straße nicht zu sehen war. Über eine Wendeltreppe in einem seiner Beine war er sogar begehbar, und in dem hohlen Bauch wartete dann schon eine Unterhaltungstänzerin. Frauen war der Zutritt verwehrt.

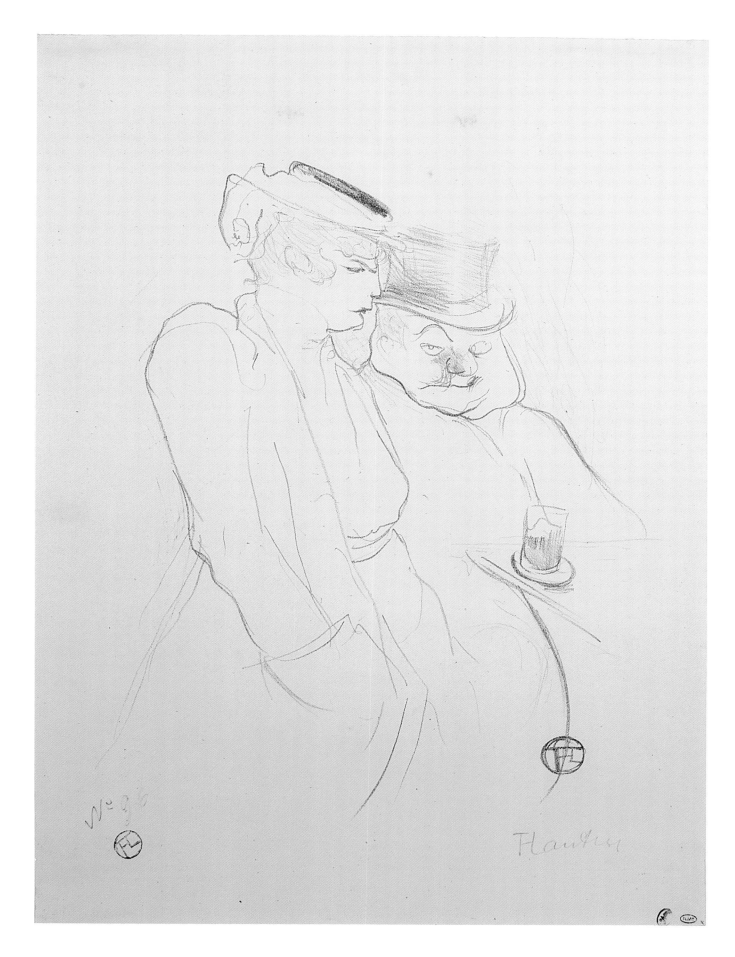

In their Forties

1893, lithograph, 28.5 x 23.5 cm

This lithograph was printed as an illustration for the magazine *L'Escarmouche*. Toulouse-Lautrec concentrates here on the speechless conversation between the pair at the table. The woman lifts up her shoulder and has her hand in her pocket. Her companion lifts his brow at her ominous facial expression and seems to wait for what will follow.

En la cuarentena

1893, litografía, 28,5 x 23,5 cm

Esta litografía fue impresa como ilustración para la revista *L'Escarmouche*. Toulouse-Lautrec se concentra aquí en la conversación sin palabras entre la pareja sentada a la mesa. La mujer levanta su hombro y guarda la mano en el bolsillo. Su compañero levanta la frente en respuesta a la expresión aviesa del rostro de ella y parece estar esperando a lo que venga después.

En Quarante

1893, lithographie, 28,5 x 23,5 cm

Cette lithographie fut publiée dans le magazine *L'Escarmouche*. Toulouse-Lautrec concentre ici son attention sur le dialogue muet entre l'homme et la femme assis à la table. La femme lève l'épaule et enfonce sa main dans sa poche. Son expression alarme son compagnon qui hausse le sourcil et semble attendre ce qui va advenir.

In den Vierzigern

1893, Lithografie, 28,5 x 23,5 cm

Diese Lithografie wurde als Illustration in der Zeitschrift *L'Escarmouche* abgedruckt. Toulouse-Lautrec richtet seinen Blick hier auf die stumme Kommunikation zwischen dem Paar. Die Frau hebt die Schulter und hat eine Hand in die Tasche gesteckt. Angesichts ihrer indignierten Mimik zieht der Begleiter nur abwartend die Augenbraue hoch.

Catulle Mendès

c. 1896, pencil on paper, 25.7 x 16 cm

French poet and man of letters, of Jewish extraction, born in Bordeaux in 1841. He established himself early in Paris, attaining speedy notoriety after the publication of his *Roman d'une nuit* in the *Revue Fantaisiste* (1861), for which he was condemned to a month's imprisonment and a fine of 500 francs. He went on to publish critical and dramatic writings, novels and short stories.

Catulle Mendès

c 1896, lápiz sobre papel, 25,7 x 16 cm

Poeta francés y hombre de letras de origen judío nacido en Burdeos en 1841. Pronto se estableció en París, donde rápidamente logró notoriedad gracias a la publicación de su *Roman d'une nuit* en la *Revue Fantaisiste* (1861), por lo que fue condenado a un mes de cárcel y a pagar una multa de 500 francos. Siguió publicando escritos críticos y dramáticos, novelas e historias cortas.

Catulle Mendès

vers 1896, mine de plomb sur papier, 25,7 x 16 cm

Poète et homme de lettres français d'origine juive, né à Bordeaux en 1841. Il s'établit tôt à Paris, acquérant vite de la notoriété grâce à la publication dans *la Revue Fantaisiste* (1861) de son *Roman d'une nuit* qui lui valut d'être condamné à un mois de prison et à une amende de 500 francs. Il continua de publier des textes critiques et dramatiques, des romans et des nouvelles.

Catulle Mendès

um 1896, Bleistift auf Papier, 25,7 x 16 cm

Französischer Dichter und Literat jüdischer Herkunft, der 1841 in Bordeaux geboren wurde. Er ging früh nach Paris und wurde dort schnell bekannt durch die Veröffentlichung seines *Roman d'une nuit* in der *Revue Fantaisiste* (1861), was ihm einen Monat Haft und eine Geldstrafe von 500 Francs einbrachte. Später veröffentlichte er noch Kritiken, Theaterschriften, Romane und Kurzgeschichten.

Catulle Mendès

c. 1896, pencil on paper, 21.6 x 14.3 cm

Catulle Mendès

c 1896, lápiz sobre papel, 21,6 x 14,3 cm

Catulle Mendès

vers 1896, mine de plomb sur papier, 21,6 x 14,3 cm

Catulle Mendès

um 1896, Bleistift auf Papier, 21,6 x 14,3 cm

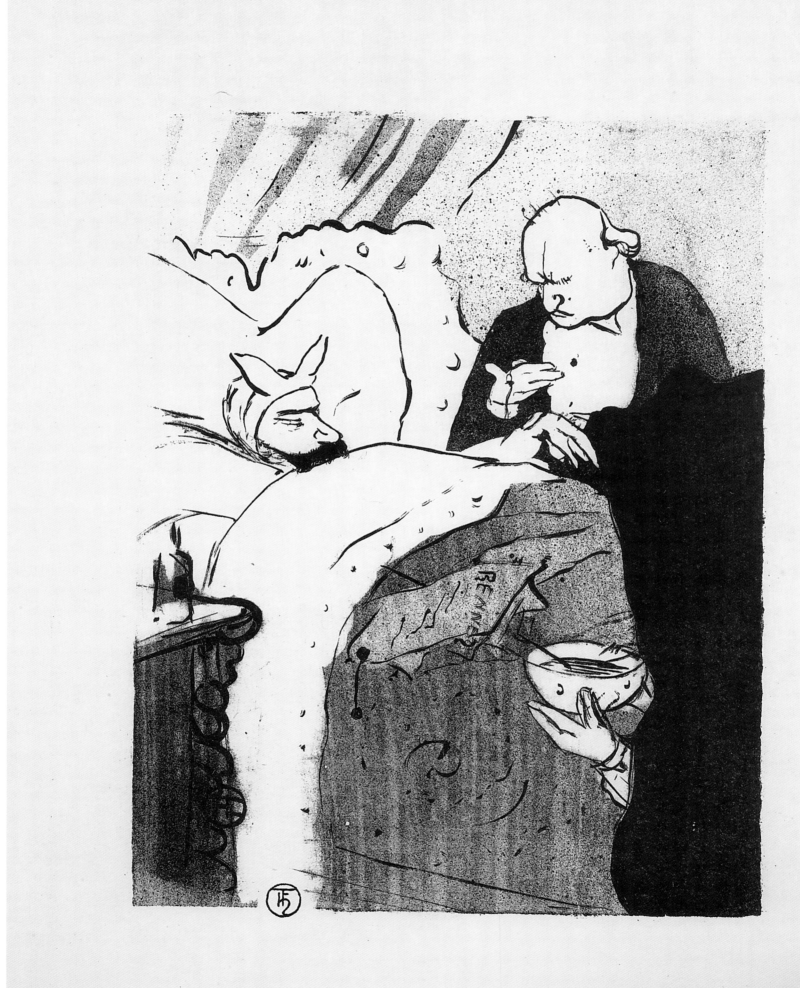

108/200

Carnot is Sick!

1893, lithograph, 24.4 x 18.6 cm

An illustration for a song sheet/monologue by Eugène Lemercier who performed at the cabaret 'Le Chat Noir'. The title is a possible reference to Marie François Sadi Carnot, then President of the French Republic, which was going through a critical political period. Carnot was assassinated the following year.

¡Carnot está enfermo!

1893, litografía, 24,4 x 18,6 cm

Ilustración para la partitura de una canción-monólogo de Eugène Lemercier, que actuaba en el cabaré Le Chat Noir. El título es una posible referencia a Marie François Sadi Carnot, a la sazón presidente de la República francesa, que atravesaba un período político crítico. Carnot fue asesinado al año siguiente.

Carnot Malade !

1893, lithographie, 24,4 x 18,6 cm

Illustration d'une partition de chanson/monologue d'Eugène Lemercier qui se produisait au Chat Noir. Le titre se réfère peut-être à Marie François Sadi Carnot, alors président de la République française qui traversait alors une période politique critique. Sadi Carnot fut assassiné l'année suivante.

Carnot krank!

1893, Lithografie, 24,4 x 18,6 cm

Illustration für einen Liedmonolog von Eugène Lemercier, der im Cabaret „Le Chat Noir" auftrat. Der Titel bezieht sich vielleicht auf den damaligen Staatspräsidenten Marie François Sadi Carnot. Die Französische Republik erlebte zu jener Zeit eine politische Krise, und Carnot wurde im folgenden Jahr ermordet.

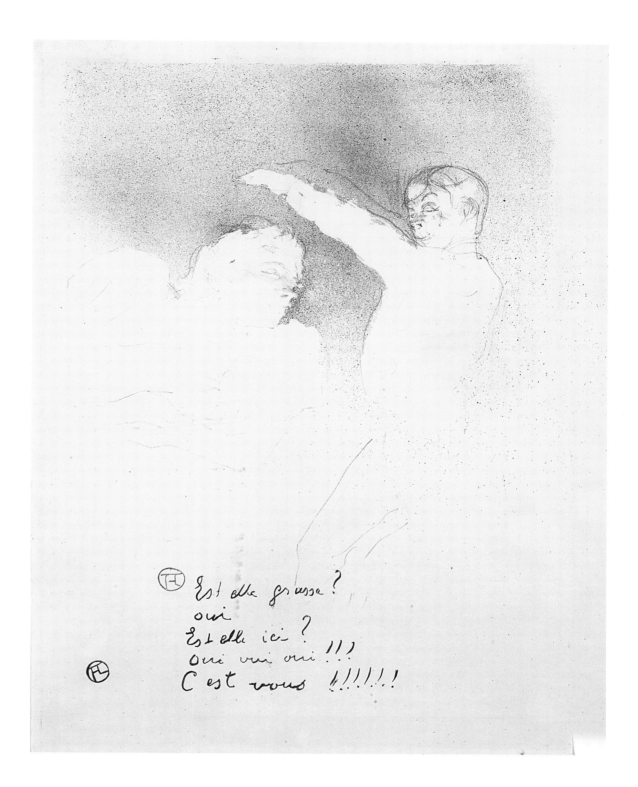

At the Variétés

1893, lithograph, 33.5 x 26.5 cm

"'Is she fat?' 'Yes.' 'Is she here?' 'Yes, Yes, Yes.' 'It's you!'" The meaning of this dialogue is now lost, but to Toulouse-Lautrec it was important enough to make him want to design this lithograph and print an edition of 100. Only a few were signed by the artist.

En el Variétés

1893, litografía, 33,5 x 26,5 cm

«¿Está gorda?» «Sí.» «¿Está aquí?» «Sí, Sí, Sí.» «¡Es usted!» El significado de este diálogo se ha perdido, pero para Toulouse-Lautrec fue lo bastante importante como para hacerle querer diseñar esta litografía e imprimir una edición de cien. Solo unas pocas fueron firmadas por el artista.

Aux Variétés

1893, lithographie, 33,5 x 26,5 cm

« 'Est-elle grosse ?' – 'Oui'. 'Est-elle ici ?' – 'Oui, oui, oui.' – 'C'est vous !!!' » La signification de ce dialogue est perdue aujourd'hui mais Toulouse-Lautrec lui accorda assez d'importance pour avoir envie de dessiner cette lithographie et de la faire imprimer en 100 exemplaires. L'artiste n'en a signé que quelques-uns.

Im Variétés

1893, Lithografie, 33,5 x 26,5 cm

„Ist sie dick?" „Ja." „Ist sie hier?" „Ja, ja, ja." „Sie sind es!" Was dieser Dialog genau zu bedeuten hat, wissen wir nicht mehr, doch er regte Toulouse-Lautrec zu dieser Lithografie an, die in einer Auflage von 100 Exemplaren erschien. Nur wenige hat der Künstler signiert.

Head of a Prostitute

c. 1894, blue crayon on paper,
13.7 x 11.1 cm

Cabeza de una prostituta

c 1894, lápiz azul sobre papel,
13,7 x 11,1 cm

Tête de Femme de Maison

vers 1894, crayon bleu sur papier,
13,7 x 11,1 cm

Kopf einer Prostitutierten

um 1894, blauer Stift auf Papier,
13,7 x 11,1 cm

Head of a Woman

1894, pencil on paper,
10.5 x 10 cm

Cabeza de mujer

1894, lápiz sobre papel,
10,5 x 10 cm

Tête de Femme

1894, mine de plomb sur papier,
10,5 x 10 cm

Frauenkopf

1894, Bleistift auf Papier,
10,5 x 10 cm

Eldorado: Aristide Bruant in his Cabaret

1892, colour lithograph, 138 x 96 cm

The singer and songwriter Aristide Bruant (1851 – 1925) was the quintessential Montmartre artist. In 1881 Bruant became a regular performer at 'Le Chat Noir'. When it moved, he took over the old establishment and renamed it 'Le Mirliton'. His popularity was such that he was also invited to perform at more upscale venues, such as the 'Eldorado' and 'Les Ambassadeurs' on the Champs-Elysées. He wanted to make an impact and turned to Toulouse-Lautrec to help him promote his show. He eventually commissioned a total of four posters from Toulouse-Lautrec. His image became immediately recognizable to all of Paris.

Eldorado: Aristide Bruant en su cabaré

1892, litografía en color, 138 x 96 cm

El cantante y compositor de canciones Aristide Bruant (1851-1925) era la quintaesencia del artista de Montmartre. En 1881 se convirtió en un intérprete habitual en Le Chat Noir. Cuando el cabaré cambió de ubicación, se hizo cargo del viejo establecimiento y le cambió el nombre a Le Mirliton. Su popularidad era tal que le invitaron también a actuar en lugares más *chic*, como Eldorado y Les Ambassadeurs, en los Campos Elíseos. Buscó tener un mayor impacto y pidió a Toulouse-Lautrec que le ayudase a promover su espectáculo. Le encargó un total de cuatro carteles. Su imagen se volvió reconocible en todo París de inmediato.

Eldorado : Aristide Bruant dans son Cabaret

1892, lithographie en couleur, 138 x 96 cm

Aristide Bruant (1851 – 1925), chanteur et chansonnier, incarnait la quintessence de l'esprit montmartrois. Il se produisit régulièrement au Chat Noir en 1881. Quand le propriétaire partit s'installer ailleurs, il racheta le cabaret qu'il rebaptisa Le Mirliton. Sa popularité était telle qu'il fut aussi invité à se produire dans des lieux plus chics comme l'Eldorado ou Les Ambassadeurs sur les Champs-Elysées. Désirant accroître sa popularité, il demanda à Toulouse-Lautrec de l'aider à promouvoir son spectacle et lui commanda finalement quatre affiches. Il fut immédiatement reconnaissable dans tout Paris.

Eldorado: Aristide Bruant in seinem Cabaret

1892, Farblithografie, 138 x 96 cm

Der Sänger und Lieddichter Aristide Bruant (1851 – 1925) war Inbegriff für den Montmartre-Künstler. 1881 trat er regelmäßig im „Chat Noir" auf, und als dieses umzog, eröffnete er in den alten Räumlichkeiten das „Mirliton". So groß war Bruants Popularität, dass er ebenfalls zu Auftritten in vornehmeren Lokalen wie dem „Eldorado" und dem „Ambassadeurs" auf den Champs-Elysées eingeladen wurde. Um seiner Vorführung größtmögliche Wirkung zu verschaffen, bat er Toulouse-Lautrec um Hilfe und bestellte bei ihm insgesamt vier Plakate für Werbezwecke. Sie machten ihn sofort in ganz Paris bekannt.

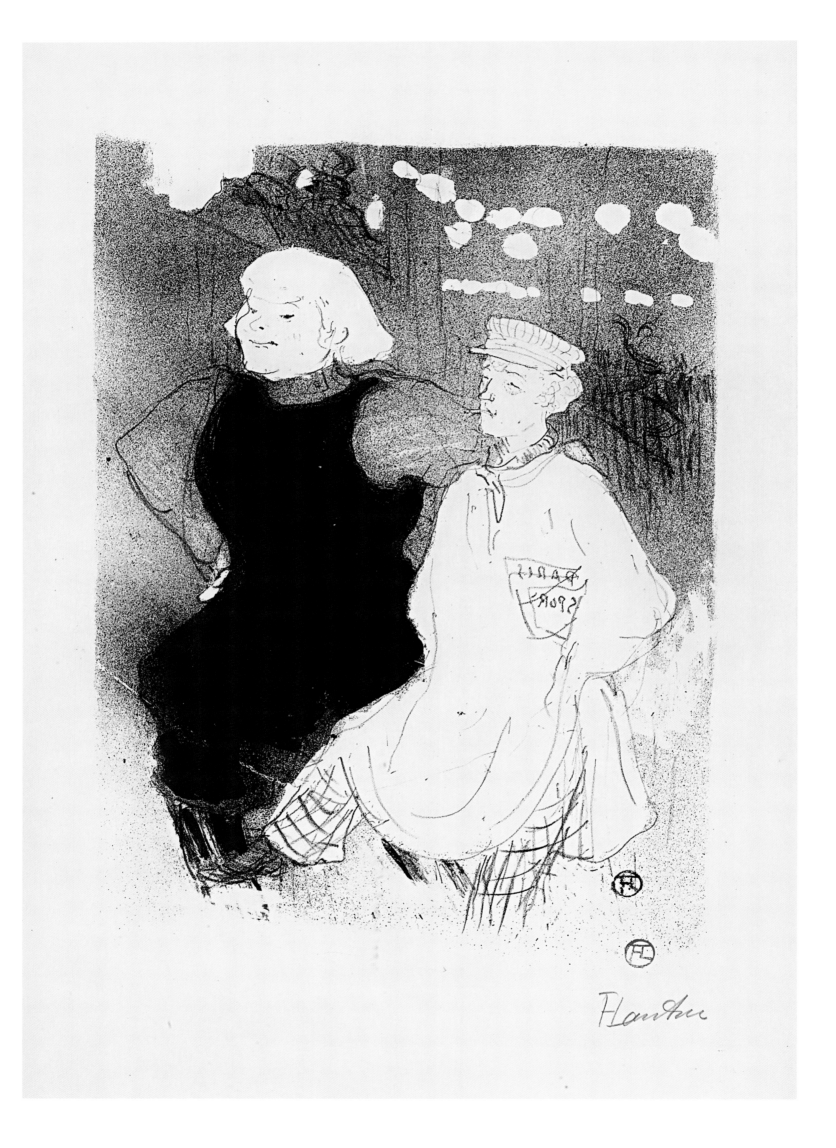

The Franco-Russian Alliance

1894, lithograph, 33.5 x 25 cm

On December 27, 1893, the Franco-Russian Alliance treaty was ratified. This alliance was necessary to contain Germany's ambitious role in Europe. Major celebrations ensued in Paris, where this alliance was seen as a deterrent for future conflicts with Germany.

La Alianza franco-rusa

1894, litografía, 33,5 x 25 cm

El 27 de diciembre de 1893 se ratificó el tratado de la Alianza franco-rusa. Esta alianza era necesaria para contener los ambiciosos planes de Alemania en Europa. Las mayores celebraciones tuvieron lugar en París, donde tal alianza se veía como una fuerza disuasoria para futuros conflictos con Alemania.

L'Union Franco-Russe

1894, lithographie, 33,5 x 25 cm

L'alliance franco-russe fut ratifiée le 27 décembre 1893. Elle était nécessaire pour contenir les ambitions de l'Allemagne en Europe. De grandes célébrations eurent lieu à Paris où l'on pensait que l'alliance permettrait d'éviter de futurs conflits avec l'Allemagne.

Die Französisch-Russische Allianz

1894, Lithografie, 33,5 x 25 cm

Am 27. Dezember 1893 wurde der Französisch-Russische Allianzvertrag unterzeichnet. Er sollte die ehrgeizigen deutschen Pläne in Europa eindämmen und wurde in Paris groß gefeiert, wo man sich eine Abschreckungswirkung für künftige Konflikte mit Deutschland erhoffte.

Two Heads of Men,
One Smoking a Pipe

1896, pencil on paper, 19.3 x 12.3 cm

Dos cabezas de hombre,
uno fumando en pipa

1896, lápiz sobre papel, 19,3 x 12,3 cm

Deux Têtes d'Hommes
dont l'un Fume la Pipe

1896, mine de plomb sur papier, 19,3 x 12,3 cm

Zwei Männerköpfe,
darunter ein Pfeifenraucher

1896, Bleistift auf Papier, 19,3 x 12,3 cm

Head of a Woman
1894, pen and ink on paper, 8.5 x 7.9 cm

Cabeza de mujer
1894, pluma y tinta sobre papel, 8,5 x 7,9 cm

Tête de Femme
1894, plume et encre sur papier, 8,5 x 7,9 cm

Frauenkopf
1894, Feder und Tinte auf Papier, 8,5 x 7,9 cm

Two Profiles of Men,
One of Monsieur Gallais
c. 1892, pen and ink on paper, 16.5 x 12.5 cm

Dos perfiles de hombre,
uno de ellos el de monsieur Gallais
c 1892, pluma y tinta sobre papel, 16,5 x 12,5 cm

Deux Profils d'Homme
dont Monsieur Gallais
vers 1892, plume et encre sur papier, 16,5 x 12,5 cm

Zwei Männer im Profil,
darunter Monsieur Gallais
um 1892, Feder und Tinte auf Papier, 16,5 x 12,5 cm

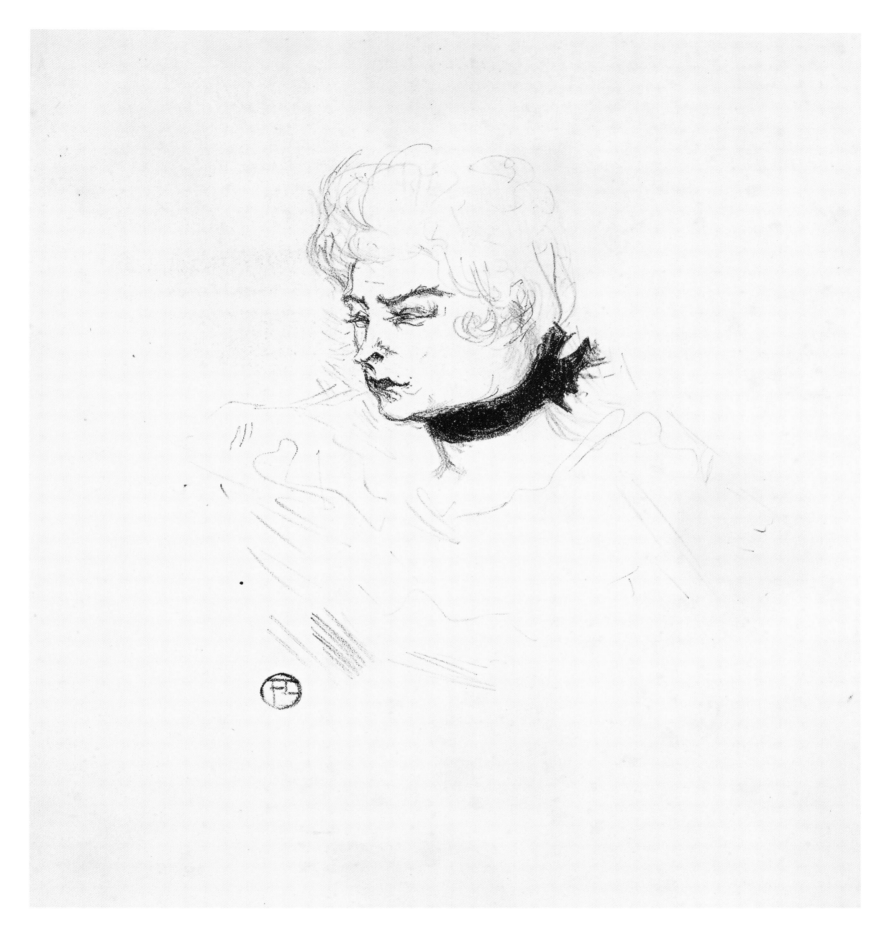

Mademoiselle Pois Vert

1895, lithograph, 18.5 x 19.6 cm

This lithograph is rare because there were only 25 impressions of this edition. Not much is known about the subject of this study except that it is believed she was a model or errand girl for a milliner. Most likely Toulouse-Lautrec merely saw her in a shop or in the street and was captivated by her combination of elegance, style and pert humour.

Mademoiselle Pois Vert

1895, litografía, 18,5 x 19,6 cm

Esta litografía es singular porque solo se realizaron veinticinco impresiones de esta edición. No se sabe mucho sobre el tema de estudio, pero se cree que era una modelo o la chica de los recados de un sombrerero. Lo más probable es que Toulouse-Lautrec simplemente la viera en una tienda o en la calle y quedase cautivado por su combinación de elegancia, estilo y descaro.

Mademoiselle Pois Vert

1895, lithographie, 18,5 x 19,6 cm

Une lithographie rare, vu qu'elle n'a été tirée qu'à vingt-cinq épreuves. On ne sait pas grand chose de la jeune femme représentée sinon qu'elle travaillait sans doute chez une modiste, servant de modèle ou de fille de courses. Toulouse-Lautrec l'a probablement aperçue dans une boutique ou dans la rue et a été fasciné par son élégance, sa classe et son humour coquin.

Mademoiselle Pois Vert

1895, Lithografie, 18,5 x 19,6 cm

Von dieser seltenen Studie entstanden nur 25 Abzüge. Über die Porträtierte weiß man nicht viel, außer dass sie vermutlich Modell oder Botin für eine Modistin war. Toulouse-Lautrec hatte sie höchstwahrscheinlich in einem Geschäft oder auf der Straße gesehen und war fasziniert von der ungewöhnlichen Mischung aus Eleganz, Stil und Kessheit.

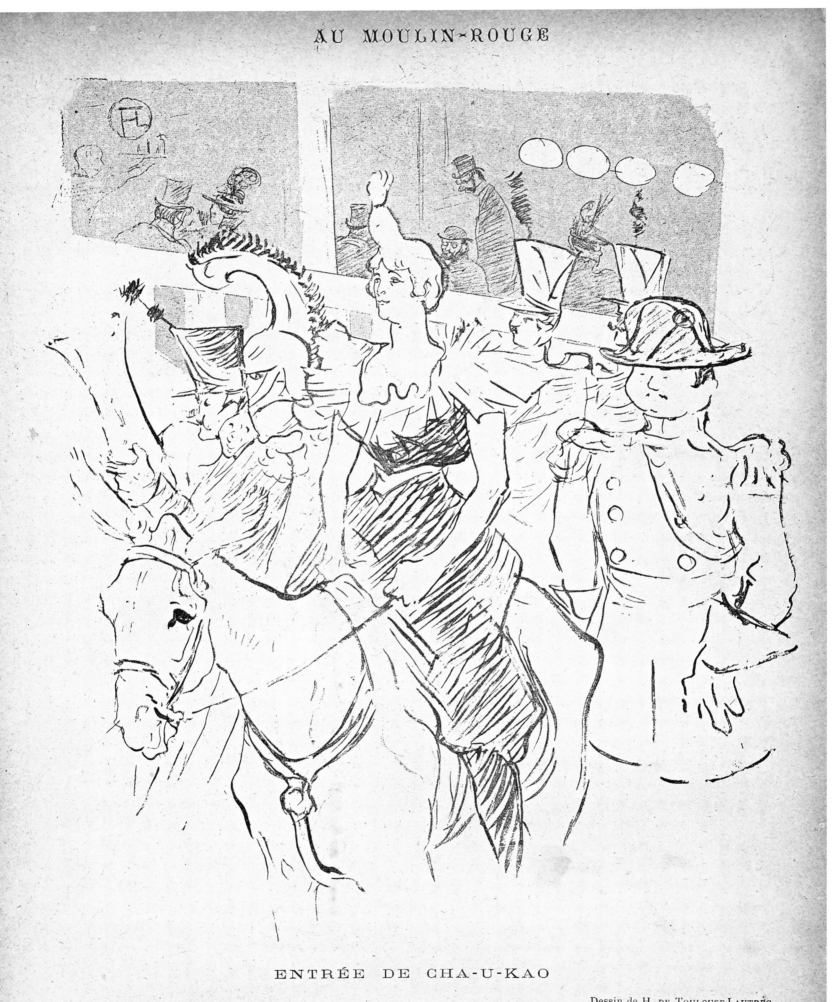

ENTRÉE DE CHA-U-KAO

Dessin de H. DE TOULOUSE-LAUTREC.

The Magazine *Le Rire*

The Magazine *Le Rire*

Le Rire ('Laughter') was a successful humour magazine founded by Félix Juven in October 1894. It appeared as Parisians began to become more educated, and to acquire more disposable income and leisure time. This led to an increase in their interest in the arts, culture and politics. The 'journaux humoristiques', of which *Le Rire* was probably the most successful, were quick to satisfy this renewed interest. Government corruption and military scandals were favourite subjects, as was the gossip surrounding entertainment stars and personalities of the day. Major artists, such as Toulouse-Lautrec, Juan Gris, Théophile Steinlen, Jean-Louis Forain and others, contributed drawings, mostly caricatures, to *Le Rire*, which featured colour etchings on both covers and in the centrefold. *Le Rire* was published until the 1950s, reappearing for a short time in the 1970s.

La revista *Le Rire*

Le Rire fue una exitosa revista de humor fundada por Félix Juven en octubre de 1894. Apareció cuando los parisinos comenzaron a culturizarse y a disponer de más ingresos y de más tiempo para el ocio. Esto trajo consigo un aumento de su interés por las artes, la cultura y la política. Los *journaux humoristiques*, de los cuales *Le Rire* era probablemente el de mayor éxito, satisficieron con rapidez este renovado interés. La corrupción gubernamental y los escándalos militares eran los temas favoritos, al igual que las habladurías sobre los artistas y las personalidades del momento. Grandes artistas, como Toulouse-Lautrec, Juan Gris, Théophile Steinlen y Jean-Louis Forain, entre otros, contribuyeron a *Le Rire* con sus dibujos, sobre todo caricaturas. La revista se caracterizaba por sus aguafuertes en color en las cubiertas y en el desplegable central. Se publicó hasta finales de los años cincuenta y reapareció por un breve periodo de tiempo en la década de 1970.

Le magazine *Le Rire*

Fondé par Félix Juven en octobre 1894, *Le Rire* était un magazine humoristique qui connut un grand succès. Il fit son apparition alors que les Parisiens commençaient à bénéficier d'une meilleure éducation, à avoir plus d'argent et de temps libre, ce qui explique leur intérêt croissant pour l'art, la culture et la politique. Les journaux humoristiques, dont *Le Rire* était probablement le plus apprécié, eurent vite fait de satisfaire cet intérêt renouvelé. La corruption du gouvernement et les scandales dans l'armée faisaient partie des sujets favoris, tout comme les commérages concernant les vedettes du spectacle en vogue. De grands artistes comme Toulouse-Lautrec, Juan Gris, Théophile Steinlen, Jean-Louis Forain et d'autres fournissaient des dessins, surtout des caricatures, au magazine qui les imprimait en couleur sur les deux pages de couverture et les pages centrales. *Le Rire* fut publié jusque durant les années 1950, refaisant une brève apparition au cours des années 1970.

Die Zeitschrift *Le Rire*

Le Rire („Das Lachen") war eine humoristische Illustrierte, die im Oktober 1894 von Félix Juven gegründet wurde. Zu jener Zeit legten die Pariser größeren Wert auf Bildung und verfügten auch über mehr Geld und Freizeit. Dies führte zu einem gesteigerten Interesse an Kunst, Kultur und Politik. Die „humoristischen Zeitschriften", unter denen *Le Rire* wohl die erfolgreichste war, beeilten sich, die neuen Bedürfnisse zu befriedigen. Korruption in der Regierung und Militärskandale gehörten zu den bevorzugten Themen ebenso wie der Klatsch rund um Stars und aktuelle Persönlichkeiten. Künstlergrößen wie Toulouse-Lautrec, Juan Gris, Théophile Steinlen, Jean-Louis Forain und andere lieferten die Zeichnungen für *Le Rire*, meist Karikaturen, darunter farbige Radierungen für Mittelseiten, Vorder- und Rückumschlag. *Le Rire* erschien bis in die 1950er-Jahre und erneut für kurze Zeit in den 1970ern.

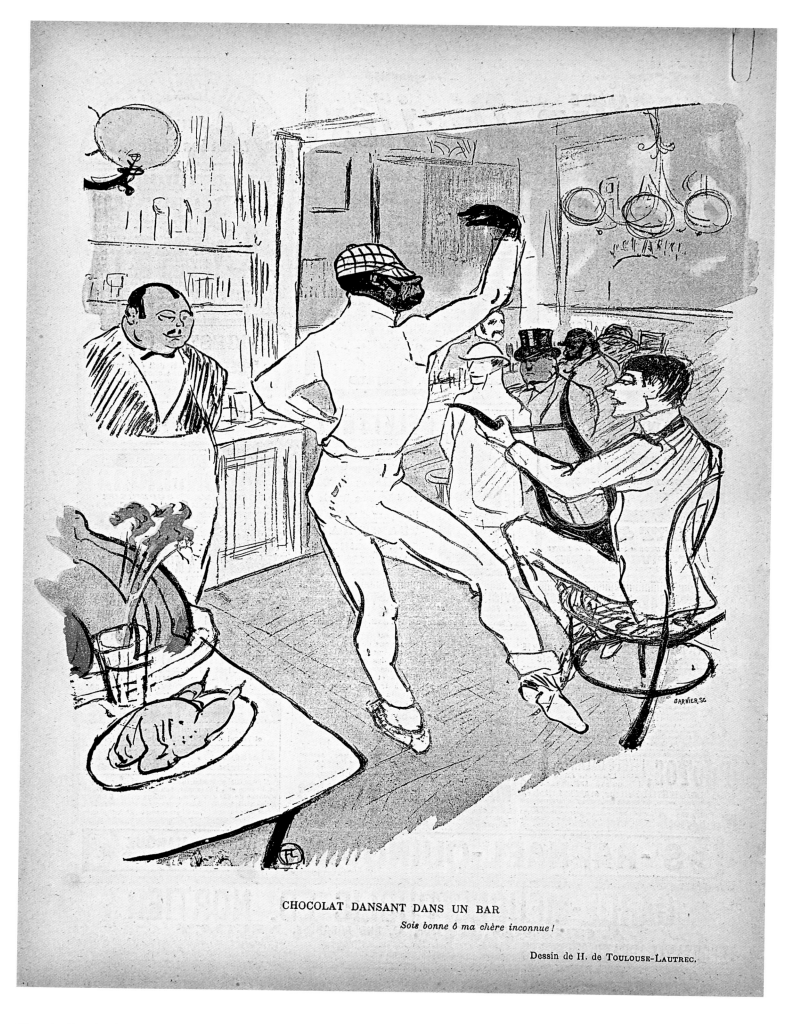

CHOCOLAT DANSANT DANS UN BAR

Sois bonne ô ma chère inconnue !

Dessin de H. de TOULOUSE-LAUTREC.

Chocolat Dancing in a Bar
1896, colour lithograph, 24 x 21.4 cm

Chocolat bailando en un bar
1896, litografía en color, 24 x 21,4 cm

Chocolat Dansant dans un Bar
1896, lithographie en couleur, 24 x 21,4 cm

Chocolat tanzt in einer Bar
1896, Farblithografie, 24 x 21,4 cm

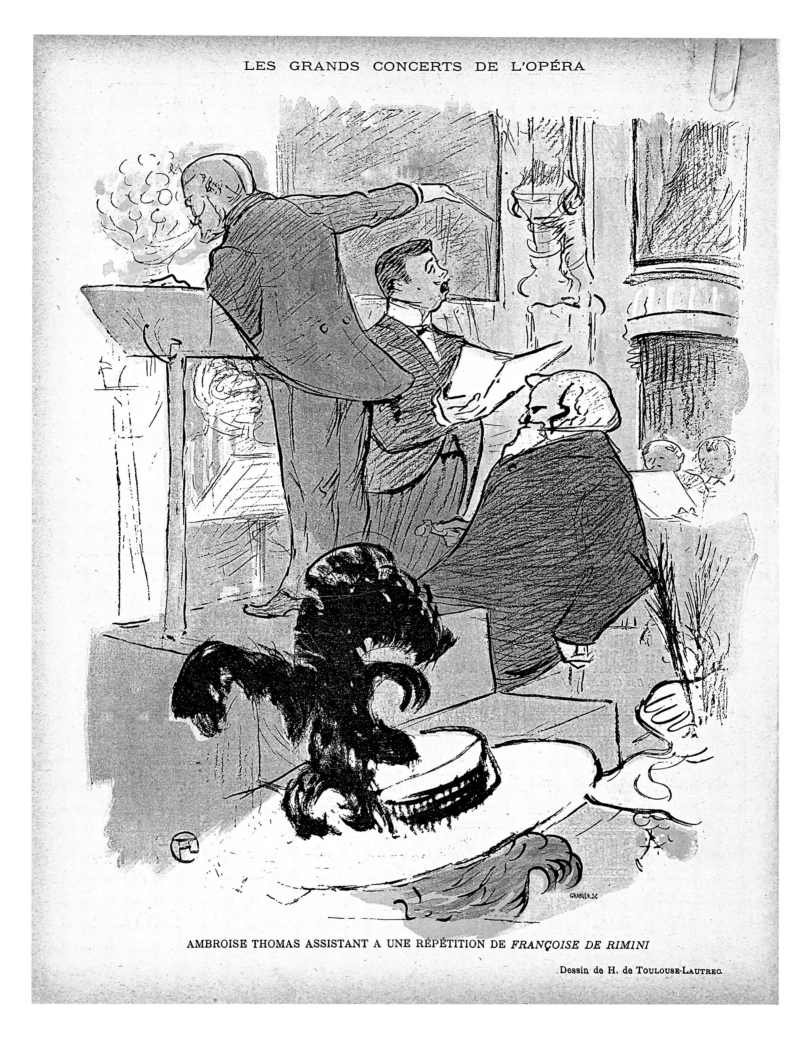

AMBROISE THOMAS ASSISTANT A UNE RÉPÉTITION DE *FRANÇOISE DE RIMINI*

Dessin de H. de TOULOUSE-LAUTREC.

Ambroise Thomas Attending a
Rehearsal of *Françoise de Rimini*

1896, colour lithograph, 25.8 x 20.1 cm

Ambroise Thomas asistiendo a
un ensayo de *Françoise de Rimini*

1896, litografía en color, 25,8 x 20,1 cm

Ambroise Thomas Assistant à une
Répétition de *Françoise de Rimini*

1896, lithographie en couleur, 25,8 x 20,1 cm

Ambroise Thomas verfolgt die
Probe zu *Françoise de Rimini*

1896, Farblithografie, 25,8 x 20,1 cm

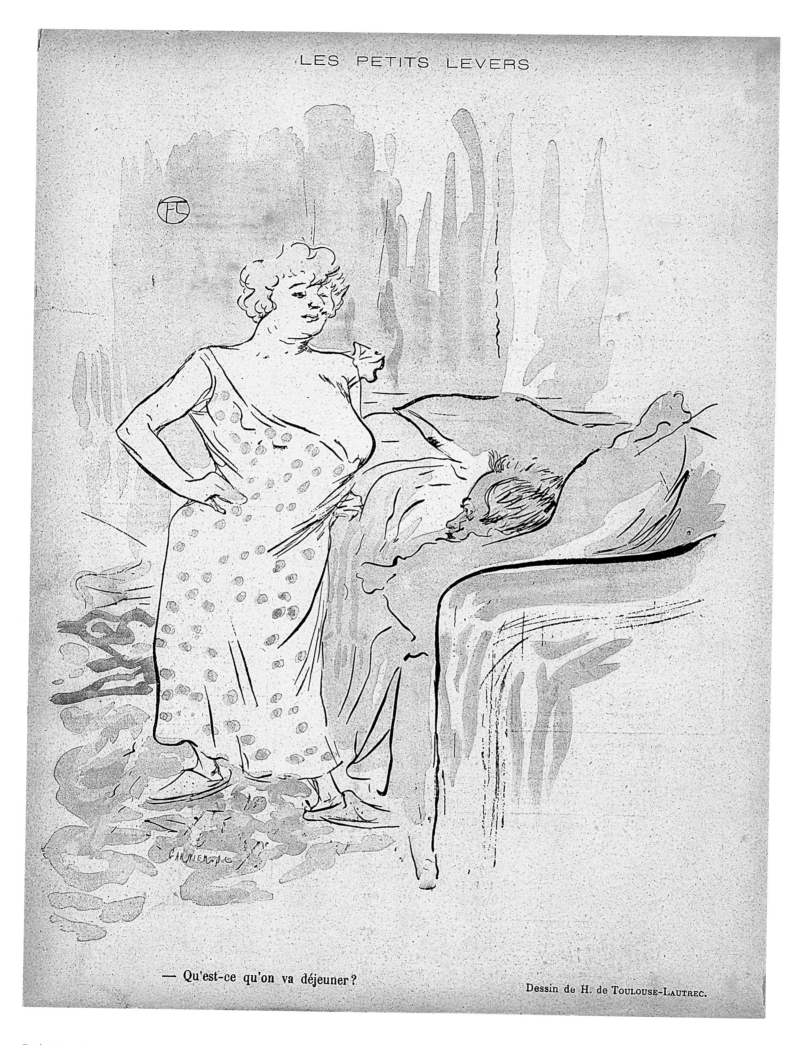

— Qu'est-ce qu'on va déjeuner ?

Dessin de H. de TOULOUSE-LAUTREC.

Early Morning
1896, colour lithograph, 25.7 x 19.8 cm

Temprano por la mañana
1896, litografía en color, 25,7 x 19,8 cm

Les Petits Levers
1896, lithographie en couleur, 25,7 x 19,8 cm

Kleine Morgenzeremonie
1896, Farblithografie, 25,7 x 19,8 cm

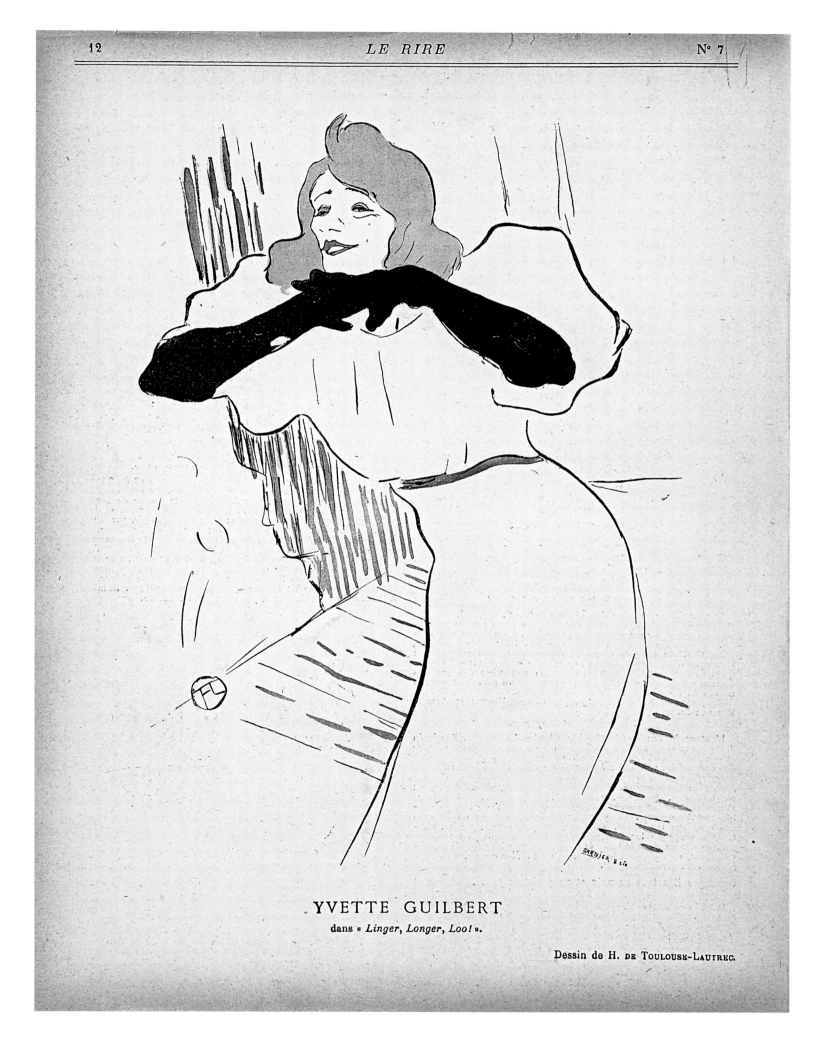

YVETTE GUILBERT

dans « *Linger, Longer, Loo!* ».

Dessin de H. DE TOULOUSE-LAUTREC.

Yvette Guilbert Singing
"Linger, Longer, Loo!"

1894, colour lithograph, 23.3 x 16.3 cm

Yvette Guilbert cantando
«Linger, Longer, Loo!»

1894, litografía en color, 23,3 x 16,3 cm

Yvette Guilbert dans
« Linger, Longer, Loo ! »

1894, lithographie en couleur, 23,3 x 16,3 cm

Yvette Guilbert in
„Linger, Longer, Loo!"

1894, Farblithografie, 23,3 x 16,3 cm

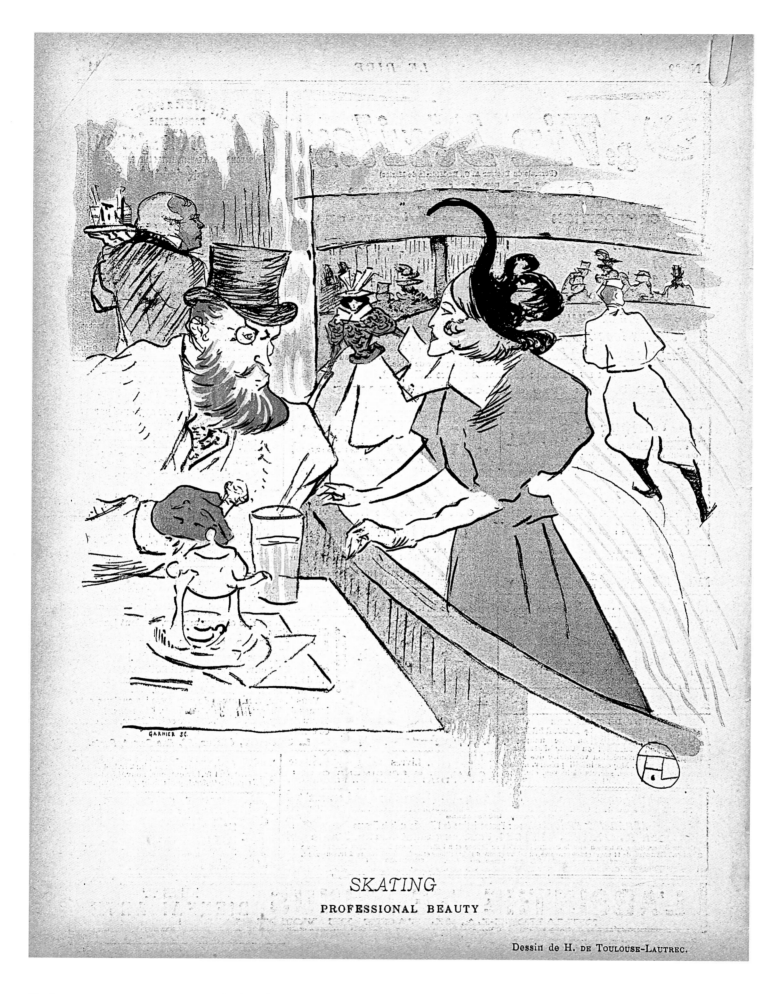

SKATING

PROFESSIONAL BEAUTY

Dessin de H. DE TOULOUSE-LAUTREC.

Skating

1896, colour lithograph, 22.3 x 21 cm

Mlle Lyane de Lancry, a so-called
'professional beauty', approaching
Edouard Dujardin at the 'Palais
de Glace', a skating rink that opened
on the Champs-Elysées in 1894.

Patinando

1896, litografía en color, 22,3 x 21 cm

Mademoiselle Lyane de Lancry, una
«belleza profesional», dirigiéndose a
Edouard Dujardin en el Palais de Glace,
la pista de patinaje abierta en los
Campos Elíseos en 1894.

Skating

1896, lithographie en couleur, 22,3 x 21 cm

Mlle Lyane de Lancry, une « beauté
professionnelle », s'approchant
d'Edouard Dujardin à la patinoire du
Palais de Glace, ouvert en 1894 sur les
Champs-Elysées.

Schlittschuhlaufen

1896, Farblithografie, 22,3 x 21 cm

Mlle Lyane de Lancry, eine
„professionelle Schönheit", nähert sich
Edouard Dujardin in der Eislaufbahn
„Palais de Glace", die 1894 auf den
Champs-Elysées eröffnet hatte.

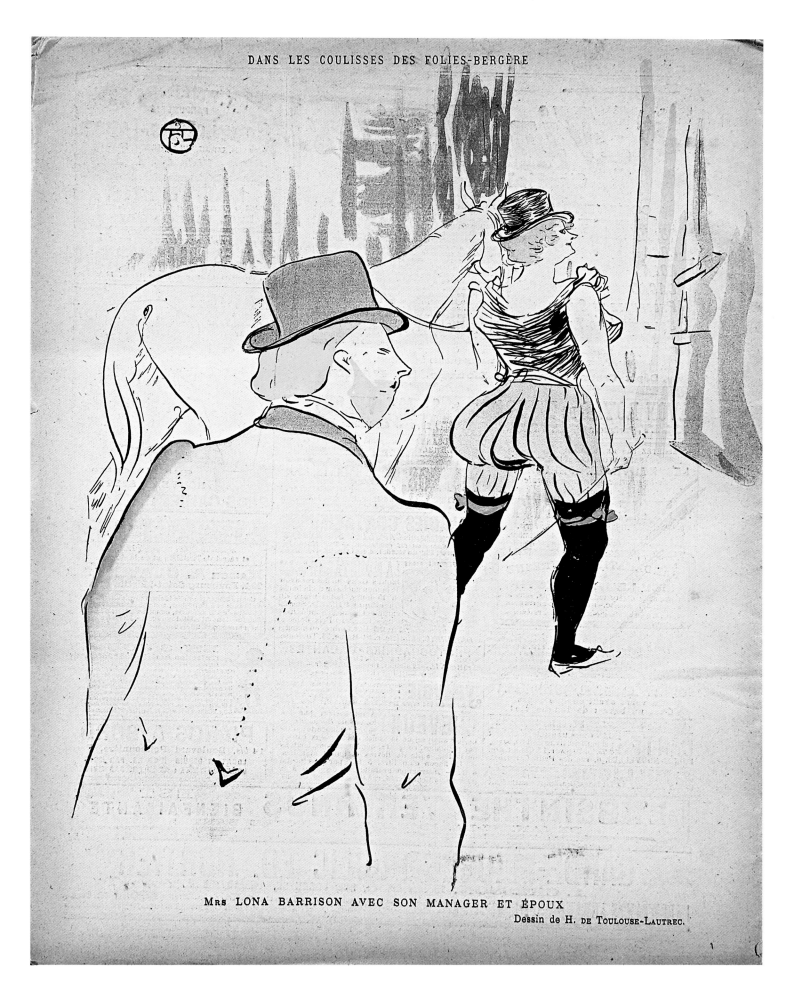

Lona Barrison and her
Manager and Husband

1896, colour lithograph, 27 x 21.5 cm

Lona Barrison con su
mánager y esposo

1896, litografía en color, 27 x 21,5 cm

Lona Barrison avec son
Manager et Époux

1896, lithographie en couleur, 27 x 21,5 cm

Lona Barrison mit ihrem
Manager und Ehemann

1896, Farblithografie, 27 x 21,5 cm

The Passenger in Cabin 54

1896, lithograph, 59.5 x 40 cm

Toulouse-Lautrec loved the sea. When visiting his mother in Malromé he would travel from Le Havre to Bordeaux on a cargo and passenger ferry. On just such a trip in 1895 the woman staying in cabin 54 caught his eye: "Something exquisite about her, an elegance, a lack of constraint, a love of life, a pleasing way of looking around..." Toulouse-Lautrec kept a photo of the lady, lost in reverie, and based his poster design on that photo. The poster was for the 'Salon des Cent', an exhibition hall for prints and posters maintained from 1894 – 1900 by the literary journal *La Plume*. This is a rare copy of the poster, printed before the colours and text were added, and one of the few that the artist signed.

La pasajera del camarote 54

1896, litografía, 59,5 x 40 cm

Toulouse-Lautrec amaba el mar. Para visitar a su madre en Malromé, viajaba de El Havre a Burdeos en un *ferry* de carga y pasajeros. En 1895, durante uno de estos viajes, la mujer del camarote 54 captó su atención: «Algo exquisito en ella, una elegancia, una falta de artificio, un amor por la vida, un agradable modo de mirar a su alrededor...». Toulouse-Lautrec guardó una fotografía de esta dama, absorta, y basó el diseño de su cartel en ella. El cartel estaba destinado al Salon des Cent, una sala de exposiciones de grabados y carteles gestionada por el diario literario *La Plume* entre 1894 y 1900. Esta es una copia singular del cartel: se imprimió antes de que se añadieran los colores y el texto y es una de las pocas firmadas por el artista.

La Passagère du 54

1896, lithographie, 59,5 x 40 cm

Toulouse-Lautrec aimait la mer. Lorsqu'il rendait visite à sa mère à Malromé, il voyageait du Havre à Bordeaux en cargo et en ferry. C'est au cours d'un tel voyage, en 1895, que son regard fut attiré par la passagère de la cabine 54 : « Elle avait quelque chose d'exquis, une élégance, une absence de contraintes, un amour de la vie, une manière plaisante de regarder ce qui l'entourait... » Toulouse-Lautrec garda une photo de la jeune femme perdue dans ses rêveries, et s'en servit pour dessiner son affiche. Celle-ci était destinée au Salon des Cent, une exposition rassemblant des gravures et des affiches, organisée de 1894 à 1900 par la revue littéraire *La Plume*. Nous voyons ici une pièce exceptionnelle, imprimée avant que les couleurs et le texte ne soient ajoutés, et l'une des rares que l'artiste ait signées.

Die Reisende von Kabine 54

1896, Lithografie, 59,5 x 40 cm

Toulouse-Lautrec liebte das Meer. Wenn er seine Mutter in Malromé besuchte, reiste er per Fracht- und Passagierschiff von Le Havre nach Bordeaux. 1895 fesselte auf einer solchen Fahrt die Dame aus Kabine 54 sein Interesse: „Etwas Exquisites an ihr, Eleganz und Ungezwungenheit, Liebe zum Leben, eine angenehme Art sich umzusehen ..." Er verwahrte ein Foto der verträumten Reisenden und verarbeitete es zu einem Plakatentwurf für den „Salon des Cent", der 1894 – 1900 von der Literaturzeitschrift *La Plume* betrieben wurde. Dieser seltene unkolorierte Zustandsdruck hat keinen Text und gehört zu den wenigen, die der Künstler signierte.

Portrait of Forain

c. 1894, pencil on paper, 5.1 x 4.7 cm

Jean-Louis Forain (1852 – 1931) was a painter, printmaker and illustrator. He contributed illustrations to the satirical magazine *Le Rire*, as did Toulouse-Lautrec.

Retrato de Forain

c 1894, lápiz sobre papel, 5,1 x 4,7 cm

Jean-Louis Forain (1852-1931) fue pintor, grabador e ilustrador. Contribuyó con sus ilustraciones a la revista satírica *Le Rire*, igual que Toulouse-Lautrec.

Portrait de Forain

vers 1894, mine de plomb sur papier, 5,1 x 4,7 cm

Jean-Louis Forain (1852 – 1931) était peintre, graveur et illustrateur. A l'instar de Toulouse-Lautrec, il a fourni des illustrations au magazine satirique *Le Rire*.

Bildnis Forain

um 1894, Bleistift auf Papier, 5,1 x 4,7 cm

Jean-Louis Forain (1852 – 1931) war Maler, Grafiker und Illustrator. Wie Toulouse-Lautrec steuerte auch er Illustrationen zur Satirezeitschrift *Le Rire* bei.

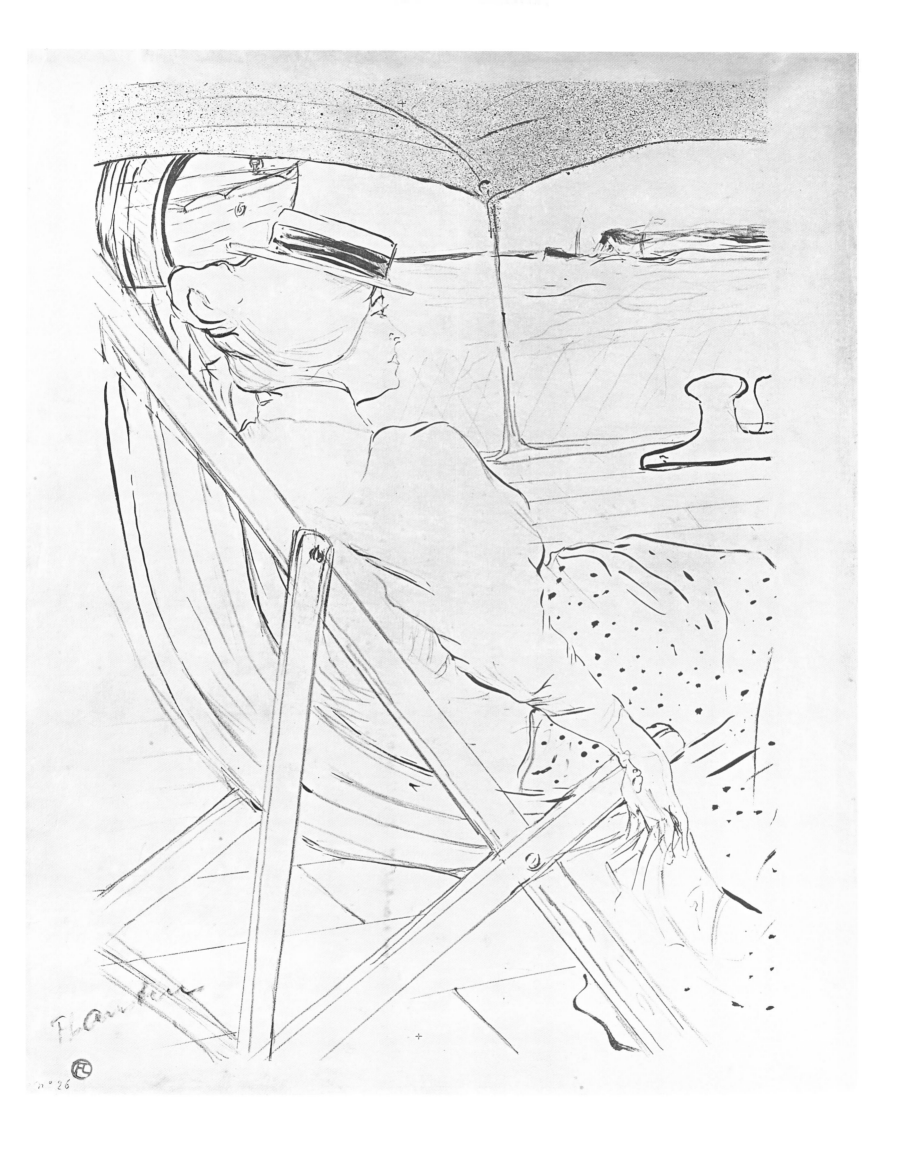

American

and other drinks

Mr and Mrs Alexandre

Natanson will be very

pleased of your company

at 8h ½ on the February

1895.

R. S. V. P.

60, Avenue du Bois de Boulogne.

Invitation Mr. and Mrs. Alexandre Natanson

1895, lithograph, 25.6 x 15.5 cm

Toulouse-Lautrec loved parties and never missed the opportunity to meet friends and enjoy wine, absinthe and other libations. Natanson, a close friend, asked the artist to organize a party for him. Toulouse-Lautrec immediately took up the task and turned it into the event everybody would talk about for years to come. From decorations to menus, to the mixing of drinks, everything was under the direct supervision of Toulouse-Lautrec. Of course he designed the invitation card.

Invitación de los Natanson

1895, litografía, 25,6 x 15,5 cm

Toulouse-Lautrec amaba las fiestas y nunca se perdía la oportunidad de reunirse con amigos y disfrutar del vino, el ajenjo y otros licores. Natanson, un amigo íntimo, pidió al artista que organizase una fiesta para él. Toulouse-Lautrec se puso inmediatamente manos a la obra y la convirtió en el evento del que todo el mundo hablaría durante años. Desde la decoración hasta la preparación de las bebidas, pasando por los menús, todo estuvo bajo su directa supervisión. Y por supuesto diseñó la invitación.

Invitation A. Natanson

1895, lithographie, 25,6 x 15,5 cm

Toulouse-Lautrec aimait les fêtes et ne perdait jamais une occasion de rencontrer des amis et de boire du vin, de l'absinthe ou d'autres boissons fortes. Natanson, un ami proche, lui demanda d'organiser une fête pour lui. Toulouse-Lautrec se mit immédiatement à la tâche et mit sur pied un événement dont tout le monde parlait encore dans les années qui suivirent. Qu'il s'agisse de décorations, de menus, de recettes de cocktails, il supervisa tout. Il dessina évidemment la carte d'invitation.

Einladung Mr. und Mrs. Alexandre Natanson

1895, Lithografie, 25,6 x 15,5 cm

Toulouse-Lautrec liebte Feste und ließ keine Gelegenheit aus, sich mit Freunden bei Wein, Absinth und anderen Spirituosen zu treffen. Auf die Bitte seines engen Freundes Natanson übernahm er auch die Organisation einer Feier und machte daraus ein Ereignis, das noch jahrelang für Gesprächsstoff sorgte. Von der Ausschmückung und Speisenfolge bis hin zum Mixen der Drinks unterstand alles seiner direkten Aufsicht. Selbstverständlich entwarf der Künstler auch die Einladungskarte.

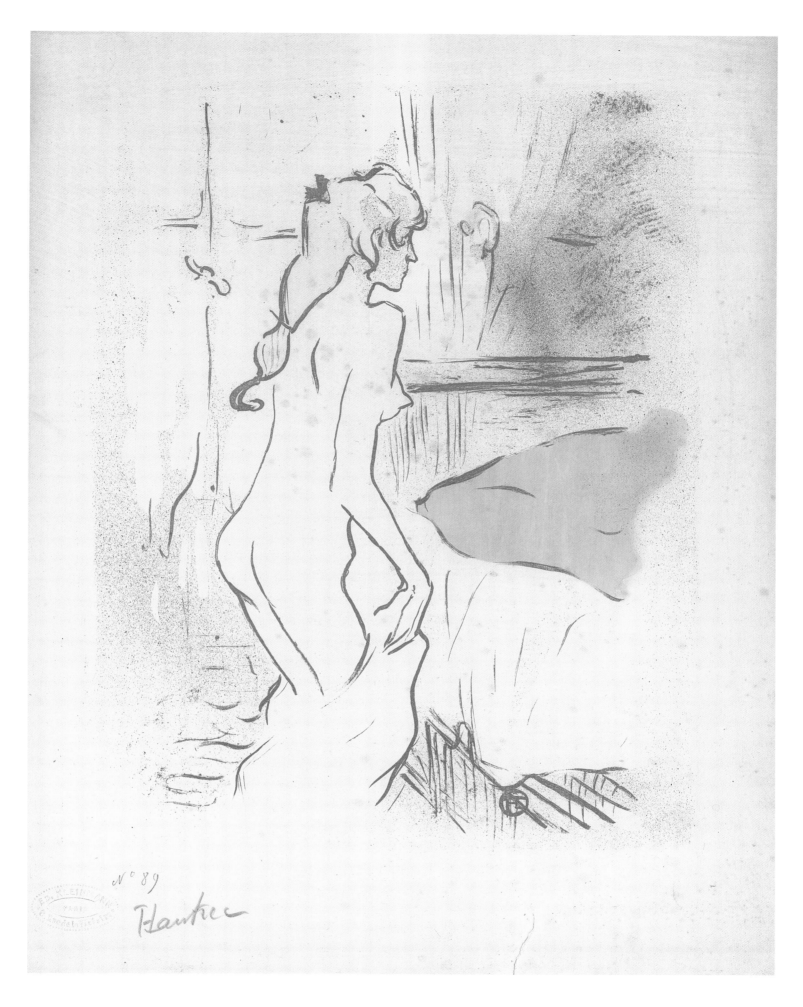

Study of a Woman

1893, colour lithograph, 26 x 20 cm

The cover for a book of poems by Hector Sombre. This print was reprinted without letters as part of Maurice Joyant's first catalogue raisonné.

Estudio de una mujer

1893, litografía en color, 26 x 20 cm

Cubierta para un libro de poemas de Hector Sombre. Este grabado fue reimpreso sin texto como parte del primer catálogo razonado de Maurice Joyant.

Étude de Femme

1893, lithographie en couleur, 26 x 20 cm

Couverture d'un livre de poèmes d'Hector Sombre. Cette lithographie a été réimprimée sans texte dans le premier catalogue raisonné de Maurice Joyant.

Studie einer Frau

1893, Farblithografie, 26 x 20 cm

Titelillustration für einen Gedichtband von Hector Sombre. Dieses Blatt wurde ohne Text in Maurice Joyants erstem Werkverzeichnis abgedruckt.

Horseman

1879 – 1881, pen and ink on paper,
9.6 x 7 cm

Jinete

1879-1881, pluma y tinta sobre papel,
9,6 x 7 cm

Cavalier

1879 – 1881, plume et encre sur papier,
9,6 x 7 cm

Reiter

1879 – 1881, Feder und Tinte auf Papier,
9,6 x 7 cm

Babylone d'Allemagne

1894, colour lithograph, 120 x 84.5 cm

This is a rare and impressive poster used to advertise a book by Victor Joze. The book describes the habits and customs of Berliners in a derogatory way, a subject for which the French invariably showed an interest. Germany was always considered a threat and the loss and recapture of Alsace-Lorraine was never forgotten by Parisians who lived only a couple of hundred kilometres away. Victor Joze's book caused a diplomatic incident with Germany. As a result, this poster was never pasted on the walls of Paris. This example of the poster has vivid colours and the folds are barely visible. A very good impression that looks as if it were printed recently.

Babylone d'Allemagne

1894, litografía en color, 120 x 84,5 cm

Este es un cartel impresionante y singular que se usó para anunciar un libro de Victor Joze. El libro describe los hábitos y costumbres de los berlineses de un modo despectivo, un tema por el que los franceses siempre mostraron interés. Alemania siempre se consideró una amenaza y los parisinos, que vivían solo a doscientos kilómetros de distancia, nunca olvidaron la pérdida y recuperación de Alsacia y Lorena. El libro de Victor Joze provocó un incidente diplomático con Alemania. Como consecuencia este cartel nunca se llegó a pegar en las paredes de París. Este ejemplar conserva los colores vivos y los pliegues apenas se ven. Una impresión muy buena que parece recién salida de la imprenta.

Babylone d'Allemagne

1894, lithographie en couleur, 120 x 84,5 cm

Cette affiche rare et saisissante devait faire de la publicité pour un livre de Victor Joze qui décrit de manière désobligeante les habitudes et les coutumes des Berlinois, un thème qui intéresse toujours les Français. L'Allemagne était toujours considérée comme une menace et les Parisiens vivant à peine à quelques centaines de kilomètres de là, n'avaient jamais oublié la perte et la reconquête de l'Alsace-Lorraine. Le livre de Victor Joze causa un accident diplomatique avec l'Allemagne, ce qui fait que cette affiche ne fut jamais collée sur les murs de la capitale. L'exemplaire ci-contre fait très bonne impression avec ses couleurs vives et ses plis à peine visibles. On dirait que l'affiche a été imprimée récemment.

Babylone d'Allemagne

1894, Farblithografie, 120 x 84,5 cm

Das ebenso seltene wie eindrucksvolle Plakat sollte ein Buch von Victor Joze bewerben, das sich abfällig über Berliner Sitten und Gebräuche äußerte – ein Thema, das bei Franzosen unweigerlich auf Interesse stieß. Deutschland galt als ständige Bedrohung, und der Verlust von Elsass-Lothringen war bei den nur wenige hundert Kilometer entfernten Parisern nicht vergessen. Victor Jozes Buch löste einen diplomatischen Zwischenfall mit dem Deutschen Reich aus, und so wurde das Plakat nie in Paris ausgehängt. Dieses Blatt besticht durch seine lebhaften Farben, kaum sichtbare Falzspuren und eine hervorragende Druckqualität.

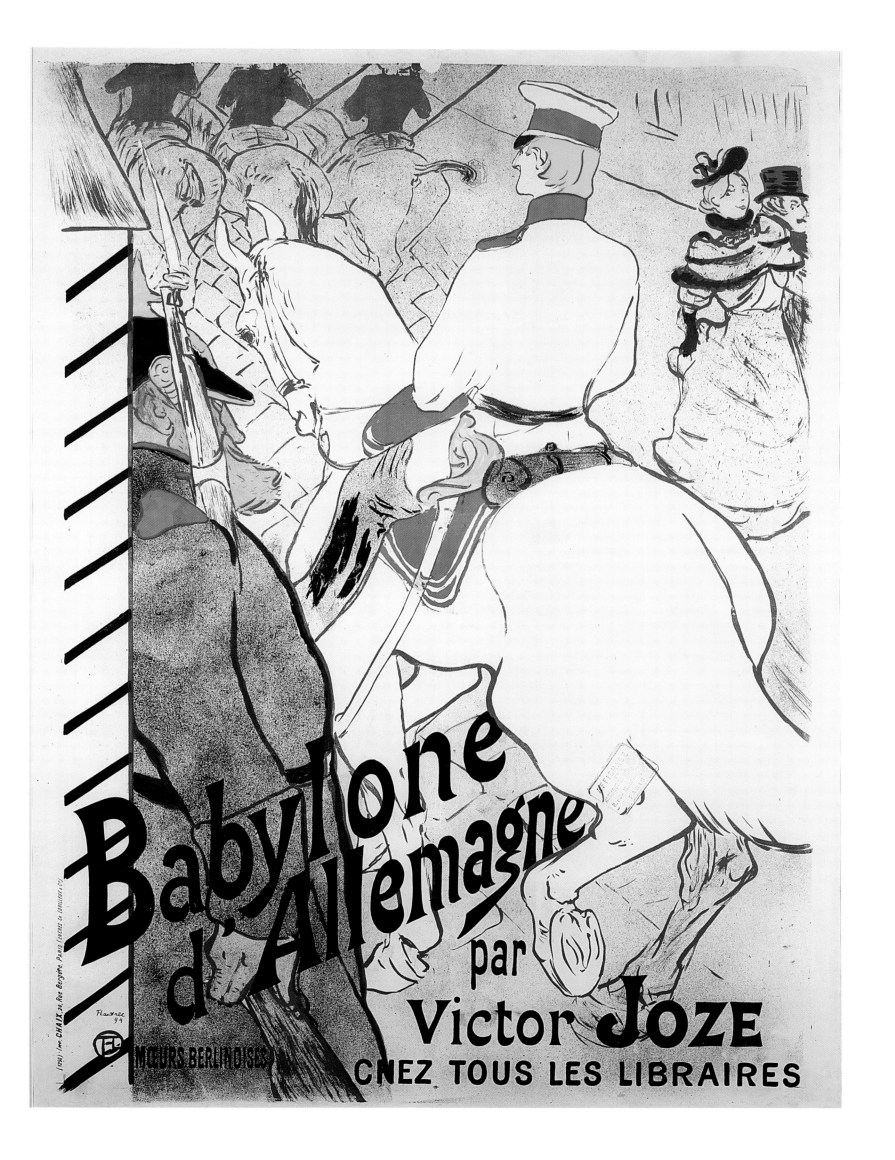

W. H. B. Sands, Publisher

1898, drypoint, 21.1 x 11.8 cm

Portrait of Toulouse-Lautrec's British
publisher W. H. B. Sands. The French artist
and Sands exchanged 55 letters between
1896 and 1900, mostly about Toulouse-
Lautrec's English *Yvette Guilbert* series.

W. H. B. Sands, editor

1898, grabado a punta seca, 21,1 x 11,8 cm

Retrato del editor británico de Toulouse-
Lautrec, W. H. B. Sands. El artista francés y
Sands intercambiaron 55 cartas entre
1896 y 1900, sobre todo acerca de la serie
inglesa que Toulouse-Lautrec hizo de
Yvette Guilbert.

W. H. B. Sands, éditeur

1898, pointe sèche, 21,1 x 11,8 cm

Portrait de W. H. B. Sands, l'éditeur anglais de
Toulouse-Lautrec. L'artiste français et Sands
échangèrent cinquante-cinq lettres entre
1896 et 1900, surtout au sujet de la série
anglaise *Yvette Guilbert* de Toulouse-Lautrec.

W. H. B. Sands, Verleger

1898, Kaltnadel, 21,1 x 11,8 cm

Ein Porträt von Toulouse-Lautrecs britischem
Verleger W. H. B. Sands. Zwischen 1896
und 1900 tauschten die beiden 55 Briefe aus,
die vor allem die englische *Yvette-Guilbert*-
Serie des Künstlers betrafen.

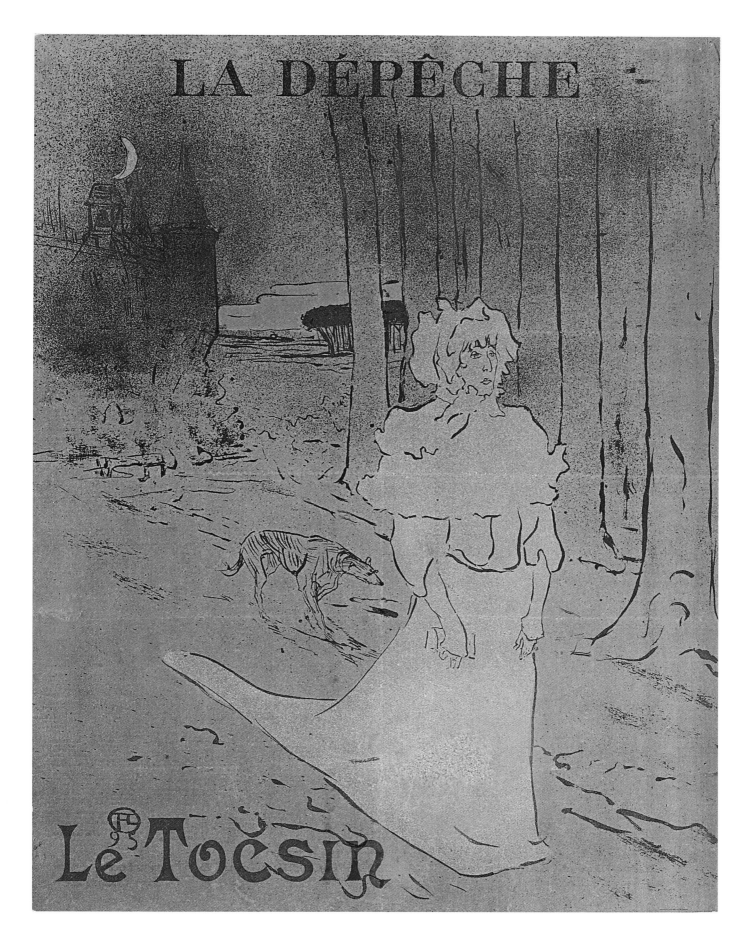

Le Tocsin

1895, colour lithograph, 55.8 x 42.7 cm

This poster was used as an advertisement for the novel *Le Tocsin* by Jules de Gastyne, which was published in serial form in the Toulouse newspaper *La Dépêche*. Toulouse-Lautrec had also designed an advertisement for *Le Pendu* for the same newspaper in 1892. The poster *Le Tocsin* is also referred to as *La Châtelaine*.

Le Tocsin

1895, litografía en color, 55,8 x 42,7 cm

Este cartel se usó como anuncio para la novela *Le Tocsin* de Jules de Gastyne, publicada por entregas en el periódico de Toulouse *La Dépêche*. Toulouse-Lautrec también había diseñado un anuncio para *Le Pendu* para el mismo periódico en 1892. El cartel *Le Tocsin* también es conocido con el nombre de *La Châtelaine*.

Le Tocsin

1895, lithographie en couleur, 55,8 x 42,7 cm

Il s'agit ici d'une affiche publicitaire pour la nouvelle intitulée *Le Tocsin* de Jules de Gastyne, publiée en feuilleton dans *La Dépêche* de Toulouse. Toulouse-Lautrec avait dessiné une publicité pour *Le Pendu* dans le même journal en 1892. L'affiche *Le Tocsin* est aussi appelée *La Châtelaine*.

Le Tocsin

1895, Farblithografie, 55,8 x 42,7 cm

Dieses Plakat diente als Werbung für Jules de Gastynes Roman *Le Tocsin*, der als Fortsetzung in der Toulouser Zeitung *La Dépêche* erschien. Für dieselbe Zeitung hatte Toulouse-Lautrec bereits 1892 eine Werbeanzeige für *Le Pendu* entworfen. Das hier abgebildete Plakat wird ebenfalls als *La Châtelaine* betitelt.

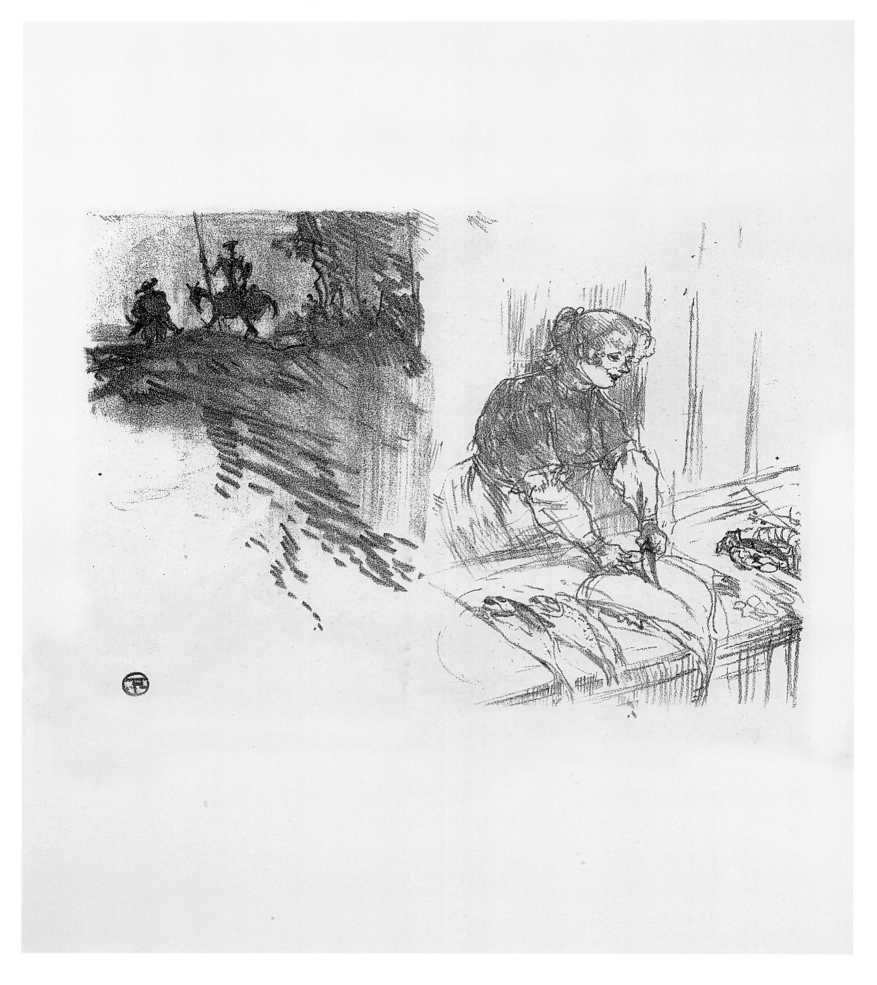

Les Courtes Joies

1897, lithograph, 18 x 25 cm

This lithograph was the cover (front and back) of a book with 115 poems by Julien Sermet, published by Joubert.

Les Courtes Joies

1897, litografía, 18 x 25 cm

Esta litografía fue la cubierta (anverso y reverso) de un libro de 115 poemas de Julien Sermet, publicado por Joubert.

Les Courtes Joies

1897, lithographie, 18 x 25 cm

Cette lithographie ornait la couverture (devant et dos) d'un ouvrage rassemblant cent-quinze poèmes de Julien Sermet, publié par Joubert.

Les Courtes Joies

1897, Lithografie, 18 x 25 cm

Diese Arbeit bildete Vorder- und Rückumschlag eines Bandes mit 115 Gedichten von Julien Sermet, den Joubert herausbrachte.

The Good Engraver
(Adolphe Albert)

1898, lithograph, 34.3 x 24.5 cm

Painter and engraver (born c. 1860)
who studied in Cormon's atelier
and exhibited at the 'Indépendants'
from 1870.

El buen grabador
(Adolphe Albert)

1898, litografía, 34,3 x 24,5 cm

El pintor y grabador, nacido en
torno a 1860, estudió en el taller de
Cormon y expuso en el Salon des
Indépendants a partir de 1870.

Le Bon Graveur
(Adolphe Albert)

1898, lithographie, 34,3 x 24,5 cm

Peintre et graveur (né vers 1860),
il étudia dans l'atelier Cormon
et exposa aux Indépendants
de 1870.

Der gute Grafiker
(Adolphe Albert)

1898, Lithografie, 34,3 x 24,5 cm

Der Maler und Stecher (geboren
um 1860) lernte bei Cormon
und stellte ab 1870 mit den
„Indépendants" aus.

Jane Avril

1895

Maîtres de l'Affiche, a poster book, was published in 1895. The then new art of the poster had become so popular that four years after the first poster was allowed to be pasted on the walls of Paris, the publisher, Jules Chéret, assembled 256 of the most famous colour posters and published the first poster book. Due to the large size of the originals, all were reproduced in a smaller format. Although this reproduction of the *Jane Avril* poster is not an original work of the artist, it is part of a compendium of Belle Époque posters much in demand by collectors around the world.

Jane Avril

1895

Maîtres de l'Affiche, un libro de carteles, fue publicado en 1895. El por entonces nuevo arte del cartel se había hecho tan popular que, cuatro años después de que permitieran pegar el primer cartel en las paredes de París, el editor Jules Chéret reunió 256 de los más famosos en color y publicó el primer libro de carteles. Debido al gran tamaño de los originales, todos fueron reproducidos en un formato más pequeño. Aunque esta reproducción del cartel de *Jane Avril* no es una obra original del artista, forma parte del compendio de carteles de la *belle époque* más demandados por coleccionistas del mundo entero.

Jane Avril

1895

Le recueil *Maîtres de l'Affiche* a été publié en 1895. Cet art alors moderne était devenu si populaire que quatre ans après l'apparition à Paris de la première affiche, l'éditeur Jules Chéret rassembla deux-cent cinquante-six des affiches en couleur les plus connues et publia le premier recueil. Leurs dimensions étant importantes, elles furent reproduites dans un format plus petit. Bien que cette reproduction de *Jane Avril* ne soit pas une œuvre originale, elle fait partie d'une collection d'affiches Belle Epoque très demandées par les collectionneurs du monde entier.

Jane Avril

1895

Die Sammelmappe *Maîtres de l'Affiche* erschien 1895. Die damals junge Kunst des Plakats wurde so populär, dass der Verleger Jules Chéret vier Jahre nach dem ersten Auftauchen von Plakaten auf den Pariser Straßen 256 der bekanntesten zu einer Plakatmappe zusammenstellte und herausbrachte. Die großformatigen Originale mussten allerdings in Verkleinerung wiedergegeben werden. Auch wenn dieser Nachdruck des *Jane-Avril*-Plakats keine Originalarbeit des Künstlers ist, gehört er zum Kompendium der bei Sammlern weltweit begehrten Belle-Époque-Plakate.

Les Programmes Illustrés des Théâtres et des Cafés-Concerts

1897, Ernest Maindron

A collection of illustrated programmes from theatres and café-concerts, as well as menus, invitation cards and small prints. These illustrated programmes were made by various artists, one of whom was Toulouse-Lautrec.

Les Programmes Illustrés des Théâtres et des Cafés-Concerts

1897, Ernest Maindron

Una colección de los programas ilustrados de teatros y cafés-cantantes, así como menús, tarjetas de invitación y pequeños grabados. Estos programas ilustrados fueron realizados por varios artistas, entre ellos Toulouse-Lautrec.

Les Programmes Illustrés des Théâtres et des Cafés-Concerts

1897, Ernest Maindron

Une collection de programmes illustrés des théâtres et des cafés-concerts, ainsi que de menus, de cartes d'invitation et de petites gravures. Ces programmes illustrés étaient réalisés par divers artistes, dont Toulouse-Lautrec.

Les Programmes Illustrés des Théâtres et des Cafés-Concerts

1897, Ernest Maindron

Eine Sammlung illustrierter Programme von Theatern und Cafés-Concerts sowie Menükarten, Einladungen und Kleingrafiken. Die Illustrationen stammen von verschiedenen Künstlern, darunter auch Toulouse-Lautrec.

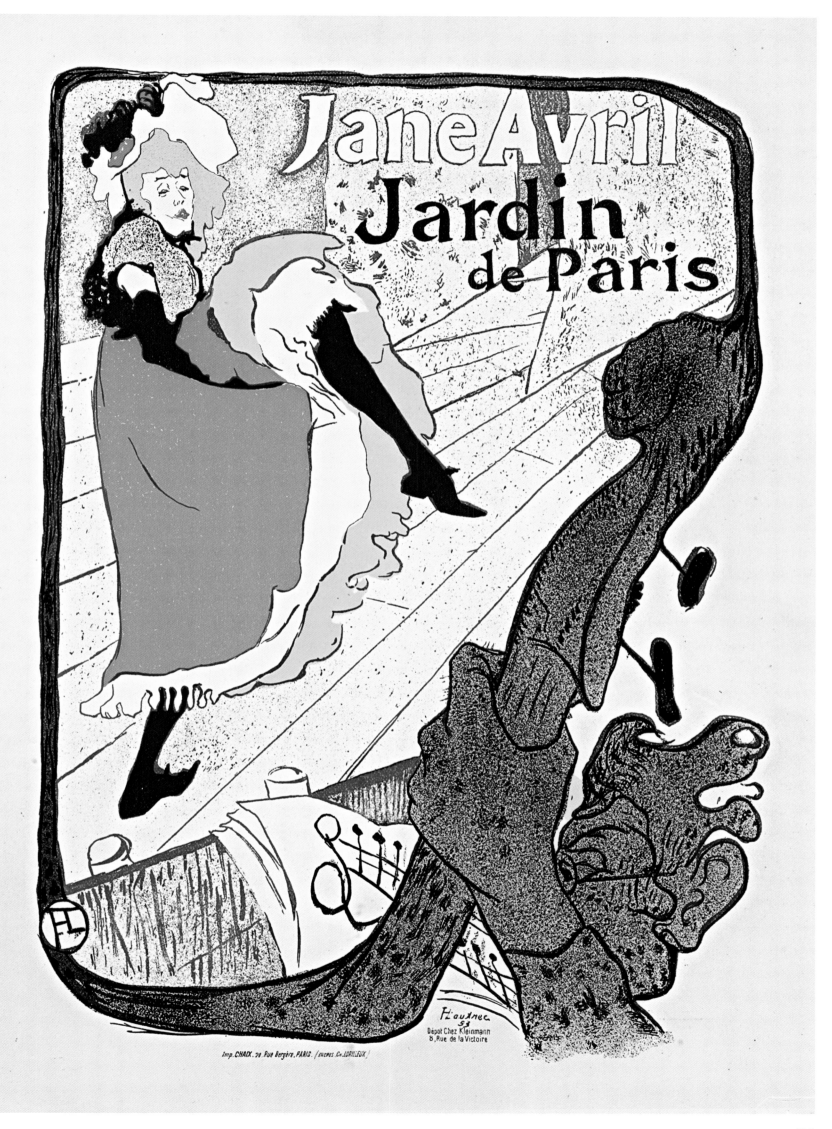

The Jockey

1899, colour lithograph, 51.1 x 35.5 cm

The publisher Pierrefort, who had visited Toulouse-Lautrec in the clinic at Neuilly in May 1899, suggested that the artist create a series showing horse-racing scenes to be published under the title *Courses*. Although Toulouse-Lautrec made a total of four prints on this theme, Pierrefort only published this one, which was printed by Stern. The print shown here is particularly striking because of the condition of its reds, including the red *crachis* (spatter) on the shirt of the jockey on the left.

El jockey

1899, litografía en color, 51,1 x 35,5 cm

El editor Pierrefort, que había visitado a Toulouse-Lautrec en la clínica de Neuilly en mayo de 1899, sugirió al artista que crease una serie de escenas de carreras de caballos para publicarla bajo el título de *Courses*. Aunque Toulouse-Lautrec hizo un total de cuatro grabados sobre este tema, Pierrefort solo publicó este, que fue impreso por Stern. El grabado aquí mostrado es especialmente llamativo por el estado de sus rojos, incluyendo el *crachis* (salpicado) en rojo de la camisa del jinete de la izquierda.

Le Jockey

1899, lithographie en couleur, 51,1 x 35,5 cm

L'éditeur Pierrefort, qui avait rendu visite à Toulouse-Lautrec à la clinique de Neuilly en mai 1899, lui suggéra de créer une série de scènes de courses hippiques à publier sous le titre *Courses*. Bien que Toulouse-Lautrec ait réalisé quatre gravures sur ce thème, Pierrefort n'en publia qu'une, imprimée par Stern. La lithographie présentée ici est particulièrement remarquable en raison de l'état de conservation de ses rouges, incluant le crachis rouge sur le maillot du jockey, à gauche.

Der Jockey

1899, Farblithografie, 51,1 x 35,5 cm

Der Verleger Pierrefort, der Toulouse-Lautrec im Mai 1899 in der Klinik in Neuilly besucht hatte, schlug ihm eine Folge von Pferderennszenen vor; sie sollten unter dem Titel *Courses* herauskommen. Obwohl der Künstler insgesamt vier Grafiken zu dem Thema schuf, veröffentlichte Pierrefort nur die hier abgebildete. Bemerkenswert daran ist der gute Erhaltungszustand der roten Farbe, etwa bei den Spritzern auf dem Blouson des Jockeys links.

The Explorer

1898, drypoint, 16.8 x 8.7 cm

Portrait of the explorer Jean-Joseph Vicomte de Brettes.

El explorador

1898, grabado a punta seca, 16,8 x 8,7 cm

Retrato del explorador Jean-Joseph, vizconde de Brettes.

L'Explorateur

1898, pointe sèche, 16,8 x 8,7 cm

Portrait de l'explorateur Jean-Joseph vicomte de Brettes.

Der Forscher

1898, Kaltnadel, 16,8 x 8,7 cm

Bildnis des Forschungsreisenden Jean-Joseph Vicomte de Brettes.

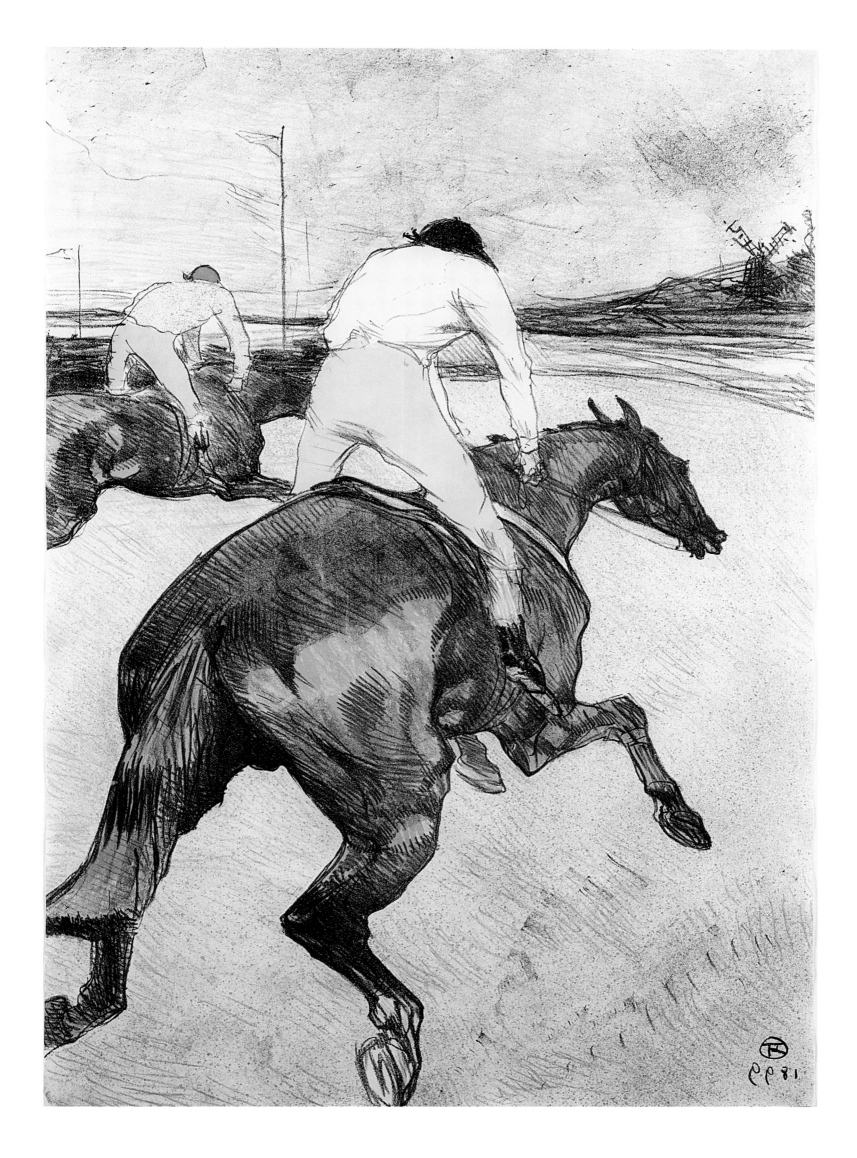

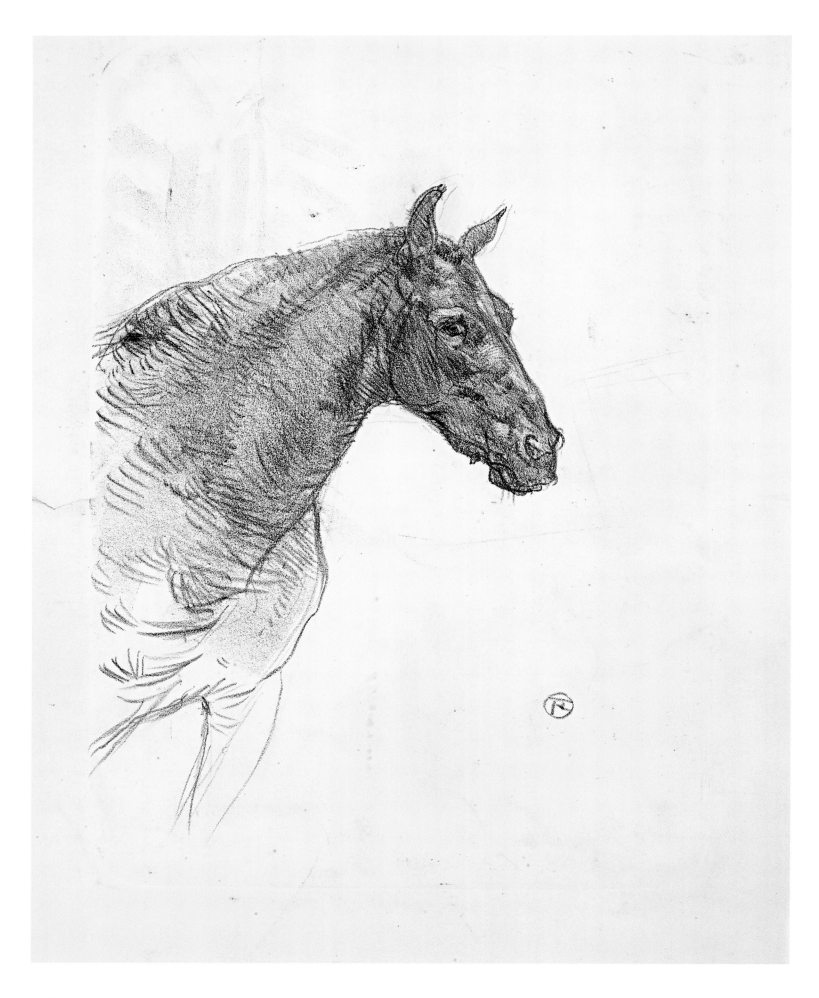

Philibert the Pony

1898, lithograph, 35.6 x 25.4 cm

Horses and horse-drawn carriages were an important element of country life on the family's estate and among the first subjects Toulouse-Lautrec drew and painted when still a boy.

El poni Philibert

1898, litografía, 35,6 x 25,4 cm

Los caballos y los coches tirados por caballos eran un elemento importante de la vida rural en la finca de la familia y fueron uno de los primeros temas que Toulouse-Lautrec dibujó y pintó cuando todavía era un muchacho.

Le Poney Philibert

1898, lithographie, 35,6 x 25,4 cm

Les chevaux et les attelages jouaient un rôle important à la campagne, dans la propriété familiale. Ils font partie des premiers sujets dessinés et peints par Toulouse-Lautrec enfant.

Das Pony Philibert

1898, Lithografie, 35,6 x 25,4 cm

Pferde und Kutschen waren nicht wegzudenken aus dem Landsitz der Familie und gehörten zu den allerersten Motiven, die Toulouse-Lautrec als Junge zeichnete und malte.

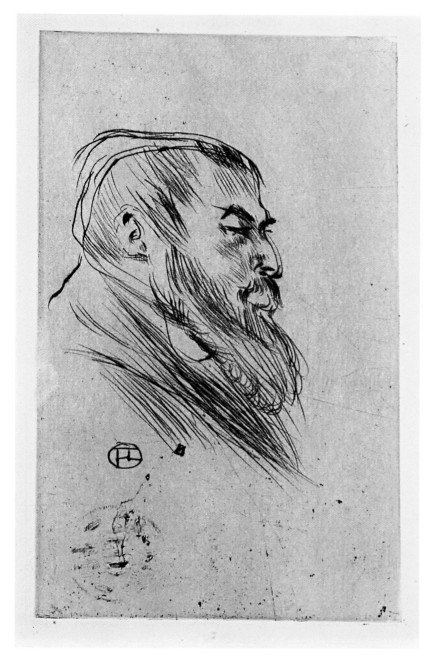

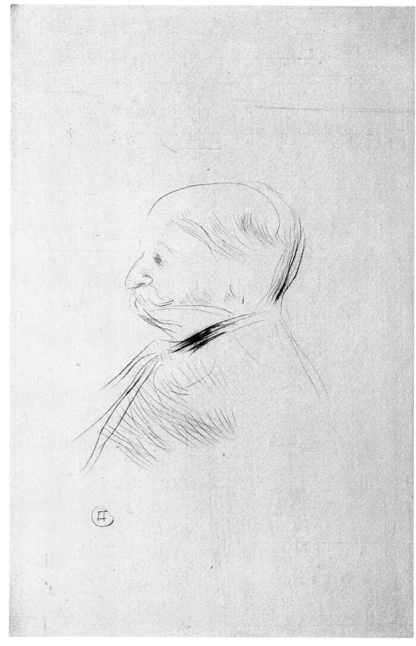

Tristan Bernard

1898, drypoint, 16.8 x 10 cm

A writer and friend of Toulouse-Lautrec, who was known for his puns and love of crossword puzzles. He was also director of the two most popular bicycle race tracks and sports editor of *La Revue Blanche*.

Tristan Bernard

1898, grabado a punta seca, 16,8 x 10 cm

Escritor y amigo de Toulouse-Lautrec, conocido por sus juegos de palabras y su afición por los crucigramas. Fue además director de los dos circuitos de carreras de bicicletas más populares y redactor deportivo de *La Revue Blanche*.

Tristan Bernard

1898, pointe sèche, 16,8 x 10 cm

Ecrivain et ami de Toulouse-Lautrec, il était connu pour ses calembours et son amour des mots croisés. Il dirigeait deux des plus populaires circuits de courses cyclistes et rédigeait la rubrique sportive de la *La Revue Blanche*.

Tristan Bernard

1898, Kaltnadel, 16,8 x 10 cm

Der Schriftsteller war mit Toulouse-Lautrec befreundet und bekannt für seinen Wortwitz und die Liebe zu Kreuzworträtseln. Zudem war er Direktor der beiden beliebtesten Radrennbahnen und Sportredakteur der *Revue Blanche*.

Portrait of a Man

1898, drypoint, 17 x 10.4 cm

Thought to be possibly a portrait of Arthur Meyer, publisher of the newspaper *Le Gaulois*. The delicate lines and lightness give this work an ethereal appearance and reflect the artist's understanding of light, shadow and texture.

Retrato de un hombre

1898, grabado a punta seca, 17 x 10,4 cm

Se piensa que posiblemente sea un retrato de Arthur Meyer, editor del periódico *Le Gaulois*. Las delicadas líneas y la ligereza confieren un aspecto etéreo a esta obra y reflejan la comprensión del artista de la luz, la sombra y la textura.

Portrait d'un Homme

1898, pointe sèche, 17 x 10,4 cm

Il pourrait s'agir d'un portrait d'Arthur Meyer, éditeur du journal *Le Gaulois*. La délicatesse des lignes et la légèreté de l'ensemble donnent à cette œuvre un aspect éthéré et reflètent la manière dont l'artiste conçoit la lumière, l'ombre et la texture.

Bildnis eines Mannes

1898, Kaltnadel, 17 x 10,4 cm

Es handelt sich möglicherweise um Arthur Meyer, den Verleger der Zeitung *Le Gaulois*. Die zarten, leichten Striche geben mit ihrer Flüchtigkeit Aufschluss über das Verhältnis des Künstlers zu Licht, Schatten und Texturen.

Horseman and Two Horses

1881, pencil on paper, 16.4 x 24.7 cm

Toulouse-Lautrec's drawings of animals, though sometimes hilarious, always testify to the artist's capacity to capture the essence of the animal, its movement, its expression. In this early drawing one can track the artist's points of interest: the uplifted hoof of the horse's leg, the curve of its neck and the difficult position of the jockey, turning his upper body to the left.

Jinete y dos caballos

1881, lápiz sobre papel, 16,4 x 24,7 cm

Los dibujos de animales de Toulouse-Lautrec, aunque a veces jocosos, siempre demuestran la capacidad del artista para capturar la esencia animal, su movimiento, su expresión. En este temprano dibujo pueden advertirse sus puntos de interés: el casco elevado de la pata del caballo, la curva de su cuello y la difícil posición del jinete, girando el torso hacia la izquierda.

Cavalier et deux Chevaux

1881, mine de plomb sur papier, 16,4 x 24,7 cm

Bien que parfois cocasses, les dessins d'animaux de Toulouse-Lautrec témoignent toujours de sa capacité à fixer sur le papier l'essence de l'animal, son mouvement, son expression. Ce dessin, réalisé dans sa jeunesse, révèle ce qui intéresse l'artiste : le sabot levé du cheval, la courbe de son cou et la position incommode du jockey qui tourne le haut de son corps vers la gauche.

Reiter und zwei Pferde

1881, Bleistift auf Papier, 16,4 x 24,7 cm

Toulouse-Lautrecs Tierzeichnungen wirken mitunter etwas komisch, zeugen aber immer von seiner Fähigkeit, Bewegung und Ausdruck eines Tieres im Kern richtig zu erfassen. Bei dieser frühen Studie ist gut erkennbar, worauf sich das Interesse des Künstlers richtete: den erhobenen Huf, den geschwungenen Hals und die schwierige Haltung des nach links gewandten Reiters.

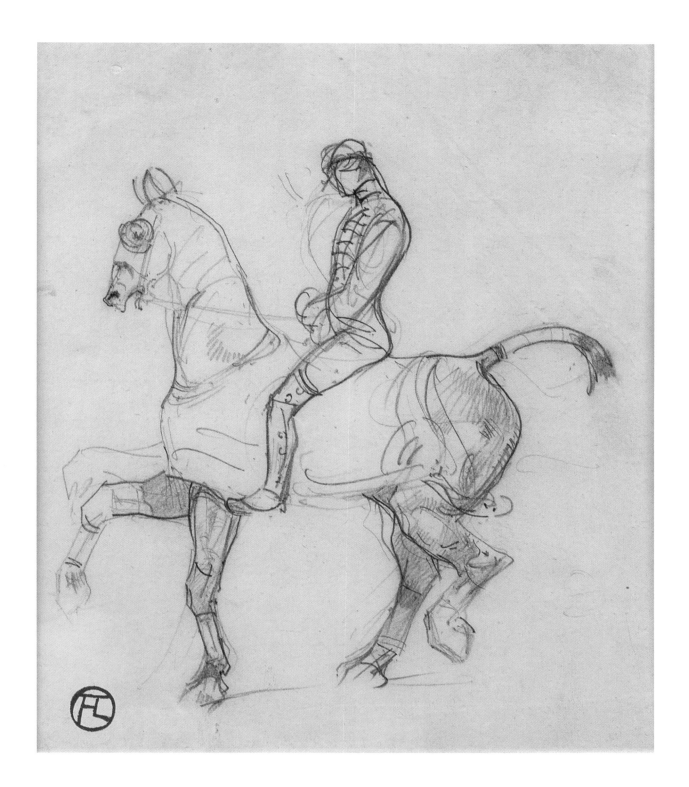

Horseman

c. 1880, pencil on paper laid down
on board, 15.9 x 14.8 cm

Jinete

c 1880, lápiz sobre papel encolado
a tabla, 15,9 x 14,8 cm

Cavalier

vers 1880, mine de plomb sur papier
tendu sur panneau, 15,9 x 14,8 cm

Reiter

um 1880, Bleistift auf Papier, auf Karton
aufgezogen, 15,9 x 14,8 cm

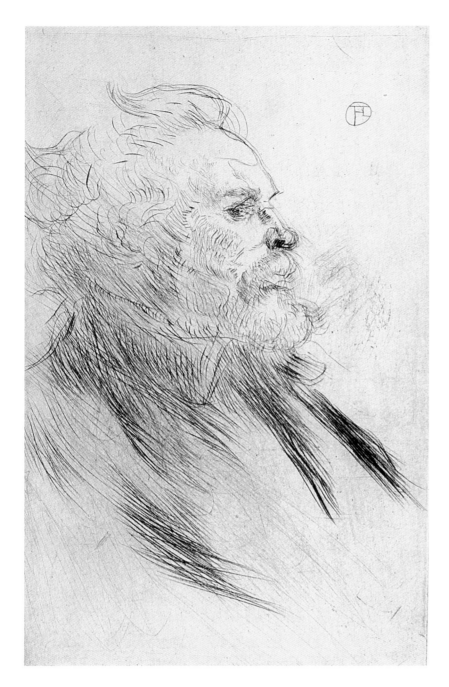

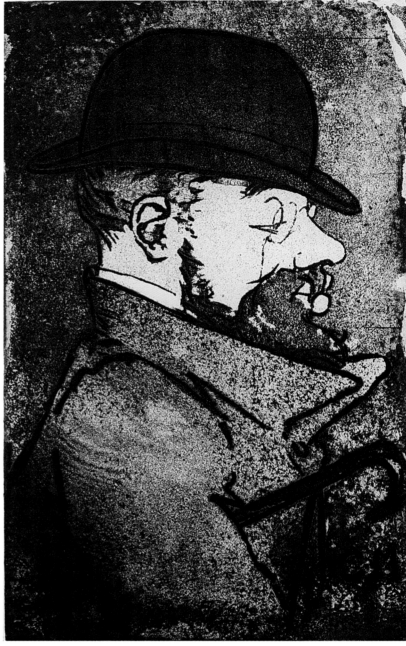

Charles Maurin

1898, drypoint, 16.9 x 9.7 cm

Charles Maurin (1856 – 1914) was a French painter and colour etcher. Inspired by the work of Japanese artists, he was one of a small group of artists who experimented with colour plates and in 1891 he patented a new technique of colour printing. He worked in a variety of media and even created designs for fabric.

Charles Maurin

1898, grabado a punta seca, 16,9 x 9,7 cm

Charles Maurin (1856-1914) fue un pintor francés y grabador a color. Inspirado por el trabajo de artistas japoneses, fue uno de los pocos artistas que experimentaron con ilustraciones en color. En 1891 patentó una nueva técnica de impresión a color. Trabajó con varios medios e incluso creó diseños para tela.

Charles Maurin

1898, pointe sèche, 16,9 x 9,7 cm

Charles Maurin (1856 – 1914) était un peintre et graveur français. S'inspirant des artistes japonais, il fut membre d'un petit groupe qui étudia de nouveaux procédés utilisant des plaques de couleur et, en 1891, il breveta une nouvelle technique d'impression couleur. Il a travaillé sur des supports variés et a même réalisé des motifs de tissu.

Charles Maurin

1898, Kaltnadel, 16,9 x 9,7 cm

Charles Maurin (1856 – 1914) war ein französischer Maler und Farbradierer. Von der japanischen Kunst ließ er sich in einem kleinen Kreis Gleichgesinnter zum Experimentieren mit Farbplatten anregen, und 1891 patentierte er eine neue Technik des Farbdrucks. Zu seinem vielseitigen Schaffen zählen auch Textilentwürfe.

Portrait of Henri de Toulouse-Lautrec

Charles Maurin
1895, lithograph, 22.4 x 13.7 cm

Maurin was not only an artist but also a teacher at the 'Académie Julian'. Some of his pupils became famous French artists, such as Henri de Toulouse-Lautrec and Félix Vallotton. Toulouse-Lautrec and Maurin became friends and in 1893 Toulouse-Lautrec made his first individual exhibition together with his former teacher.

Retrato de Henri de Toulouse-Lautrec

Charles Maurin
1895, litografía, 22,4 x 13,7 cm

Maurin no solo fue artista, sino también profesor en la Académie Julian. Algunos de sus alumnos se convirtieron en famosos artistas franceses, como Henri de Toulouse-Lautrec y Félix Vallotton. Toulouse-Lautrec y Maurin se hicieron amigos y en 1893 Lautrec hizo su primera exposición individual junto con su antiguo profesor.

Portrait d'Henri de Toulouse-Lautrec

Charles Maurin
1895, lithographie, 22,4 x 13,7 cm

Maurin n'était pas seulement un artiste, il enseignait aussi à l'Académie Julian. Certains de ses élèves sont devenus célèbres, comme Henri de Toulouse-Lautrec et Félix Vallotton. Toulouse-Lautrec et Maurin se lièrent d'amitié et, en 1893, Toulouse-Lautrec fit sa première exposition personnelle avec son ancien professeur.

Bildnis Henri de Toulouse-Lautrec

Charles Maurin
1895, Lithografie, 22,4 x 13,7 cm

Maurin unterrichtete außerdem an der „Académie Julian". Einige seiner Schüler wurden später berühmt, wie etwa Henri de Toulouse-Lautrec und Félix Vallotton. Toulouse-Lautrec und Maurin wurden Freunde, und 1893 hatte Toulouse-Lautrec seine erste Einzelausstellung gemeinsam mit seinem ehemaligen Lehrer.

Francis Jourdain

1898, drypoint, 16.9 x 10 cm

Francis Jourdain (1876 – 1958) was a French painter, etcher, designer and writer. He often went to the gallery 'Le Bard de Boutteville' where he met Toulouse-Lautrec.

Francis Jourdain

1898, grabado a punta seca, 16,9 x 10 cm

Francis Jourdain (1876-1958) fue un pintor, grabador, diseñador y escritor francés. Frecuentaba la galería Le Bard de Boutteville, donde conoció a Toulouse-Lautrec.

Francis Jourdain

1898, pointe sèche, 16,9 x 10 cm

Peintre, graveur, dessinateur et écrivain français, Francis Jourdain (1876 – 1958) se rendait souvent à la galerie Le Bard de Boutteville où il rencontrait Toulouse-Lautrec.

Francis Jourdain

1898, Kaltnadel, 16,9 x 10 cm

Francis Jourdain (1876 – 1958) war ein französischer Maler, Radierer, Designer und Schriftsteller. Er besuchte häufig die Galerie „Le Bard de Boutteville", wo er Toulouse-Lautrec kennenlernte.

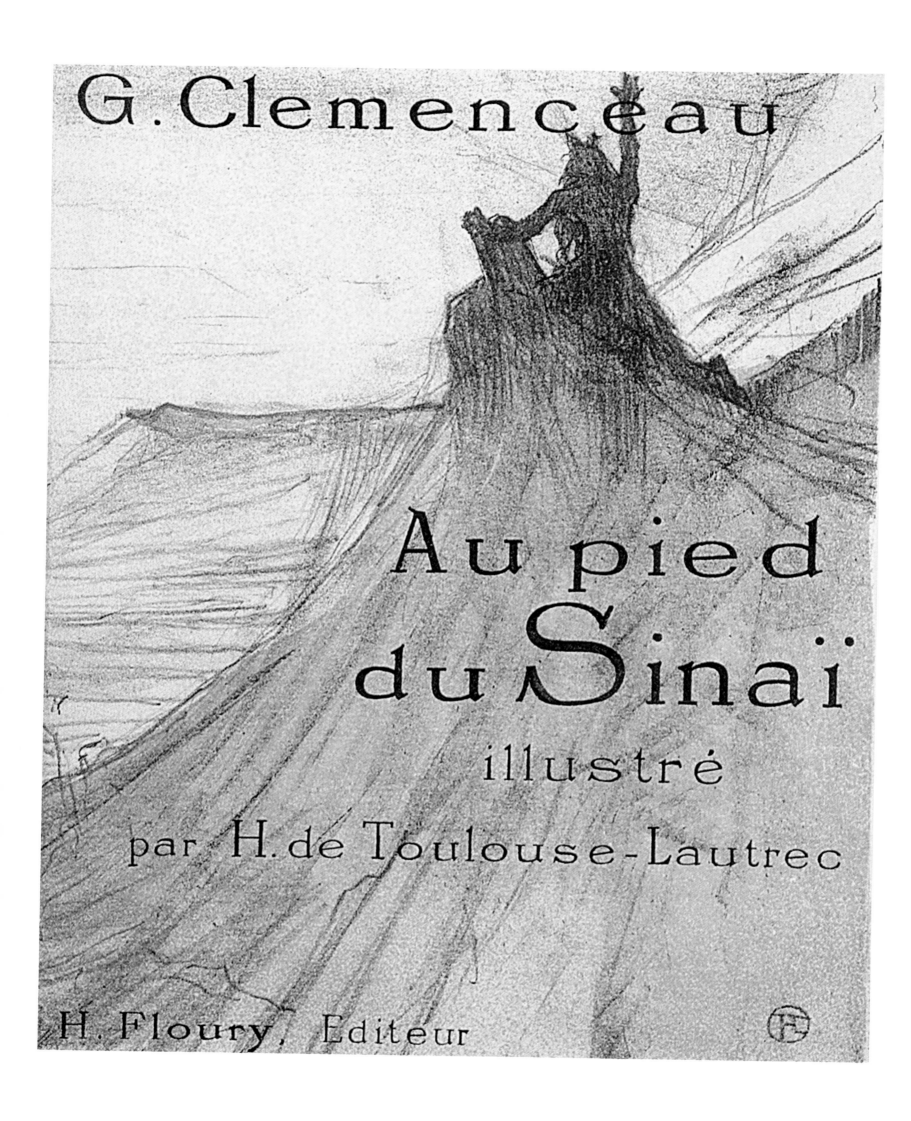

G. Clemenceau

Au pied
du Sinaï

illustré

par H. de Toulouse-Lautrec

H. Floury, Editeur

The Book *Au Pied du Sinaï*

The Book *Au Pied du Sinaï*

Au Pied du Sinaï was written by Georges Clemenceau during the years of the Dreyfus affair (1894 – 1899). Published in 1898, the book describes in six chapters sketches of Jewish life mainly in Eastern Europe. Though Clemenceau based his main characters and the conditions they were living in on the impressions he got while travelling through countries such as Poland, and although he was an advocate of Judaism and a supporter of Dreyfus, his book is not just an account of the situation of the Jews at the end of the nineteenth century. Since Clemenceau partly uses irony in characterizing people and their environment, *At the Foot of Sinai* (English edition 1922) is to modern readers at least debatable.

Toulouse-Lautrec created the lithographs for the book. The deluxe edition contained 10 lithographs, which were printed four times each on different paper, as well as four extra lithographs which had been refused for the normal edition.

El libro *Au Pied du Sinaï*

Au Pied du Sinaï fue escrito por Georges Clemenceau durante los años del caso Dreyfus (1894-1899). Publicado en 1898, el libro describe en seis capítulos esbozos de la vida judía, en especial en la Europa del Este. Aunque Clemenceau se basó en las impresiones que acumuló viajando por países como Polonia a la hora de crear sus personajes principales y sus condiciones de vida, y aunque era un defensor del judaísmo y un partidario de Dreyfus, su libro no es solamente un relato de la situación de los judíos a finales del siglo XIX. Puesto que Clemenceau usa en parte la ironía al caracterizar a la gente y su entorno, para los lectores modernos *Au Pied du Sinaï* resulta como poco discutible.

Toulouse-Lautrec creó las litografías para el libro. La edición de lujo contenía diez litografías, que fueron impresas cuatro veces cada una en distinto papel, así como cuatro litografías adicionales que habían sido rechazadas para la edición normal.

Le livre *Au Pied du Sinaï*

Au Pied du Sinaï a été écrit par Georges Clemenceau alors que l'affaire Dreyfus divisait la France (1894 – 1899). Publié en 1898, l'ouvrage décrit en six chapitres des scènes de la vie juive, surtout en Europe de l'Est. Bien que ses personnages principaux et leurs conditions de vie soit basés sur les impressions que l'auteur avait rassemblées en traversant des pays comme la Pologne, et bien qu'il se fasse l'avocat du judaïsme et soit un défenseur de Dreyfus, son livre n'est pas seulement un compte-rendu de la situation des Juifs à la fin du dix-neuvième siècle. L'ironie dont use parfois l'auteur pour dépeindre les gens et leur environnement fait qu'*Au Pied du Sinaï* est à tout le moins contestable aux yeux du lecteur moderne.

Toulouse-Lautrec a illustré cet ouvrage. L'édition de luxe comprenait dix lithographies qui furent tirées quatre fois, chacune sur du papier différent, quatre planches supplémentaires furent refusées pour l'édition ordinaire.

Das Buch *Au Pied du Sinaï*

Au Pied du Sinaï wurde von Georges Clemenceau zur Zeit der Dreyfus-Affäre (1894 – 1899) verfasst und erschien 1898. Darin skizziert er in sechs Kapiteln das jüdische Leben insbesondere in Osteuropa. Der Autor griff für die Beschreibung von Hauptfiguren und Lebensumständen auf eigene Eindrücke zurück, die er bei Reisen durch Polen gewonnen hatte. Obwohl er ein Befürworter des Judentums war und sich für Dreyfus einsetzte, ist sein Buch keinesfalls nur eine Schilderung der Situation der Juden zu Ende des 19. Jahrhunderts. Die teils ironische Darstellung von Land und Leuten macht *Jüdische Gestalten* (deutsche Übersetzung 1924) heute zumindest fragwürdig.

Toulouse-Lautrec schuf die Illustrationen zur französischen Ausgabe. Die Luxusedition enthielt 10 Lithografien – je viermal auf unterschiedlichem Papier gedruckt – sowie vier Sonderlithografien, die nicht in die Standardausgabe aufgenommen worden waren.

Flauduc

Baron Moses Begging

(from the book *Au Pied du Sinaï*)
1897, lithograph, 17.5 x 14.2 cm

Baron Moses, heir to a vast fortune, does not know how it feels to be hungry. He decides to starve himself to learn what hunger is. The scene depicted by Toulouse-Lautrec is when Moses's stomach is finally aching from hunger and he starts begging on the street for a piece of bread, but he is being ignored by the passers-by.

El barón Moïse mendigando

(del libro *Au Pied du Sinaï*)
1897, litografía, 17,5 x 14,2 cm

El barón Moïse, heredero de una gran fortuna, no sabe lo que es sentir hambre. Así que decide privarse de comida y aprender de esta manera qué es el hambre. La escena representada por Toulouse-Lautrec es el momento en el que a Moïse finalmente le duele el estómago por de comida y comienza a pedir en la calle un pedazo de pan, pero los transeúntes lo ignoran.

Le Baron Moïse Mendiant

(du livre *Au Pied du Sinaï*)
1897, lithographie, 17,5 x 14,2 cm

Ignorant ce qu'est la faim, le baron Moïse, héritier d'une grande fortune, décide de se priver de nourriture pour la comprendre. Toulouse-Lautrec nous montre Moïse qui, torturé par ses crampes d'estomac, commence à mendier dans la rue pour avoir un morceau de pain, mais les passants l'ignorent.

Baron Moses beim Betteln

(aus dem Buch *Au Pied du Sinaï*)
1897, Lithografie, 17,5 x 14,2 cm

Als Erbe eines großen Vermögens kennt Baron Moses keinen Hunger. Er beschließt daher, dieses Gefühl selbst zu erfahren. Die von Toulouse-Lautrec abgebildete Szene zeigt, wie Moses vor Hunger schließlich Bauchschmerzen bekommt und auf der Straße um ein Stück Brot bettelt, von den Passanten aber ignoriert wird.

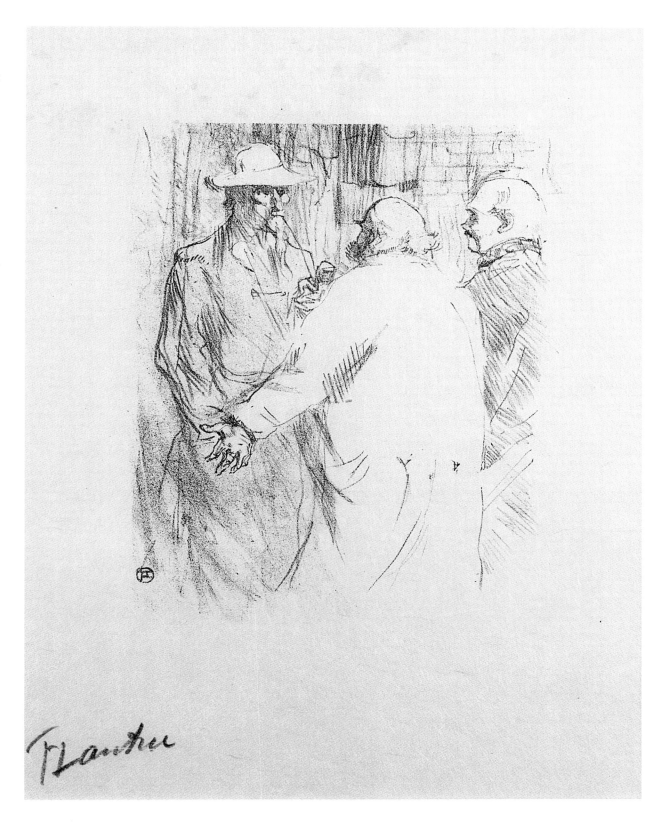

Clemenceau in Busk

(from the book *Au Pied du Sinaï*)
1897, lithograph, 17.6 x 14.4 cm

Clemenceau visits the Ruthenian Catholic church of Busk and is received by the priest, "a tall old man in black garb and a straw hat of vast proportions, absorbed in smoking his long pipe".

Clemenceau en Busk

(del libro *Au Pied du Sinaï*)
1897, litografía, 17,6 x 14,4 cm

Clemenceau visita la iglesia católica rutena de Busk y es recibido por el sacerdote, «un anciano alto, con vestiduras negras, sombrero de paja de grandes dimensiones, fumando absorto su larga pipa».

Clemenceau à Busk

(du livre *Au Pied du Sinaï*)
1897, lithographie, 17,6 x 14,4 cm

Clemenceau visite l'église catholique ruthène de Busk et est reçu par le curé, « un grand vieillard en houppelande noire, le chef couvert d'un vaste chapeau de paille, fort attentif à sa pipe longue d'une coudée. »

Clemenceau in Busk

(aus dem Buch *Au Pied du Sinaï*)
1897, Lithografie, 17,6 x 14,4 cm

In der ruthenisch-katholischen Kirche von Busk wird Clemenceau vom Priester empfangen, „einem großen alten Mann, schwarz gekleidet und mit riesigem Strohhut, der sich ganz seiner Langpfeife hingibt".

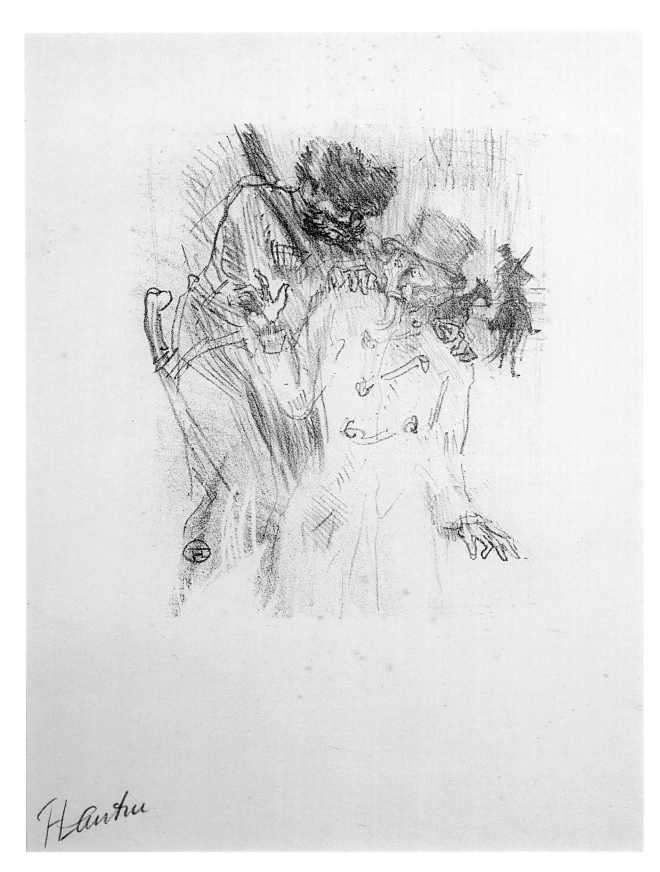

Schlome Fuss in the Synagogue

(from the book *Au Pied du Sinaï*)
1897, lithograph, 18 x 14.2 cm

After a few years Schlome returns home as a rich man, but finds his family on the brink of starvation due to the insufficient aid of the community. On the day of Yom Kippur he demands that the council beg his family members for forgiveness. Toulouse-Lautrec's illustration shows the moment when Schlome prevents the rabbi entering the tabernacle and the crowd gets furious.

Schlomé Fuss en la sinagoga

(del libro *Au Pied du Sinaï*)
1897, litografía, 18 x 14,2 cm

Después de unos años, Schlomé regresa a casa como un hombre rico, pero encuentra a su familia al borde de la inanición debido a la escasa ayuda de la comunidad. Durante el Iom Kipur, exige al consejo que pida perdón a los miembros de su familia. La ilustración de Toulouse-Lautrec muestra el momento en el que Schlomé impide el acceso del rabino al tabernáculo y la muchedumbre se enfurece.

Schlomé Fuss à la Synagogue

(du livre *Au Pied du Sinaï*)
1897, lithographie, 18 x 14,2 cm

Au bout de quelques années, Schlomé rentre chez lui après avoir fait fortune et trouve sa famille sur le point de mourir de faim car la communauté ne l'a pas suffisamment secourue. Le jour du Yom Kippour, il demande que le conseil aille demander pardon à genoux à sa femme et ses enfants. Toulouse-Lautrec montre le moment où Schlomé barre au rabbi l'accès au tabernacle et la foule furieuse qui se précipite sur lui.

Schlome Fuss in der Synagoge

(aus dem Buch *Au Pied du Sinaï*)
1897, Lithografie, 18 x 14,2 cm

Einige Jahre später kehrt Schlome als reicher Mann zurück und findet seine Familie, die von der Gemeinde kaum unterstützt wurde, am Rand des Verhungerns vor. Zu Jom Kippur verlangt er vom Rat eine Entschuldigung bei seinen Angehörigen. Toulouse-Lautrecs Illustration zeigt Schlome vor der erregten Menge, wie er dem Rabbi den Zugang zum Tabernakel verwehrt.

Schlome Fuss being Arrested

(from the book *Au Pied du Sinaï*)
1897, lithograph, 17.3 x 14 cm

This story is about the Jewish community of Busk in Galicia and the poor tailor Schlome Fuss being arrested to serve in the Austrian army.

Arresto de Schlomé Fuss

(del libro *Au Pied du Sinaï*)
1897, litografía, 17,3 x 14 cm

Esta historia trata sobre la comunidad judía de Busk en Galicia y el pobre sastre Schlomé Fuss que es arrestado para servir en el ejército austriaco.

Arrestation de Schlomé Fuss

(du livre *Au Pied du Sinaï*)
1897, lithographie, 17,3 x 14 cm

Cette histoire se passe dans la communauté juive de Busk, en Galicie, et rapporte comment le pauvre tailleur Schlomé Fuss a été arrêté pour servir dans l'armée autrichienne.

Die Festnahme von Schlome Fuss

(aus dem Buch *Au Pied du Sinaï*)
1897, Lithografie, 17,3 x 14 cm

Hier geht es um die jüdische Gemeinde im galizischen Busk und die Zwangsrekrutierung des armen Schneiders Schlome Fuss in habsburgische Armeedienste.

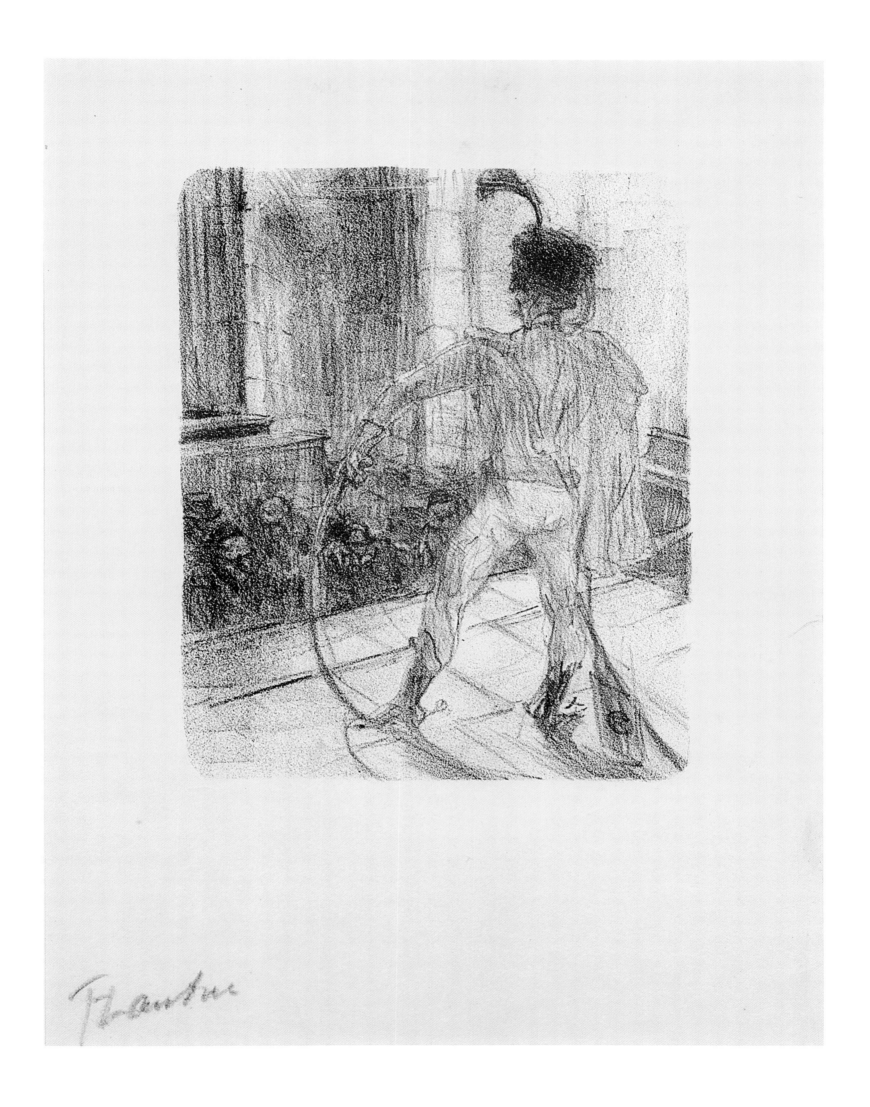

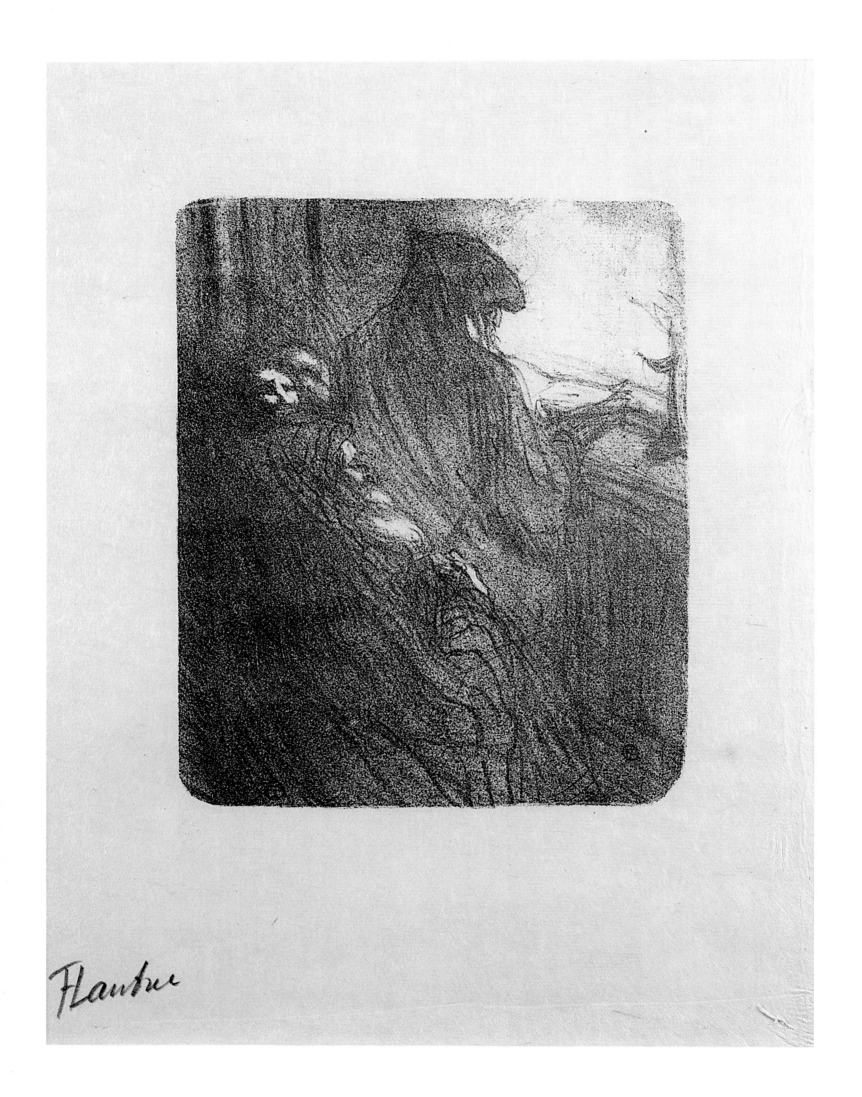

Flaubert

Praying Polish Jews

(from the book *Au Pied du Sinaï*)
1897, lithograph, 17.6 x 14.2 cm

A chapter of the book is devoted to the rituals of prayer during the Sabbath.

Judíos polacos rezando

(del libro *Au Pied du Sinaï*)
1897, litografía, 17,6 x 14,2 cm

Un capítulo del libro está dedicado a los rituales de rezo durante el sabbat.

La Prière des Juifs Polonais

(du livre *Au Pied du Sinaï*)
1897, lithographie, 17,6 x 14,2 cm

Un chapitre de l'ouvrage est consacré aux rituels de la prière durant le Sabbat.

Gebet polnischer Juden

(aus dem Buch *Au Pied du Sinaï*)
1897, Lithografie, 17,6 x 14,2 cm

Ein Kapitel des Buches ist den rituellen Gebeten am Sabbat gewidmet.

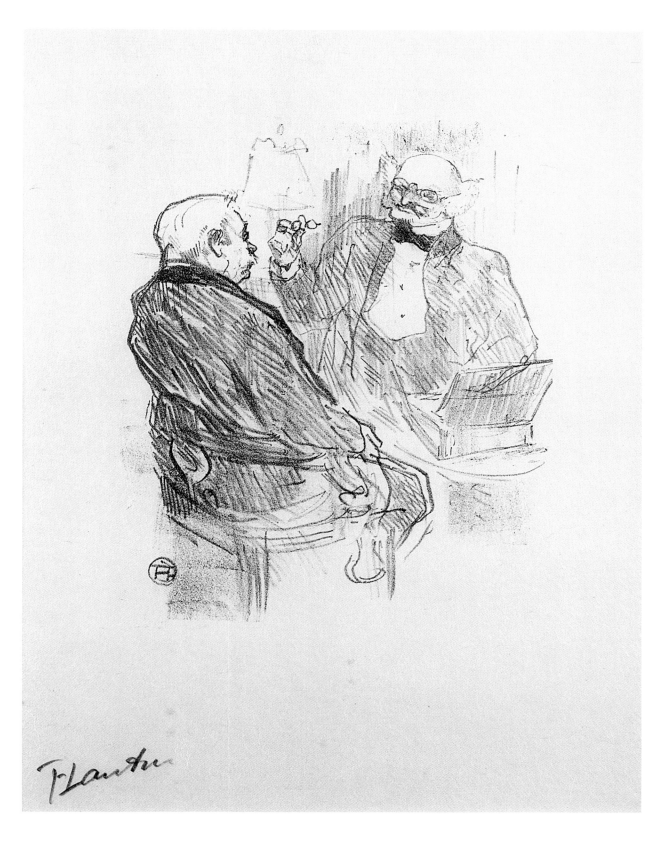

Georges Clemenceau and the Oculist Mayer

(from the book *Au Pied du Sinaï*)
1897, lithograph, 17.5 x 14.2 cm

An anecdote of how Georges Clemenceau became far-sighted and paid too much.

Georges Clemenceau y el oculista Mayer

(del libro *Au Pied du Sinaï*)
1897, litografía, 17,5 x 14,2 cm

Una anécdota de cómo Georges Clemenceau empezó a ver bien y pagó demasiado.

Georges Clemenceau et l'Oculiste Mayer

(du livre *Au Pied du Sinaï*)
1897, lithographie, 17,5 x 14,2 cm

Une anecdote rapporte comment Georges Clemenceau devint presbyte, ce qui lui revint fort cher.

Georges Clemenceau und der Augenarzt Mayer

(aus dem Buch *Au Pied du Sinaï*)
1897, Lithografie, 17,5 x 14,2 cm

Eine Anekdote: Wie Georges Clemenceau weitsichtig wurde und zuviel bezahlte.

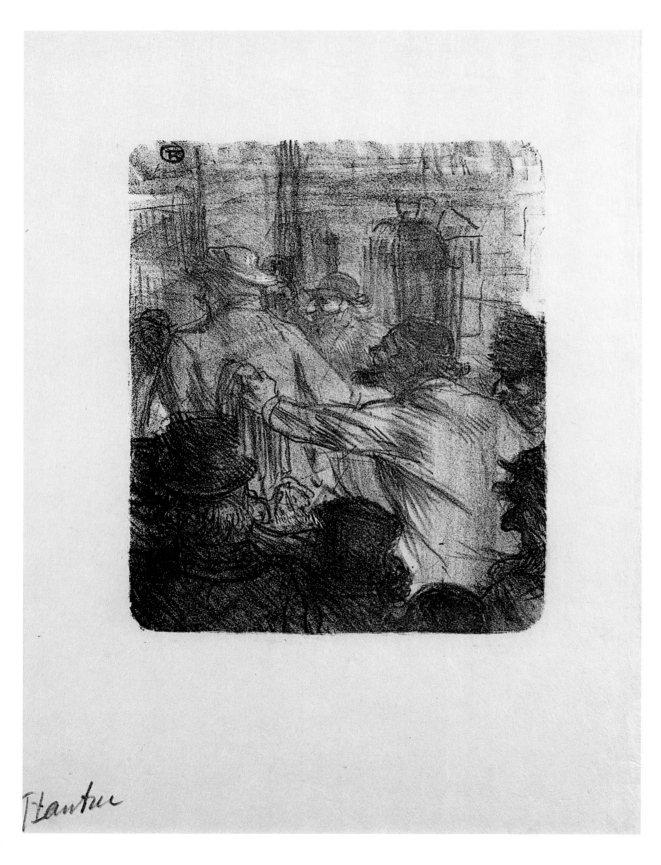

A Basement Shop in Cracow

(from the book *Au Pied du Sinaï*)
1897, lithograph, 17.3 x 14.3 cm

Georges Clemenceau presents in his book a description of the people of Cracow: the Polish, the Jews and their living circumstances. This lithograph depicts how Toulouse-Lautrec imagines the dark rear shops of the Jewish ghetto.

Una trastienda en Cracovia

(del libro *Au Pied du Sinaï*)
1897, litografía, 17,3 x 14,3 cm

Georges Clemenceau describe en su libro a las gentes de Cracovia: los polacos, los judíos y las circunstancias de su vida. Esta litografía muestra la imagen que Toulouse-Lautrec tenía de las oscuras trastiendas del gueto judío.

Une Arrière-boutique à Cracovie

(du livre *Au Pied du Sinaï*)
1897, lithographie, 17,3 x 14,3 cm

Dans son ouvrage, Georges Clemenceau décrit la population de Cracovie, les Polonais, les Juifs, et la manière dont ils vivent. Cette lithographie montre les sombres arrière-boutiques du ghetto juif telles que les imagine Toulouse-Lautrec.

Hinterhofladen in Krakau

(aus dem Buch *Au Pied du Sinaï*)
1897, Lithografie, 17,3 x 14,3 cm

Georges Clemenceau schildert in seinem Buch die Lebensverhältnisse der Krakauer – der Polen wie der Juden. Diese Lithografie verrät, wie sich Toulouse-Lautrec die düsteren Hinterhofläden im jüdischen Ghetto vorstellte.

The Cloth Hall, Cracow

(from the book *Au Pied du Sinaï*)
1897, lithograph, 17.6 x 14.4 cm

The Cloth Hall (Sukiennice) in Cracow is filled with a bustling and noisy crowd. Eager vendors try to seduce potential buyers.

El Mercado de los Paños, Cracovia

(del libro *Au Pied du Sinaï*)
1897, litografía, 17,6 x 14,4 cm

Una muchedumbre alborotada abarrota el Mercado de los Paños (Sukiennice) de Cracovia. Los vendedores tratan de atraer a los potenciales compradores.

La Halle aux Draps, Cracovie

(du livre *Au Pied du Sinaï*)
1897, lithographie, 17,6 x 14,4 cm

La Halle aux draps (Sukiennice) de Cracovie est remplie de gens qui s'affairent. Les vendeurs tentent d'attirer les acheteurs potentiels.

Die Tuchhallen, Krakau

(aus dem Buch *Au Pied du Sinaï*)
1897, Lithografie, 17,6 x 14,4 cm

In den Krakauer Tuchhallen (Sukiennice) herrscht ein äußerst reges Treiben. Die Verkäufer locken potenzielle Kunden an.

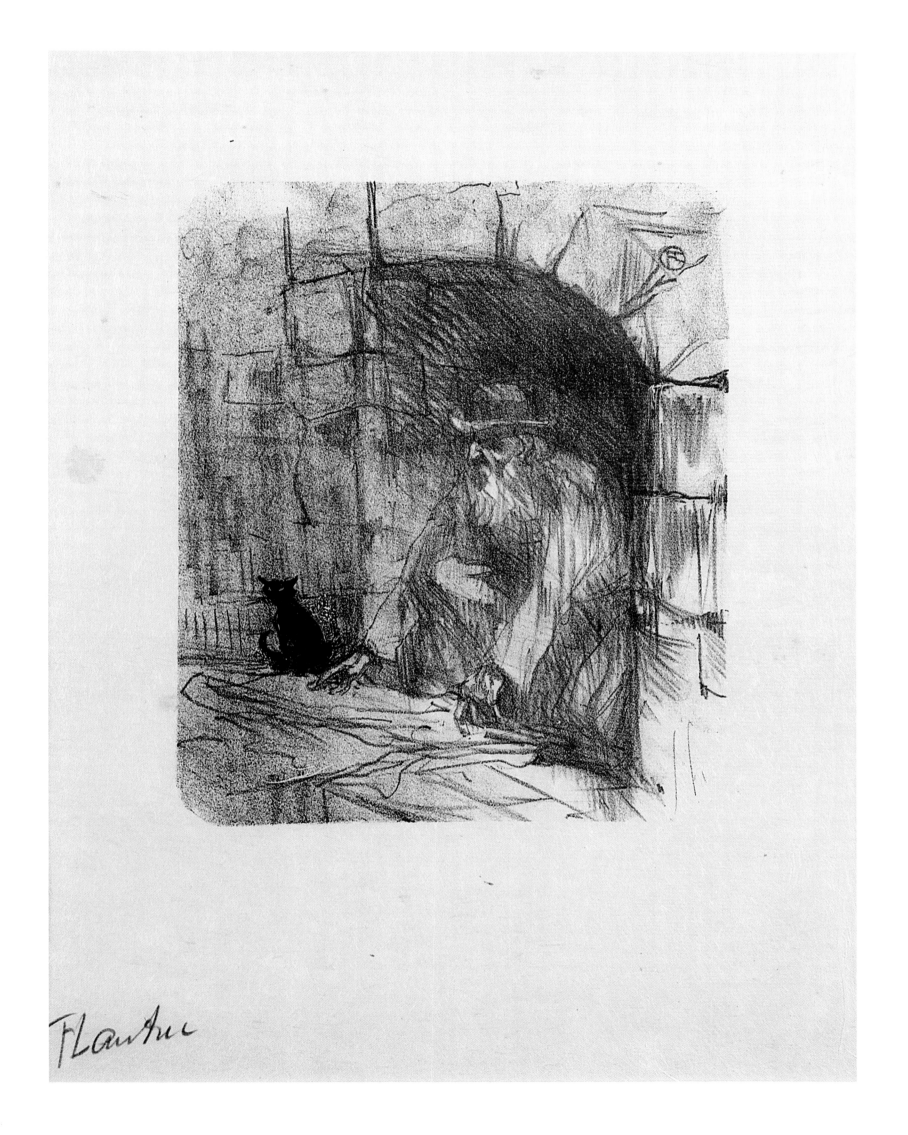

Lautrec

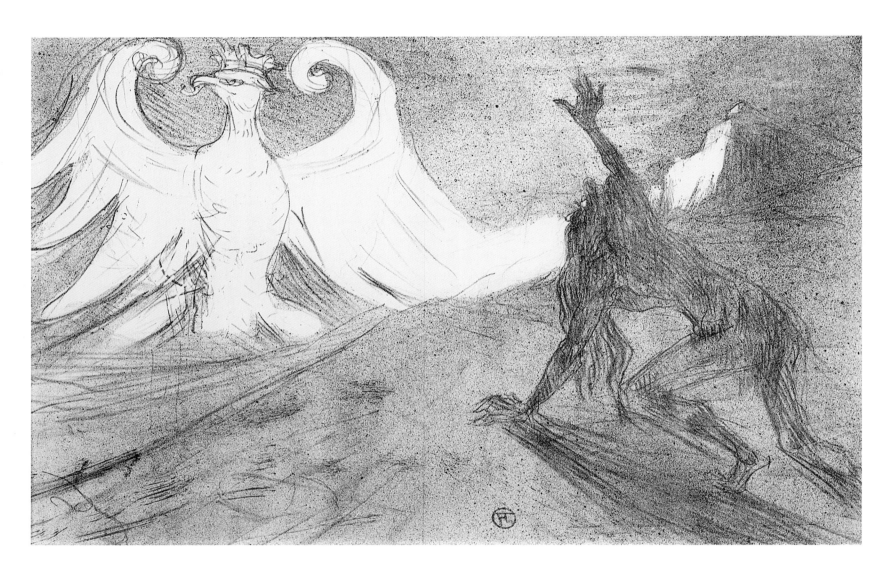

Au Pied du Sinaï (Cover)

1897, lithograph (refused), 26.2 x 41.6 cm

This lithograph was refused as a cover, but was added as an extra print in the deluxe edition.

Au Pied du Sinaï (Cubierta)

1897, litografía (rechazada), 26,2 x 41,6 cm

Esta litografía fue rechazada como cubierta, pero se añadió como un grabado adicional en la edición de lujo.

Au Pied du Sinaï (Couverture)

1897, lithographie (refusée), 26,2 x 41,6 cm

Refusée pour la couverture, cette lithographie a été reproduite à part dans l'édition de luxe.

Au Pied du Sinaï (Umschlag)

1897, Lithografie (abgelehnt), 26,2 x 41,6 cm

Die Lithografie wurde für den Umschlag abgelehnt, der Luxusausgabe jedoch als Sonderdruck hinzugefügt.

The Cemetery in Busk

(from the book *Au Pied du Sinaï*)
1897, lithograph (refused), 18.6 x 15.8 cm

El cementerio de Busk

(del libro *Au Pied du Sinaï*)
1897, litografía (rechazada), 18,6 x 15,8 cm

Le Cimetière de Busk

(du livre *Au Pied du Sinaï*)
1897, lithographie (refusée), 18,6 x 15,8 cm

Der Friedhof von Busk

(aus dem Buch *Au Pied du Sinaï*)
1897, Lithografie (abgelehnt), 18,6 x 15,8 cm

Henri de Toulouse-Lautrec (1864 – 1901)

1864	Born 24 November.	Nace el 24 de noviembre.	Né le 24 novembre.	Geboren am 24. November.
1872	Begins his schooling at the Lycée Fontanes (now Condorcet) in Paris. Starts to frequent René Princeteau's studio.	Comienza su educación en el Lycée Fontanes (ahora Condorcet) en París. Empieza a frecuentar el estudio de René Princeteau.	Entre au Lycée Fontanes (aujourd'hui Condorcet) à Paris. Commence à fréquenter l'atelier de René Princeteau.	Einschulung im Lycée Fontanes (heute Condorcet) in Paris. Besucht das Atelier von René Princeteau.
1878–1879	Fractures his legs.	Se fractura las piernas.	Se fracture les jambes.	Bricht sich nacheinander beide Beine.
1882	Enters Bonnat's studio and later that year begins to work in Cormon's studio.	Entra en el estudio de Bonnat y más tarde ese mismo año comienza a trabajar en el estudio de Cormon.	Entre dans l'atelier Bonnat et, plus tard dans l'année, commence à travailler dans l'atelier du peintre Cormon.	Tritt ins Atelier von Bonnat ein; später im selben Jahr Wechsel in Cormons Atelier.
1885	Meets Aristide Bruant and Suzanne Valadon, who becomes his mistress. Begins to frequent the Montmartre cabarets and dance halls.	Conoce a Aristide Bruant y Suzanne Valadon, que se convierte en su amante. Comienza a frecuentar los cabarés de Montmartre y salones de baile.	Fait la connaissance d'Aristide Bruant et de Suzanne Valadon qui devient sa maîtresse. Commence à fréquenter les cabarets et les bals de Montmartre.	Begegnung mit Aristide Bruant und Suzanne Valadon, die seine Geliebte wird. Verkehrt in den Cabarets und Tanzlokalen auf dem Montmarte.
1886	Meets Van Gogh. Leaves Cormon's studio. Exhibits at the Mirliton.	Conoce a Van Gogh. Abandona el estudio de Cormon. Expone en Le Mirliton.	Fait la connaissance de Van Gogh. Quitte l'atelier Cormon. Expose au Mirliton de Bruant.	Trifft Van Gogh, verlässt Cormons Atelier und stellt im Mirliton aus.
1888	Exhibits with 'Les Vingt' in Brussels. Quarrels with Suzanne Valadon. Contracts a venereal disease.	Expone con Les Vingt en Bruselas. Peleas con Suzanne Valadon. Contrae una enfermedad venérea.	Expose à Bruxelles avec Les Vingt. Se brouille avec Suzanne Valadon. Contracte une maladie vénérienne.	Ausstellung mit „Les Vingt" in Brüssel. Streit mit Suzanne Valadon. Zieht sich eine Geschlechtskrankheit zu.
1889	Exhibits for the first time at the Salon des Indépendants.	Expone por primera vez en el Salon des Indépendants.	Expose pour la première fois au Salon des Indépendants.	Stellt das erste Mal im Salon des Indépendants aus.
1891	Produces a poster (his first) for the Moulin Rouge.	Hace un cartel para el Moulin Rouge. Es su primer cartel.	Crée une affiche (sa première) pour le Moulin Rouge.	Gestaltet sein erstes Plakat für das Moulin Rouge.
1892	Begins to focus on lithography: four posters and two colour lithos.	Comienza a centrarse en la litografía: cuatro carteles y dos litografías en color.	Commence à concentrer son intérêt sur la gravure : quatre affiches et deux lithographies en couleur.	Wendet sich der Lithografie zu: vier Plakate und zwei Farblithografien.
1893	Becomes acquainted with the *Revue Blanche* circle. Begins to paint theatrical subjects.	Toma contacto con el círculo de *La Revue Blanche*. Empieza a pintar temas teatrales.	Lie des relations avec le milieu de la *Revue Blanche*. Commence à peindre des sujets issus du théâtre.	Bekanntschaft mit dem Kreis der *Revue Blanche*. Malt Sujets aus dem Theaterleben.
1894	Takes up residence in the house of ill repute in the Rue des Moulins.	Comienza a residir en una casa de mala reputación en la rue des Moulins.	S'installe dans une maison mal famée de la rue des Moulins.	Wohnt im Freudenhaus in der Rue des Moulins.
1895	Designs posters for May Belfort, May Milton and the *Revue Blanche*. Paints panels for La Goulue's booth. Visits London, where he participates in the exhibition *A Collection of Posters* and meets Oscar Wilde.	Diseña carteles para May Belfort, May Milton y *La Revue Blanche*. Paneles de pinturas para el camerino de La Goulue. Visita Londres, donde participa en la exposición *A Collection of Posters* y conoce a Oscar Wilde.	Dessine des affiches pour May Belfort, May Milton et *la Revue Blanche*. Peint un décor pour la baraque foraine de La Goulue. Visite Londres, il participe à l'exposition *A Collection of Posters* et rencontre Oscar Wilde.	Plakatentwürfe für May Belfort, May Milton und die *Revue Blanche*. Malt Dekorationen für La Goulues Schaubude. Besuch in London, wo er sich an der Ausstellung *A Collection of Posters* beteiligt und Oscar Wilde begegnet.
1896	Publishes *Elles*, prints depicting prostitutes.	Publica *Elles*, grabados que representan a prostitutas.	Publie *Elles*, des estampes montrant les pensionnaires des maisons closes.	Veröffentlicht *Elles* mit Grafiken von Prostituierten.
1897	First signs of alcoholism during the summer.	Primeros signos de alcoholismo durante el verano.	Premiers signes d'alcoolisme durant l'été.	Im Sommer erste Anzeichen von Alkoholismus.
1898	Exhibits at the Goupil Gallery, London, and travels there for the opening. Illustrates Jules Renard's *Histoires Naturelles*. His health begins to deteriorate.	Expone en la galería Goupil, en Londres, adonde viaja para la apertura. Ilustra *Histoires Naturelles* de Jules Renard. Su salud comienza a deteriorarse.	Expose à la Goupil Gallery de Londres et s'y rend pour l'inauguration. Illustre les *Histoires Naturelles* de Jules Renard. Sa santé se dégrade.	Stellt in der Goupil Gallery in London aus und reist zur Vernissage an. Illustriert die *Histoires Naturelles* von Jules Renard. Seine Gesundheit verschlechtert sich.
1899	Taken to an asylum at Neuilly after an attack of delirium tremens. Stays there until May and is released into the care of a guardian. Starts drinking again on his return to Paris in the autumn.	Es trasladado a un sanatorio mental en Neuilly después de sufrir un ataque de delirium tremens. Permanece allí hasta mayo, después le dan de alta al cuidado de un asistente. En otoño, a su regreso a París, comienza a beber nuevamente.	Interné en février dans une maison de santé de Neuilly après une crise d'éthylisme. Il y séjourne jusqu'en mai. Recommence à boire lorsqu'il rentre à Paris en automne.	Einlieferung in eine Anstalt in Neuilly nach einem Anfall von Delirium tremens. Im Mai wird er in die Obhut eines Betreuers entlassen. Im Herbst Rückkehr nach Paris, wo er wieder zu trinken beginnt.
1900	Further deterioration of his health. Visits the Exposition Universelle de Paris in a wheelchair.	Su salud continúa deteriorándose. Visita la Exposición Universal de París en una silla de ruedas.	Sa santé continue de se détériorer. Visite l'Exposition Universelle de Paris en fauteuil roulant.	Weitere Verschlechterung seiner Gesundheit. Besuch der Pariser Weltausstellung im Rollstuhl.
1901	Puts his Parisian studio in order, March-July. In August has a paralytic attack. Is taken to his mother's country home in Malromé where he dies on 9 September.	Ordena su estudio parisino entre marzo y julio. En agosto sufre un ataque de parálisis. Es trasladado a la casa de su madre en Malromé, donde muere el 9 de septiembre.	Met de l'ordre dans son atelier parisien de mars à juillet. Attaque de paralysie au mois d'août. Sa mère l'emmène chez elle à Malromé où il meurt le 9 septembre.	Ordnet von März bis Juli sein Pariser Atelier. Nach einem Schlaganfall im August wird er auf den Landsitz seiner Mutter in Malromé gebracht, wo er am 9. September stirbt.